ALBRECHT DÜRER

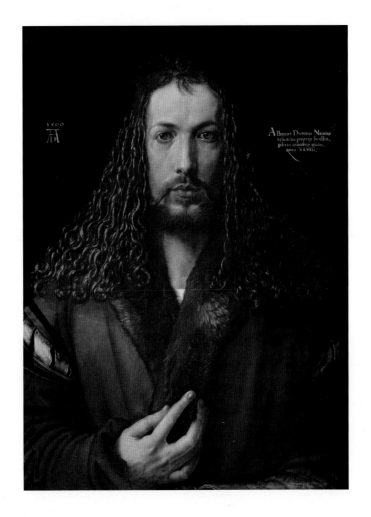

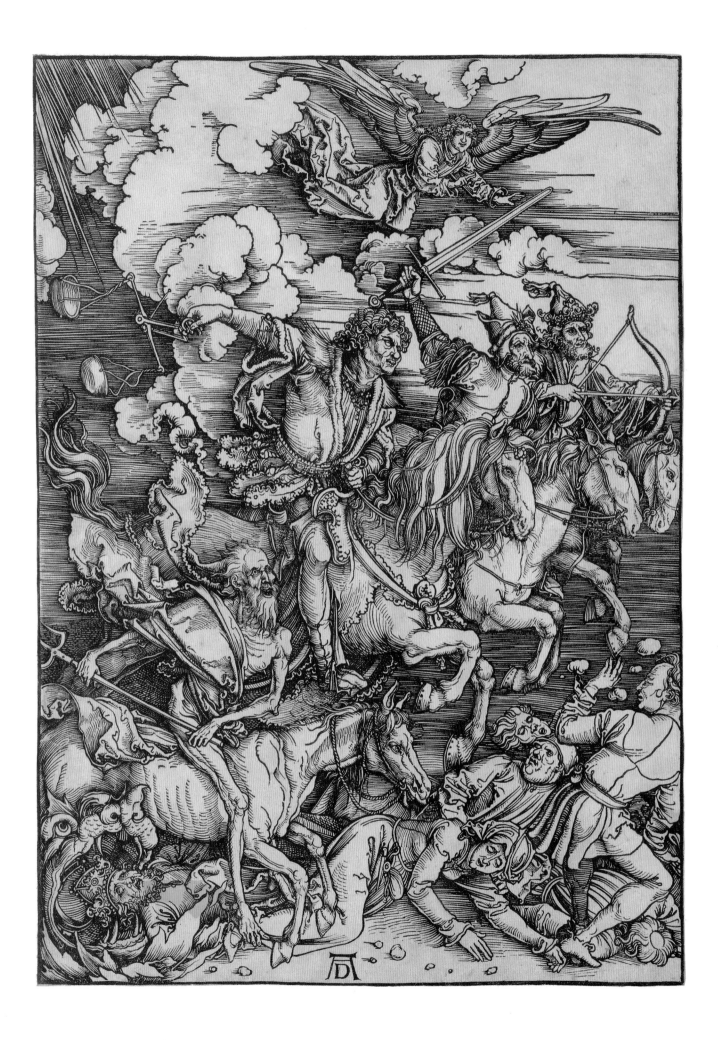

ALBRECHT DÜRER

HIS LIFE AND WORKS IN 500 IMAGES

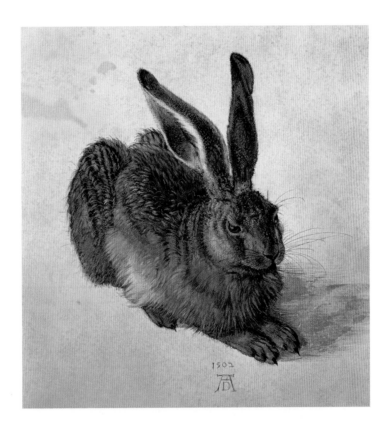

AN ILLUSTRATED EXPLORATION OF THE ARTIST IN CONTEXT,
WITH A BIOGRAPHY AND GALLERY OF HIS PAINTINGS AND DRAWINGS

ROSALIND ORMISTON

LORENZ BOOKS

This edition is published by Lorenz Books
an imprint of Anness Publishing Ltd
www.annesspublishing.com
info@anness.com

Publisher and editorial: Joanna Lorenz
Designer: Nigel Partridge
Indexer: Valeria Padalino
Production: Ben Worley

PUBLISHER'S NOTE
Although the information in this book is believed
to be accurate at the time of going to press,
neither the author nor the publisher can accept
any legal responsiblity or liability for any errors or
omissions that may have been made.

ADDITIONAL CAPTIONS:
Endpapers: front: Eight Studies of Wildflowers *(see
page 217); back:* Rhinoceros *(see page 216).*
Page 1: Self-portrait at age 28 *(see page 149) and
Albrecht Dürer's autograph.*
Page 2: The Four Horsemen, *in* The Apocalypse
series *(see page 131).*
Page 3: Young Hare *(see page 156).*

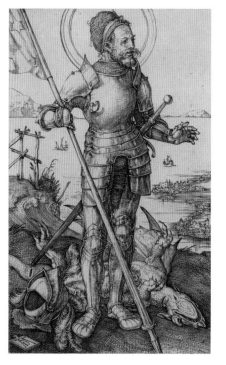

Left: St George on Foot, *1502. Dürer's masterful
engraving depicts St George (275–303) in armour
with helmet removed, and seemingly looking toward
an unseen person with whom he is speaking. He
carries a banner illustrated with a cross within a
circle, the emblem of the Order of St George. At his
feet a fabulous dragon lies on its back, dead. Dürer
added great detail, from the scales of the dragon's
skin to the seascape below the hill on which St
George stands triumphant.*

Opposite above, left to right: Detail from Self-portrait
with a Thistle *(see page 109);* Stag beetle *(see
page 176);* Aquilegia/Columbine, *c.1495–1500, a
drawing in watercolour and gouache on parchment.
Here Dürer has captured the botanical essence of
the plant, still attached to a clump of earth, with
its delicate leaves, flowing tendrils and purplish-blue
flowers.*

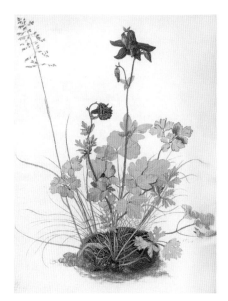

CONTENTS

INTRODUCTION

On the sudden death of German artist Albrecht Dürer on 6 April 1528, at his home in Nuremberg, tributes and condolences poured in. Accolades acknowledged Dürer's extraordinary talent, calling him 'the most excellent painter of all Germany and Italy.'

Recognition of Albrecht Dürer, artist, poet, writer, and theorist, reached across Europe. He was praised as the *Apelles Germaniae* (German Apelles), honoured by noble patronage, commissioned by the Elector of Saxony, Frederick the Wise, and Holy Roman Emperor Maximilian I. The fame of his art, in many mediums – woodcut, etching and engraving, drawing, watercolour and oil painting – resulted in his creation of an AD copyright monogram, to deter forgers.

Growing up, Dürer lived in his family's house in Nuremberg. His father, Albrecht Dürer the Elder, a goldsmith, was a prosperous man. He and his younger wife, Barbara Dürer, *née* Holper, were parents to eighteen children. Only three, Albrecht, and his younger brothers Endres Dürer, a

Below: A print from a c.1670 woodcut showing the interior of a printing works in Nuremberg, a city prosperous from the print and book publishing trade. Dürer had his own printing press to create prints for sale from woodcuts, etchings and engravings.

goldsmith like his father, and Hans Dürer, who followed Albrecht to become a painter, lived into adulthood. The Dürer family chronicle records that Albrecht was allowed to change profession, from apprentice goldsmith under his father's tuition to an art apprenticeship in the workshop of the notable Nuremberg painter Michael Wolgemut. The move marked the beginning of Dürer's remarkable career as an artist. A silverpoint drawing *Self-portrait at the age of thirteen* reveals Dürer's maturity at an early age with this difficult medium, a skill probably taught to him by his father. It may indicate an early interest in the work of German artist Martin Schongauer, whose *Angel of the Annunciation, c.*1470 (see page 27) bears resemblance to Dürer's self-portrait.

PRINT-PUBLISHING

Nuremberg, Dürer's birthplace, was a prosperous city due to its central location in northern Europe, its university, and its prolific print-publishing trade. Dürer's godfather was Anton Koberger, a noted publisher on an international scale. Book publishers

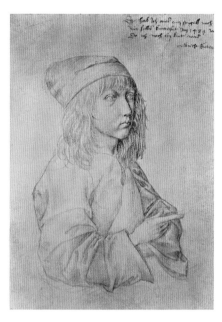

Above: Self-portrait at the age of thirteen, 1484. The drawing in silverpoint pencil shows the draughtsman skills that Dürer as a young boy had already learnt from his father. (See also page 102.)

wanted illustrations, and there was a growing demand for solo or print series from European artists as collectors' items. Prints could sell in thousands of copies. As a professional artist, Albrecht Dürer capitalised on this trade, and employed an agent to travel Europe, selling his prints. His mother Barbara, and wife Agnes Frey (1475–1539), sold his work at Nuremberg and Frankfurt print fairs. Dürer's remarkable woodcuts vied with his religious and secular paintings for the greatest praise.

DÜRER'S JOURNEYS

Albrecht Dürer's travels through Europe were extensive, from 1490–94 as a journeyman, then on solo trips in northern Europe, possibly twice to Italy around 1494–96 and in 1505–07. Later, from 1520–21, he toured the Netherlands with his wife and a servant. Wherever he travelled, Dürer made

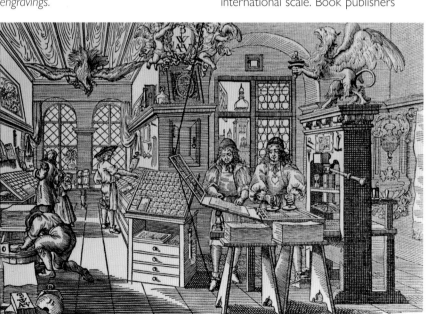

useful contacts, such as the brothers of the late Martin Schongauer in Colmar, France, whom he much admired, and artist Giovanni Bellini (c.1430–1516) in Venice. He exchanged works with other highly-respected artists, such as Raphael Sanzio (1483–1520) and Lucas van Leyden (active 1508–33).

A LONG-LASTING LEGACY

After suffering a debilitating illness for years, Dürer died, a rich man, in 1528. Four volumes of his theoretical works were published the same year. Agnes Dürer continued to promote and protect her husband's legacy. After his death there was a mania for his work (or many forgeries of it) for another half century. Meanwhile, a younger German artist, the Augsburg-born Hans Holbein the Younger (1497–1543), would take on the attribute of *Apelles Germaniae*.

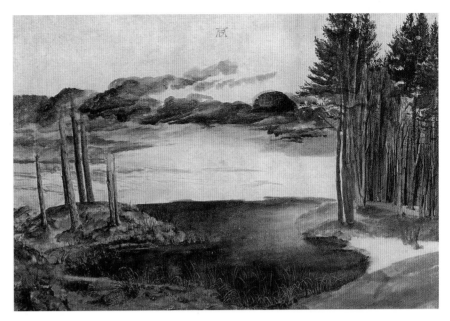

Above: Landscape with a Woodland Pool, c.1497, 26.2 x 36.5cm (10.3 x 14.3in), created in watercolour and body-colour on paper. This is one of Dürer's earliest landscapes, possibly of a scene outside Nuremberg.

ALBRECHT DÜRER – A TIMELINE

1471 Albrecht Dürer the Younger was born on 21 May in Nuremberg to goldsmith Albrecht Dürer the Elder (1427–1502) and Barbara Dürer, *née* Holper (1452–1514). He was the third child of eighteen children. Only three children, all male, survive to adulthood, Albrecht with his younger siblings Endres (1484–1555) and Hans (1490–c.1538).
1481–82 Dürer receives basic formal education in reading, arithmetic, writing, and possibly Latin.
1484–85 Apprenticed in his father's goldsmith workshop. First self-portrait – a silverpoint drawing – aged thirteen.
1486 November 30, changes his career course from goldsmith to painter and begins an apprenticeship with noted Nuremberg artist Michael Wolgemut (1434–1519).
1489 November 30, three years later, he completes his apprenticeship with Wolgemut and begins to travel as a journeyman.
1490–94 Travels to the Upper Rhine, including Colmar, from autumn 1491 to spring 1492, to meet artist Martin Schongauer, who died however before Dürer arrived. Possible stays in Alsace and Basel, and Strasbourg.

1494 Returns to Nuremberg 18 May and marries Agnes Frey on 7 July. In the autumn Dürer travels to Italy via Innsbruck and southern Tyrol, and on to Venice.
1495 Receives first commission for paintings from his friend, the patrician, scholar and humanist Willibald Pirckheimer (1470–1530).
1497 Dürer begins to sign his work with the monogram 'AD'.
1498–1500 Creates a series of remarkable woodcuts, *The Apocalypse*, 1497–98, which brings Dürer fame across Europe. Gains membership to the exclusive patrician 'Gentleman's Taproom' club in Nuremberg. Paints major self-portraits in 1498 and 1500.
1501–04 Nature studies, engravings, and study of human proportion occupy Dürer's work. Albrecht Dürer the Elder dies on 20 September 1502. His widow, Barbara, with their son Hans, move in with Albrecht and his wife Agnes in 1504.
1505–07 Second visit to Italy. Has great success with an altar panel *Madonna of the Rose Garlands*, 1506, commissioned for the church of San Bartolomeo by the German Dominican community in Venice.
1508 Dürer receives a large-scale commission – the Heller altarpiece – which is delayed due to his poor health, creating discord between him and the patron Jakob Heller.

1509 Nominated as member of the Great Council of Nuremberg. Buys a large house in Zisselgasse, his home and workshop.
1512 Dürer is employed by Emperor Maximilian I.
1513–14 Dürer creates three masterful engravings: *Knight, Death, and Devil*, 1513; *St Jerome*, 1514; and *Melencolia I*, 1514. Dürer's mother Barbara dies on 6 May 1514.
1515 Awarded an annual stipend by Maximilian I for services to the emperor.
1519 Travels across Switzerland with Nuremberg friends Pirckheimer and Anton Tucher.
1520–21 Travels to the Netherlands with his wife Agnes and a maid. Is present in Aachen at the coronation of Charles V. Dürer's annual stipend is renewed by the emperor. In late 1520 he contracts an unspecified disease, from which he never fully recovers. Returns to Nuremberg in July 1521.
1528 On 6 April Albrecht Dürer dies and is buried in the Johannis Friedhoff cemetery in Nuremberg.
1538 Death of Hans Dürer.
1539 Death of Agnes Dürer.
1555 Death of Endres Dürer.

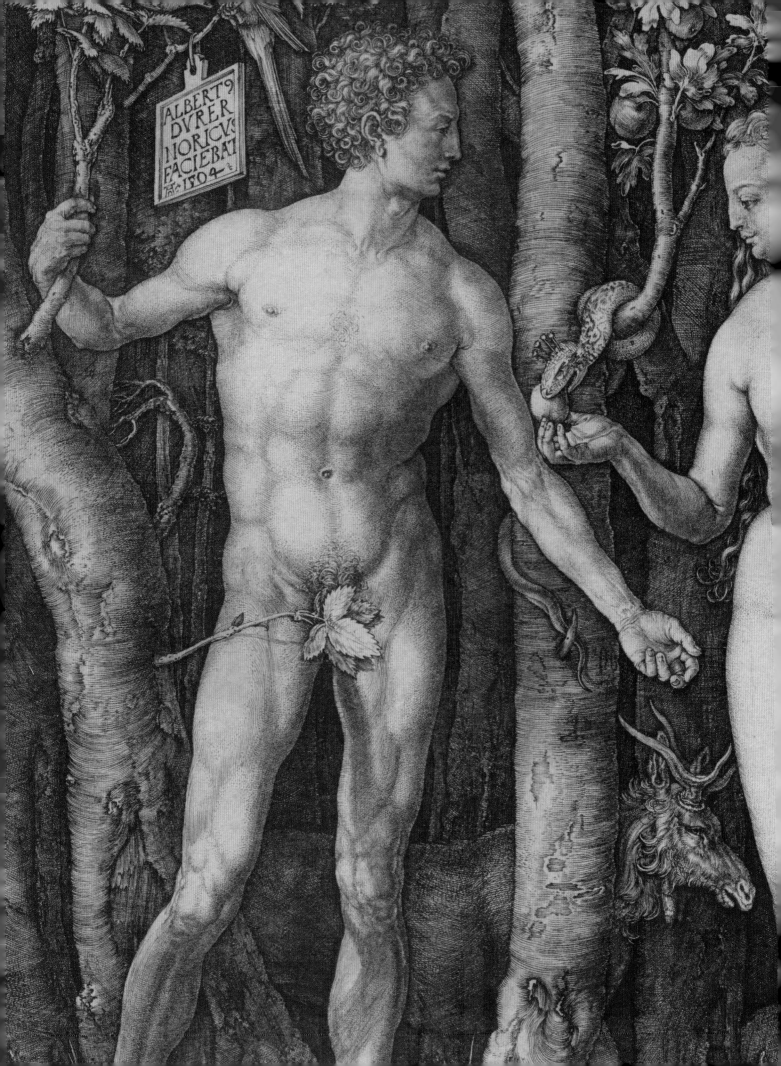

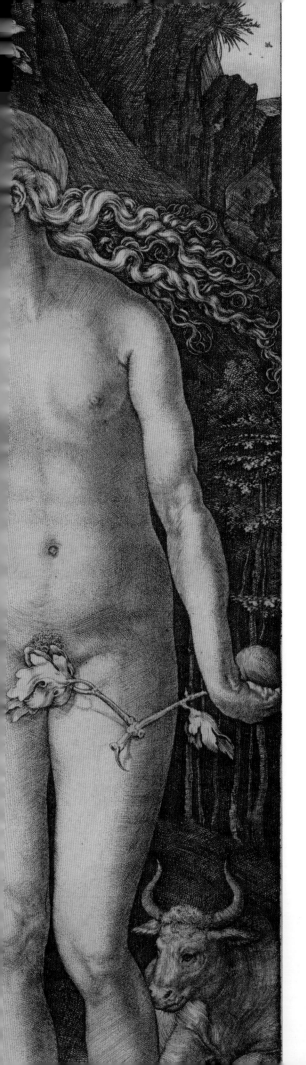

ARTISTIC GENIUS

The 15th and early 16th century in Western art history acknowledges an astonishing wealth of talented masters of art. It includes artists from Masaccio to Leonardo da Vinci and Michelangelo Buonarotti, whose work encapsulates the Renaissance in Italy. In the Low Countries, innovative painters and sculptors broke from the late medieval Gothic style to embrace humanistic values, as visualised in the art of Hubert and Jan van Eyck, amongst an eminent group. Albrecht Dürer of Nuremberg studied Italian and Netherlandish art. He greatly admired the work of fellow German Martin Schongauer. From these and many other art sources, Dürer's power of observation translated into masterpieces in portraiture, landscapes and altarpieces, recognised by patrons that included kings. Yet, it is his graphic work, the woodcuts and engravings, that gained him vast celebrity status across continents. His genius was to market himself through mass-production of his graphic work via the printing press. In addition, he created a copyright, a recognisable 'AD' monogram logo, visible on each original work and reproduced on every one of the thousands of prints he made, to be sold via agents to galleries, and at print fairs and art markets, throughout northern and southern Europe and beyond.

Left: Adam and Eve, 1504 (detail, see page 173) was one of Dürer's largest engravings, full of detail and reflecting his interest in the proportions of the human figure.

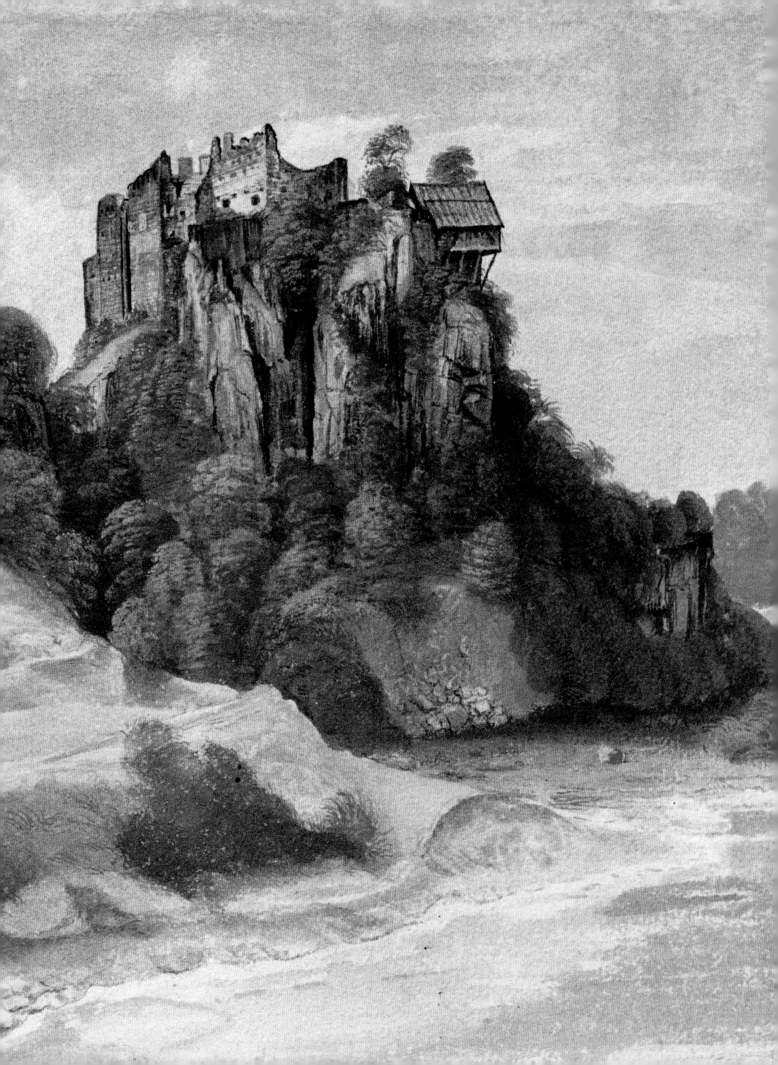

ARTIST AND TRAVELLER

In 1506, Albrecht Dürer was successfully working in Venice. In a letter to his Nuremberg mentor and friend Willibald Pirckheimer, he wrote 'Here I am a gentleman, at home a parasite' (October 1506). In a few words Dürer revealed the vast difference between Italy, where 'artist' had been elevated to a respected profession, and Germany, where an artist was categorised as an artisan trade. Dürer altered that perception dramatically, marketing his remarkable woodcuts and engraved prints across Europe, while mixing in the society of important patrons to gain elite commissions.

Travelling across Europe several times, from Germany to Italy to the Netherlands, enhanced Dürer's knowledge of artistic practices and enlarged his social network. His art was informed by many sources but his genius was unique. His woodcut series *The Apocalypse* in 1497–98 established him as the leading graphic artist of the day. His large-scale *Madonna of the Rose Garlands*, 1506, consolidated his reputation in Italy as a master painter.

Above: Piper and Drummer, 1504, by Albrecht Dürer. From the exterior of the right wing of the Epiphany altar created for Wittenberg Castle Church, the so-called Jabach Altarpiece. (See also page 161.)

Left: View of a castle overlooking a river, 1494–96 (detail, see page 113). The watercolour by Albrecht Dürer is of Segonzano castle in the Cembra Valley, Trentino, Italy.

NUREMBERG – CITY OF GOLD

Nuremberg in Germany, Dürer's birthplace, was granted free Imperial status in 1423 by Sigismund of Luxembourg (reign 1411–37). The city, a prosperous centre for business, attracted excellent craftsmen. By the late 1400s, around 120 gold and silversmiths were resident, including Albrecht Dürer the Elder.

Nuremberg was first documented in 1050. The fortified city walls date from the 13th to mid-15th centuries. Flowing through the city is the Pegnitz river, dividing the northern parish of Saint Sebald and the southern parish of Saint Lawrence. The city attracted artisans in metal, working with copper, silver, gold, and brass. Silver and copper mines in Saxony and Bohemia were sources of the raw metals.

THE CITY OF ART

When Cardinal Aeneas Silvius Piccolomini (1405–64 – he became Pope Pius II from 1458), an Italian over

Below: Forest map of Nuremberg, 1516. A view of the city of Nuremberg from the north showing the Sebalder and Lorenzer forests. The painting is attributed to cartographer and physician Erhard Etzlaub (c.1455–1532), who became a citizen of Nuremberg in 1484.

20 years resident in Germany, visited Nuremberg in 1452, he extolled its beauty as a work of art. In his journal *Commentaries*, Piccolomini effused how, travelling toward Nuremberg, one first caught sight of the city's grandeur. He commented on the wide streets, the elegant houses fit for princes, the majestic Imperial Castle, and the splendour of the St Lawrence and St Sebald churches. Michael Wolgemut's woodcut created some years after, *View of Nuremberga* (opposite), shows the city from the south-east, with the same distinctive landmarks.

Nuremberg stood at a European crossroads of key trade routes for import and export, with trade offices across Germany, and a financial centre. The free Imperial city had around 40,000 inhabitants in the early 1500s. In 1525 the city adopted Lutheranism, breaking away from the Roman Catholic church, which dramatically changed the

Above: Coin-striking in a monetary workshop, an engraving by Hans Schäufelein (1480/85–1540), who probably worked in Albrecht Dürer's Nuremberg workshop around 1503–04.

FAMILY COMPANIES

Many workshops were run by generations of families, such as that of Peter Vischer the Elder, a sculptor and brass maker in Nuremberg. Considered the 'Dürer' of sculpture, he was head of the city's main bronze foundry, working with his five sons. Vischer's major works included the 1513 figures of Theodoric and King Arthur in bronze, for a tomb designed by Albrecht Dürer the Younger for Emperor Maximilian I. Vischer's father, Hermann Vischer the Elder (died 1488), sculptor and bronze worker, had established the foundry. A goldsmith apprenticeship took three years to complete, with little allowance to work in other cities once registered in the guild, in order to maintain loyalty and to protect working methods and city commissions. Exceptions were made for respected artisans not resident in the city.

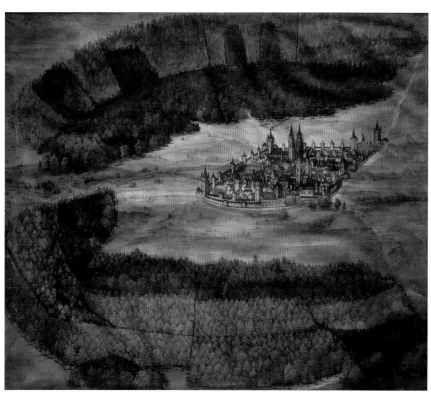

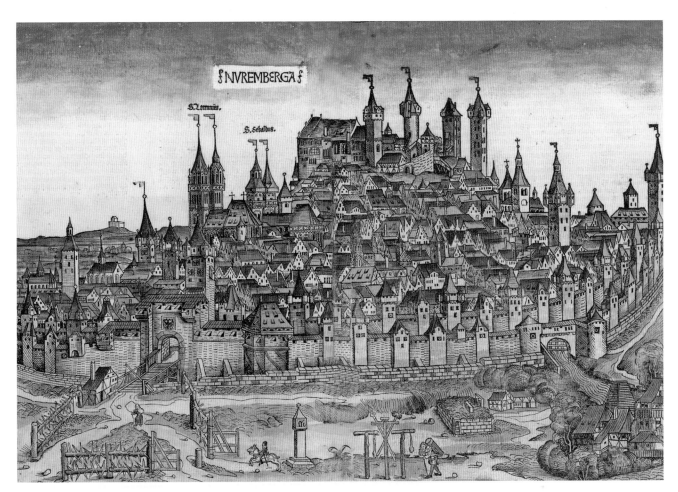

Above: View of Nuremberga, *from the famous Nuremberg Chronicle, 1493, depicted in a coloured woodcut by Michael Wolgemut. Wolgemut became mentor/ tutor to Albrecht Dürer the Younger in Nuremberg, giving him a three-year apprenticeship.*

lives of inhabitants. For artisans who created religious works the Reformation was a major loss of livelihood that had to be restructured to appeal to a secular market.

PRODUCTIVE BUSINESSES

Great masters of metalwork from Nuremberg included Hans Krug I (died 1519), the first in a family of late 15th-

Right: A coin portrait of Elector of Saxony Frederick III the Wise, created by Hans Krug the Elder, in Nuremberg, c.1509. Created in silver with metal working, the front shows a bust of Frederick III, and the reverse shows an eagle with a coat of arms on its chest. Both sides have a rim of lettering and coats of arms.

to early-16th-century goldsmiths. He ran a prosperous workshop with his sons Hans Krug II (died 1529), Ludwig and Erasmus, who was of Dürer's generation. There followed masters such as Melchior Baier, Wenzel Jamnizer, Hans Petzold and Freidrich Hildebrandt. From the 14th to 16th centuries Nuremberg was pivotal for coin production too. Metalworkers liaised with artists, who produced original drawings, and models in plaster, lead or wood.

The city prized the quality of its workmanship not only in metal but in architecture – Hans Beham the Elder (c.1455–1538) was the most famous in Dürer's period – and in sculpture, with Peter Vischer the Elder (1455–1529). After the death of Michael Wolgemut, Dürer and his assistants gained the majority of commissions for paintings. Keeping it within family ties, his godfather, Anton Koberger, dominated print-publishing across Germany and Europe.

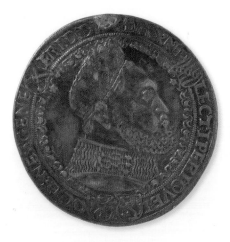
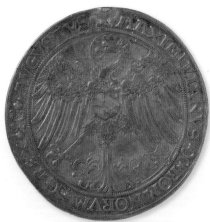

DÜRER'S PARENTS

Albrecht Ajtósi – Dürer the Elder – a goldsmith, settled in Nuremberg around 1455, a city valued for its metal foundries and quality of goldsmiths. Many workshops in the city were run by families of metal workers. Perhaps Dürer planned for a family dynasty of goldsmiths too. He married Barbara Holper in 1467.

Dürer the Younger greatly respected his parents, They were a devoted family. He trained under his father, dutifully apprenticed as a goldsmith until confessing that he would rather be an artist. The death of each parent greatly affected him, notable in diary entries and poignant artworks.

THE DÜRER FAMILY

Albrecht Ajtósi (1427–1502) was born in Ajtós, near Gyula, a village in eastern Hungary, the son of Anton Ajtósi and his wife Elisabetha. The family tended cattle and horses. Albrecht had a sister Catharina, and two brothers, Lassien, a bridle-maker, and Johannes, a theologian and pastor in Grosswardein, eight miles from Ajtós. Little is recorded of his early life except that he trained locally as a goldsmith in Gyula, then travelled as a journeyman, gaining work experience. He is listed as serving in the militia in 1444.

In Germany, Ajtósi (meaning door or doorframe in Hungarian) altered his name to Dürer. 'Tur' is the modern German equivalent for door. From family records, Dürer the Younger tells that his father dwelt a long time in the Netherlands and lived amongst 'the great artists'. He took up permanent residence in Nuremberg in 1455. From 25 June that year he was employed as assistant to a master goldsmith, Hieronymus Holper (died c.1476).

A NUREMBERG MARRIAGE

In 1467 Dürer married Barbara Holper (1452–1514), the fifteen-years-old daughter of Hieronymus and Kunigunde Holper. The same year, alongside his father-in-law, he was appointed to be a gold and silver assayer, an official 'weigher and tester' of minted coins. The following year, on 7 July 1468, Dürer the Elder was appointed a Master goldsmith, allowing him to

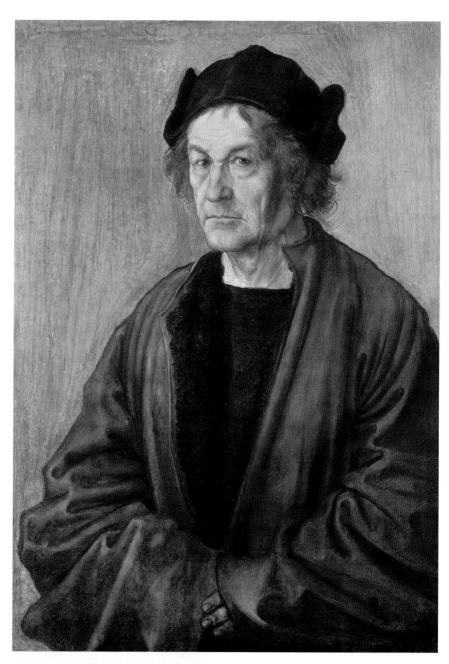

Above: The Painter's Father. *Probably a 16th-century copy of the lost Dürer original c.1497, it entered the collection of King Charles I of England in 1636.*

Left: A depiction of a goldsmith's workshop in late 16th-century Nuremberg, colour lithograph card series, c.1905.

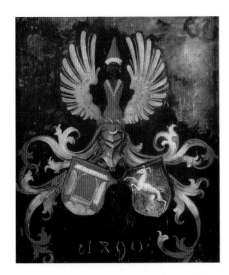

Above: An Alliance Coat of Arms of the Dürer and Holper Families, *1490. A symbiosis of the heraldic arms of Albrecht Dürer the Elder and Barbara Holper.*

run a workshop with apprentices and assistants. A week later on 13 July his first child was born, a daughter Barbara, named after her mother. Records show that on 12 May 1475 Dürer bought a large house, no. 493 on the corner of Under der Vesten and Schmiedegasse, in Nuremberg. (The house was destroyed by bombing during World War Two.) It was an impressive location, purchased possibly to accommodate his growing family and various business ventures. At one point, Dürer was an investor in a goldmine, 1481–83. Dürer's wife, much younger than her husband, gave birth to eighteen children. The Dürer-Holper family chronicle – it was a custom to keep a family record

DÜRER-HOLPER COAT OF ARMS

A Dürer-Holper Coat of Arms was created following the 1467 marriage. On two shields, the paternal left side depicts a door, a symbol of the Hungarian name 'Ajtósi' (ajtókeret = door frame) and German 'Dürer'; and on the maternal right side is a ram, the Holper family emblem. Rich in colour, the Coat of Arms was painted by Dürer the Younger on the reverse of a portrait of his father in 1490 (see page 103).

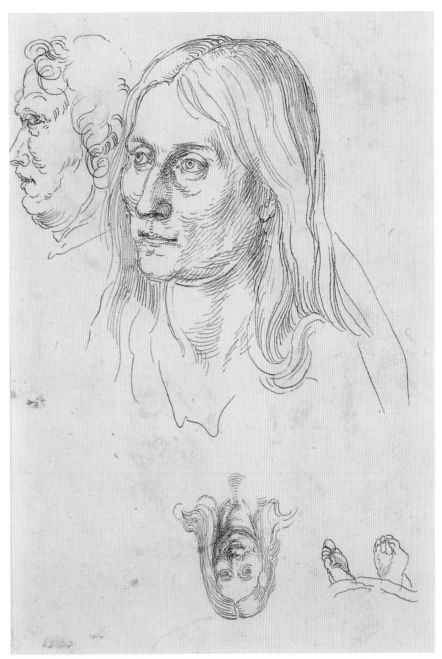

in Nuremberg – lists the children. Only three survived to adulthood: Albrecht, born 21 May 1471; Endres, born April 1484; and Hans, born February 1490.

A GOOD FATHER

Dürer the Elder was a superb draughtsman, a talent he passed on to his surviving three sons, who all chose artistic professions: Albrecht and Hans as artists, Endres as goldsmith. A self-portrait drawing by their father reveals his virtuosity (see page 88), an intimate yet unsentimental depiction in silverpoint. Care for his family is evident in a letter, dated 24 August 1492, sent

Above: Study sheet with probable portrait of Barbara Dürer, plus other drawings of heads and feet, by Albrecht Dürer the Younger in black ink on paper, 1493–94.

to his wife from Linz, where he had been summoned to show work to his patron Emperor Frederick III, from whom he received a first commission in 1489. In a warm, personal letter, Dürer calls her his 'dear wife.' He reports on his meeting with the emperor, and gently reminds Barbara to 'instruct the apprentices to get on with things.' It was usual for artisans' wives to oversee a business during a husband's absence.

APPRENTICESHIPS

In 1484, after a school education, Albrecht Dürer was assigned as an apprentice in his father's goldsmith workshop. A three-year apprenticeship would teach him drawing, and the practical knowledge to create, cast and finish works in various metals. He then entered an apprenticeship with Michael Wolgemut.

From 1481 Dürer was educated at school in Nuremberg, a traditional syllabus of reading, writing, basic Latin and arithmetic. Between the ages of ten and twelve he joined his father's busy workshop. Dürer the Younger's remarkable skills of engraving began with this apprenticeship.

Only three Dürer drawings from this period are extant. A silverpoint drawing *Self-portrait at the age of thirteen*, 1484 (see page 102) shows him as a young boy at the time he worked for his father. This self-portrait was kept by Dürer's parents. During his

apprenticeship, the younger Dürer was exploring the potential of silverpoint, of which Dürer the Elder was a master, as seen in his self-portrait of the same year (see page 88). In a different medium, black charcoal, the younger Dürer drew *A Lady holding a Hawk*, c.1484–86. Text by an unknown hand states that it was created in the presence of Konrad Lomayer, possibly a journeyman employed in the workshop, who became a master goldsmith in 1490. The intricate *Madonna and Child enthroned with two angels making music*, 1485, in pen and ink, is the third

Below: Portrait of Michael Wolgemut, *c.1516, by Dürer the Younger, painted in oil on linden wood. A fine portrait of Dürer's arts tutor. (See also page 218.)*

Right: The Imperial Window, *1493, created by Michael Wolgemut in stained glass for the Church of Saint Lawrence in Nuremberg, Germany.*

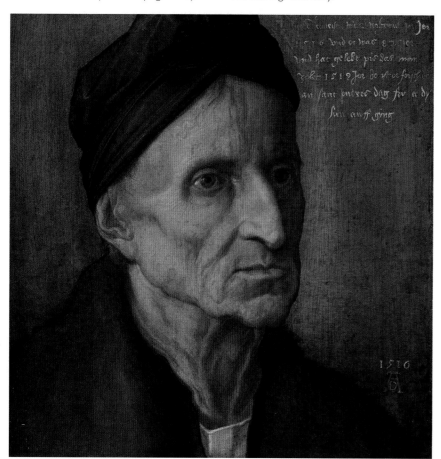

remaining drawing from Dürer's first apprenticeship (see page 102). Dürer clearly utilised the goldsmith skills gained under his father's tutelage to later create masterful woodcuts and engravings.

FROM GOLDSMITH TO PAINTER

After two years' apprenticeship, Dürer wanted to change profession to become a painter. The drawing, etching, engraving and woodcut skills he was learning may have led to this decision. The Dürer family chronicle records him asking his father for permission. Dürer wrote:

'But when I could work neatly my desire drew me more to painting than to goldsmith's work, so I laid it before my father; but he was not well pleased, regretting the time lost while I had been learning to be a goldsmith. Still, he let it be as I wished...'

WOLGEMUT'S WORKSHOP

Dürer's tutor Michael Wolgemut was a successful painter and woodcut designer, living in the same street as the Dürer family, four doors away at Burgstrasse 21. Wolgemut's work straddled late Gothic to early Renaissance art. He is noted for realism in portraiture, as in *Portrait of Ursula Tucher* (see right) and *Portrait of Levinus Memminger, c.*1485 (see page 60), which have a compositional style that informed Dürer's own portraits. Wolgemut also created intricate woodcut designs, such as *The Parable of the Good Samaritan* (see below). The illustrations for the *Nuremberg Chronicle* (see pages 13, 24–25 and 28) and his stained glass (opposite) proved his dexterity in any medium. Wolgemut's methodology and teaching is evident in Dürer's pendant portraits of his parents (see page 103), which were created around 1490 at the time of completing his apprenticeship. Durer's later *Portrait of Michael Wolgemut,* 1516 (opposite), is remarkable for its intimate realism.

Below: An illustration of the second part of the biblical parable of the Good Samaritan, a woodcut created c.1491 by Michael Wolgemut.

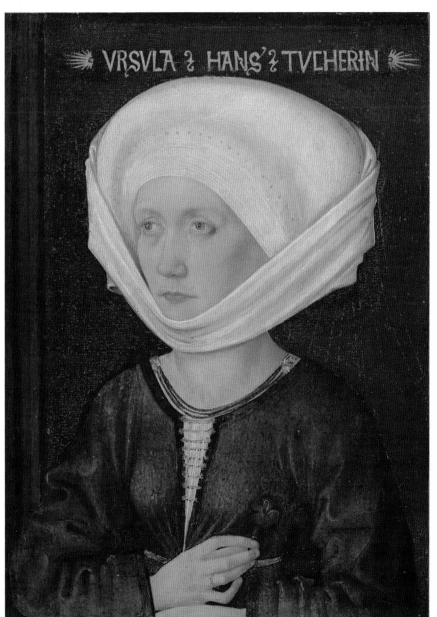

The next move heralded the beginning of Dürer 's remarkable career as an artist. On 1 December 1486 he entered an apprenticeship with the noted Nuremberg painter Michael Wolgemut (1434–1519) who created woodblock illustrations for the *Nuremberg Chronicle* 1493. In the workshop Dürer would have been taught practical knowledge of pigment grinding, gilding, panel priming, paint techniques, engraving and woodcut design. He also collected prints and copied artworks. A workshop would hold prints of prominent artists' works as models to learn from. Dürer much admired the work of Alsace painter-engraver Martin Schongauer

Above: Portrait of Ursula Tucher, *1478, by Michael Wolgemut, in oil on linden wood. Wolgemut was noted for the realism of his portrait depictions.*

(*c.*1450–91) who was also the son of a goldsmith. (Dürer tried to visit him later, in 1492, but Schongauer had died; see page 26.) Schongauer was a master in the field of woodcuts and engraving, with prints widely sold across Europe. The refined skill, steady hand and precise incision with which goldsmiths engraved the surface of gold and silver objects was utilised by Dürer when he transferred to an art apprenticeship. Accurate, clearly defined detail is visible in his woodcuts and engravings.

FRIENDS AND FAMILY

The three surviving children of Dürer the Elder and Barbara Holper, all male, followed artisan professions. Albrecht and Hans became artists, and Endres trained as a goldsmith. Dürer created a network of colleagues and friends in Nuremberg. Willibald Pirckheimer, a humanist scholar, was his valued friend and mentor.

There were many people in Albrecht Dürer the Younger's life who proved to be beneficial contacts in his early years starting out as an artist. He received support from members of the Dürer and Holper families, and from social connections in the Nuremberg community.

Below: Painter in studio before a painting. *This 19th-century engraving depicts Willibald Pirckheimer standing behind Albrecht Dürer, who is seated before an easel in his studio.*

ANTON KOBERGER
In 1471 Albrecht Dürer the Elder asked his neighbour, friend and business colleague Anton Koberger to be godfather to Dürer the Younger. Before his step into publishing, Koberger (c.1445–1513) had trained as a goldsmith in Nuremberg. A wealthy, successful man, with printing presses across Germany, the younger Dürer is thought to have taken advantage of this link to use the presses to print his own art, and also to gain work as a woodcut designer for the Koberger press.

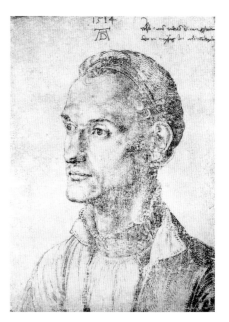

Above: Portrait of Endres Dürer, *1514, by his older brother Albrecht Dürer the Younger, in silverpoint pencil, 29.6 x 21cm (11.6 x 8.2in).*

WILLIBALD PIRCKHEIMER
Willibald Pirckheimer (1470–1530) was one of the most influential people in Dürer's life. Born on 5 December 1470, and five months older than Dürer, he was from a wealthy, humanist family. He grew up in Eichstatt, 70 km (50 miles) south of Nuremberg. In 1488, when Dürer was in the middle of an art apprenticeship with Michael Wolgemut, Pirckheimer, aged eighteen, began a seven-year study of law, first at Venice's local university in Padua, and then in Pavia, south of Milan. He graduated in 1495, the year Dürer was setting out on his travels, perhaps to visit Venice. It was possibly the year they met. Pirckheimer, a Renaissance classicist, an intellectual and humanist, became a mentor and close friend of Albrecht Dürer for 30 years, as correspondence between them highlights. Pirckheimer had a vast library of scholarly books and ancient manuscripts. He collected

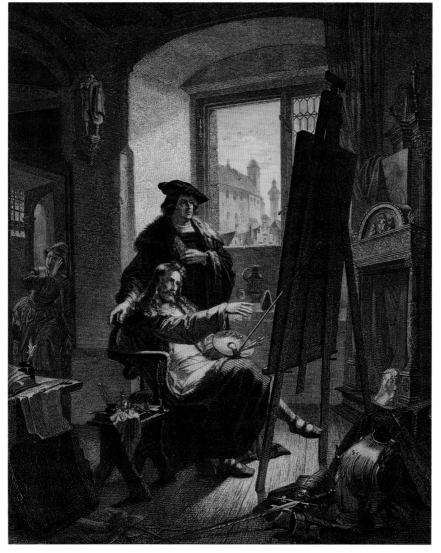

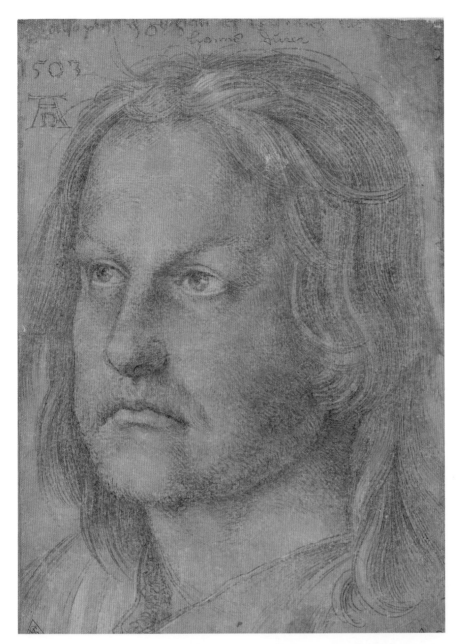

ENDRES DÜRER

Endres (1484–1555), the fourteenth child of Dürer the Elder and Barbara Holper, was born in the year that his brother Dürer the Younger began a goldsmith apprenticeship. After schooling, Endres trained himself as a goldsmith with his father, and he would eventually take over the family's goldsmith business. Endres outlived both his brothers Albrecht and Hans.

HANS DÜRER

Hans (1490–c.1538) was the third child to be so-named, following the deaths of two older brothers. He followed Albrecht to become a painter, possibly trained by his older brother. Dürer's letter dated 2 April 1506, written to Pirckheimer, mentions regret at not bringing his brother Hans with him to Venice, '…which would have been useful both to me and to him and he would have learned the language…' but their mother would not allow it. He asks Pirckheimer to keep an eye on Hans. In a follow-up letter, dated 25 April, Dürer asks his friend to remind Dürer's mother to get Hans work: '… tell her to take my brother to [Michael] Wolgemut that he may work and not be idle.' The wording reveals Albrecht taking responsibility for his much younger sibling, perhaps as father-figure.

Below: A topographical map of Nuremberg, Germany, c.1400–53, showing the walled city in the distance.

Above: Hans Dürer, c.1510, by Albrecht Dürer the Younger, in silverpoint heightened with white on brown prepared paper, 20.8 x 14.7cm (8.1 x 5.7in). Hans was the youngest living brother of Albrecht.

and translated ancient texts, and shared his knowledge with Dürer, who was keen to be educated in philosophy and humanism, to increase his knowledge and understanding of intellectual argument. Dürer made two portraits of Willibard Pirckheimer, in 1503 (see page 167), and in 1524 (see page 242). Pirckheimer kept Dürer's personal letters too, including those from Venice in 1506.

NORTHERN RENAISSANCE

An era in western European painting described as the 'Northern Renaissance' refers to the emergence of naturalism and greater realism in art from the Netherlands around 1350, moving on from the International Gothic style of the Middle Ages. German artists were informed by techniques of Netherlandish innovators.

This period saw the stature of the artist grow, with a greater appreciation of the methods used to create remarkable works such as the Ghent Altarpiece, which was admired and copied.

NETHERLANDISH REALISM

An inventive method of painting in oils involved a slower process of layering the oil, in a different technique to the fast-drying egg tempera practised by artists in southern Europe for its jewel-bright colours. The new method created an extraordinary realism in all genres of art from portraiture and landscape to still life. For example, it is evident in the early Netherlandish art of the Master of Flémalle, Robert Campin (1375/8–1444) in *The Betrothal of the Virgin* (see right). This can be compared to a work by the Florentine artist Fra Angelico (c.1367–1455), *The Annunciation*, 1426 (see opposite). Both masterpieces, close in date, are painted using different methods. Other northern European practitioners include Hubert van Eyck (c.1370–1426) and Jan van Eyck (c.1390–1441), Petrus Christus (c.1410–73), Hugo van der Goes (1440–82), Dieric Bouts (c.1415–75), and the remarkable German painter

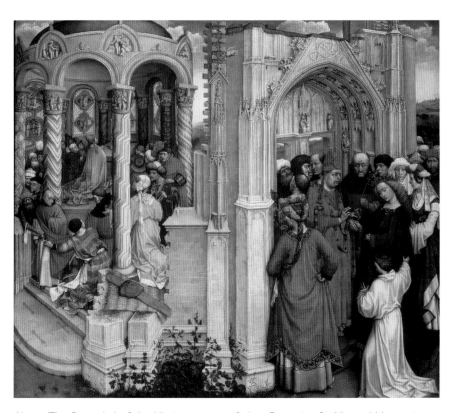

Above: The Betrothal of the Virgin, *1420–30, by Master of Flémalle (Robert Campin). A crowded lively scene, to observe the betrothal of the Virgin Mary.*

Hans Memling (c.1430/40–94) who lived in the Netherlands.

AN ITALIAN NATURALISM

Naturalism appeared in Italian art in the late 1200s and early 1300s, moving away from the rigid depictions in Byzantine art. Florentine artist and architect Giotto di Bondone (1267–1337) was an early practitioner of naturalism and realism, visible in his vast frescoes in the Scrovegni Chapel, Padua. Events from the life of Christ are set in the contemporary architectural setting of an Italian town. Panels from the Siena Cathedral altarpiece *Maestà* (1307–11) in egg tempera on wood, by another early practitioner, Duccio (active 1278; died 1319), places Christ amongst his

Below: Portrait of a Young Woman in a Pinned Hat, c.1440, by Rogier van der Weyden, illustrating the realism of an early Netherlandish painter.

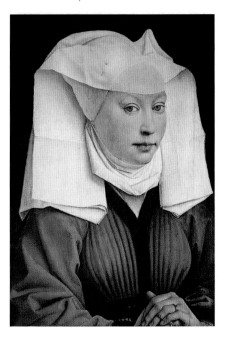

HUMANISM IN GERMANY

Interest in painted or sculptured realism reflected a growing interest in humanism, informed through classical literature, and expressed in art, design, and architecture. Aeneas Silvius Piccolomini, the future Pope Pius II, had lived in Germany since the early 1430s. He held various official ecumenical roles. Piccolomini was instrumental in spreading knowledge of humanism throughout Germany, through his speeches, writings, texts, treatises, biographies and memoirs.

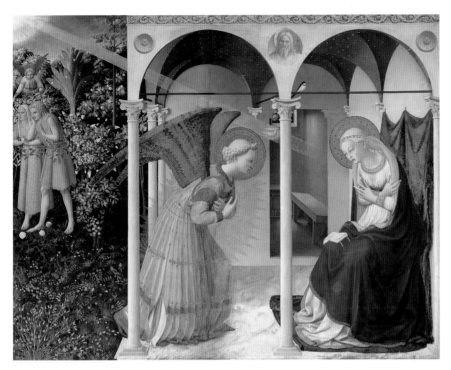

Left: The Annunciation, *1426, Fra Angelico (c.1367–1455) shows the contrast between the Netherlandish realism of Robert Campin and van der Weyden's paintings in oils with Italian artists' preference for works in tempera.*

people in realistic representations of spacial settings. This new style was interrupted by the onset of the Black Death (1347–51), a plague crossing Europe that decimated populations, and drastically reduced cultural patronage. Italy's recovery, most prominent in Florence, launched a fresh demand for the work of many artists, craftsmen and architects. Church coffers, filled with the monetary assets of the plague dead, paid for new churches, chapels and art in the 'new sweet style'. It led to the rise of the status of the artist.

HUBERT AND JAN VAN EYCK

A work that epitomises early Netherlandish art is *The Ghent Altarpiece* (*The Adoration of the Mystic Lamb*), 1432, begun by Hubert van Eyck and completed by his younger brother Jan van Eyck. It was a painting Albrecht Dürer requested to see in April 1521 on his tour of the Netherlands. The built-up translucent layers of thinly applied oil-based colour create an illusion of light and shadow. The clear layers allow filtered light to reflect luminosity on faces, clothing, objects and walls. The slow-drying method allowed time to include microscopic detail. The van Eycks were not originators of this method but utilised it to full effect. In portraiture, Jan van Eyck's *Portrait of Giovanni Arnolfini and his Wife,* 1434 (now in the National Gallery, London) creates an illusion of real people in a solid space. The intimate realism of *Portrait of a Young Woman in a Pinned Hat* by van der Weyden (see opposite) illustrates the potential of the translucent oil method to depict reality.

Right: The Ghent Altarpiece, *1432, by Hubert van Eyck and Jan van Eyck. This innovative work of realism by the Van Eyck brothers was admired by artists across Europe.*

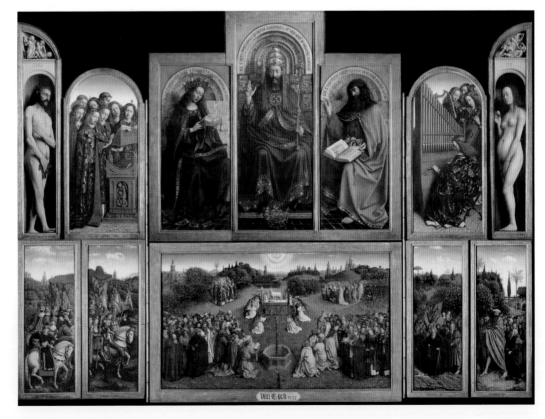

ENGRAVING AND ETCHING

Two methods of illustration, engraving and etching, gained popularity with artists and print-publishers in the 1500s. Engravings were created by incising lines with a burin on metal; etching involved a chemical process after drawing on metal with a stylus. Dürer transformed their use into a profitable market for prints.

Today Albrecht Dürer is recognised for his woodcuts, engravings and etchings as much as his paintings. An apprenticeship in the skills of goldsmithing and drawing for engravings, tutored by his father, led to his successful multi-skilled career.

ENGRAVING ON METAL

The art of engraving involves the use of a burin, a hand-held tool with a diamond-shape point and chisel-like edge, which is pushed along to incise deep lines on a metal surface. Practised on copper, iron or steel by the early 16th century, it needed careful precision to create subtle detail. The angle of the point and pressure exerted on the burin defined the depth and width of drawn line. In Germany, Martin Schongauer and Albrecht Dürer became experts. Schongauer's *The Temptation of St Anthony* 1470–75 (see page 26), and *Christ Bearing His Cross* (see below), Dürer's largest engraving

Below: Christ bearing his Cross, c.1475, an engraving by Martin Schongauer. Schongauer's work greatly influenced Albrecht Dürer.

Above: A detail of Dürer's largest engraving St Eustace, 1501 (see page 153). It was possibly based on an earlier work The Vision of St Eustace, c.1438–42, by Antonio Pisanello (see page 42).

St Eustace, 1501 (see above and 153) and *Adam and Eve*, 1504 (see page 8 and 173), are examples of remarkable innovation in this medium. The lengthy process of cleaning the plate after printing made it a better option for single prints or limited editions, not book illustration. Dürer produced over 100 engravings during his career.

In Italy, Francesco Parmigianino (1503–40), a painter and printmaker, excelled in engraving, as did Venetian-

born Jacopo de' Barbari (1440/50–1515), an artist who was working in Nuremberg in 1500, with *The Holy Family with St Elizabeth and the Infant St John* (see below). Often, the best artist-engravers were initially trained as goldsmiths or linked to that profession. The delicacy of fine-line engraving is a skill that takes time to master. Painters were not sufficiently trained, and etching was a simpler technique.

DANIEL HOPFER

In 1500, decorative etching on metal objects, primarily armour, had existed for over 200 years. Daniel Hopfer (1471–1536), an etcher of armour working in Augsburg, is credited as the first to produce prints on paper from a metal etching. Hopfer created etchings of popular subjects, such as *Death and the Devil surprising Two Women*, c.1515 (see right). He is recognised as the first to capitalise on the commercial production of printed etchings, publishing from a large stock of saleable, popular subjects. He created a business

Below: The Holy Family with St Elizabeth and the Infant St John, c.1499–1501, Jacopo de' Barbari. *The Venetian-born artist was noted for his skilled creation of exceptional engravings.*

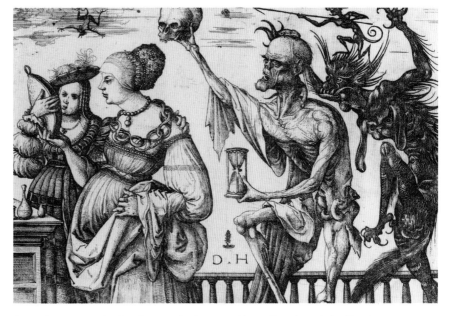

from the potential of making multiple prints from engravings. His method was mirrored in European publishing companies.

ETCHING ON METAL

Daniel Hopfer's technique spread across Europe. The corrosive action of acid was employed to create a design on metal for printing, a different technical process to engraving. A flat metal surface was cleaned, and the etching ground covered with a thin layer of acid-resistant wax, usually a beeswax.

Above: Death and the Devil surprising Two Women, c.1515, by Daniel Hopfer. *Hopfer is credited with the innovation of transferring a metal etching on to paper for printing, and the first to make it a commercial enterprise.*

When the wax was dry and hard a metal stylus, or sharp needle, was used to draw a composition, similar to drawing on paper. Different tips, such as chisel-shapes, created different line widths. On completion the metal plate would be immersed in a mordant bath of nitric acid or salts-in-vinegar solution, depending on the metal, to 'bite' into the incised unprotected lines, dissolving the metal. This process could be repeated several times to create a finished design with tonal layering. To print, the plate was warmed and rubbed with oil to remove the etching ground (the acid-resistant substance), and rubbed dry with a cloth. A coating of ink was applied, which sank into the exposed incisions, often with multiple depth densities. Prepared paper was placed on the metal plate, and heavy rollers moved across it, to create a print. The plate would be recoated with ink and the process repeated. Dürer's etching *Abduction of Proserpine* (see page 213) reveals his genius in this medium. A drawback to etching was rusting of the acid-riven incisions. Dürer's plates suffered from rusting but dense cross-hatching hid imperfections.

PRINTMAKERS AND PUBLISHERS

Print presses by the 1500s could produce hundreds of copies depending on the quality of the original work. The choice of woodblock, etching and engraving methods allowed publishers to commission the best practitioners. Artists were drawn to cities with publishing houses, to find work.

In 1436, a German goldsmith Johannes Gutenberg (1400–68) created designs for a machine that would print multiple copies. By 1440 a reusable typeface was in process and within years a working printing press was achieved. In 1454 Gutenberg's first major commercial commission was to print Indulgences for the Catholic church.

Ironically, 60 years on, in 1517, it was the printing press that aided German theologian Martin Luther (1483–1546) to distribute the text of his 95 theses against the sale of Indulgences, an act that ultimately led to the Reformation. The first book to be printed in multiple copies was the 42-line Gutenberg Bible in 1455.

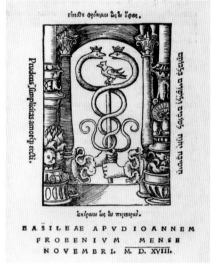

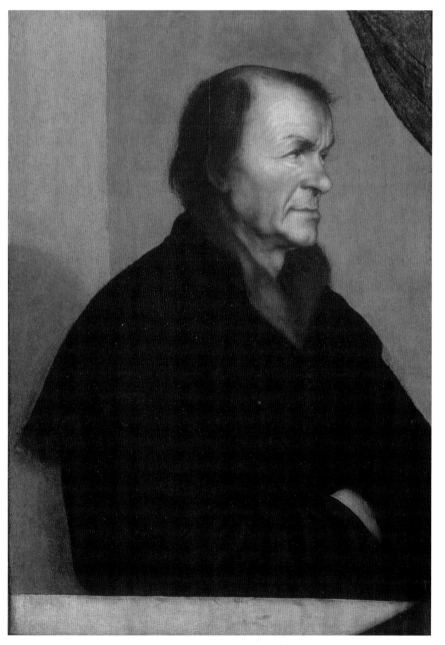

Above: Printer's mark of Johannes Froben showing two hands holding the caduceus (the traditional symbol of Greek god Hermes), from the 1518 third edition of Utopia by Sir Thomas More. The woodcut was created by Hans Holbein the Younger.

Left: Portrait of Johannes Froben, c.1522–23, by Hans Holbein the Younger. Froben, a humanist, was a successful book publisher and printer in Basel.

Below: View of Basel, *woodcut illustration from the Nuremberg Chronicle, 1493. A stunning vision of the German city of Basel by Hartmann Schedel, one of the first cartographers to utilise a printing press.*

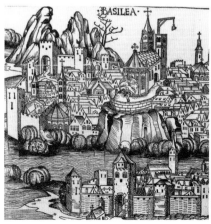

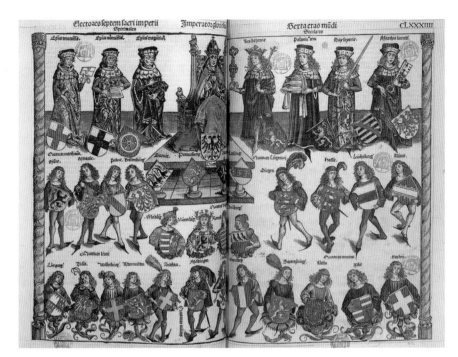

Above: The state hierarchy of the Holy Roman Empire, *1493, by Michael Wolgemut, from the Nuremberg Chronicle, to which he was a major contributor.*

THE NUREMBERG CHRONICLE

Hartmann Schedel (1440–1514), a Nuremberg physician, humanist and bibliophile, commissioned an intricate printing project in the early 1490s. It would be a vast work of 336 pages, the *Liber Chronicarum* (Nuremberg Chronicle) with 1,809 woodcuts from 645 blocks to illustrate the text. The text divided into the Seven Ages of Man and from the Creation until the Last Judgement. The woodcuts were created by Michael Wolgemut with his stepson-in-law Wilhelm Pleydenwurff (c.1460–94). Koberger's contract stipulated that either Wolgemut or Pleydenwurff had to be present during the woodblock printing process, to correct errors. Wealthy city patrician Sebald Schreyer and brother-in-law Sebastian Kammermeister (1446–1503) funded the publication. It was published in July 1493, the first print-book issued simultaneously in Latin and vernacular German, thus greatly widening its readership.

PUBLISHING HOUSES

By the 16th century 2,300 German print-publishers were active, a figure that highlights the growth of the publishing industry in Germany and indicating a diversity of printed works. Centres for print-publishing thrived in Augsburg and Basel, Erfurt, Frankfurt and Nuremberg, including playing-card printing from woodblocks. Nuremberg had nearly 40 registered card-makers between 1422 and 1500. During his journeyman years Dürer stayed in Basel and probably was employed by his godfather's publishing houses to create illustrations for books.

KOBERGER PRESS

In 1470 Anton Koberger launched his print shop in Nuremberg, eventually operating sixteen printworks. As the city's leading publisher he employed agents across Germany and parts of Europe. He is associated with major publications, including *Liber Chronicarum* (or the Nuremberg Chronicle). Koberger engaged the Wolgemut-Pleydenwurff workshop to create the illustrations. He promoted the book with the message that 'nothing like this has hitherto appeared to increase and heighten the delight of men of learning…'. This book and the Gutenberg Bible were the most famous publications of the 15th century.

JOHANNES FROBEN

The invention of the printing press signalled the creation of 'scholar-publishers', owners of printing presses, wealthy patricians able to promote their own agenda through print propaganda. Johannes Froben (1460–1527) began his publishing career working for Nuremberg-based Anton Koberger. Froben then lived in Basel, working as a corrector for the Amerbach publishing house, then printing independently from 1491. A junior partnership with bookseller Wolfgang Lauchner (1465–1518), and marriage to his daughter in 1500, took Froben deeper into the print trade. In 1513, the purchase of one of Amerbach's print shops 'Haus zum Sessel' in Basel with four printing presses – he enlarged it to seven – placed him at its centre. Johannes Froben published over 320 titles, with his distinctive printer's mark (see opposite). His catalogue included works by the Dutch theologian and philosopher Desiderus Erasmus (c.1466–1536), and *Utopia* by Sir Thomas More (1478–1535).

Below: The View of Utopia, *attributed to Ambrosius Holbein (c.1493–c.1519), from Sir Thomas More's* Utopia. *First published in Basel in 1516, this woodcut illustration is from the title page of the 1518 edition, and would have been hand-tinted at a later date.*

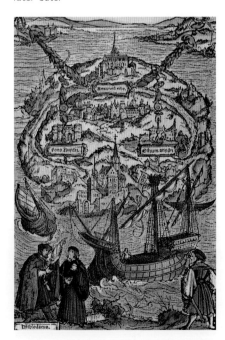

A JOURNEYMAN IN EUROPE

1490–94 were pivotal years to Dürer's career. He had served two apprenticeships, as trainee goldsmith and trainee painter, and set out in April 1490 as a journeyman, travelling through southern Germany. Martin Schongauer had recently died when Dürer visited Colmar, but Schongauer's brothers made him welcome.

Dürer's journeyman years are challenging to place in a chronological order. Letters to and from home and friends, and artworks created, are the keys to understanding this period.

FROM APPRENTICE TO JOURNEYMAN

Dürer completed his apprenticeship with Michael Wolgemut on 30 November 1489. In Nuremberg it was not a requirement for graduate apprentices to leave the city for work experience, but it was the wish of Dürer's father. 'And having set out after Easter in the year 1490, it was after Whitsun 1494, that I returned',

Below: The Temptation of St Anthony, *1470–75, Martin Schongauer. A work that influenced Albrecht Dürer's own engravings and woodcuts.*

he wrote. A *wanderjahr* (journeyman), working a day's work for a day's pay, gained experience in different workshops. The four-year circuit Dürer took is not known, but he did want to meet Martin Schongauer, whose work he much admired, possibly for a position as assistant in the workshop.

MARTIN SCHONGAUER

Dürer travelled to Colmar in Alsace, now France, a town on the German border, arriving in 1492. The famous engraver, painter and printmaker Martin Schongauer (c.1450–1491) – affectionately known as 'Martin the beautiful' to his friends – had established a workshop here in 1471. Dürer probably saw prints from remarkable engravings such The Temptation of St Anthony (see below left), and *Christ bearing his Cross, c.1475*

(see page 22). Schongauer's earliest extant works date to 1469, the year he worked in Nuremberg for Hans Pleydenwurff (c.1420–72).

Schongauer's most important work, the oil-on-panel altarpiece *Madonna of the Rose Bower*, 1473 (also known as *Virgin and Child in the Rose Garden*), was commissioned for the church of St Martin, Colmar (see page 48). He had been living in Breisach on the French-German border and died there in February 1491. The artist's brothers Caspar and Paulus, goldsmiths, and

Below: St Jerome removing a thorn from the foot of a lion, *1492. Created for a book published in Basel by Nikolaus Kesler, the woodcut is considered to be Dürer's first depiction of St Jerome. It is thought that Dürer travelled to Basel during his journeyman years, to find work.*

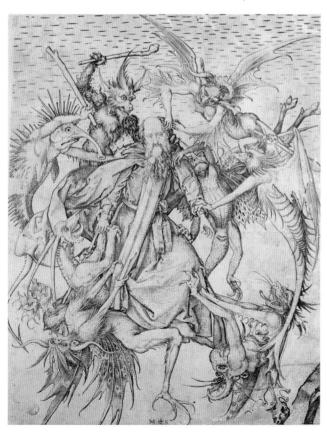

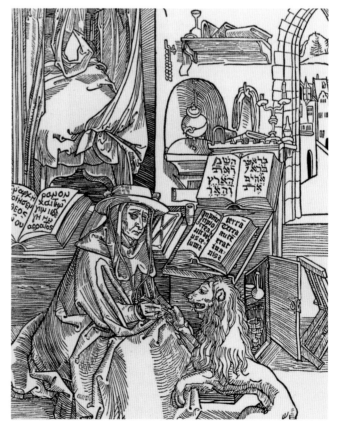

FIRST LANDSCAPES

Dürer's landscapes are of views he saw at home and travelling. Some would be used as backdrop in paintings, as in *Madonna and Child,* *c.*1496–99 (see page 141), and appear more than once. The city backdrop of Nuremberg appears in *Madonna of the Rose Garlands,* 1506 (see page 182), and the later engraving *St Anthony,* 1519 (see page 62). Sketches might be made on the spot and finished later. Some landscapes are imagined but many created from an exact location, such as *View of Trente,* 1494 (see page 112). Dürer's earliest surviving pure landscape *Rocky landscape with tower and hikers* (see right) is a study of hillside rock formations with a roughly sketched castle in the background. The location is unknown.

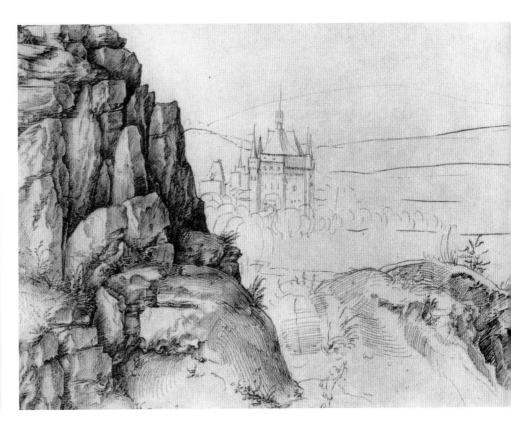

Ludwig, a painter, lived in Colmar. They invited Dürer to stay, showing him the altarpiece and workshop. Dürer met Martin's other brother Georg Schongauer, a goldsmith, in Basel.

FRANKFURT, BASEL, STRASBOURG

Anton Koberger had offices across Germany, with forty printing presses and over one hundred workers. Dürer's choice to visit Frankfurt am Main, Basel and Strasbourg may be linked to

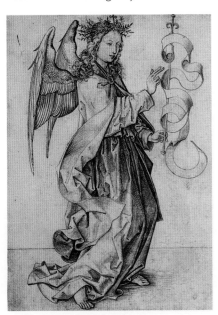

his godfather's business. A document found in the Pirckheimer family records mentions portraits of a man and woman painted by Dürer in Strasbourg. The biographer of German and Flemish artists, Carel van Mander in *Schilderboek,* published 1604, remarked that Dürer had visited the Netherlands too in this period, but this is not certain.

SUMMONED HOME

During 1493 Dürer was in Strasbourg, living close to the cathedral. His years away from Nuremberg had widened his field and knowledge of art practice. He became a master of copperplate engraving, an art not much practised in Nuremberg. In Strasbourg he painted *Christ as the Man of Sorrows,* 1493–94 (see page 108) and improved his portraiture technique, from *Self-portrait,* 1490–94 (see page 104) to the remarkable *Self-portrait with a Thistle,* 1493 (see page 109). Historians debate whether or not the latter was an engagement portrait sent in response

Left: Angel of the Annunciation, *c.1470. Schongauer's engraving is thought to have influenced Durer's early self-portrait (see page 102).*

Above: Rocky landscape with tower and hikers, *1490–92. This drawing is the earliest surviving pure landscape by Dürer.*

to an arranged marriage, set up by his father, to Agnes Frey, in Dürer's absence from the city. A letter from his father recalled him to Nuremberg to marry.

Below: Angel playing a lute, *c.1491. Dürer mastered silverpoint drawing at an young age.*

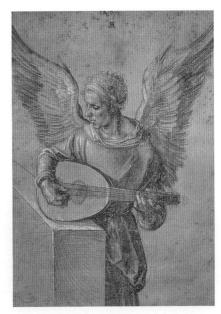

COLLECTIBLE WOODCUTS

The ancient technique of woodblock printing, practised in China for over 1000 years, was utilised in the 14th century in Europe as a commercial medium for single and multiple prints on paper, leading to woodblock series published as books. Dürer practised woodblock cutting, honing it until he was a skilled practitioner.

Like many German artisan families practising as goldsmiths, painters, sculptors, textile and tapestry makers, the Dürer family were connected through their shared knowledge of art techniques and superior skills.

CREATING A WOODCUT

A woodcut relief, usually an inch or more in depth and often made from pear wood, is the oldest method of printmaking. The design outline is drawn onto a seasoned, planed wooden block, which has been sawn along the grain, or it is drawn on paper and glued on, or traced from a prepared paper. Using a variety of tools, the wood is removed around the design, leaving raised surfaces. These are inked and used to print on primed paper. Large works were created using several woodblocks, printed separately. As presses increased in size, larger works were printed.

DÜRER IN BASEL

Albrecht Dürer's multidimensional apprenticeships in goldsmithing and art practice primed him to create

GERMAN MASTERS OF WOODCUTS

Several German artist-printmakers of Dürer's era created magnificent woodcuts. There was Erhard Reuwich (c.1455–90) of Utrecht and also Dürer's tutor Michael Wolgemut of Nuremberg (see page 17). Hans Burgkmair the Elder (1473–1531) of Augsburg was, like Dürer, commissioned by Emperor Maximilian I. Nuremberg-born Sebald Beham (1500–50), Lucas Cranach the Elder (c.1472–1553) of Kronach and Erhard Schön (c.1491–1542) of Nuremberg are a few other examples of exemplary woodcut practitioners, masters of the emerging technique.

innovative works in numerous mediums and subjects, an exceptional accomplishment. He stayed in Basel during his 1490–94 journeyman travels, and in 1491–93 worked as a woodcut designer. A woodblock for a book

illustration *St Jerome removing a thorn from the foot of a lion*, 1492 (see page 26), and *Daedalus and Icarus*, 1493 (see opposite below left), place him in the city. Basel had a well-established book publishing industry, and Dürer gained commissions for singular works and book illustrations, as in *The Comedies of Terence* (see pages 106–07), and for *The Ship of Fools* by Sebastian Brant. An outbreak of plague in the city in 1492–93 may have prompted him to leave.

RELIGIOUS WOODCUTS

Adam and Eve, 1491 (see opposite below right), a woodcut by Michael Wolgemut, is a decorative narrative that illustrates the bible account (Genesis chapter 3) from the 'Creation of Eve' to the 'Fall of Man', taking place within the Garden of Eden. By contrast, Dürer's woodcut *The Expulsion from Paradise*, 1510 (see opposite above) is aggressive and sexual, connoting the enormity of the couple's culpability. The drama focuses on the naked mortal bodies of Adam and Eve at the moment of their expulsion from Eden by God's angel Jophiel, brandishing her sword. This powerful depiction is one of 36 woodcuts, plus frontispiece, in Dürer's *Small Passion* series created over a number of years and published in 1511 in a devotional book (see pages 59 and 198–99). Its style highlights a change in religious narrative. It followed the *Large Passion* of twelve woodcuts created 1497–1510 (see pages 59 and 134–36) and *The Apocalypse*, the 1497–98 series of fifteen woodcuts, highly sought after by collectors, which secured Dürer's art reputation (see pages 36, 40–41, 101 and 130–33).

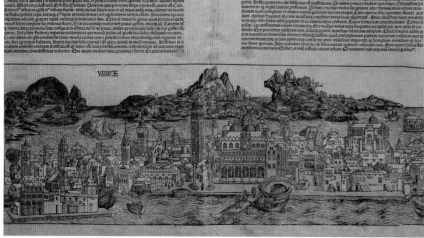

Left: A woodcut illustration by Michael Wolgemut, A topographical view of Venice, from the Nuremberg Chronicle, published in 1493 by Anton Koberger.

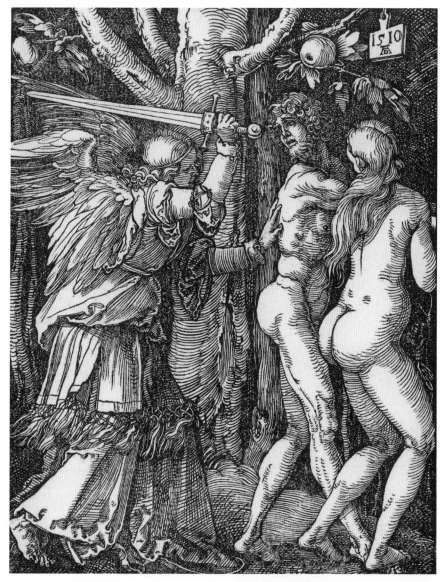

Left: The Expulsion from Paradise, *1510 (from the* Small Passion), *woodcut. There is a vast difference between the traditional scene from the Old Testament in Wolgemut's depiction (see below right) and Dürer's menacing vision here.*

MONUMENTAL PRINTS

Multi-block woodcuts and multi-plate engravings were used for large-scale architectural illustrations. Dürer utilised the method for *The Triumphal Arch of Emperor Maximilian I,* 1515 (see pages 78 and 224–25). It was produced by Dürer and assistants, and the artist Albrecht Altdorfer. Copies of this oversize illustration, created from 195 woodblocks, printed on 36 sheets of paper, in total measuring 3.57 × 2.95 metres (over 11ft), were to be placed in public buildings, as propaganda – promotion of the House of Habsburg. The original intention was to colour them but only a few were completed. This method created by Dürer, to use art illustration to promote the power of Emperor Maximilian, could be viewed as an early form of poster advertising.

Below left: Daedalus and Icarus, *1493, woodcut by Dürer the Younger.*

Below: Adam and Eve, The Garden of Eden, the Creation of Eve, and The Fall, *1491, woodcut by Michael Wolgemut.*

AN ARRANGED MARRIAGE

On 7 July 1494, Albrecht Dürer the Younger married Agnes Frey, the daughter of a prosperous brass maker Hans Frey and Anna Rummel from a wealthy patrician family. The couple's parents arranged the union while Dürer was travelling.

Weeks after his return to Nuremberg at Whitsun, Dürer was married into one of the 90 most elite families in the city. It was a prosperous social step-up in society. In addition, marriage was the official requisite for owning a

Below: Self-portrait with a Thistle, 1493. Dürer's first painted self-portrait, this work may have been an engagement painting for Agnes Frey, as it was painted on a vellum that could be easily transported.

workshop in Nuremberg. Dürer needed to establish a permanent workplace. The wedding dowry that Agnes brought with her would launch it. Dürer was 23 years old, Agnes Frey was nineteen. The marriage brokers were the parents of the couple. Living in the same neighbourhood the couple would have known each other but Dürer had been away four years. After the wedding, it is thought that they may have lived for a time with her family.

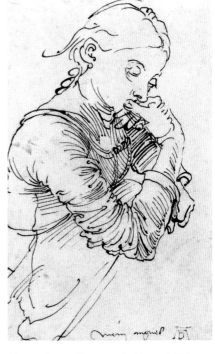

Above: Agnes Dürer, née Frey, 1494, Albrecht Dürer, pen and black ink, signed in Dürer's own handwriting: 'Mein Agnes' ('My Agnes'). It was created when Dürer returned to Nuremberg for an arranged marriage to Agnes Frey. She was nineteen years old. (See also page 110.)

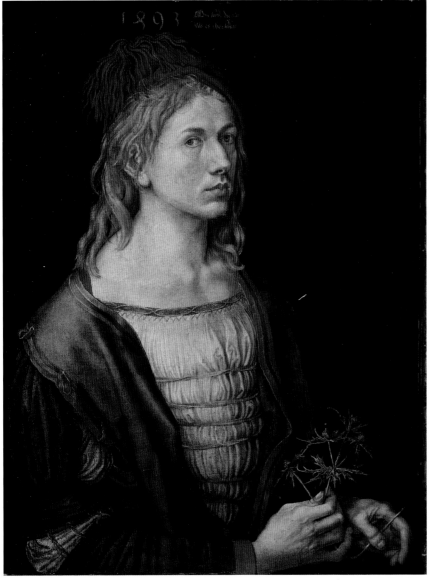

'AN EVIL WOMAN'?

In a letter written by Willibald Pirckheimer, after Dürer's death, he made a damning remark, blaming Agnes Frey's monetary greed for his friend's death. Pirckheimer called her 'Das pos weyb', an evil woman. Nonetheless, what is known is Agnes Frey's support for Dürer throughout their marriage. She and his mother Barbara helped run the workshop business in his absence, dealing with his agents, overseeing prints created from Dürer's etchings, engravings and woodcuts, and travelling to print fairs to sell them.

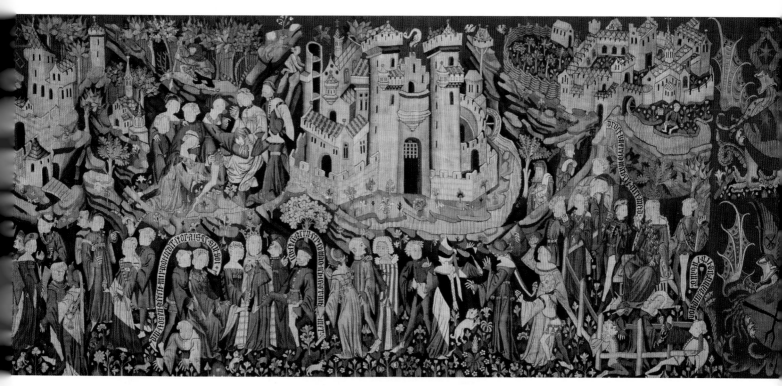

Above: An Allegory of Courtly Love, *c.1400, German school tapestry. In Dürer's era, arranged marriages to create ties between prosperous families, from nobility to tradespeople, was a normal practice.*

ENGAGING PORTRAITS

Dürer created *Self-portrait with a Thistle* (see opposite and page 109) before he returned to Nuremberg. The eryngium – thistle – he holds in his hand can be interpreted as a courting gift but the inscription *'My sach die gat als oben schtat'* ('My affairs must go as ordained on high') could refer to a higher being, God. Or, to his situation as a wanderer, wanting to return home. The thistle is symbolic of multiple connotations. Dürer gives no clue. An interesting contrast is Dürer's quickly-sketched pen and ink drawing *Agnes Frey* (see opposite, above). He writes on it *'Mein Agnes'* ('My Agnes'). He portrays her seated at a table in semi-profile with elbows on the table, her chin resting on the fingers of her right hand, which are close to her mouth. She is deep in thought. Her youth is accentuated in her clothing, long hair, and shy demeanour. It was perhaps the first drawing that Dürer made of Agnes. He used her as a model for his artworks. Seven drawings are extant.

A MARRIAGE UNION

If Dürer had no say in getting married, it is doubtful that Agnes Frey did either. Arranged marriage was a custom of the period. The union of the Dürer-Frey families was good for business: Hans Frey was a noted brass maker, a respected person, owner of properties, and holding public office in Nuremberg. Dürer the Elder was a respected, prosperous man with public status in the community. Albrecht Dürer later wrote in the family chronicle in 1524:

'And when I returned home, Hans Frey had made an agreement with my father and gave me his daughter, miss Agnes by name, and with her he gave me 200 florins, and held the wedding – it was on a Monday before Margaret's Day in the year 1494.'

Dürer's letters to his friends show an unkind view of his wife – he did not choose her; she did not choose him – but she was a mainstay for his business. Agnes and Dürer's widowed mother supervised his studio, and the vast print production of his woodcuts and engravings when Dürer was travelling, which was often. A letter from a friend of Dürer after his death painted Agnes as a moneygrubber, but one should consider her position. Married to a noted artist, her place was to be a support to him. No records or letters enlighten historians if she had her own talents. It is conceivable that Agnes lacked companionship and love.

Below: A Young Couple Threatened by Death, *1498. One of Dürer's commercial copperplate engravings, possibly sold as a print at market fairs.*

AN INDEPENDENT MASTER

In late 1494, Dürer had a new wife and the means to set up a workshop, but chose to leave Nuremberg and travel toward Italy. His exact route is unknown but the works he created establish a trail. He began to develop his influential network of patrons. It is amusing to spot Durer's habit of placing himself in the picture.

Dürer set off from Nuremberg in late 1494, possibly because of the outbreak of plague from September that year, returning late Spring 1495. He was heading south towards Venice, over the Alps, a journey of around 600km (380 miles), via Innsbruck, the Brenner Pass, and South Tyrol. Agnes Dürer may have accompanied her husband for part of his journey in order to stay with relations. A member of her mother's family, Peter Rummel, lived in Innsbruck and had business connections in Italy, which would be useful to Dürer. To gain knowledge from Italian art and artists in Venice was a key objective of his travels.

LANDSCAPE LOCATOR

Clues to Dürer's itinerary are the locations depicted in the drawings and watercolours he created. His collection included views of Innsbruck, Arco and Trente, such as *View of Trente*, 1494, (see above) and *View of the Arco Valley in the Tyrol Meridional*, 1495 (see page 121,

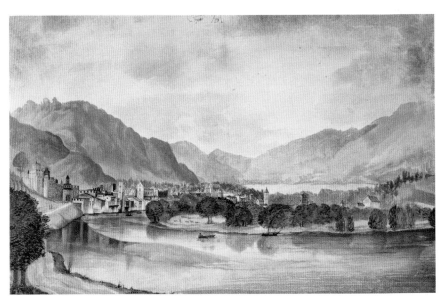

Above: View of Trente, *1494, Albrecht Dürer. One of Dürer's many landscape paintings, possibly for use as a stock image in the workshop, and as background for major painting commissions. (See also page 112.)*

and *View of Innsbruck from the North*, c.1495 (see page 120). Drawings could be created on location. These were produced when landscape painting was unknown in Europe.

Dürer took a great interest in women's and men's fashion too, and made drawings of Venetian women, observing differences between Nuremberg and Venetian dress (see pages 76–77). Although he was an outsider, Dürer had an amiable personality and inestimable social skills to network, to make friends and gain contacts where he travelled.

NETWORKING

By 1496 Dürer, at 25, was established as a portrait painter. The painting of Frederick III in 1496 (see opposite) is proof that he had early gained the attention of nobility. He would later go on to create many works for Maximilian I, Holy Roman Emperor, including portraits (see pages 222–23). Marriage into Nuremberg's social elite brought prestigious commissions, such as the companion portraits of wealthy patricians Hans and Felicitas Tucher, 1499 (see page 144). His social network

Left: The Landauer Altarpiece, All Saints Day, *1511 (see page 202). This detail highlights Dürer's enjoyment of placing himself within historic, contemporary or biblical scenes.*

ALBERTVS · DVRER
NORICVS · FACIE
BAT · ANNO · A · VIR
GINIS · PARTV ·
· 1511 ·

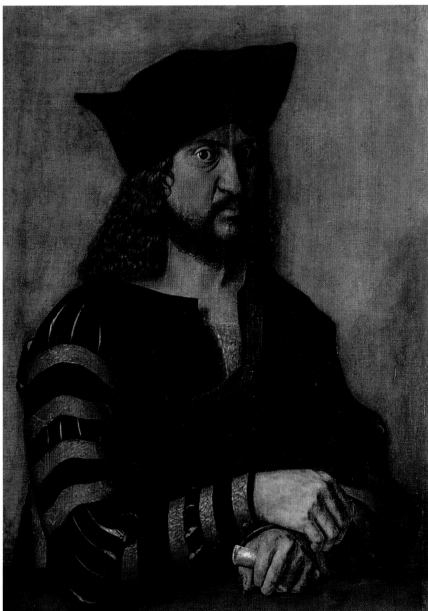

Above: Portrait of Frederick III, Elector of Saxony, *1496, tempera on canvas, 76 x 57cm (30 x 22in), Gemäldegalerie, Berlin, Germany. Dürer portrays Elector Frederick III 'the Wise' (1463–1525) seated, his body in three-quarter profile facing toward his left. The background is neutral, which pushed the features and clothing of the Frederick to the forefront. The elector's characteristic serious expression is captured. His eyes are fixed firmly on the viewer, in a questioning manner. Dürer meticulously paints the elector's rich clothing with great realism. Both men were good friends for over 30 years.*

SPOTTING DÜRER

Examining Dürer's works closely, it is possible to find self-portraits appearing in different guises. Is he *The Prodigal Son* (see page 123)? The 'look-at-me' self-portrait in *The Landauer Altarpiece, All Saints Day* (see detail, opposite) is the visual signature of a famous artist. In the *Heller Altarpiece* (see detail, below), he is similarly pictured with a sign in the background. He is in the *Madonna of the Rose Garlands* (see page 183), and, wearing black, in *The Martyrdom of the Ten Thousand* (see page 197). Could he be Hercules (see page 152), the drummer (page 161), and Melchior, one of the Magi (page 170)? *The Men's Bath* (see page 125) portrays a public scene of men bathing together. Has Dürer placed himself within the setting? When one studies faces in his works, Dürer appears.

Above: A detail of the Heller Altarpiece, *1507–09, with Dürer placing himself in the background of the main scene. (See pages 64 and 191.)*

also included humanists and literary contacts of his close friend and mentor Willibald Pirckheimer, who introduced Dürer to an inner circle of wealth and intellect. This opened up private collections of drawings, prints, paintings and humanist texts for him to study.

AN EYE FOR BUSINESS

Dürer's artistic versatility conceived intimate drawings like *The Women's Bath*, 1496 (see page 129), and engravings such as *The Prodigal Son*, 1496 (see page 37 and 123), *The Small Courier*, c.1496 (see page 124), and many woodcuts such as *The Men's Bath*, c.1496–97 (see page 125) that brought a profitable income from private

collectors, print fairs and markets. One can see Dürer producing the type of works that would be popular with his friends and patrons, both noble and middle-class, in religious, secular and even bawdy illustrations. Artists' portfolios might include explicit or lewd drawings, to be sold privately.

MADONNA AND CHILD

Jan van Eyck, Giovanni Bellini and Andrea Mantegna were three artists admired by Albrecht Dürer. Elements of their techniques, from composition to colour, can be found in his early masterwork *Madonna and Child*, painted c.1496–99 after his return to Nuremberg (see also page 141).

The Madonna and Child was a popular theme for artists. This early religious work by Dürer shows influence of van Eyck's painting methods as well as northern Italian use of geometric shapes and perspective.

PORTRAYING THE MADONNA
Looking at a detail of *The Virgin and Child with Canon Joris van der Paele* by Netherlandish artist Jan van Eyck (see opposite left), it is the naturalism of the face and bodies of Virgin and Christ child that draws the viewer into the painting. Van Eyck paints them not as the Holy Family but a young mother with her playful infant.

Below: Madonna and Child, *late 1480s. Giovanni Bellini uses the pyramidal shape to centre the subject, and draws the curtain back to reveal a landscape beyond, adding depth to the composition.*

READING HISTORY

From the early 1400s in Italy, primarily Florence, an interest in Humanism led to interest in the literary and humanist texts of ancient Greece and Rome. Many were read in Latin and Greek, or in translation, leading to a rebirth of interest in the ancient Roman past, and a new embracing of the Classical era 100 BC–100 AD, primarily in architecture and sculpture as well as art. Rediscovered texts by Vitruvius (1st century BC), a Roman architect, civil and military engineer, discussed proportion and creating harmony and beauty in building construction. This understanding transformed parts of Florence and Rome from medieval cities to visions of a triumphal Roman heritage.

Drawing back from the detail, the complete composition reveals the Virgin is enthroned under a regal canopy with Saint George, Saint Donatian and the patron Canon Joris van der Paele honouring her presence.

The realism of *Madonna and Child* by Giovanni Bellini (see below left) informed Dürer's *Madonna and Child* (see below right and page 141), painted 1496–99 after his return to Nuremberg. When Dürer visited Venice, arriving in October 1494, did he see Bellini's work? His painting so closely resembles Bellini's in composition and colour that it was thought to be the latter's work until 1934. Bellini was commissioned for

Below: Madonna and Child, *c.1496–99. Informed by Bellini's paintings, Dürer copies the pyramidal shape, and includes a landscape seen through the window behind the Madonna with her lively child.*

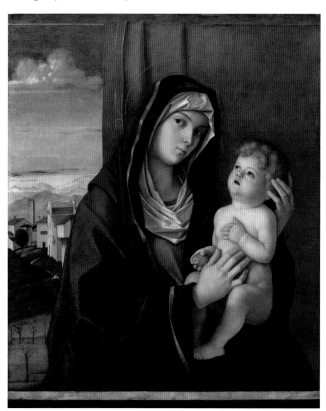

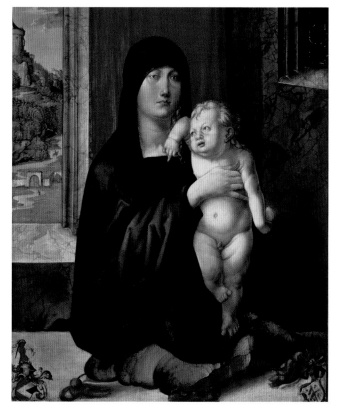

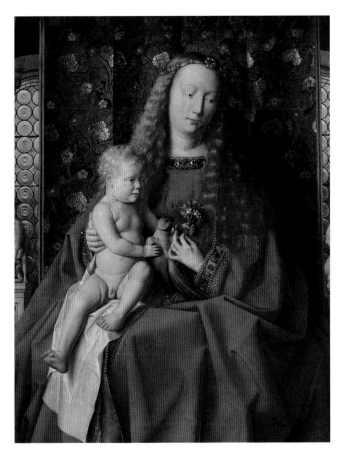

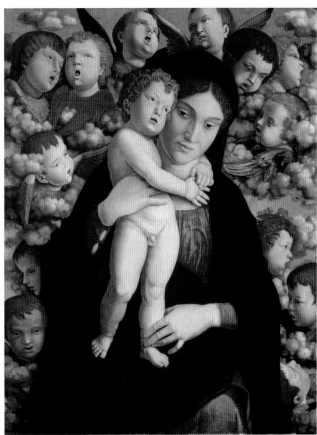

Above: Detail of the Virgin and Child with Canon Joris van der Paele, 1434–36, *by Jan van Eyck. In Dürer's paintings of the Holy Family one can see the composition and colouring informed by both Jan van Eyck and Giovanni Bellini's paintings.*

many Madonna and Child portrayals, including *Virgin enthroned with Four Saints*, 1488, in the Sacristy of the Frari church in Venicem, and possibly seen by Dürer in 1494–95.

Andrea Mantegna was another artist that Dürer admired, making copies of works to inform his own. *Virgin and Child with Angels* (see above right), also uses a pyramidal shape with the Madonna filling the picture frame. The Christ child is portrayed with great naturalism, standing on her lap, his infant arms enfolding her in a protective embrace.

Bellini used a pyramidal, triangular composition to place his Madonna within a pictorial frame. It was his trademark; the shape giving a sense of proportion to the composition. A parapet separates her from the viewer. Behind her, a partly drawn curtain creates an inner space. The landscape

is glimpsed beyond, adding depth and realism. The realism of the flesh tones is remarkable. Leonardo da Vinci (1452–1519) used a pyramidal form with a landscape glimpsed through windows, in the oil on panel *Madonna of the Carnation* (see right) but his Madonna wears contemporary dress with a fashionable hairstyle, which highlights differences in Florentine and Venetian portrayals. In his own *Madonna and Child* Dürer mirrors Bellini's pyramidal shape, seated position, natural infant, symmetrical spacing, and a drawn curtain revealing a glimpse of a landscape, and intensely rich colours.

NEW THINKING

Italian artists were living through a renaissance of classical learning in art and architecture, informed by republished ancient texts and contemporary theorists. Dürer wanted to learn more. Pirckheimer had a collection of texts, which Dürer could read. When the Venetian artist Jacopo de' Barbari was working in Nuremberg in 1500, Dürer asked him to explain proportional theories but was refused.

Above: Virgin and Child with Angels, *also known as* Madonna of the Angels, *c.1485, Andrea Mantegna. Dürer did not get to meet the Venetian painter Andrea Mantegna but he greatly admired the naturalism in his work.*

Below: Madonna of the Carnation, *c.1478, by Leonardo da Vinci, a master of naturalism and realism.*

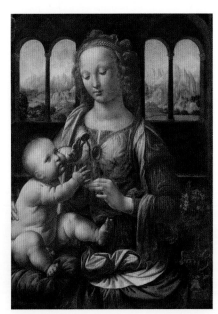

MARKETING DÜRER

Two work contracts agreed in July 1497 show Albrecht Dürer taking on two agents to sell prints from his engravings and woodcut designs. They were to travel outside Nuremberg 'from one country to another, and from one town to another', and sell at the highest price possible.

Albrecht Dürer was the first artist in the modern era to market his work through the use of professional agents. The strict contracts gave him a level of control over sales.

TERMS AND CONDITIONS

The first contract dated 8 July 1497 was an agreement between Dürer and Konrad Schweitzer; the second contract dated 26 July 1497 was offered to Georg Coler. Both men were to be employed by Dürer for one year on a fixed salary paid weekly, plus expenses for bed and board, to promote him and sell his prints from copperplate engravings and woodcuts, at the best price obtainable with a minimum set by Dürer. He did not rely on patronage alone to promote his name and sell his work. One can see Dürer as a 25-year-old entrepreneur, setting up business. Each contract (in the City

Below: The Apocalypse, The Whore of Babylon, *1497–98, woodcut, 39 x 28cm (15.3 x 11in). Dürer's* Apocalypse *series made him famous and prints were sought-after by collectors and publishers.*

Above: Frankfurt an der Oder, c.1580, *by Georg Braun and Franz Hogenberg. The city of Frankfurt on the Odor river regularly held large fairs for print-publishing, which attracted buyers and sellers from across Europe. Dürer's prints were sold here.*

Archive, Nuremberg) was a standard document, modified to set out terms and conditions. Coler and Schweitzer were paid to promote Dürer's work outside Nuremberg, carrying with them mass-produced prints from engravings and woodcuts, with more sent as necessary. The contract specified that the agent had to move on speedily from one location to another. They were not allowed to be 'distracted from selling such prints by any amusement or frivolity.' Dürer took on other agents, not always with satisfactory results, due to agents' poor accounting. One print collection was lost when an agent unfortunately died in Rome. Terms were changed to include a guarantor, to pay for lost works, or money unpaid, as in a contract dated 21 August 1500, whereby Hans Arnolt stood as guarantor for his brother Jakob, the selling agent. One of the witnesses was Dürer's godfather, Anton Koberger.

MARKETABLE PRINTS

Dürer's 1498 large-size *The Apocalypse* print series from fifteen woodcuts was intended as a complete 'book'

narrative of the Revelation of St John the Divine. It would have been of special interest to collectors (see left and pages 40–41, 101 and 130–33). Dürer created series from engravings and woodcuts that were highly saleable and prized. In the 1512 edition of *Cosmographia Pomponij Mele*, published in Nuremberg, the German humanist Johannes Cochlaeus (1479–1552), a friend of Pirckheimer, wrote: 'The merchants of Italy, Spain and France are purchasing Dürer's engravings as models for painters of their homelands.' This was solid praise, but the downside was difficulty in discouraging forgers profiting from original works. The copyright 'AD' monogram (see page 55) was introduced by Dürer in 1495 in an effort to prevent fakes and copies, although forgers then included it on their works as well.

Left: Bullock, c.1493, by Dürer, pen and black ink on ivory laid paper, 17.5 x 14cm (6.8 x 5.5in). The young bull appears at centre in this preparatory drawing but is moved to the left side, a part view in reverse, in the work shown right.

ART FAIRS

In Dürer's absence, Agnes travelled to Frankfurt, a prosperous publishing city, to sell prints at the art fairs, while his mother Barbara, sold works from a stall in Nuremberg market. Agnes and Albrecht Dürer did not have children, for reasons unknown. The absence of a childcare role did allow Agnes to play a large part in running Dürer's business. In addition, after the death of his father in 1502, his mother Barbara moved to Dürer's house in 1504. They may have been responsible for print production

in the workshop. Exactly how many printers worked for Dürer is unknown. It is possible that his workshop assistants worked across different media, painting preparation, painting, woodcut and print making.

CATTLE IN NUREMBERG AND VENICE

The widespread distribution of Dürer's prints could account for a detail in a painting by the Venetian master Giovanni Bellini. *The Assassination of St Peter Martyr*, 1507 (see below) includes a teasing visual reference to the cattle from Dürer's engraving *The Prodigal Son*, 1496 (see above right). The tail of the bovine is just visible in the left of the painting. Bellini may have purchased one but Dürer, a great admirer of Bellini, possibly gave him a print. Exchanges of prints and drawings was one of Dürer's pleasures.

Above: The Prodigal Son, 1496. In this engraving by Dürer, part of the bovine's body is glimpsed, nearly out of view on the left side. The setting is a German farmhouse. (See also page 123.)

Below: The Assassination of St Peter Martyr, 1507, by Giovanni Bellini. Dürer's prints of his engraving The Prodigal Son was popular and well-known in Venice. Bellini copied the young bovine, placing it exiting his painting at left.

DÜRER'S WORKSHOP

Around 1500 it is thought that Dürer opened his workshop to assistants. It was the year that he created a remarkable self-portrait, establishing him as Nuremberg's most famous artist and Germany's new 'Apelles', bringing him many more commissions. He had a team of skilled workshop assistants.

When Dürer first employed permanent assistants is not recorded, but 1500 was a moment that commissions increased. It was a seminal year for Albrecht Dürer. At age 28 he was famous. His *Self-portrait*, 1500 (see page 149), advertised a confident, highly gifted portraitist, an exceptional woodcut designer, an etcher, engraver, and entrepreneurial businessman. In this year Nuremberg patrician, author,

Below: The Martyrdom of Saint Sebastian, *1507, by Hans Baldung Grien. The painter earned his nickname Grien (green) for including the colour in every work. He depicts himself here, in a self-portrait, wearing a green cloak.*

humanist and friend of Dürer, Konrad Celtis, referred to him as the modern-day equivalent of the lauded ancient Greek painter Apelles.

HANS BALDUNG GRIEN
The remarkable artists that worked for him define Dürer's reputation and workshop standards. Hans Baldung Grien (1484/85–1545), born in St Pierre-le-Vieux in Strasbourg, joined the workshop in 1503, during his 'wanderjahr' journeyman years. The friendly addition 'grien' to Baldung's surname reflected a fondness to wear the colour green. It does make him easy to spot in paintings, as a self-portrait in the central panel of *The Martyrdom*

of Saint Sebastian, 1507 (see below), reveals him standing behind the saint. Such was his talent and rapport with Dürer that they continually worked together. A later pencil drawing is thought to be a self-portrait by Grien in 1534 (see page 74).

HANS SCHÄUFELEIN
Another notable assistant, Hans Schäufelein (c.1480/85–1540), entered Dürer's workshop around 1503–04 and during his employment created works that included an altarpiece triptych representing three stages from the Passion of Christ, a masterly work with multiple figures, possibly intended for a Nuremberg church (now in Ober-Sankt

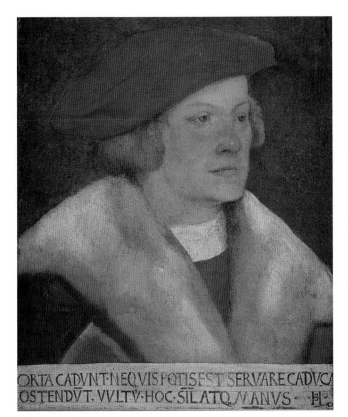

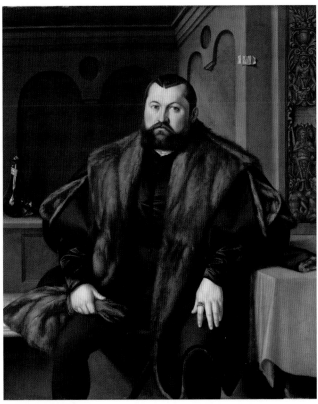

Above: Portrait of Hans Schäufelein, *c.1534/35, by Albrecht Dürer, oil on panel, 32.5 x 25.5cm (12.7 x 10in). Schäufelein was a respected painter, often running Dürer's workshop and commissions in his absence.*

commissions. The fluidity of his paint technique, the luminosity in its light and shadow application, defined his art and reputation. He was a noted painter of stained glass too. *Portrait of a Young Man* (see below), is a self-portrait.

Above: Portrait of Sigismund Baldinger, *1545, by Georg Pencz. Pencz was a highly regarded artist in his own right, as well as a member of Dürer's workshop, joining in 1523. He is noted for the realism of his portraiture.*

Viet, Vienna). It was commissioned by Frederick III 'the Wise', Elector of Saxony, perhaps designed by Dürer and Hans Baldung Grien, and painted by Schäufelein, Grien and assistants while Dürer was living in Venice between 1505–07. The artist is noted for woodcuts produced for books published between 1505 and 1507, the year Schäufelein left Dürer's workshop. He created many paintings.

HANS SUESS VON KULMBACH

Hans Suess von Kulmbach (c.1480–1522) had been apprenticed to the Italian artist-engraver Jacopo de' Barbari, who worked in German cities, including Nuremberg, from 1500–05. In 1507 von Kulmbach joined Dürer's workshop. When Dürer stopped painting altarpieces in 1511, the same year that von Kulmbach became a citizen of Nuremberg, he received many of Dürer's important

Below: Portrait of a Young Man, *1520–22, a self-portrait by Hans Suess von Kulmbach. Surrounding himself with talented painters gave Dürer the freedom to travel and work for long periods away from Nuremberg.*

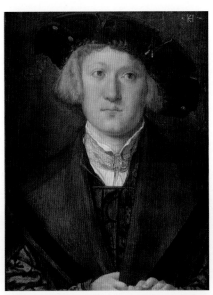

GEORG PENCZ

The German engraver-painter-printmaker Georg Pencz (1500–50) joined Dürer's workshop in 1523. Pencz was the most gifted of Dürer's assistants, an outstanding engraver and portraitist, influenced by northern Italian painting. Long after Dürer's death, Pencz created one of his finest works, a magnificent masterpiece *Portrait of Sigismund Baldinger*, 1545, painted in the Dürer tradition of rich colour, realism, and intimacy (see above). In 1525 Pencz was briefly imprisoned with two painter-engraver brothers – who had been trained by Dürer – Hans Sebald Beham (1500–50) and Berthold Beham (1502–40), for radical religious views. The calibre of painters who were employed by Dürer as workshop assistants shows how much he was in demand, not only to apprentice painters but to artists who were of the same quality.

THE APOCALYPSE

A series of fifteen extraordinary woodcuts, known as *The Apocalypse*, published in 1498, gained Dürer recognition across Europe. Its success allowed him to be less reliant on patrons, and promoted the craft of woodcutting to a higher art form. (See also pages 36, 101 and 130–33.)

By 1498 Dürer had married, travelled to Venice for the first time, and was working for an impressive list of patrons. In this year he painted a stunning *Self-portrait* (see page 140), and published a series of woodcuts that elevated printmaking to the level of painting. Through Dürer, German artists were now distinct from artisans.

A LITERARY FIRST

The Apocalypse, depicting various episodes from the Book of Revelation, was the earliest book created, illustrated, published and sold at the expense of the artist, the copyright holder. It narrated the life of St John the Evangelist. Dürer placed the text on the left side of the page in a two-column presentation, with the illustration arranged on the visually

Below: God overthrows the Antichrist, *1493, a woodcut by Michael Wolgemut. The Antichrist is defeated by Archangel Michael and dragged by devils toward hell near the Mount of Olives, outside Jerusalem.*

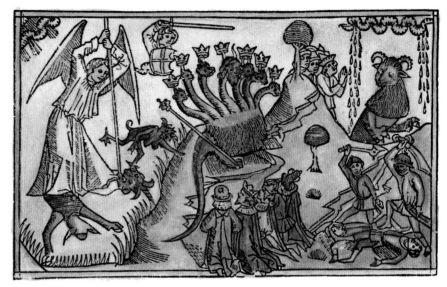

more significant right side; the text was secondary to image. The book was published simultaneously in German and Latin in 1498. Apart from single print editions, prized by collectors, a second edition of the book, combined with two other successful woodcut series, *Life of the Virgin* and the *Large Passion,* was published in 1511.

THE MARTYRDOM OF ST JOHN

The opening woodcut of *The Apocalypse* is a terrifying depiction, a scene-setter for what is to follow. *The Martyrdom of St John* (see opposite top) is based on a legend from a North African theologian, Tertullian (2nd century AD), that John the Apostle, also known as St John the Evangelist, was plunged into boiling oil to be martyred for his faith but miraculously escaped death. The ordeal is watched by a potentate and an unruly crowd.

The Oriental costume of some of the onlookers reference other works created by Dürer around that time, for instance *An Oriental Ruler Seated on his Throne, c.*1495 and *Three Orientals, c.*1496–97 (see page 122 for both); the latter is part of Dürer's stock of costume depictions. At the time *The*

Above: War in Heaven, *1478–80, artist unknown. The woodcut shows The Beast, from Revelation 12: 7–10 and Revelation 13 from the Cologne Bible.*

Apocalypse series was made, there were growing fears of a Turkish invasion in Europe. An inference to Turkish people appears in some woodcuts including *The*

ART OF WOODCUTTING

Wolgemut's *God overthrows the Antichrist,* 1493 (see left) illustrates the powerful medium of the woodcut to explain and explore a subject. Publishing from woodblocks was a team job. In his early career Dürer would have designed, and probably cut, his own woodblocks. From 1498 he employed a specialist woodblock cutter, a *formschneider.* The names of the cutters were usually added to the woodblock. From 1515 also Dürer employed Hieronymus Andreae (1485–1556), a woodcutter, typographer, printer and publisher, who helped produce works such as *The Triumphal Arch* for Maximilian I (see pages 224–25).

Beast with the Seven Heads and the Beast with Lamb's Horns in *The Apocalypse* series (shown on page 101), where some of the crowd are in Oriental dress. In this intense interpretation of Revelation 13, the people at lower left and forefront kneel in trepidation as to what the seven-headed beast will do.

THE FOUR HORSEMEN OF THE APOCALYPSE

The Revelation of St John (Apocalypse) is the final chapter of the New Testament and narrates possible atrocities to occur at the end of the material, human world with death as the great leveller. St John was a poet and evangelist. He was kept prisoner on the island of Patmos by order from Rome. Revelation was written to Christian churches in seven cities of Asia Minor, primarily using symbols and images. Many interpretations have been made, the most prominent seeing the Apocalypse as a symbolic attack on non-Christian Roman emperors and the subjugation of people within the Roman Empire.

The fourth woodcut, *The Four Horsemen of the Apocalypse* (see below and pages 2 and 131) became the most famous of Dürer's series. It illustrates the bible narration Revelation 6: 1–8. It is dramatic and powerful, encapsulating fear and confusion. Dürer depicts the first four – Conquest, War, Famine and Death – of seven seals that need to be

Right: The Apocalypse, The Martyrdom of St John, *1498, woodcut, 39.4 x 28.5cm (15.5 x 11.2in). Dürer's illustration was based on the legend that John the Apostle was thrust into a cauldron of boiling oil to be martyred, but survived due to divine intervention.*

opened for the Apocalypse to begin. The bible narration gives colour to the horses, white, red and black followed by the pale rider of Death. Dürer, without colour, uses gradations of incised lines to denote difference. On the woodcut, the four horsemen are presented in reverse order, Conquest at far right, firing a

Left: The Apocalypse, The Four Horsemen, *1497–98, woodcut. Arguably Dürer's most remarkable and most popular print in the series (see also pages 2 and 131).*

Right: The Apocalypse, The Apocalyptic Woman, *also known as* The Woman clothed with the Sun and the Seven-headed Dragon, *1498, Dürer, woodcut, 39.7 x 28.4cm (15.6 x 11in). Revelation 12 describes a woman clothed with the sun, with the moon under her feet and a crown of twelve stars on her head – widely recognised as the Virgin Mary – and a colossal dragon with seven heads and ten horns and seven crowns on its heads, its tail sweeping stars out of the sky.*

bow; War raising a large sword; Famine, with scales raised, a symbol of feast or famine in the balance; and skeletal Death riding an emaciated horse. As people are trampled on, falling under hooves in tumultuous chaos, the magical realism of a monstrous dragon eating a Bishop is squeezed in at bottom left.

ANIMAL MAGIC

Albrecht Dürer owned several dogs, horses, a monkey, rabbits and parrots. They appear in his engravings, etchings, woodcuts and paintings. Wherever he travelled, he observed and drew domestic and wild animals, birds, and insects, alive or dead, to create a naturalistic backdrop or landscape.

An early 15th-century painting *The Vision of St Eustace* (see above) by Italian artist Antoni di Puccio Pisano, called Pisanello (1394?–1455) fills the scene with animals and birds, as did Albrecht Dürer's copperplate engraving *St Eustace*, 1501 (see page 153). Both follow the narrative of the Roman Placidus, St Eustace's name before he converted to Christianity; while hunting, he sees a vision of a stag with a crucifix between its antlers. Both works are filled with wildlife, and Pisanello's includes a bear. Both artists were famous for their talent in depicting the essence of an animal's character.

DÜRER'S FABULOUS DETAIL

Look for the half-asleep lion in *St Jerome in his Study*, 1514 (see page 210), or the parrot and tiny mouse in *Adam and Eve*, 1504 (see page 173), or sleeping dog in *Melencolia I*, 1514 (see page 209), to appreciate Dürer's rapport with animals, and love of wildlife. Whether as incidental inclusion, used as a symbol, or the subject of a work, it is impossible not to notice them. Some, like the animals in *Adam and Eve*, 1504, were symbolic representations. The farmyard animals surrounding *The Prodigal Son*, 1496 (see page 123), nearly upstage the neglectful prodigal on bended

Above: The Vision of St Eustace, c.1438–42, by Antonio Pisanello. Dürer possibly saw a copy or a drawing of this painting which informed his own version of St Eustace in his 1501 engraving (opposite).

knee. Dürer invigorates the swine with personalities. They jostle as they hunt for food and water. Meticulous detail includes bristly hair on their backs. Animals and insects are everywhere, as in *The Virgin with a Butterfly (or Dragonfly, or Mayfly)* c.1495 (see page 117), the curious monkey in *Madonna with the Monkey*, c.1498 (see page 141), and hares in *The Holy Family with Three*

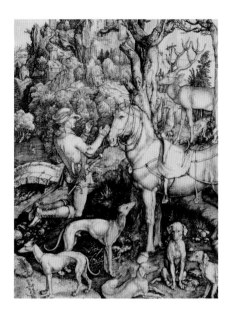

Above: St Eustace, *1501 (detail), by Dürer. (See also page 153.)*

Hares, *c.1497–98 (see page 143)*. In *Adoration of the Magi*, 1504, the eye is drawn to a miniscule detail, a beautifully painted stag beetle (see page 171). There is a magical quality to Dürer's insects and animals. The head of a killed

Below: Sketch sheet, *1496–97, feather with black-brown ink on paper, 38.4 x 28.1cm (15 x 11in). Dürer's small sketches of animal heads and a fort were drawn on the reverse of another work.*

Right: Male deer head, *c.1503, brown ink on paper, by Albrecht Dürer.*

deer (see page 176), with an arrow through its cranium, has skin texture and softness of fur, and a glazed-over dead eye. Realism informs *Young Hare*, 1502, and his studies of lions, 1521 (see pages 156 and 237), both drawn from life. The watercolour observation of the *Left Wing of a Blue Roller* bird, c.1500 (see page 155) astonishes in its accuracy and breathtaking realism. The wing has been ripped off, and Dürer shows this in the uneven flesh, but the intense beauty of colour in each feather is the focus of this major work. Dürer's study of bird wings is echoed in the realism of his winged angels flying through the air in *St Michael Fighting the Dragon*, 1498 (see page 133).

A PARADE OF HORSES

Dürer's familiarity with horses, their character, body form, muscles, head movements, standing, walking and galloping gaits, feature in seminal works. As a rider he understood the movements of a horse's body from a swiftly galloping horse, in *The Small Courier*, c.1496 (see page 124), a slightly impatient horse in *A Lady on Horseback and a Lansquenet*, c.1497 (see page 137),

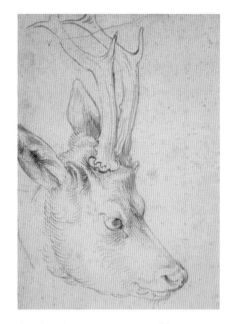

the thundering movement of horses in *The Four Horsemen of the Apocalypse* (see page 131), and boredom of the tethered horse in *The Ill-Assorted Couple*, c.1495 (see page 115).

Below: Horse, *1503, pen and ink and brush drawing on black ground with a hint of green, 21.5 x 26cm (8.4 x 10.2in). The dark background highlights the whiteness of the horse's body, and accentuates the movement of its legs. Dürer created many works featuring horses, paying careful attention to their anatomy.*

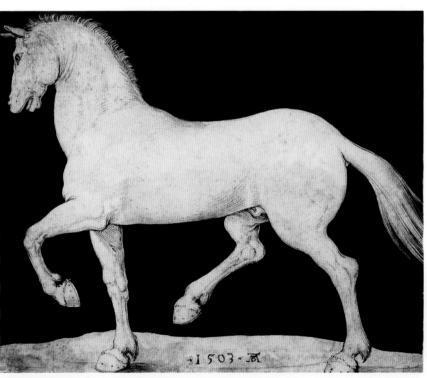

A WEALTH OF PATRONAGE

Dürer mixed with the society of rich Nuremberg patricians; a network of elitist men with useful contacts for art patronage. He took advantage of visits to the city by nobility, to gain commissions. Frederick III was Dürer's earliest significant patron of importance, along with Jakob Heller, and the Paumgartner brothers.

Albrecht Dürer had the ability to charm most clients with his likeable personality. It was a useful skill for a professional aspiring to receive commissions and create a reputation as a major artist. The succession of work from patrons show that Dürer pleased his clients with his meticulous artworks.

FREDERICK III

Frederick III 'the Wise' (1463–1525), Elector of Saxony from 1486, commissioned Dürer for portraits and for religious works. *Portrait of Frederick III, Elector of Saxony* 1496 (see page 33) was probably commissioned and created when the prince visited Nuremberg between 14–18 April. Dürer was able to finish paintings in five days using egg tempera, a faster drying medium than oils. His relationship with Frederick III lasted a lifetime – a later engraved *Portrait of Frederick III*, 1524 (see page 242) was based on a silverpoint drawing created in 1522–23 (see page 241), when Frederick III again visited Nuremberg.

Frederick III commissioned a work in c.1503 for his church in Wittenberg Palace. The central panel of the so-called Jabach Altarpiece (named for a later owner), c.1503–04, is lost but two paintings on the exterior wings remain, if separated (see page 161). One panel shows a drummer (Dürer in a

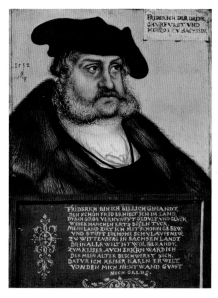

Above: Portrait of Frederick III *by Lucas Cranach the Elder, and workshop, dated 1532, one of 60 posthumous portraits of Frederick 'the Wise' commissioned by his nephew John Frederick I (1503–54). The inscription was authored by Martin Luther.*

self-portrait) and another man as flute player. The other exterior panel depicts the prophet Job castigated by his wife. The elderly man is covered in boils. This choice of depiction may relate to the altarpiece being commissioned to mark the end of a plague. The two interior panels feature four saints (see page 160).

Another commission probably instigated by Frederick was *Adoration of the Magi*, 1504 (see page 170). This work also features a Dürer self-portrait as Melchior, one of the Magi. He

Left and right: Jakob Heller commissioned Dürer for what became known as the Heller Altarpiece (see pages 64–65 and page 191). He was pictured bottom left on the left side panel, and his wife Katharina Melem on the right side panel. Each has their coat of arms displayed. The panels were painted by Dürer's workshop in 1507–09.

DELAYS TO COMMISSIONS

Successful early commissions led Dürer to accumulate a wealth of patrons seeking his portraits and altarpieces. At times he was overstretched. A large panel painting for Frederick III, *The Martyrdom of the Ten Thousand*, 1508, was delayed because Dürer was ill, which then deferred the timing of his next commission, the Heller Altarpiece. This is known through Dürer's letters to the disgruntled patron, Jakob Heller, explaining respectfully why there was a delay.

appears again in *The Martyrdom of the Ten Thousand*, 1508 (see pages 196–97), another Frederick III commission.

THE PAUMGARTNER BROTHERS

'Stephen Paumgartner has written to me to buy him fifty Carnelian beads for a rosary…' wrote Albrecht Dürer from Venice mid-October 1506, in a letter to Willibald Pirckheimer. Paumgartner is mentioned in seven of ten extant letters from Venice, which reveal Dürer's circle of strong intimate friendships in Nuremberg. Stephen, and his brother Lukas Paumgartner, are thought to be the men portrayed leaning on a ledge in the foreground of *The Men's*

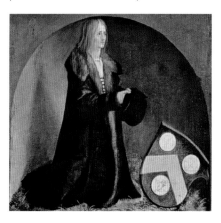

Right: A sensational pair of paintings of the Paumgartner brothers dressed as saints were depicted in the side panels on the Paumgartner altarpiece, c.1498. On the left panel, Stephen Paumgartner is shown as St George. He holds the dragon he has killed, its head dangling, life extinguished.

Far right: On the right panel of the altarpiece, Lukas Paumgartner is depicted as St Eustace, a Roman soldier who converted to Christianity, wearing dazzling armour.

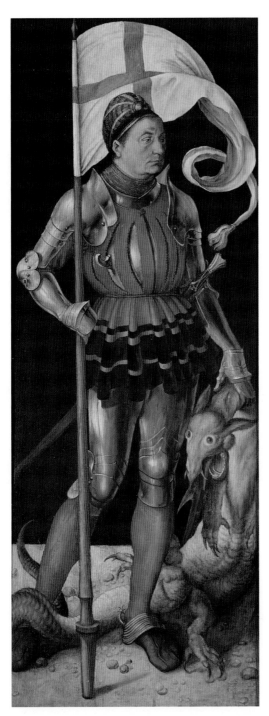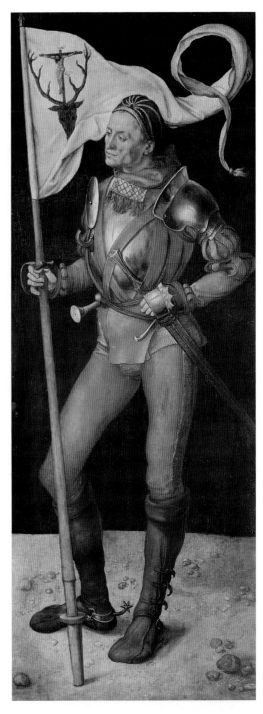

Bath, c.1496–97 (see page 125), with Pirckheimer possibly seated at right, and Dürer standing at left by the water pump. Is it a snapshot of Dürer's friends and patrons? The Paumgartner brothers commissioned Dürer to paint a triptych for St Catherine's church in Nuremberg. The central panel depicts the Nativity with Mary and Joseph, the infant Jesus, and members of the Paumgartner family (see page 151), possibly painted in 1500. The distinctive side panels (see above), painted earlier in c.1498,

feature striking portraits – possibly the first time that donors are depicted as saints – of Stephen as St George with dragon in the left panel, and Lukas as St Eustace in the right panel, both richly clothed as knights.

JAKOB HELLER

Dürer's most difficult client must have been Jakob Heller (1460–1522), a commodities trader from Frankfurt. He commissioned a multi-figured triptych altarpiece (see page 64), and

the contract was agreed. The work was designed by Dürer but he was to paint the central panel and his workshop the side panels. Problems ensued when Dürer became ill and his workload suffered delays. Heller had to wait two years for the altarpiece to be finished, creating tension and animosity between Dürer and his patron, as letters between them reveal. After its completion Dürer decided that any future large-scale works would be created by his workshop.

LETTERS FROM VENICE

Dürer travelled to Venice again in the autumn of 1505. Letters dated January to mid-October 1506 give insights on his everyday life, his patrons, fellow artists, and frustration at bargaining for Venetian luxuries desired by his friends in Nuremberg. He writes of his reception in Venice as a respected gentleman.

A primary source of Dürer's 1505–07 stay in Venice are letters, dated 1506, written to Willibald Pirckheimer, who financed the Venice venture with a loan. They are eloquent, informative and humorous, including intimate, louche comments on mutual friends. Dürer is selling artworks, painting portraits, and negotiating with jewel merchants and carpet traders on behalf of Pirckheimer.

VENICE, 6 JANUARY 1506

'I have an altar panel to paint for the Germans…' [*The Madonna of the Rose Garlands*, 1506] '… they are giving me 110 Rheinish gulden, which will not cost me as much as five florins… I shall have finished laying and scraping the ground-work in eight days, then I shall at once begin to paint.' Dürer's hands were scabby from the physical work, but he started to sketch the altarpiece.

Below: A letter from Albrecht Dürer to Willibald Pirckheimer, dated 25 April 1506, one of many from his regular correspondence sent from Venice during his approximately year-long stay.

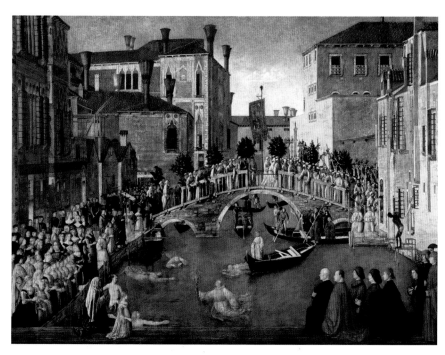

Above: Miracle of the Relic of the Holy Cross at the Bridge of San Lorenzo, *1500, by Gentile Bellini. One of Bellini's famed paintings of his native city, Venice.*

VENICE, 7 FEBRUARY 1506

Dürer's social life is meeting a cross-section of Venetian society, 'men of sense, and scholarly, good lute-players, and pipers, connoisseurs in painting, men of much noble sentiment and honest virtue, and they show me much honour and virtue.' He also writes that some are 'the most thieving rascals…'. Friends advise him 'not to eat and drink with their painters, for many are my enemies and copy my work… they criticise it and claim it is not done in the antique style…' But Dürer adds that 'Gianbellini' (Giovanni Bellini) 'has praised me highly to many gentlemen…' and that Bellini came to his workplace to visit and asked Dürer to create a work for him and he would pay. Dürer adds 'He is very old and yet he is the best painter of all.'

VENICE, 28 FEBRUARY 1506

Dürer's news is that he has sold 'all my little panels except one,' and that two were sold for money, three in exchange for three rings. His presence in Venice has brought attention: 'I have such a crowd of foreigners [Italian] about me, that I am forced sometimes to shut myself up… the gentlemen all wish me well but few of the painters.' Enclosing two letters for his mother, he states surprise that neither she nor his wife had written to him for some time: 'I begin to think I have lost them', which could be interpreted as an offhand remark, or a fear of the plague.

VENICE, 8 MARCH 1506

Dürer reports on how much effort he has made to buy stones and rings for Pirckheimer, 'running around to all the German and Italian goldsmiths…'

VENICE, 2 APRIL 1506

Dürer writes, '…the painters here are very unfriendly to me. They have

summoned me three times before the magistrates, and I have had to pay four florins to their School.' He regrets undertaking the altarpiece. It had lost him money because it was taking so long to complete. The fee would have to pay his living expenses.

VENICE, 25 APRIL 1506
This letter focuses on the purchase of jewels for Pirckheimer.

VENICE, 18 AUGUST 1506
A riveting letter, with interjections in Italian, discusses Pirckheimer's immoral life in Nuremberg. Dürer suggests that if his friend were to turn himself into 'a silky-faced beau' to become as charming as himself, women would find him attractive. Dürer thanks Pirckheimer for visiting Agnes, mindful that he has been away from Nuremberg some time.

Below: Enthroned Madonna and Child with Angel Musicians and Saint Mark, Saint Augustine, and Doge Agostino Barbarigo (Barbarigo Altarpiece), 1488, by Giovanni Bellini (c.1430–1516). Dürer would have seen this painting during his stay in Venice.

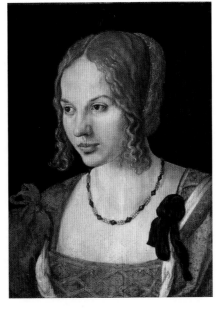

Above: Portrait of a young Venetian woman, *1505, one of the many portraits painted by Dürer during his Venetian sojourn (see also page 177).*

VENICE, 8 SEPTEMBER 1506
'My picture… is well-painted and finely coloured. I have got much praise but little profit.' Dürer had lost work because of the time taken to paint the altarpiece. But he added, ' I have shut up all the painters, who used to say that I was good at engraving but that in painting I didn't know how to handle my colours. Now they all say they never saw better colouring.'

VENICE, 23 SEPTEMBER 1506
On finishing *The Madonna of the Rose Garlands* (see page 182), Dürer writes 'there is no better painting in all the land, for all the painters praise it…they say they have never seen a nobler, more charming painting.' On its completion, Dürer then painted the dramatic *Christ, Among the Doctors* in just five days (see page 186).

VENICE, @ 13 OCTOBER 1506
The last extant letter mentions going to Bologna for eight to ten days, to learn the secrets of the art of proportion from a man willing to teach him, then returning to Venice before heading home to Nuremberg. He had been offered a monetary stipend from the Doge to stay in Venice but declined it. Dürer summed up his thoughts on leaving, 'How I shall freeze after all this sun! Here I am a gentleman, at home a parasite.'

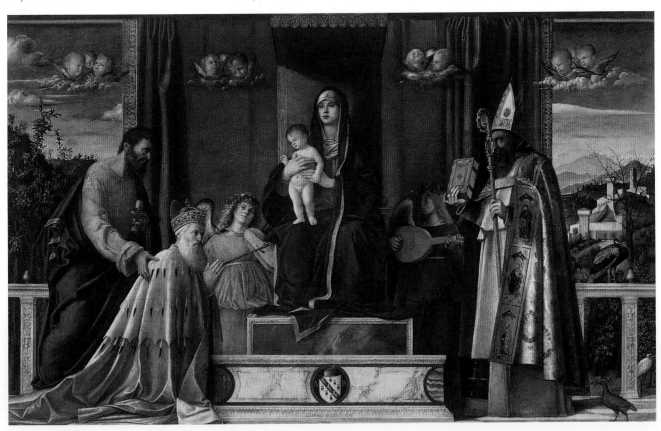

MADONNA OF ROSES

Dürer's stay in Venice from 1505–07 was rewarded with an altarpiece commission from the German Dominican brotherhood. *Madonna of the Rose Garlands*, 1506 (see pages 182–83), altered Venetian opinion on Dürer, from considering him as a graphic artist to seeing him as a highly skilled painter.

The busy trade routes of German merchants, selling commodities across Europe and beyond, meant that major cities had a German community. Within the Venetian group, centred around the Fondaco dei Tedeschi merchant house, was a recently established Brotherhood of the Rosary. Dürer, a fellow German, got to know them. The commissioned work *Madonna of the Rose Garlands* was for the brotherhood's chapel in the German community church of San Bartolomeo, near to the Rialto bridge and close to the merchant house.

Above: Madonna and Child with Saints Peter, Catherine of Alexandria, Lucy, and Thomas, *1505, by Giovanni Bellini. The altarpiece in the Church of San Zaccaria was painted at the time Dürer was visiting Venice.*

Left: Madonna of the Rose Bower (*or* Virgin and Child in the Rose Garden), *1473, by Martin Schongauer, one of the artists who influenced Dürer.*

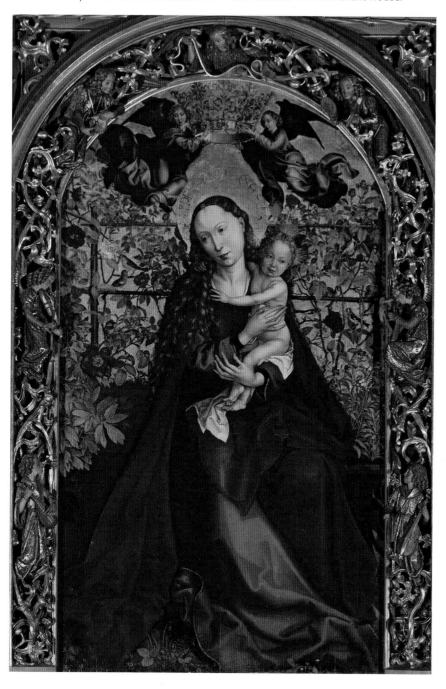

BROTHERHOOD OF THE ROSARY

'Rosary' is from the Latin *rosarium* – meaning rose garden, associated with recited prayer incantation using 'rosary' prayer beads, a rose symbolizing each prayer. A legend dating to 1214 stated that the Virgin Mary had given St Dominic a rosary. A Brotherhood of the Rosary within the Dominican community was inaugurated in the city of Cologne in 1475, to spread the praying of the rosary.

A Venetian brotherhood was established in 1505. Fraternity brothers and sisters recited three rosaries of the Marian Psalter each week, comprising 150 Ave Maria (Hail Mary), a prayer to the Virgin Mary, and 45 Paternoster (Our Father), the Lord's Prayer. Later this was reduced to one rosary per week to help encourage the laity to join in. Recitation of the rosary continues to be an important part of daily prayer.

MADONNA OF THE ROSE GARLANDS, 1506

Rose garlands were symbols of rosary prayers. The written commission from German members of Brotherhood of the Rosary, in Venice, was that the work by Dürer should represent the veneration of the Queen of Heaven by an imagined community of the faithful.

Albrecht Dürer referred to this painting as 'Maria pild' – a painting of the Madonna – in a letter from Venice. Writing to his friend Willibald Pirckheimer, on 23 September 1506, he stated 'Let me tell you that there is no better Madonna picture in the land than mine'. In 1606 the painting was transported by Emperor Rudolf II from San Bartolomeo to Prague. In 1618 it was near-irreparably damaged by water when placed in hidden storage during the Thirty Years War. In the 19th century, restorers altered much of what did remain of the original panel. The work is now known through painted copies made soon after its creation, engravings and drawings, and from Dürer's original studies. It was originally known as *Rosenkranzfest*, or *Feast of the*

Below: Virgin of Victory (Pala della Vittoria), 1496, by Andrea Mantegna.

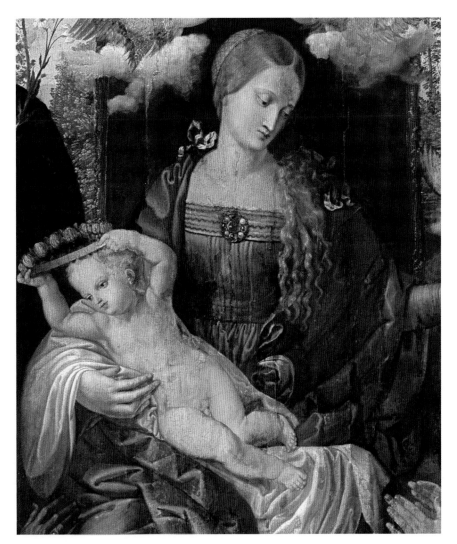

Rosary, the now-used title *Madonna of the Rose Garlands* being a 19th-century invention.

COMPOSITION

Jacob Sprenger (1435–95) published a book *Erneute Rosenkranzbruderschaft* in 1476, with statutes of the Brotherhood of the Rosary and a woodcut illustration depicting the Virgin and Child enthroned with kneeling members of the brotherhood, dispensing rose garlands to the people. Two angels hold a crown above the Virgin's head. This inaugural woodcut was Dürer's starting point for his own depiction.

In Dürer's painting, the veneration of the Madonna is witnessed by well-known people in the German Brotherhood and in Venice, including the architect for the rebuilding of the Fondaco dei Tedeschi, the heart of German business in Venice. Dürer's

Above: Detail of the Madonna of the Rose Garlands *(see page 182 for the whole painting)..*

superlative work shows influence of the Italian Renaissance in his use of symmetry and proportion, and of Venetian artists' use of intense colour. The symmetrical placing of figures to either side of the 'pyramidal' composition of the Madonna at centre is in Andrea Mantegna's *Virgin of Victory*, 1496 (see left), and Bellini's Barbarigo Altarpiece also titled *Enthroned Madonna and Child with Angel Musicians and Saint Mark, Saint Augustine, and Doge Agostino Barbarigo*, 1488 (see page 47). The angel-musician seated at the foot of Dürer's Madonna (see page 184) is a homage to Bellini's angel-musician in *Madonna and Child with Saints* (the San Zaccaria Altarpiece), 1505 (see opposite above).

RENAISSANCE FUSION

Netherlandish and German artists found a common interest in humanism and theories of proportion inspired by Italy's Classical Roman heritage. The absorption of art methods and theories circulating between northern and southern Europe enlightened Dürer and informed his work.

In central Italy, a rigorous focus on classicism in architecture and art, stemming from Florence in the 1420s, reached Rome and filtered through to Venice in the mid to late 15th century. The spread of humanism and interest in Vitruvian theories of proportion in the human body, and classical design, created a new art and architecture, much changed from the beginning of the century. Giovanni Bellini's *Christ Blessing*, c.1500 (see below), reflects a new naturalism and ground-breaking realism. The composition is mirrored in Dürer's remarkable *Self-portrait*, 1500 (see page 149), also informed by his studies of humanism, and of theories on the proportion of the human body in relation to its depiction in art.

Right: St Jerome Reading in a Landscape, c.1480–85, by Giovanni Bellini. Jerome, a revered saint, was a popular subject for paintings. Dürer's St Jerome in the Wilderness, *c.1496, has a similar composition to the Bellini painting (see page 127).*

Below: Christ Blessing, c.1500, Giovanni Bellini. Did this work influence Dürer's self-portrait of 1500?

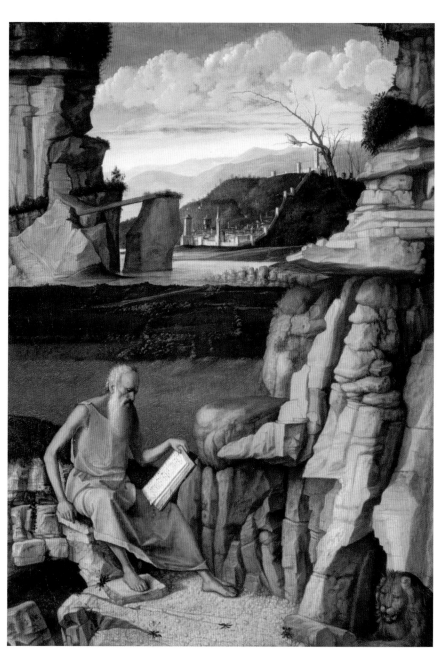

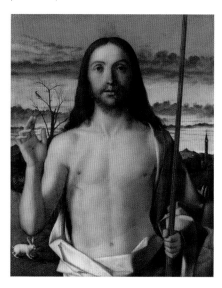

GIOVANNI BELLINI

The revered reputation of Giovanni Bellini – who lived and worked in Venice all his life – rested on magnificent paintings like his portrait of Doge Leonardo Loredan (see page 75), and the richly colourful *St Jerome Reading in a Landscape*, c.1480–85 (see above), which places the hermit and his lion seated in an outcrop of rocks. The viewer is led through the landscape to a walled city on two levels, in the far distance and mountains beyond. Bellini's meticulous detail is breathtaking. A smaller version informed by this work is Dürer's *St Jerome*, c.1496 (see page 127), emulating the Venetian's love of intense jewel-bright colour. In

Above: Battle of the Sea Gods, *c.1485–88, an engraving by Andrea Mantegna. Dürer made his own copy of this work.*

a less rocky, more verdant, European landscape, St Jerome kneels at prayer in front of a crucifix.

ANDREA MANTEGNA

The north Italian painter-engraver Andrea Mantegna (1431–1506), born near Padua, was an artist equal in brilliance to brother-in-law Giovanni Bellini, two of the most influential artists of the Renaissance. Dürer's art was informed by Mantegna's love of antiquity, and his compositional invention with perspectival techniques such as foreshortening, and innovative architectural settings. Dürer wanted to meet him while in Venice but to his regret left it too late. Mantegna died in Mantua on September 13, 1506. Dürer's pen and ink drawing *Battle of the Sea Gods* in 1494 (see page 114)

was closely copied from Mantegna's engraving of the same name (see above), capturing the fearful chaos of the epic battle. The work explores one of the myths of antiquity, which was a popular subject in Renaissance Italy.

RAPHAEL

Dürer never met Raphael, but the latter was influential in his work. Dürer requested an exchange of drawings, not only with Raphael but other Italian artists. The drawing arrived in Nuremberg in 1515. Dürer sent a drawing to Raphael too. These exchanges indicate how respected Dürer was in Italy at the time.

DÜRER'S RENAISSANCE

Artists from northern and southern Europe were interested in developing painting techniques and humanist naturalism expressed in art. Many travelled for work, to find patrons and new concepts. Long before he set off on journeys through Europe, Dürer was aware of the new art emerging from Italy. *The Holy Trinity*, 1425–27,

Left: The Beheading of St John the Baptist, *1510, Albrecht Dürer, woodcut, 19.5 x 13cm (7.67 x 5.1in). Raphael would have seen this woodcut.*

Right: Two Nude Men, *1515, Raphael (Raffaello Sanzio), in red chalk. An inscription on the back written by Dürer indicates he received the drawing in 1515. The drawing by Raphael of male nudes was a gift to Dürer, and in it Raphael pays homage by referencing a figure from Dürer's* Beheading of St John the Baptist, *noticeable in the stance and gesticulation of the nude figure on the right.*

JACOPO BELLINI'S WORKSHOP

The workshop of artist Jacopo Bellini (1396–1470) was the most progressive and successful in Venice. Jacopo, instigator of the Renaissance style in northern Italy, was himself informed by the work of Brunelleschi, Masaccio and Donatello in Florence. He opened a workshop in 1424. He trained his sons, Gentile Bellini (c.1429–1507) and Giovanni Bellini (c.1430–1516) as painters, remaining connected with the workshop after apprenticeship. When Andrea Mantegna married Nicolosia, daughter of Jacopo and Anna Bellini, in 1453, it brought him into the Bellini family, increasing commissions and reputation.

by Masaccio (1401–28) was the first European artwork to include a perspectival vanishing point, and *David*, 1440, by Donatello (1386–1466) was the first nude sculpture of the modern era, referencing Italy's ancient past.

Dürer's knowledge of Renaissance art informed his work but did not replace its essential northern European character, based on Netherlandish and German art. He learned from the Italian Renaissance without it overshadowing his own style.

NATURE STUDIES

Albrecht Dürer's studies of nature display the meticulous detail that is present in his work. He was a keen observer and the drawings and paintings were created as stock illustrations for later use in commissioned work, similar to his reusable animal collection.

Reference to the natural world appears throughout Dürer's art from drawings and engravings to panel paintings. Looking closely, we can share his careful observations of tufts of grass, identify a delicate wildflower or the unique leaf-type of different trees, and view a quiet

Below: The Virgin and Child (The Madonna with the Iris), 1503–07, workshop of Albrecht Dürer, oil on linden wood, 149.2 x 117.2cm (58.7 x 46.1in). This was created to Dürer's design and composition.

pool or a lake, a sharp rocky outcrop, or the smoky blue-grey appearance of distant hills. These feature often as incidentals to the principal subject but are always noticeable, such as the lush grape vines in *Bacchanal with Silenus* (after Mantegna), 1494 (see page 114). His focus included ground-level botanical observation, like the exquisite woodland *Tuft of Cowslips*, 1526 (see opposite, below), which served as a template. Dürer emulates Schongauer's inclusion of flora, as in his *Madonna of the Rose Bower*, 1473 (see page 48).

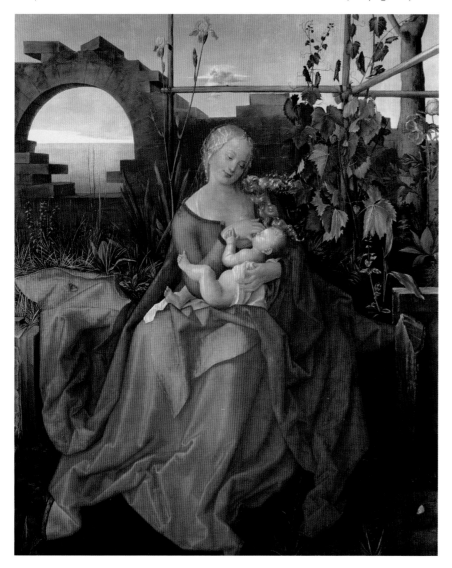

Above: Celandine, 1495–1500, one of Dürer's stock images, painted in watercolour and opaque on very fine, smooth parchment, 28.7 x 14.9cm (11.2 x 5.8in). The date was added later.

WORKSHOP STOCK IMAGES

The delicacy of light filtering through the fragile leaves of the wild plant *Celandine* (see above), make it a work of art but it would have been created as a workshop stock illustration, to add realism to a composition. The plant specimens were often cleaned, trimmed, thinned, or shortened, and then placed to create an optimal spacial structure. The large painting *The Virgin and Child (The Madonna with the Iris)* (see left), was credited to Dürer but now attributed to his workshop, and chiefly his assistant Hans Baldung Grien. However, the plants and grasses

that act as a vibrant backdrop of lush green foliage, complementing the scarlet of the Madonna's dress, are formed from Dürer's stock of nature studies. He created the watercolour *Iris* (see page 165), a life-size study of the plant produced on two pieces of paper. The iris is a symbol of the Virgin Mary, and visible behind her in the Grien workshop painting. At her left is bugleweed, lily of the valley and a peony, and to her right are plantain and grasses. In the engraving *Erasmus of Rotterdam*, 1526 (see page 247) Dürer depicts the theologian's working environment and adds a touch of realism in the small jug of lily of the valley flowers on the desk.

PIECES OF TURF

Two works in particular concentrated on random clumps of grasses. *The Small Piece of Turf*, c.1495–1500 (see page 119), and later, the most important *The Great Piece of Turf*, 1503 (see page 164), are botanical masterpieces of draughtsmanship. Each clump was dug up from its outdoor habitat, then drawn to scale in the workshop. To create *The Great Piece of Turf*, Dürer used a low viewing point, as an insect or small mammal would see it. He used the largest piece of paper he had, to illustrate all the wild grasses, plants and flowerheads, and roots, in their

Below: Tuft of Cowslips, 1526, Albrecht Dürer, gouache on vellum, 19.3 x 16.8cm (7.5 x 6.6in), an exquisite illustration of wildflowers showing the artist's meticulous diligence.

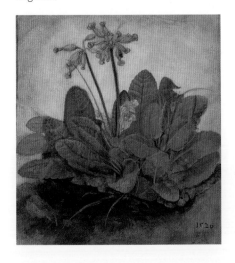

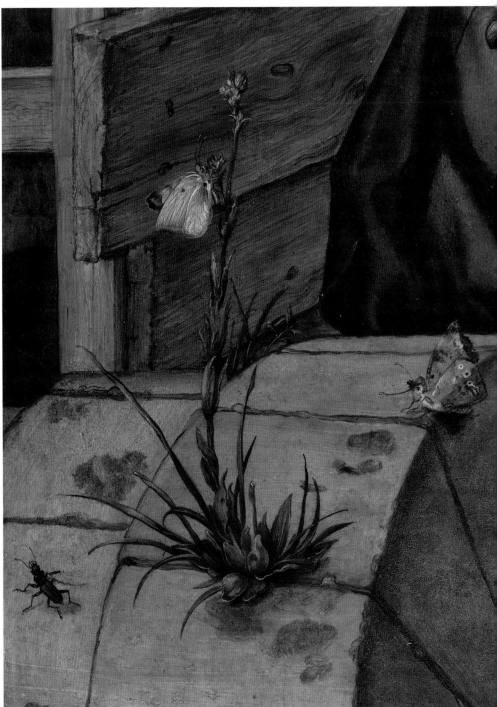

Above: Detail of a wild plant, a beetle and butterflies, from Adoration of the Magi, 1504 (see page 170), revealing how Dürer paid attention to the smallest detail in every work.

original size. From the condition of the dead-head dandelions, it was probably produced in late Spring to early May. One can feel the damp grass in the lush growth. In the undergrowth of daisies and plantain leaves Dürer added the date, 1503. His monogram is missing, probably lost when the paper was cut by several centimetres at top right, at a later date.

Dürer's regular additions to his stock images was normal practice for artists in high demand for their religious paintings. The background was usually filled in by workshop apprentices using the stock imges as a guide, and the major figures painted by senior assistants and the master painter.

FIGHTING PLAGIARISM

The Italian engraver Marcantonio Raimondi is quoted as a plagiarist of Dürer's work but Andrea del Sarto, Jacomo Pontormo and Giorgio Vasari all appropriated content from Dürer prints, as did other copyists. To deter forgers, Dürer issued a copyright statement supported by Emperor Maximilian I.

Even before Dürer's stay in Venice from late 1505 until early 1507, where plagiarism of his work was rife, the problem of original work had led him around 1495 to create a monogram 'AD', placed on all his work. There is discussion that a first visit by Dürer to Italy c.1494–95 was to challenge the forgers with a court injunction. In many religious commissions, Dürer

Below: The Dream of the Doctor (Temptation of the Idler), *Wenzel von Olmutz after Albrecht Dürer; the engraving shows how popular Dürer's work was to copyists.*

painted himself into the scene, proof that the work was a genuine Dürer. *The Landauer Altarpiece, All Saints Day,* 1511 (see page 202), one of Dürer's most famous paintings, shows the artist including a self-portrait at this occasion, proof that the work was a genuine Dürer. Any copier would therefore need to acknowledge the artist's presence in the work created.

A WARNING TO COPIERS

Printed in Latin, Dürer issued a 'Warning to Copiers and Pirate Printers' in four book editions of woodcuts dated 1511: the earlier *Apocalypse* series

reprinted, *Life of the Virgin*, *Small Passion*, and *Large Passion*. The direct language left would-be copiers in no doubt of Dürer's intent:

'Beware, you highway robber and thief of other men's labour and invention, take heed that you do not lay rash hands on these our works. For be it known that the Most Glorious Emperor of the Romans, Maximilian,

Below: The Dream of the Doctor (Temptation of the Idler), *c.1498, the original work that Dürer created for print sales (see also page 148). It was copied by other artists, see left.*

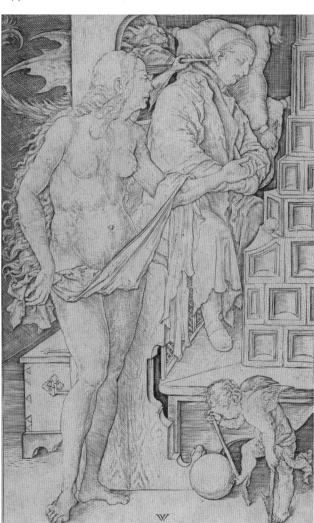

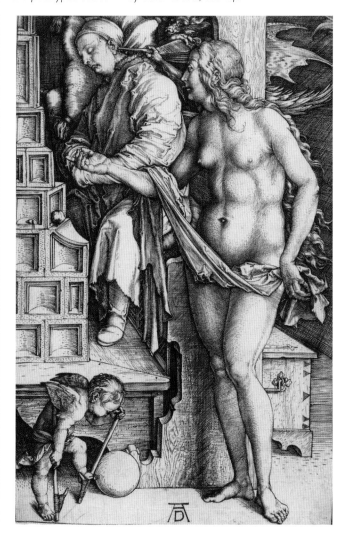

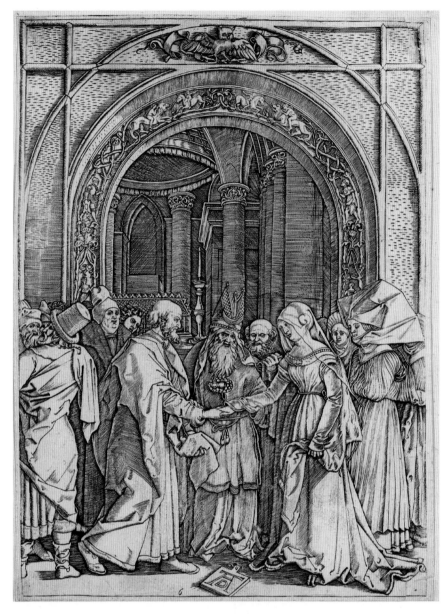

Above: Copyright mark of Albrecht Dürer (this one from 1502), to confirm a work as original and deter copyists.

Above: The Betrothal of the Virgin, c.1506, from the Life of the Virgin series by Marcantonio Raimondi (c.1480–1530), an engraving after Dürer. Raimondi was known as a plagiariser of Dürer's work.

has granted us a privilege, lest anyone dare print these images from forged blocks, or sell such prints without the borders of the Empire…'. [copied from Ashcroft, Volume I, p.338]

Dürer warned that such thieves of copyright would have their goods seized and would put themselves in 'greatest peril.' He had found copying of his work rife. It was easy for a good woodcutter to recreate the woodblocks, or an engraver, to recreate prints. Some even included a forged AD monogram for

authentication. He accepted that it was difficult to stop copying but said his monogram should not be included.

AD MONOGRAM

It was not only exact copies of a Dürer woodcut or engraving that plagiarists sold. An artist created a similar work on a theme of a Dürer design, such as the St Eustace, and pass it off as a 'signed' original with Dürer's AD monogram. A pen and ink drawing, *St Hubertus* (St Eustace) (see right) by a German artist Wolf Huber (1480–1549), a near-contemporary of Dürer, includes a fake AD monogram and the date written in the style of Dürer. The monogram is included in *The Betrothal of the Virgin, c.1506* by Marcantonio Raimondi

after Dürer's original (see left). Martin Schongauer used a monogram for drawings and engravings as well, yet his work was also copied profusely. The first to pirate his work was Wenzel von Olmütz (active 1490–99) who used the monogram 'W' on his forgeries of Schongauer's work, passing it off as his own. To show how closely works were copied, compare two editions of *The Dream of the Doctor* (*Temptation of the Idler*), originated by Dürer c.1498 and copied by von Olmütz soon after (see opposite). There is no attempt to disguise that it is copied.

Below: St Hubertus (St Eustace) in front of the stag miracle, 1530(?), a drawing by Huber Wolf, was informed by Dürer's woodcut of St Eustace (see page 153).

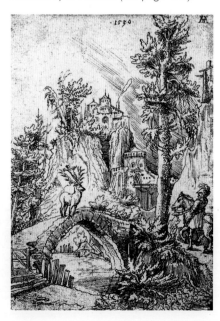

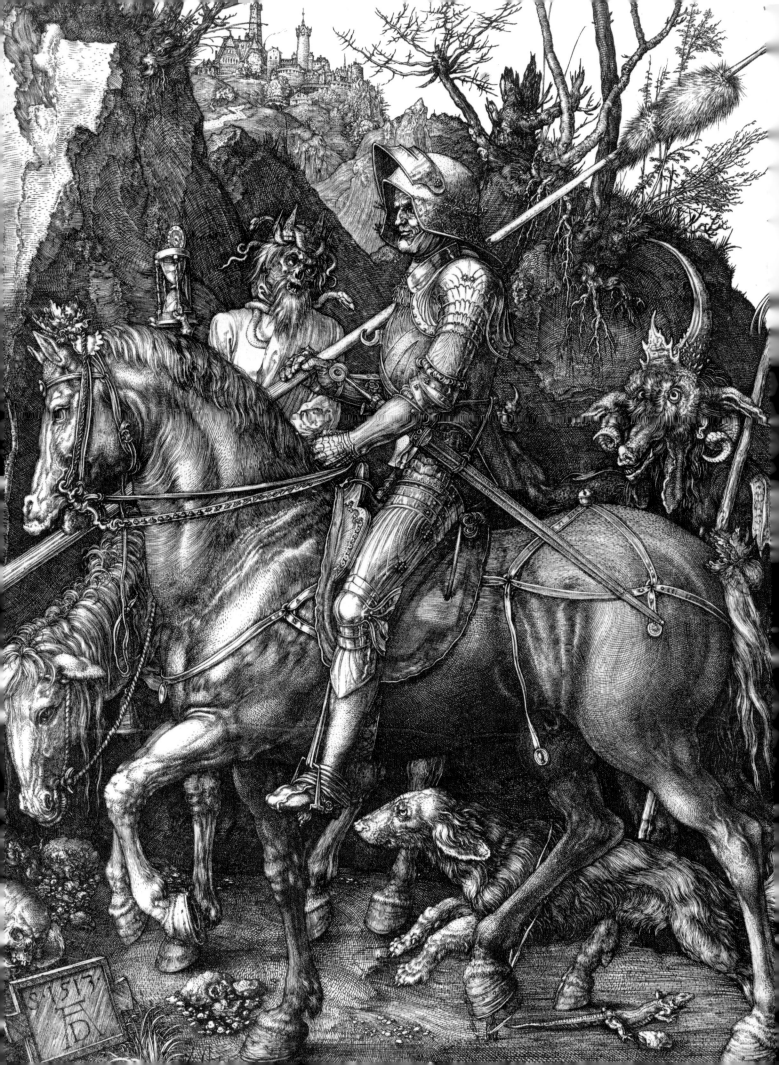

THE 'APELLES OF BLACK LINES'

At the time Albrecht Dürer was achieving international success with his groundbreaking *Apocalypse* series, he was also creating further series: eleven drawings and two series of woodcuts on Christ's Passion, and a series of nineteen woodcuts on the *Life of the Virgin*. Some would be marketed as individual collector prints, and they were published in book form in 1511. In addition to print promotion, Dürer worked for prominent patrons, and continued travelling for work. Three of his most famous engravings were created in 1513 and 1515. After a working visit to the Netherlands from 1520–21, Dürer returned to Nuremberg with a debilitating illness. He concentrated on writing, including poetry, and on portraiture, incorporating many of his friends. By 1523 he was devoting time to prepare, write and proofread his theoretical texts for *Four Books of Human Proportion*, which he had begun researching in 1512. It was published in October 1528, a few months after his death in April that year.

Above: The Virtue 'Ratio' (Reason) steering the team of horses for the Large Triumphal Chariot, *one of the eight-block woodcuts that Durer printed in 1522, adapted from the huge promotional work celebrating the life and achievements of Dürer's patron Emperor Maximilian I created earlier in 1518 (see also pages 226–27).*

Left: Knight, Death and Devil, *1513, copperplate engraving (see also pages 70 and 208).*

THE PASSION SERIES

In 1511, three series of woodcuts were published: two devoted to the Passion of Christ, the other to the Life of the Virgin. An earlier Passion series of drawings, the 'Green' in 1504 and a later 'Engraved' published in 1512, show Dürer's versatility to invigorate the same narrative with differing perspectives.

Passion cycles were produced in book form for private meditation. It was a visual narrative of the Passion of Christ, often in a sequence of nine, eleven or twelve plates, but as many as 40 in a series are known to have been published, beginning with the Expulsion of Adam and Eve from the Garden of Eden and concluding with

Christ's descent into Hell. In his series, Dürer introduced light and shade, depth, volume and texture; the values of his painting technique, transferred to woodcuts and engravings. In each series he created different compositions for the narratives, for example, of Christ's Resurrection, as shown in the three examples here. For the woodcut

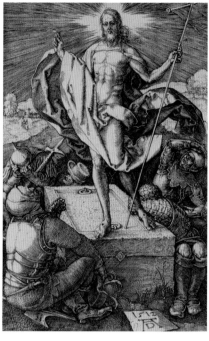

Above: The Resurrection *from Dürer's* Engraved Passion *series, 1512, 11.7 x 7.5cm (4.6 x 2.9in). Christ's resurrection is narrated in the Bible, Luke 24. Standing on his tomb, he holds the Flag of Peace.*

Left: The Annunciation, *the seventh in Dürer's woodcut series* Life of the Virgin, *c.1503, 30.2 x 21.6cm (11.8 x 8.5in). Archangel Gabriel appears to the Virgin Mary, to announce that she will give birth to Jesus Christ, Saviour of the World.*

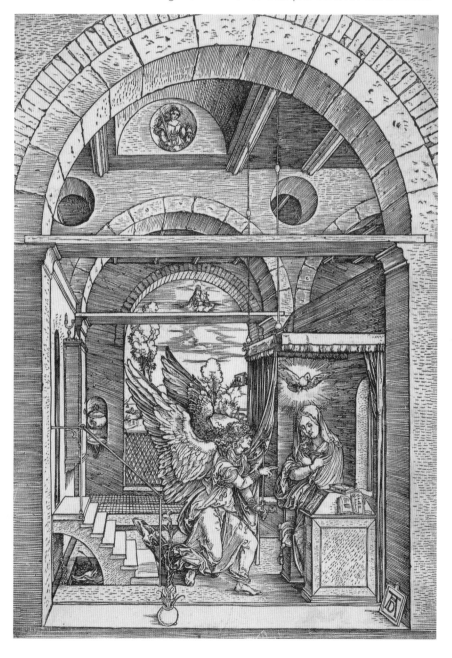

series, his finished drawings, rendered in reverse, would be transferred to woodblocks and incised with a woodcarving knife by a specialist.

LARGE PASSION

The *Large* or *Great Passion*, so-called because of the size of the prints, was created in a series of initially eleven but eventually twelve woodcuts with a title page. The first of four passion cycles, it was created between 1497 and 1510 and published in 1511 simultaneously with the second publication of Dürer's

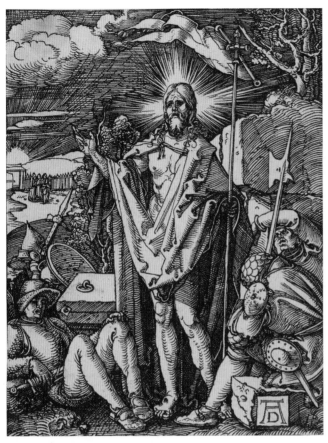

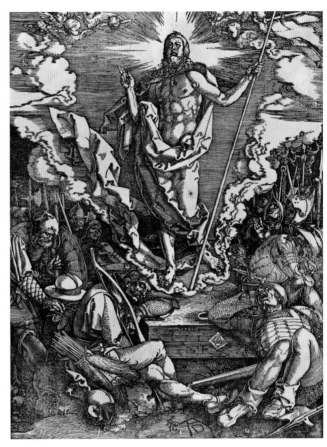

Above: The Resurrection *from Dürer's* Small Passion *woodcut series, c.1510, 12.7 x 9.8cm (5 x 3.8in). As the sun rises, and guards sleep, he is restored to life. In the distance members of the Holy Family make their way to visit the tomb.*

Above: The Resurrection, *from Dürer's* Large Passion *series, woodcut, 1510, 39 x 28cm (15.3 x 11in). Resurrected on the third day after crucifixion, Christ is depicted in glory, exalted.*

popular *Apocalypse* series and the *Life of the Virgin*. They formed what is now known as 'Three Great Books'. Dürer's engravings and woodcuts were remarkable for spacial depth, movement and volume. The *Large Passion* represents the pinnacle of his experimentation in woodcut technique. The large format attracted collectors; the first seven, dated 1497–1500, were sold as solo single-sheet prints before the series was completed for publication. (See also pages 134–36.)

GREEN PASSION

So-called for the green paper on which it was drawn, the *Green Passion* (1504) is considered to be by Dürer, although some sources question if workshop assistants were involved. The colour primer of the paper was an experiment to mirror the blue-tinted paper found in Venice. The purpose of the series is unknown but possibly created as preparatory drawings for stained glass windows. The eleven chiaroscuro drawings are in pen and black ink, heightened with white on prepared paper. The drawn architecture of the buildings was created with a compass. The series begins with the *The Captivity of Christ* and ends with *The Entombment of Christ*. (See also pages 174–75.)

THE LIFE OF THE VIRGIN

A series of nineteen woodcuts plus a title page, known collectively as the *Life of the Virgin* and published in 1511, took the artist ten years to complete, beginning with the *Birth of the Virgin*, and concluding with her *Assumption* and *Coronation*. Notable is Dürer's use of linear perspective in one of the last woodcuts, Dormition of the Virgin, informed by his stay in Venice in 1505–07. Latin verses written by Benedictus Chelidonius accompanied the illustrations. (See pages 162–63.)

ENGRAVED PASSION

Sixteen small engravings known as the *Engraved Passion*, fifteen created 1507–12 with the last (*St Peter and John Healing a Cripple*) in 1513, are the size of playing cards. Each one underlines Dürer's immense skill to create a strong narrative within a tiny pictorial space.

SMALL PASSION

The series takes its name from the small quarto size format. Dürer created this series of 36 woodcuts plus a frontispiece over a period, with most created in 1509–10. In 1511 it was published as a portable devotional book and also sold in solo prints. A commentary in Latin verse accompanied the illustrations, written by Friar Benedictus Chelidonius (1460–1521) of the Benedictine monastery in Nuremberg with whom Dürer collaborated. (See also pages 198–99.)

SELF-PORTRAITURE

Self-portraits were often used by artists to show their artistic skills to prospective clients. Dürer's self-portraits tell us not only his physical appearance and his artistic dexterity, but how he viewed himself. His paintings were designed as self-promotion, and can be compared to the works of other artists at the time.

Dürer knew the value of self-promotion and the importance of his own image. As well are refining the art of self-portraiture, he is present in many of his works, in sketches and woodcuts, and in religious narratives. Dürer was aware of marketing himself as well as his pictures.

LEARNING FROM MASTERS

Looking at *Portrait of Levinus Memminger* c.1485 (see right) by Dürer's tutor, Michael Wolgemut, one can see many similarities of composition in Dürer's *Self-portrait at age 26*, 1498. He follows the half-length seated pose, facing toward the sitter's left, with the sitter looking out at the viewer, with hands at waist level. Both works have a view into the distance through a window behind the sitter. The effect gave a sense of an interior and exterior space.

Artist Jan van Eyck (c.1390–1441) whom Dürer greatly admired, painted Christ as Salvator Mundi, possibly as part of a diptych (see below). This work,

Below: Portrait of Christ (detail), one of the later copies of Jan van Eyck's now-lost 1440 work. The original may have informed Dürer's own portraiture.

along with one by Bellini (see page 50), offers a comparison to Dürer's later *Self-portrait at age 28*, 1500 (see page 149). Is Dürer presenting himself in that painting in the style of Jesus Christ, or is it simply a portrait?

Above: Portrait of Levinus Memminger, c.1485, Michael Wolgemut (1434–1519). Levinus Memminger was a Nuremberg judge. On the left is his coat of arms, with his initials that are repeated in the colourful landscape skies.

SELF-PORTRAIT DEPICTIONS

In his *Self-portrait with a Thistle*, 1493 (see pages 30 and 109), painted on a dark, plain background, Dürer depicts a young man with an inquisitive stare, fashionably dressed with hair slightly unkempt. It is spectacular in its edginess. Dürer is holding the stem of an of an eryngium (sea holly) plant. The plant's symbolism encompasses independence, attraction, fertility, fidelity and more. The inscription reads: *My sach die gat als oben schtat* ('My affairs must go as ordained on high'). Some historians have favoured this work as an engagement 'this is me' portrait for Agnes Frey. It was painted on parchment, which is easier to transport by courier, if not proof of Dürer's intent to send it to Agnes as a courting gift.

PORTRAITS OF A RENAISSANCE MAN

Self-portrait at age 26, 1498 (see below and page 100), denotes more than an historical portrait of the artist. This is the year that Dürer became a celebrity, after the publication of *The Apocalypse* woodcut series that brought him instant fame. The cloth backdrop and landscape viewed behind the sitter are Venetian in style, acknowledging the influence of Italian Renaissance portraiture. Dürer portrays himself in very fine clothing. He wears a pair of beautiful gloves. The imagery connotes that he is an artist of talent and intellect, a 'gentleman'. *Self-portrait at age 28*, 1500 (see page 149) confirms his remarkable talent, by then celebrated across Europe. The plain background pushes attention on him. Light streams on to his face, highlighting Dürer's strong features with trademark beard, and the rich colour of his long, curled hair, and the soft fur of his favourite coat.

'DÜRER WAS HERE'

Many of Dürer's religious works contained a self-portrait. *Madonna of the Rose Garlands*, 1506 (see page 183) shows the artist at far right, standing under a tree, holding a paper with verification of himself as the artist. So too, in *The Martyrdom of the Ten Thousand*, 1508 (see page 197), where Dürer with his humanist friend Konrad Celtis are depicted standing in the midst of the massacre. Dürer holds a placard, verifying his authorship. The grand altarpiece commissioned by Martin Landau, a metal trader of

DÜRER UNDRESSED

Letters from Dürer's friends to each other, often sent greetings to, or inquired after, 'the bearded one'. Dürer's facial hair defined him without name. The bearded face appears in self-portraits from 1498. Is there a subliminal message in the nude self-portrait of *c.*1500–05? Staring up at the mirror, Dürer reveals his muscular naked body and bearded face, with his characteristic intense, inquisitive eyes fixed clearly on himself (see below). Another work, a semi-naked nude, *c.*1509–11 (see page 200), was sent to a doctor to show where he had an internal pain, pointing to it with a finger, while his eyes are fixed on the observer.

Nuremberg, *The Landauer Altarpiece, All Saints Day*, 1511 (see page 202), also features Dürer standing in the earthly landscape, holding a sign of authorship. There are many other examples of his appearances in his own works, some more disguised than others (see also pages 32–33).

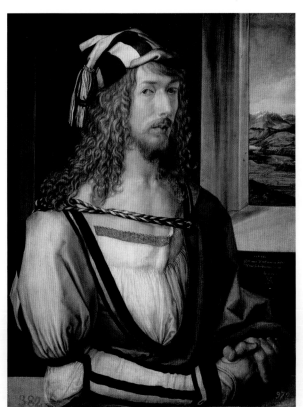

Left: Self-portrait at age 26, 1498. Dürer's assured self-portrait depicts an aspiring gentleman, denoted by the soft kid gloves he wears and fashionable clothing.

Right: Self-portrait – nude study, 1500–05, Albrecht Dürer, pen and ink and wash on stained green paper. With his long hair hidden in a hairnet Dürer reveals his toned and muscular naked body. (See also page 158.)

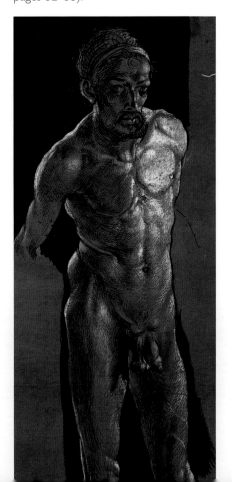

THE HOUSE ON ZISSELGASSE

In 1509 Dürer purchased a large house on the corner of the Zisselgasse, in Nuremberg. A home for his wife, his mother and brother Hans, and a workspace too. A document of 14 June 1509 transferred the property to him from the Estate of a Nuremberg citizen, the late Bernhard Walther.

In the same year that Albrecht Dürer became a *genannter*, nominated member of the Great Council of Nuremberg, the highest honour awarded to a citizen of non-patrician birth, he purchased, as sole proprietor, a freehold house in Nuremberg. It was on the Zisselgasse by the Tiergärtner, a prestigious address. He paid '275 Rhenish gulden in gold coin'. The previous owner, the German merchant, astronomer and humanist Bernhard Walther (1430–1504), had paid 150 Rhenish gulden to purchase the house in 1501. The house would act as home and workplace for Dürer, his family and possibly his assistants.

Below: St Anthony in front of the castle walls of Nuremberg, 1519, Albrecht Dürer, copperplate engraving, 9.6 x 14.3cm (3.7 x 5.6in). In 1509 Dürer purchased a prestigious house situated on a hill below the Imperial Castle.

A PRESTIGIOUS LOCATION

Located beneath the imposing walls of the Imperial Castle of Nuremberg, close to Menagerie Gate, it was a half-timbered vast house on the corner of the Zisselgasse. The freehold purchase allowed Dürer freedom to use it as he wished. Dürer's acquisition fitted with membership of the Great Council, which was reserved for patricians, high-ranking professionals, and elite members of Nuremberg society. Dürer was referred to in notes as 'the artistic painter whose like there has never been in all of Germany.' At the age of 38, a substantial house was fitting for his exceptional status and affluence.

A FAMILY HOME

On the death of their father in 1502, Dürer's younger brother Hans Dürer was 'taken in' by Agnes and Albrecht. Barbara, Dürer's mother, moved to their house shortly after in 1504, when

Above: House of Albrecht Dürer in Nuremberg, Germany, coloured engraving, possibly by Salvatore Puglia. The view of Dürer's impressive detached house is from the album 'Giornale letterario e di belle arti', published May 1, 1841.

her finances were diminished. It is not known exactly where they had lived until the 1509 house purchase, but the previous occupant Bernhard Walther had died in 1504, and the house may possibly have been rented by Dürer before it was purchased.

A WORKING ENVIRONMENT

The house was built in the early 15th century, around 1418. It has five floors, the lower two built in sandstone, the upper three half-timbered. In 1501 after Bernhard Walther purchased the house, he modified it to create an astronomical observatory on the attic floor, adding small windows. Deeds show that the equipment was to be removed when no longer required, probably at the death of Walther in 1504. The large, spacious interiors of the house allowed Durer to have a home for his family, plus a large studio workplace on the second floor for himself, his

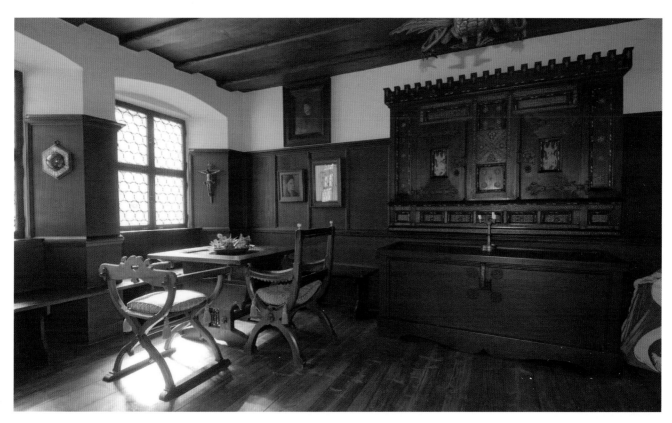

assistants, apprentices and pupils. The room receives a north-easterly light flooding through large-scale bottle-glass windows. Due to the generous size of the house, with spacious rooms and lots of light – essential for painting and printmaking – it is thought to have accommodated a press for etchings and woodcuts with room for assistants. In what capacity, if any it was used for practical work is unknown. There are no records of the house being used as a workshop. Intriguingly there are two kitchens, on the first and second floors. Perhaps one for the family and for assistants in a workshop. Why there were two is not recorded.

Above and below: Interior views of Albrecht Dürer's House in Nuremberg, built mid-15th century (20th-century photographs). The artist lived here from 1509–28.

ALBRECHT DÜRER HOUSE

During the Second World War, 1939–45, the city of Nuremberg was heavily bombed and much of its infrastructure demolished, including historic buildings and part of the castle. Incredibly, Albrecht Dürer's house on the Zisselgasse remained intact. In the present day, it is open to the public, at Albrecht-Dürer-Str. 39. The kitchen still has the original open stove. Some rooms are furnished in keeping with the early 16th-century period, when the Dürer family inhabited it.

THE HELLER ALTARPIECE

Altarpiece commissions took time. After a protracted altar panel commission for Jakob Heller, a wealthy commodities trader and money broker, painted 1507–09, Dürer decided that 'very careful nicety does not pay' and left the painting of future large works to his assistants.

The Heller altarpiece – a triptych – was a co-creation by Dürer with his workshop. He was commissioned for the front of the altarpiece. The artist Matthias Grunewald created the external back panel in grisaille (see opposite). However only the central front panel was painted by Dürer; the side panels were painted by his workshop to his design. Over one hundred years later in 1615, Dürer's central panel was sold to Maximilian I of

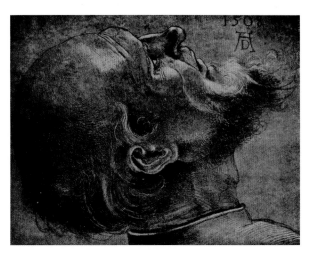

Below: Heller Altarpiece *triptych, 1507– 09. The central panel by Jobst Harrich is a copy of the original panel painted by Albrecht Dürer, which was destroyed in a fire. The side panels created by Dürer's workshop are now at the Staatliche Kunsthalle of Karlsruhe, Germany.*

Bavaria and a copy was made to replace it (now at the Stadel of Frankfurt). This was created by Dürer copyist Jobst Harrich (1579–1617). He included Dürer's self-portrait in the background

Left: Head of an Apostle looking up, *1508, Albrecht Dürer, brush in black ink heightened with white body colour on green tinted paper, 18.9 x 24.1cm (7.4 x 9.4in), one of the meticulous preparatory drawings that Dürer created for the Heller Altarpiece (see also pages 192–3).*

of the scene. Dürer's original was later destroyed by a fire in Munich in 1729, so Harrich's 1615 copy is how we know what the original work looked like (see below and also pages 191–93).

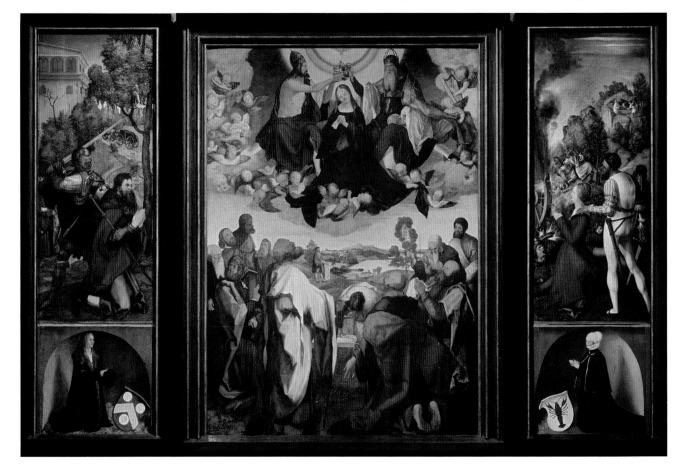

THE HELLER ALTARPIECE

Jakob Heller (1460–1522), of Frankfurt am Main, wanted a lasting memorial for himself and his wife Katharina Melem (died 1518), a retable for the chapel of St Thomas Aquinas, in the Dominican convent in Frankfurt, where the Heller tombs would lie. Dürer was commissioned to paint the central panel that depicted *Assumption and Coronation of the Virgin Mary* (now known as the Heller Altarpiece). The side moveable wings – closed to cover the central panel except on Sunday and Feast days – were to be painted by Dürer's workshop, probably led by Hans Dürer. At the bottom of the side panels are portraits of the donors, Jakob Heller and his wife Katharina. The grisaille painting *Adoration of the Magi* displayed on the external back of the panel was commissioned by Heller from Matthias Grunewald (1470–1528).

Nine extant letters, written by Dürer to Jakob Heller, reveal how some patrons expressed disregard for their painters, however famous. A delayed completion date and additional fee had Heller complaining via his agent Hans Imhoff. After this Dürer stated he would not be treated as a contract painter. The letters from Dürer to Heller reveal an initial excitement, later followed by the

frustration of a commission that took near two years to complete. The original fee did not cover extra outlay for materials. After polite but disagreeable exchanges, the fee was then increased from 130 to 200 guilders.

PAINSTAKING PREPARATION

Dürer wanted the panel to be exceptional – 'something that not many men can equal' – but in a letter dated 28 August 1507 he warned Heller that he had been ill with 'a long bout of fever', which had delayed the work schedule. He coaxed Heller to allow the best quality paint pigments and paint techniques to be used, at some expense. '…I intend so soon as I hear that you approve, to paint the ground some four, five, six times over, for clearness, and durability's sake, using the very best Ultramarine…' (Letter 24 August 1508). Dürer made detailed preparatory drawings, of which eighteen survive, including *Praying Hands* and *Feet of an Apostle* (see page 193). They are considered important because they are all that is left to show Dürer's work on the panel, which he took painstaking care to create. He wrote, 'I have painted it with great care… using none but the best colours I could get,' but his enthusiasm changed to frustration in a letter of 29 August 1509 to Heller: 'No one could ever pay me to paint a

Above: Adoration of the Magi, St Peter and Paul, Thomas of Aquinas and St Christopher, St Laurence, and Elisabeth of Thuringia (Heller Altarpiece, *1507–09). The back of the altar frame was created in grisaille by Matthias Grunewald, 190 x 260cm (74.8 x 102in), Staatliche Kunsthalle, Germany.*

picture again with so much labour… therefore I shall stick to my engraving.' The physical exertion and mental agility required to create the panel is clear from these words.

ORIGINALS AND COPIES

Dürer's painting is only known today through his preparatory drawings, the Harrich copy, and the Dürer workshop side panels. The loss by fire of Dürer's original work shows how important official copies of major works, made near to the time of the original creation, were to preserve the artist's oeuvre. Dürer, like many artists who worked for influential patrons, found their work later sold or exchanged or accidentally destroyed. And reputation did not protect artworks; Dürer was famous at his death but time evaporated his prestige and memory. Today the preservation of artworks is a priority for museums, but in Dürer's era, the patron, not the painter's status, took precedence.

NOT A CONTRACT WORKER

Reading Dürer's letters to Heller reveal that he expected his patrons to value him beyond that of a craftsman on contract work. Heller, a businessman, expected deference; Dürer also expected it. The Heller altarpiece was one of the last large-scale commissions that Dürer accepted. Patrons wanted works to be by Dürer's hand. An entrepreneur Georg Thurzo (1467–1521), from Augsburg, offered 400 florins for a panel like Heller's. 'I turned him down flat because it would have reduced me to beggar' wrote Dürer to Heller in a letter dated 26 August 1509, not financially feasible for 'diligent dabbing' as he called it.

WRITING THEORIES

On his return from Venice in 1507, Albrecht Dürer began preparations to write and publish a manual on the practice of painting, to assist artist-apprentices. The first step was to read ancient and contemporary treatises on art to understand various theories before writing his own commentary. (See also pages 90–91.)

One can imagine in the art circles of Venice that discussions would centre on theories and practice of painting, and on perspective in relation to art and architecture. Dürer's circle may have stemmed from Giovanni Bellini's friends, including Giorgione (1477–1510), Vittore Carpaccio (1465–1525) Cima da Conegliano (1459–1517) and Lorenzo Lotto (1480–1556). During his stay in Venice Dürer had purchased *Elements of Geometry* written by the ancient writer Euclid (of Alexandria),

Below: De Pictura: Schema Generale della Costruzione Legittima (*'General scheme of legitimate construction'*), by *Leon Battista Alberti. Dürer's treatises were informed by respected theories such as Alberti's on art practice and proportion.*

the 'father '...of geometry' (active 323–283BC), published in Venice in Latin in 1505. Another resource for Dürer for theoretical writings was the library of his friend Willibald Pirckheimer.

NUREMBERG LIBRARIES

Flourishing as a prosperous Free Imperial City, Nuremberg had many collections of rare manuscripts, texts and books owned by its wealthy patricians. Dürer's friends, notably Konrad Celtis and Willibald Pirckheimer, gave him access to sources he needed, and advised and helped with translations. In addition Dürer knew the Nuremberg mathematicians Johannes Werner (1468–1522) and young Thomas Venatorius (1488–1551). Excellent sources were to be found

in the collection of the late Johann Müller, of Konigsberg, known as Regiomontanus (1436–76), the German scholar, astronomer and mathematician who had moved to Nuremberg in 1471, where he remained until around 1475 when he was called to Rome by Pope Sixtus IV. He wrote: '...I have made observations in the city of Nuremberg... for I have chosen it as my permanent home not only on account of the

Below: Study of a female nude seen from the front with a foreshortened circle, 1500, Albrecht Dürer, pen and *brown ink with green wash. Her head is turned to her half-left. On the reverse [verso] is another study of a female nude seen from the front with construction lines and some alterations to her left leg.*

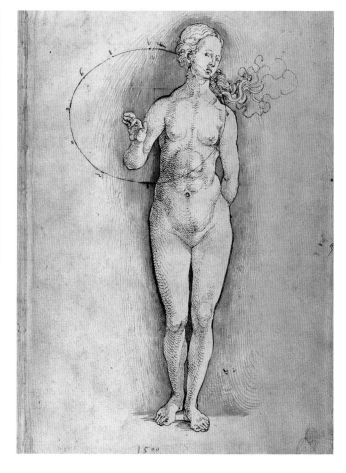

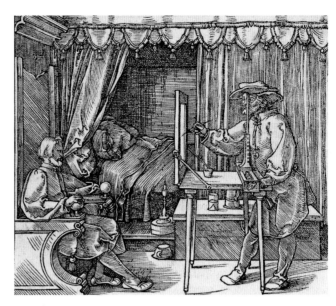

Right: An artist using Dürer's drawing machine to paint a figure, shown on a page from Course in the Art of Drawing *by Albrecht Dürer, published Nuremberg 1525. Many art theorists created drawings to show how to draw perspective using a geometrical machine.*

Above: Proportion, an illustration from Four Books of Human Proportion *('Vier Bucher von Menslicher Proportion'), published posthumously in Nuremberg, 1528. Dürer shows the human body, from front and side and an arm, in proportion.*

availability of instruments, particularly the astronomical instruments on which the entire science is based, but also on account of the great ease of all sorts of communication with learned men living everywhere, since this place is regarded as the centre of Europe because of the journeys of the merchants.'

Regiomontanus built an observatory, a workshop, and his own printing press. His remarkable Nuremberg collection included ancient texts in translation,

Below: Proportion drawings of an infant, before 1519, from Dürer's treatise.

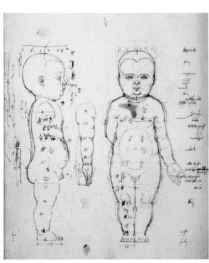

and contemporary treatises such as *De Pictura* ('On Painting'), written in 1435 but published in 1450 by one of the most important Italian humanist scholars, the architect Leon Battista Alberti (1404–72).

TREATISES ON PAINTING

A practical manual on painting was planned by Dürer in 1515, possibly instigated by giving instruction to his own workshop pupils, and his younger brother Hans. Dürer would be familiar with seminal texts on painting, such as *Il Libro dell'Arte* ('The Craftsman's Handbook'), 1437, a practical book on methods and techniques by the Florentine painter Cennino Cennini (c.1370–c.1440), as well as the treatise *De Pictura* by Alberti.

Dürer's notes on painting were rarely dated, which makes it difficult to place them in order of creation. His illustrations of human proportion date from 1500. Pages include his copies of Leonardo da Vinci's drawing *The Proportions of the Human Figure (after Vitruvius)* (see right). Durer gave instruction on how to measure the male and female adult figure, and children (see above and left, and pages 90–91 and 246). Dürer disagreed with Vitruvius that the head should be one-eighth of the length of the whole body, asserting that 'The head shall amount to seven and a half lengths'.

However, Dürer abandoned his plan to write a treatise on painting,

moving instead toward studies of human proportion, mechanisation and fortifications, all interests of Leonardo da Vinci. as well. Dürer continued to research and write, adding texts and illustrations to support his theories. They were collected together and published in 1528, just before his death, and also posthumously. (See also pages 90–91.)

Below: The Proportions of the Human Figure (after Vitruvius), c.1490, Leonardo da Vinci (1452–1519). Da Vinci's illustration was based on the writings of the Roman architect-engineer Vitruvius (1st century BC).

DEATH OF HIS MOTHER

Barbara Dürer was much younger than her husband – fifteen years old when she married the 40-year-old Albrecht Dürer the Elder. He died in 1502. She outlived him by twelve years and died on **19 March 1514**. Her last moments were painful, which affected Dürer deeply, and intensified his lifelong fear of death.

As a widow Barbara Dürer spent ten of her last years living with her son Albrecht and his wife Agnes. She was supportive to both. There is no written record of this, but she sat for Dürer as a model, as Agnes did, appearing in Dürer's religious portrayals such as The

Below: Portrait of Barbara Dürer, 1490. An early portrait in oils by her son, possibly a post-apprentice graduation work, and one of a pair with a portrait of his father (see page 103).

Holy Family with Joachim and St Anne, 1511 (see opposite and page 204).

A FAMILY HOME

Two years after her husband's death, Barbara Dürer moved in with Albrecht and Agnes – because as Dürer, in his personal record said, 'her means had quite run out'. Exactly where Dürer was living in 1504 is unknown, but taking his mother in assumes that he was not living in his father's house in Unter der Vesten. Perhaps – as previously

discussed – he rented the house in Zisselgasse before he purchased it in 1509. From 1502 his younger brother Hans, aged twelve, possibly beginning an apprenticeship with Dürer, also lived with him and Agnes. It would be a responsibility for Dürer, as eldest son, to support the fatherless family. It is known from Dürer's letters from Venice in 1506 that his mother helped the family's business by selling his prints in Nuremberg market.

A PAINFUL DEATH

Dürer's mother and father were deeply religious. In their companion portraits of 1491, each holds a rosary (see page 103). The unintended absence from his father's moment of death in 1502 determined Dürer to be with his mother when she died. He recorded her passing in melancholic detail. The words underline a deep love for his mother, and her devout belief in God. A charcoal portrait drawing of her aged 63 years (see opposite, above right) is unforgiving in the honesty of her skeletal features. Her face is gaunt, her forehead greatly wrinkled. The high cheekbones accentuate the sunken cheeks, drawn skin, and protruding eyes that connote a weight loss and frailty. Two inscriptions on the work relate to its creation. One, at top right in charcoal, reads 'On oculi [19 March] This is Albrecht Dürer's mother, she was 63 years old.' Another inscription in the corner adds, 'she died in the year 1514 on Tuesday before Holy Cross Week at the second hour of the night.'

DÜRER'S GRIEF

Dürer wrote that in 1513, a year before her death, Barbara was taken so ill that she was given the Last Sacraments. She recovered, and Dürer's account shows how much she meant to him. '...My honest mother coped with

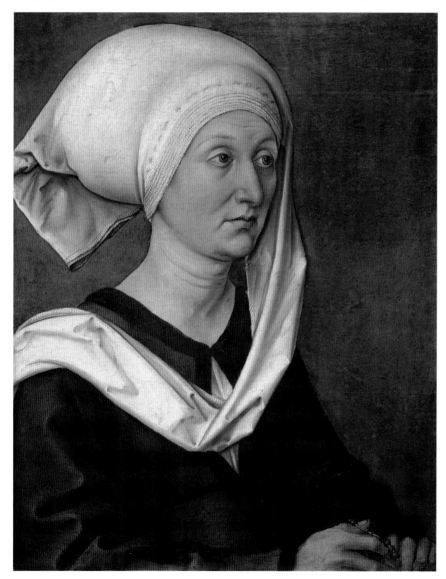

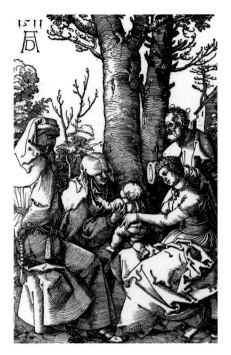

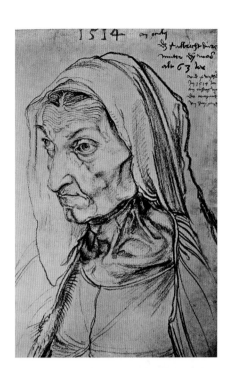

Right: Dürer's Mother (Portrait of Barbara Dürer), *1514, Albrecht Dürer, charcoal on paper, 42.1 x 30.3cm (16.5 x 12in). The portrait was created by Dürer two months before her death, and completed on 19 March 1514, at a time when they both knew that she was terminally ill. She died on 16 May. The drawing is signed with an inscription and dated by the artist. It is a poignant vision of Barbara Dürer, aged 63, a loyal wife, and a mother to eighteen children, of whom only three would outlive her. Dürer recorded her passing in the Family Chronicle, 1524.*

Above: The Holy Family with Joachim and St Anne, *1511, Albrecht Dürer, woodcut, 23.5 x 15.8cm (9.2 x 6.2in). Barbara Dürer is posing as St Anne – mother of the Virgin Mary, and grandmother of the infant Christ. (See also page 204.)*

bearing eighteen children… put up with poverty, scorn, and derision, spiteful words, terrors and great adversity yet she was never vindictive.' He records: '… my worthy mother Barbara Dürer passed away as a Christian should, with all the sacraments, absolved by papal power from guilt and torment… [a paid-for papal indulgence]…death dealt her two mighty blows to the heart… and [she] passed away in pain. That caused me such grief as I cannot put into words…'

The artworks created in 1514 may respond subliminally to her life, and her role as a mother. Dürer's most beautiful Madonna engraving, made in the year of his mother's death, *Madonna by the Wall* (see right) has the Imperial Castle, Nuremberg in the background, a view seen from the family home.

Right: The Madonna by the Wall, *1514, Albrecht Dürer, engraving, 14.9 x 10.2cm (5.8 x 4in). In a beautiful composition, set below the walls of Nuremberg, the Madonna sits with the infant Christ.*

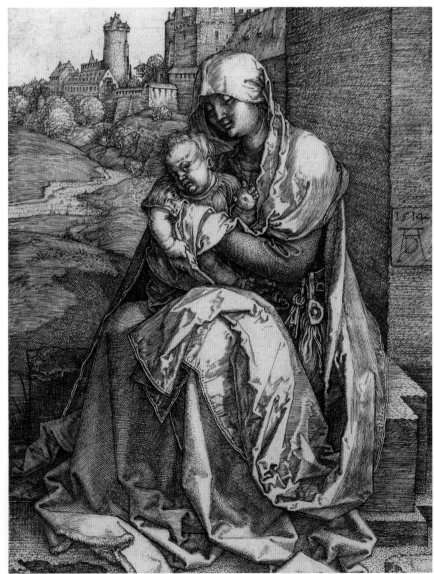

THREE ENGRAVINGS

Engraving on metal was a vital part of a goldsmith's training, which Dürer learnt in his father's workshop. The extent of his skill is evident in three copperplate engravings produced in 1513 and 1514, the most important engravings he ever produced.

From 1513 to 1515 Dürer stopped painting to concentrate on the research and writing of his texts on theories of proportion in the human body. A continued income was possible from the creation of engraving and woodcut prints. The period coincided with his mother's terminal illness in 1513, leading to her death in 1514. This was a great shock to Dürer and may have focused his thoughts on the material and spiritual life.

KNIGHT, DEATH AND DEVIL, 1513

Amongst other Dürer works featuring horses, the c.1497 woodcut *A Lady on Horseback and a Lansquenet* (see page 137), *A Maximilian Knight on Horseback*, 1498 (see page 142), an engraving *The Small Horse*, 1505 (see page 179) and *The Large Horse*, 1509 (see page 194) pre-empted this work.

Below: Knight, Death and Devil, *1513, 24.5 x 18.8cm (9.6 x 7.4in). This engraving highlights the immense skills of narrative illustration that Dürer achieved, placing the Christian knight, his faithful dog, and the horned devil all travelling together with the aura of death. (See also pages 56 and 208.)*

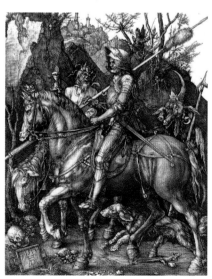

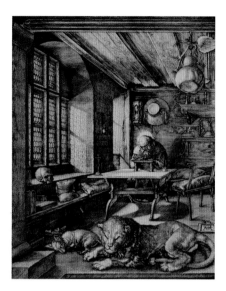

Above: St Jerome in his Study, *1514, engraving, 24.4 x 18.8cm (9.6 x 7.4in). St Jerome was depicted by Dürer many times in various media. In each the patience and goodness of the elderly saint is depicted through expressions, actions and location. (See also page 210.)*

Similarities can be made to the work by Hans Burgkmair the Elder who depicted *Emperor Maximilian I* as a medieval knight in 1508 (see page 78), and also to Dürer's own engraving *St George on Horseback*, 1508 (see page 194). What is striking about the *Knight, Death and Devil* engraving is its complexity: the depth of light and shade amongst the figures; the knight, travelling through an abandoned landscape; and the view to distant hills where a castle is glimpsed, and the knight's destination. The Christian knight – *Der Reuther* (The Horseman) – as Dürer called him, is approached by Death, hourglass in hand, on a pale, tired horse, and a goatish, one-horned Devil. The knight journeys on with his dog – who has sensed the unearthly creatures – running speedily at his side, adding earthly realism to an unworldly apparition.

ST JEROME IN HIS STUDY, 1514

Dürer created many depictions of St Jerome. This most famous engraving places the saint in his study, an everyday setting, writing at his desk in a room filled with a sense of peace and calm. Dürer creates this atmosphere with the little dog and large lion dozing close to each other, familiar objects such as slippers and a skull, and the cardinal's hat hanging on the wall. Rays of sunshine filter through the bottle-glass windows. Cushioned wooden seats, close to St Jerome, suggest visitors. The uncertainty expressed in *Melencolia I* can be contrasted here with the serenity of a contemplative life in a study. This work was created in the same year that Dürer's Nuremberg friend Spengler, a friend of Martin Luther, published a translation of St Jerome's biography.

The subject of the hermit St Jerome was popular for artists and Dürer as a devotional subject. Another remarkable woodcut by Dürer compares to the

Below: Melencolia I, *1514, Albrecht Dürer, engraving, 23.8 x 18.7cm (9.3 x 7.3in). Despite the numbered title, only one work was made. (See also pages 208–09.)*

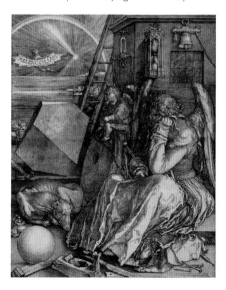

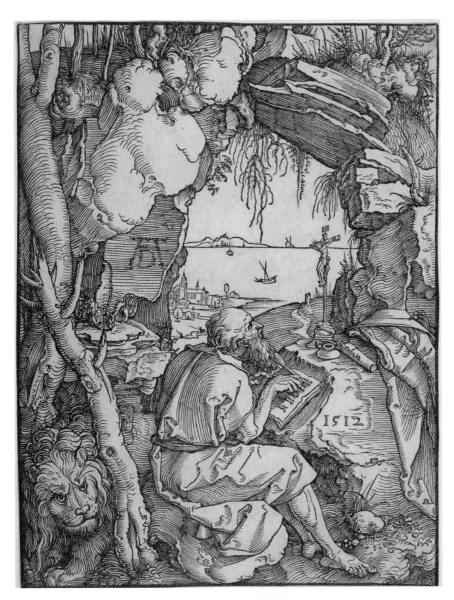

MELENCOLIA I, 1514

Melencolia I is Albrecht Dürer's most famous engraving. Giorgio Vasari (1511–74), author of *Lives of the Most Excellent Painters, Sculptors, and Architects* (1550 and 1568), called it '*che feciono stupire il mondo*' ('a work of art marvelled at by the entire world'). The mystery of the angel surrounded by a complexity of objects has left historians baffled. In a multifaceted composition Dürer infuses despair, isolation, and compassion for a disconsolate angel.

Countless theories developed from the moment *Melencolia I* was distributed as a print. Many cite the Italian philosopher, humanist and Neo-Platonist, Marsilio Ficino (1433–99) as possibly the first to bring attention to melancholia as a characteristic of artists. He was informed by the text *Problemata* by the Ancient Greek philosopher Aristotle (384–322BC). Ficino's book would have been accessible to Dürer from his friend Pirckheimer's library. There are also possible astrological symbols (see also pages 208–09).

Below: Victory reclining amid trophies, c.1510, Jacopo de' Barbari print from engraving, 13.97 x 19.37cm (5.5 x 7.6in). Barbari, a Venetian artist, was resident in Nuremberg around 1500. Is there a connection between his depiction of Victory and Dürer's *Melencolia I, 1514?*

Above: St Jerome in a Cave, 1512, woodcut, 17 x 12.5cm (6.7 x 5in). Dürer was a master draughtsman, dextrous in both engraving and woodcut, and St Jerome was a favourite theme he visited many times in his works.

engraving of *St Jerome in his Study*. In this earlier woodcut (see above) Dürer places the saint outdoors in a cave with the faithful lion behind him at left. Seated, St Jerome writes while looking up to the crucifix resting on a ledge in front of him. Beyond the cave walls in the far distance is a view of the earthly world with a church building close to the water's edge and sailing boats beyond. Dürer has included the year, 1512, and his AD monogram 'drawn' on a rockface, directly opposite the crucifix.

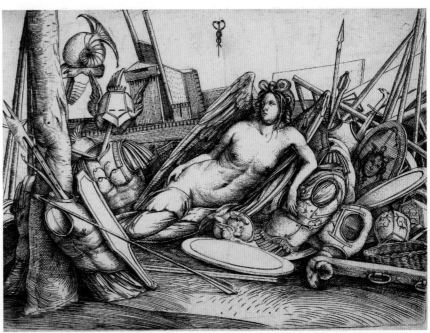

THE RHINOCEROS

Albrecht Dürer's pencil-drawn interpretation of an adult single-horned Indian rhinoceros was created from descriptions and sketches of an animal brought to Portugal in 1515. His armour-plated visualisation (shown on page 216), although incorrect, became the identifying image of the animal for nearly 200 years.

The occasion for drawing the animal was the arrival in Portugal on 20 May 1515 of an adult single-horned Indian rhinoceros (*Rhinoceros unicornis*), not seen before in Europe. It was a gift from Sultan Muzafar II of Gujurat (reigned 1511–26), to his colonial ruler, Dom Manuel I, king of Portugal (reigned 1495–1521). The magnificent rhinoceros was transported to Portugal via cargo ship. The journey took months with several stops on the journey. It was the first live rhinoceros to land in Europe since the 3rd century AD.

THE GREATER ONE-HORNED RHINOCEROS

The greater one-horned rhinoceros is identified from its single black horn, 20–61cm (8–24in) in length, just above the animal's nose. This rhino species is huge; it weighs 4000–6000 pounds (up

Below: A map of the voyage of Vasco da Gama 1497–98, shows the trade route to India at the time. The rhinoceros took many months at sea to reach Portugal.

Above: A Rhinoceros and Indian Elephant, unknown artist, comparing the two creatures made to fight each other for the pleasure of Dom Manuel I.

to 2721kg), is 3.8m (12.5ft) in length and 1.8m (6ft) in height. After its arrival in Lisbon, the impressive creature's fame was widespread. From a description and an anonymous sketch, Dürer drew *Rhinoceros*, 1515 (see opposite above) in pen and ink. It was followed by a woodcut (see page 216). This would

be the most well-known depiction of a rhinoceros for near 200 years, in spite of incorrect scaly legs, a scallop shape on the face, and a small spiral horn at the base of the upper neck.

Dürer added text below the drawing, probably an extract from a news report: '...on 1 May was brought to our King of Portugal in Lisbon such a living animal

RHINOCEROS V ELEPHANT

The ancient Roman writer Pliny the Elder (23/4–79AD) in *Naturalis Historia* ('Natural History') stated that the rhinoceros was the sworn enemy of the elephant. The ruler of Portugal, now owning a rhinoceros and an elephant, decided to test Pliny's statement and pit them in a fight against each other. The elephant ran away as soon as it caught sight of the rhinoceros.

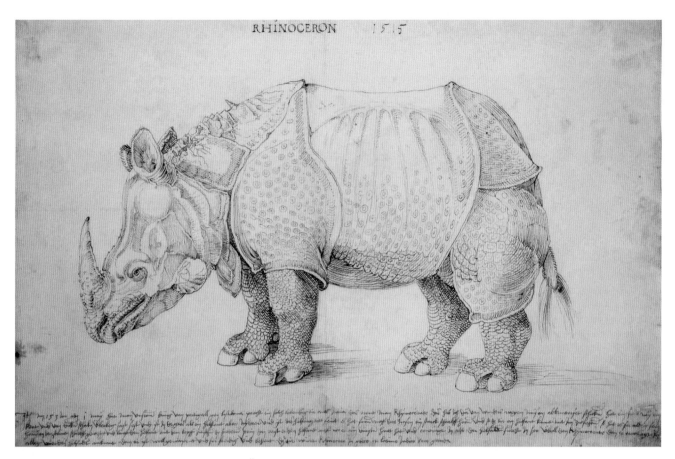

Above: Rhinoceros, 1515, Dürer, pen and ink drawing, 27 x 42cm (10.6 x 16.5in).

from India called a Rhinocerate. Because it is such a marvel, I considered that I must send this representation. It has the colour of a toad and is covered all over with thick scales, and in size it is as large as an elephant, but lower, and is the deadly enemy of the elephant. It has on the front of the nose a strong sharp horn: and when this animal comes near the elephant to fight it always first whets its horn on the stones and runs at the elephant with his head between its forelegs. Then it rips the elephant where its skin is thinnest and then gores it. The elephant is greatly afraid of the Rhinocerate; for he always gores it whenever he meets an elephant. For he is well armed, very lively and alert. The animal is called rhinocero in Greek and Latin but in India, gomda.'

A few months after arrival, the king gifted the animal to Pope Leo X, but the ship carrying the rhino to Rome capsized in poor weather and the animal, chained to the deck, was drowned along with the crew.

DÜRER'S POPULAR PRINT

Several thousand impressions of Dürer's woodcut were printed. Other artists made drawings and woodcuts, such as the nearer representation *Rhinoceros* by Hans Burgkmair (see below), possibly based on the original anonymous sketch too. Artists copying Dürer's version are obvious by the addition of the non-existent extra horn on the upper neck.

A third version found in the Vatican Library contains elements of both artists' depictions.

Below: Rhinoceros, 1515, Hans Burgkmair, woodcut, 22.4 x 31.7cm (8.8 x 12.4in). Many artists depicted this new species of animal to arrive in Europe. However it was Dürer's depiction, although inaccurate, that became the most popular.

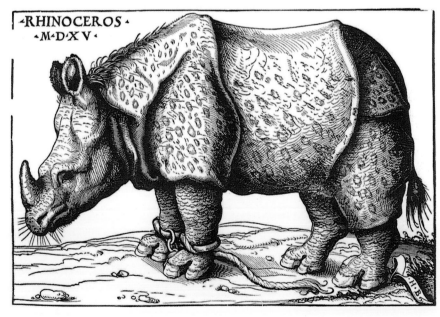

DÜRER'S NETWORK

The intellectual and artistic talent in Nuremberg resulted in a wealth of co-productive works, bringing together writers and artists, artisans and illustrators. Dürer capitalised on connections in his social network of goldsmiths, humanists, historians and talented assistants. One friend, Celtis, led to Maximilian I as patron.

The professional assistants in Dürer's workshop were also notable artists. During Dürer's extended stay in Venice, 1505–07, he could rely on a skilled team at home to fulfil contracts, such as *The Virgin with Child* (see page 52). Some, like Hans Baldung Grien (see below and also page 38) were lifelong friends. When Dürer visited the Netherlands in 1520–21, he took Baldung's prints with him to sell.

Dürer's assistants were the mainstay of his successful workshop, creative and skilled in the variety of media in which he worked. He created a vast catalogue of drawings and engravings to be used, but it needed talented artists to reproduce the essence of his work. He surrounded himself with the most innovative. Many artist-journeymen, post-apprenticeship, travelled to Nuremberg in order to work for Dürer. These included the young Mathes Gebbel (1500–74), a goldsmith who became the most important medallist of his time, who struck a medal of Dürer in 1527, the year before he died (see page 92).

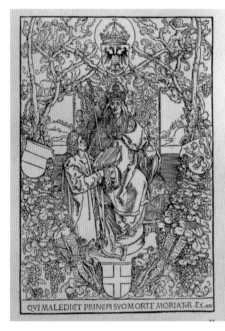

Above: Philosophy and a Habsburg Emperor, *from* Quatuor Libri Amorum *by Konrad Celtis of Nuremberg, 1502, 21.7 x 14.7cm (8.5 x 5.7in). Dürer's woodcut illustrates an enthroned woman as the personification of Philosophy, with Celtis's verses describing provinces of Germany from the four compass points.*

humanist, poet and playwright must have inspired Dürer, who went on to write poetry, and theoretical texts. Such was Celtis's admiration for Dürer that he wrote four epigrams in 1500 on Dürer's talent: 'To the Painter Albrecht Dürer of Nuremberg'; 'On the Same Author Dürer'; 'On his Dog'; 'On the

KONRAD CELTIS

The historian Konrad Celtis (1459–1508), son of a winemaker, was active in the circle of Maximilian I. He met Albrecht Dürer through their mutual friend Willibald Pirckheimer. The scholar,

Left: Self-portrait, c.1534, Hans Baldung Grien (1484/5–1545), drawing in black pencil. A quirky self-portrait by Hans Baldung, a lifelong friend of Dürer and an excellent artist working at times in Dürer's workshop.

Right: Konrad Celtis *by Hans Burgkmair the Elder (1473–1531), 1507, woodcut. This portrait was produced as an epitaph for Celtis by one of the leading woodcut artists – alongside Dürer – of the time.*

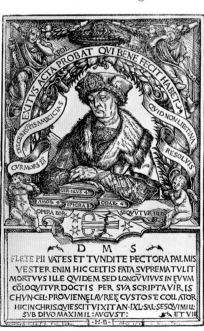

Same Albrecht Dürer'. Through this relationship one can see the social network that leads from Nuremberg's elite to the court of the Holy Roman Emperor, Maximilian I. The woodcut for the frontispiece of Celtis's work *Philosophia* was designed by Dürer (see opposite above).

MAXIMILIAN I

Dürer was determined to win the patronage of the Holy Roman Emperor, Maximilian I. He wanted a lifelong pension, which was granted in 1512. His fame and his contacts brought them together. Dürer painted a portrait of the Emperor (see below) from references, but the first face-to-face portrait was in 1518 (see page 222). Several important works commissioned from Dürer by Maximilian I included an over-lifesize Triumphal Arch, to be used as Imperial propaganda leading up to the 1518 Diet of Augsburg (see pages 224–25). Dürer's intellectual Nuremberg circle, known to the emperor, included Pirckheimer, Celtis, Sebald Schreyer and Hartmann Schedel.

Below: Portrait of Emperor Maximilian I, after 1504, Albrecht Dürer and workshop, oil on wood, 54.6 x 36.1cm (21.4 x 14.2in). Dürer owned a drawing of a profile painting of Maximilian I, c.1502 by Ambrogio de Predis, which may have acted as a template for this work.

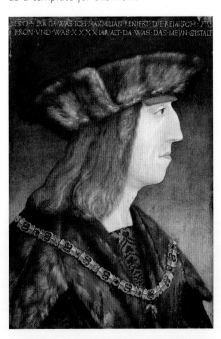

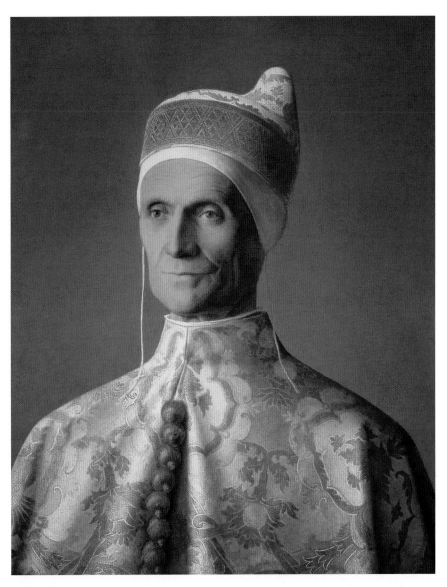

VENETIAN PATRONS

Dürer's journeyman years kickstarted important contacts, such as the humanist Sebastian Brant (1457–1521), whom he met in Basel. Work and social contacts in Venice were possibly carried forward from Dürer's first sojourn in 1495 and consolidated during his 1505–07 stay in the city. The influential Bellini family were friends, and also the German community of merchants, from whom several portraits were commissioned. The Doge of Venice's admiration for Dürer led to an offer of an annual stipend to stay in Venice, which endorsed Dürer's reputation in Italy amongst artists and the elite. Nonetheless his polite refusal to take this up affirms the existence of a strong network of patrons waiting for him in Germany.

Above: A portrait of Leonardo Loredan (1436–1521), Doge of Venice (1501–21), c.1501–02, by Giovanni Bellini. Bellini was a master of portraiture which other artists tried to emulate. The realism of this painting of the Doge is outstanding.

NUREMBERG FRIENDS

In Nuremberg, Dürer had long-established friends who were influential in providing connections and commissions. The wealthy Nuremberg patrician and mayor Jakob Muffel (1471–1526) was in charge of the city council when Dürer presented two large religious panels for the town hall in 1526 (see page 87). One of Dürer's very last oil portraits included one of his lifelong friend, also painted in 1526, the year Muffel died (see pages 212 and 247).

FOLLOWING FASHION

Dürer took a great interest in formal and informal fashion, for his own attire, and for sketches to add to his workshop stock of images. His self-portrait of 1498 shows him wearing fashionable clothing, not only a portrait of his artistic skills but a sign of desired affluence and ambition.

Dürer created many drawings of Netherlandish, German and Venetian fashions with notes on texture, fabrics, style and patterns. His drawings from Venice c.1495 show Dürer was interested in the fashion of the residents. He copied details from other artists' work too, for source material, possibly seeing Bellini's *St Mark Preaching in Alexandria, Egypt*, 1504–07,

Below: Women of Nuremberg and Venice, *1495, Albrecht Dürer, pen and ink on grey-brown paper, 24.5 x 15.9cm (9.6 x 6.2in). One of Dürer's many drawings of fashionable clothing, comparing the dress of different cities.*

or copies of it, during his second visit to the city in late 1505–07. There are several studies of drapery, later used in engravings and paintings.

VENICE AND NUREMBERG

In his studies of Venetian women's dress, Dürer captured the volume of the fabric, and its movement. His eye observed details, from the cut and texture of fabrics to shoes, hairstyles, headdresses, and hats, usually for a stock catalogue to reproduce in other works. He compared Venetian to Nuremberg fashionable clothing, focusing on the differences. The detailed *A Venetian Lady* shows the reverse

of the dress as well (see below). It reappears worn by *The Whore of Babylon* in *The Apocalypse* series of woodcuts, 1497–78 (see page 36). He made many studies of women's fashion, as in *Nuremberg Woman Dressed for Church* and *A Nuremberg Woman in a Dance Dress* (see opposite). Both reappear in the *Life of the Virgin* series 1511 (see pages 162–63).

Below: A Venetian Lady, *1495, Albrecht Dürer, ink and brush on paper 29 x 17.3cm (11.4 x 6.8in). This is a careful study of a Venetian woman's clothing and headdress, front and back, both of the fabric and intricacy of the design.*

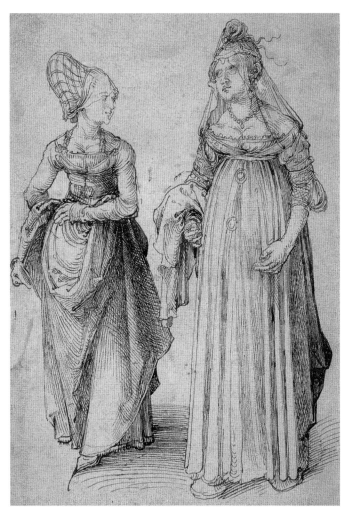

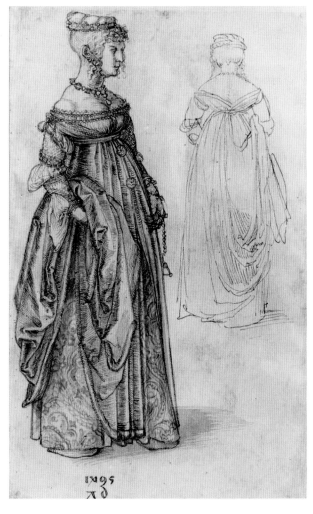

PERSONAL STYLE

Dürer was very aware of clothing and of fashion at an early age. In *Self-portrait at the age of thirteen*, 1484 (see page 102) the tassel of young Dürer's hat, the strands visible to the left side of his face, mingle with his shoulder-length hair. The face has character and Dürer concentrates on the folds in his clothing. Fourteen years on, in *Self-portrait*, 1498 (see pages 100 and 140) Dürer is dressed as a fashionable gentleman, inspired by the social circle he frequented. He is now famous and his clothing signified his status. The beautiful open doublet in black and white matches his broad stripe hat. A plaited silk cord holds the edges of his cloak together. Soft, expensive, goatskin-grey gloves complete the image. It is a 'this is me, right now' depiction. He states 'I painted it according to my figure. I was twenty-six years old.' Two years on, and the hats are gone. *Self-portrait*, 1500 (see page 149) shows a mature adult, with strong facial features. The dark, reddish tones of his glossy hair carefully complement the rich browns of the fur collar coat.

Below: Design for men's court dress, front and back view, *1515, pen and ink and watercolour, 28.2 x 21cm (11 x 8.25in), The Albertina Museum, Vienna, Austria. This is possibly a robe that Dürer designed for himself, as court dress.*

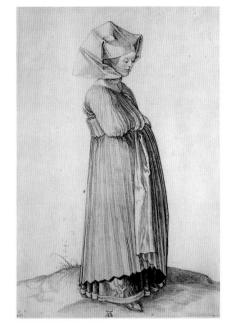

Above: Nuremberg Woman Dressed for Church, *1500, Albrecht Dürer, pen and ink with watercolour, 32 x 20.5cm (12.6 x 8.07in).*

FOLLOWER OF FASHION

Dürer's letters from Venice to Pirckheimer, dated 8 September 1506, humorously refer to the artist's clothing. 'My French coat sends you its regards, and so does my French skirt'; and in a letter of 23 September, 'My French coat, the cassock and the brown skirt send you their best regards'. The description matches the clothing worn in Dürer's self-portrait in the later *Landauer*

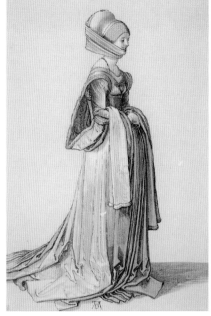

Above: A Nuremberg Woman in a Dance Dress, *1500, Albrecht Dürer, pen and ink with watercolour, 32.5 x 21.8cm (12.79 x 8.5in).*

Altarpiece, 1511 (see page 32). It must be an in-joke between them – or did Pirckheimer pay for the clothing? Dated to 1515 are two coloured drawings of a court dress for men, created at a time when Dürer regularly attended the royal court, and which may relate to designs for garments he wanted to be made for himself. They show the front and reverse of a superb striped decorative cloak (see left).

NETHERLANDISH FASHION

Dürer wrote, 'I have also drawn two Netherlandish costumes with white and black on grey paper'. A highly-finished drawing *A Young Woman in Netherlandish dress*, 1521 (see page 238) is from his sketchbook. Apart from the clothing and fabrics Dürer purchased, his sketchbook is filled with depictions and differences, as shown in the headwear of *A Young Girl of Cologne*, and *Agnes Dürer in Boppard*, 1520 (see page 239). There are two pen and ink drawings of a talented lute player, the Imperial Captain Felix Hungersperg, 1520 (see page 230), whom Dürer met in Antwerp during his visit to the Netherlands. Dürer paid notable attention to the details of the headwear and clothing of this military man.

EMPEROR MAXIMILIAN I

Maximilian I of Austria is known to have stayed in Nuremberg from 3rd to 15 February 1512, and possibly had an extended stay until 21 April, giving Albrecht Dürer, the city's 'superstar', an opportunity to meet him. It resulted in many commissions, and the eventual reward of a pension, or 'liferent'.

In a letter dated 12 December 1512, Emperor Maximilian I (1459–1519) instructed the council of Nuremberg to exempt Dürer, 'the learned and skilled painter, [to] live free of dues, taxes and levies…' in recognition of his services to the city through his art. The city council refused. Nonetheless, 1512 was a good year for Dürer. While the emperor was in Nuremberg, he commissioned him to create works for

Below: The Triumphal Arch of Emperor Maximilian I, *1515, Albrecht Dürer, woodcut, 357 x 295cm (140.5 x 116.1in), published 1517–1518. A poster print exercise on a grand scale.*

the 1518 Diet of Augsburg celebrations, where Maximilian would hold court. Plans included a vast poster-style triumphal arch, distributed to cities, towns, and villages, to promote the emperor who understood the power of prints as mass circulation propaganda tools. For this Dürer created the paper *Triumphal Arch* (see below and pages 224–25) from the largest woodcut ever produced. In addition, paintings of Emperors Sigismund and Charlemagne (see page 203) were commissioned for the imperial regalia treasury in Nuremberg's Town Hall. The emperor's patronage of Dürer accelerated the artist's career.

Above: Equestrian Portrait of the Emperor Maximilian I, *1508, by Hans Burgkmair, woodcut from two blocks in black and gold on vellum. A fine portrait of the emperor, similar in composition to Dürer's later equestrian work* Knight, Death and Devil, *1514 (see page 70).*

PORTRAIT OF AN EMPEROR

On 28 June 1518, during the Imperial Diet at Augsburg, Dürer was given permission to draw the Emperor. On the drawing (see opposite below left) he recorded what happened: 'This is Emperor Maximilian, whom I, Albrecht Dürer, portrayed up in his small chamber in the tower at Augsburg on the Monday after the feast day of John the Baptist in the year 1518.' The emperor looks dignified as befitting his position but there were traces of tiredness too. Seven months later Maximilian died on 12 January 1519. Dürer used the drawing to create a posthumous woodcut and two painted portraits (see pages 222–23).

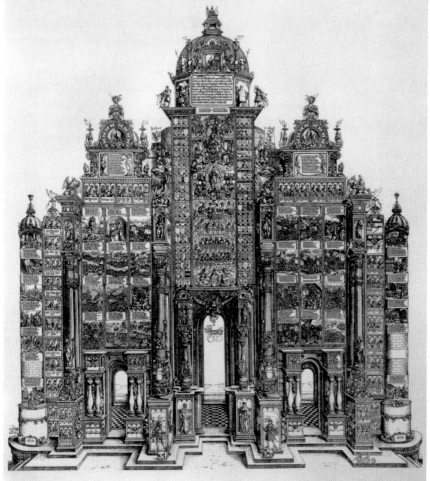

Right: The patrons of the visual arts in the House of Habsburg, *1891, ceiling frescoes by Julius Victor Berger (1850–1902). Depicted in the imagined scene are the Habsburg emperors of history with their favourite artists. In the centre is Maximilian I (styled after a Holbein portrait) holding a drawing by Dürer, who is shown standing to his left. The double-edged eagle of the Holy Roman Empire hangs behind.*

DÜRER AND STABIUS

The emperor's 'arch' had been in planning since 1506 in association with the Austrian cartographer, astronomer and historiographer Johannes Stabius (1450–1522). The Austrian imperial court painter Jörg Kölderer (c.1465–1540) participated in the architectural composition but this assignment was transferred to Dürer in 1512. The design was rearranged and created with the aid of the German architect, engraver and painter Albrecht Altdorfer (1480–1538), in collaboration with painters Wolf Traut (c.1485–1520) and Hans Springinklee (1490–1540) from Dürer's workshop. The whole project was overseen by Stabius, a humanist from Vienna, who at times functioned as Dürer's go-between for Maximilian I, who often made Dürer

Below: Portrait of Emperor Maximilian I, *1518. On 28 June 1518, in Augsburg, Dürer was given permission to draw the Emperor, from which a woodcut and a portrait were created (these are shown on pages 222–23).*

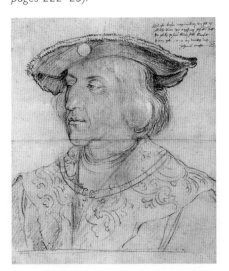

wait years to be paid. The 'arch' was completed in 1515, the same year that Maximilian rewarded Dürer with a liferent (pension). Dürer and Kölderer collaborated to get the 'triumphal arch' published in 1518. Maximilian received 700 copies.

MAXIMILIAN COMMISSIONS

Maximilian I showered Dürer with commissions, ranging from pen and ink drawings for the emperor's prayer book, over-lifesize statues for his tomb, and stained glass for St Sebald church in Nuremberg. The vast *Triumphal Procession of Maximilian I* (see pages 226–27) was published by Dürer after the emperor died in 1519, in great monetary debt to the Augsburg merchant Jakob Fugger 'the Rich' (1459–1525). Dürer painted Fugger's portrait (see right) thus continuing his patronage from influential clients.

Below: Portrait of Jakob Fugger, *1518–20, by Albrecht Dürer, oil on canvas, 69.4 x 53cm (27.3 x 20.8in). Dürer portrayed Fugger, an influential and wealthy merchant from Augsburg, in a half-length, three-quarter portrait.*

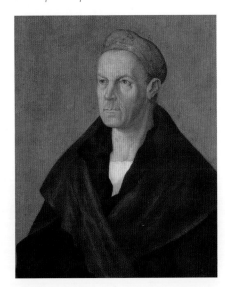

GERMAN ART REFORM

On 31 October 1517 Dr Martin Luther, following his criticism of the Roman Catholic church, nailed 95 theses to the door of the Castle Church in Wittenberg, Germany, to complain of the sale of indulgences. This incident was momentous and his actions reverberated across Europe, leading to the Reformation.

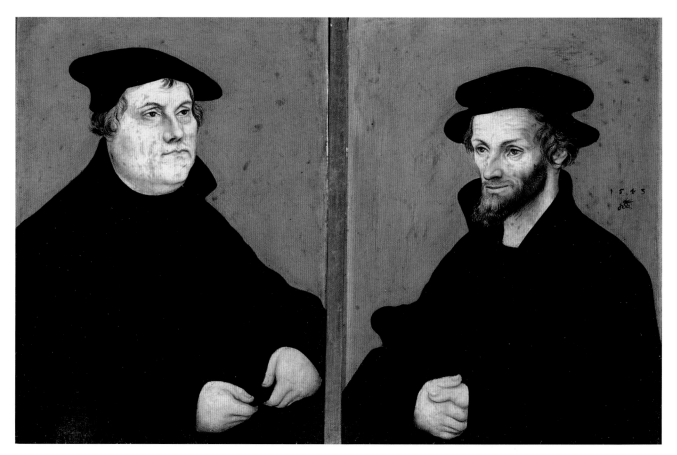

After a visit to Rome in 1510, Luther's anger stemmed from the conspicuous lack of morality, and corruption, amongst the clergy there. The selling of 'indulgences' was taking place in the city and across Europe, to raise money for the church, and in part, to build a new St Peter's Basilica in Rome. An indulgence – in the form of a paid-for receipt sanctioned by the church – could pardon 'sins' of individuals, both living and dead. Luther's reformative protest would lead to outbreaks of iconoclasm against the Catholic church. A consequence of the Protestant Refomation for artists, artisans and architects, however, was that it removed a wealth of religious patronage, itself a major source of livelihood, and created a necessity for art to reform in order to gain other commissions.

NUREMBERG – PROTESTANT CITY

Nuremberg, a city of religious tolerance, accepted Lutheranism as its religious faith in 1525. Its patrician society was led by many free-thinking, intellectual humanists. Albrecht Dürer was part

Above: Double Portrait of Martin Luther and Philipp Melanchthon, *1543, by Lucas Cranach the Elder (1472–1553). Dürer had been good friends with Melanchthon since 1518, and was a great admirer of Martin Luther.*

MARTIN LUTHER

Martin Luther (1483–1546), instigator of the Reformation, was born in Eisleben, Germany. Initially he studied philosophy at Erfurt University, then took up Law. He was ordained a priest in 1507. He entered an Augustinian hermitage in Wittenberg in 1511 and studied theology. Luther became a Doctor of Theology in 1512, teaching at Wittenberg University. In 1520, Albrecht Dürer wrote, indicating his own anxious frame of mind:

'…God help me that I may go to Dr Martin Luther… to make a portrait of him with great care and engrave him on a copper plate to create a lasting memorial of the Christian man who helped me overcome so many anxieties.'

In 1524, Luther left the priesthood to marry an ex-nun, Katharina von Bora. He died in February 1546, and is buried in Castle Church, Wittenberg. Melanchthon was also buried here.

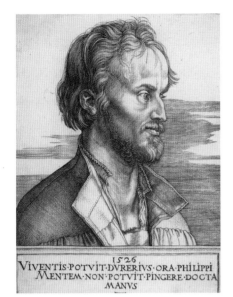

VIVENTIS·POTVIT·DVRERIVS·ORA·PHILIPPI
MENTEM·NON·POTVIT·PINGERE·DOCTA
MANVS

Above: Durer's 1526 engraving of Philipp Melanchthon. Born Philipp Schwartzerd, Melanchthon is recognised for the 'Augsburg Confession' of 1530, a statement of Lutheran beliefs.

of this group and aligned his views with Luther. While carefully avoiding offence to his Catholic patrons, he studied humanism, and agreed with its principles. The new wave of Lutherans and Calvinists rejected narrative elements that were not biblical, thus removing saints and the presence of patrons at depictions of the Nativity or Crucifixion, for example. The walls and chapels of churches were whitewashed, and decorative work, paintings, sculptures and altarpieces removed, or destroyed, to create a plain interior.

PHILIPP MELANCHTHON

Melanchthon (1497–1560), a colleague of Luther, and highly important spokesperson for Lutheran reforms, was a professor of Greek at Wittenberg university, an educationalist and theologian. He and Luther were often depicted together. Melanchthon stayed in Nuremberg from November 1525 until February 1526. He visited the Abbess Caritas Pirckheimer (1467–1532), sister of Dürer's friend Willibald, at the Franciscan convent of St Klara in Nuremberg, one of the last sanctuaries for Roman Catholics in the city after the religious reforms, to agree an arrangement whereby she

Above: Leaflet against the Catholic Church, 1520s, by Lucas Cranach the Elder. The artist was instrumental in promoting Martin Luther's religious reforms. The content of many leaflets were antagonistic toward the materiality of the church.

could continue to practice her religion, ordering the Nuremberg council to allow it. Dürer and Melanchthon, friends since 1518, discussed theological beliefs, Dürer being supportive of Lutheran reform. The engraving *Portrait of Philipp Melanchthon*, 1526 (see above) resulted from a drawing created during this visit, the earliest portrait of the theologian. The text beneath it states, 'Dürer was able to depict Philipp

as if living but even his studied hand could not portray the man's mind'. Melanchthon is recognised for the 28 articles that made up the confession of the Lutheran churches, known as the 'Augsburg Confession' of June 25th, 1530. It was presented at the Diet of Augsburg to Emperor Charles V and Roman Catholic theologians. Some of the articles were rejected, leading to Melanchthon presenting 'Apology of the Augsburg Confession' in 1531.

Below: Calvinist service in the Reformed church of Stein, Nuremberg, a 17th-century copper engraving. Reform church interiors were plain with minimal decoration and no ornate furnishings.

JOURNAL OF AN ARTIST

On 12 July 1520 Albrecht Dürer, accompanied by his wife Agnes and her maid, left Nuremberg to journey to the Netherlands. They would be touring for a year. Dürer kept a written account of his travels, with sketchbooks for visual references. It is a glimpse into a famous artist's life.

Dürer may have left Nuremberg to escape a plague that was widespread in the city, and in order to request that his annual pension be continued by the new emperor Charles V. Dürer was welcomed and honoured wherever he journeyed. Dürer mentions a customs officer who knew Agnes, gifting 'a can of wine'. She received other gifts, of Arras cloth, to make a mantle; and 'a little green parakeet'. Dürer created a picture of Agnes during their travels, in his drawing notebook (see page 238).

Below: Albrecht Dürer sketching the panorama of Antwerp in 1520, *painted in 1873 by Jan Antoon Neuhuys (1832–91), a 19th-century envisioned view of Dürer on his travels through the Netherlands. Jan Antoon Neuhuys was a Dutch history and genre painter who studied and exhibited in Antwerp.*

DÜRER'S JOURNAL

The journal mentions around 120 portraits and paintings created for commission or gifts. It is a record of where he stayed, what he ate, who he met, what he bought, and what he was gifted. Most importantly for Dürer was a financial record of how much he spent. It was a year-long trip of just over 1,700km (1,000 miles). Dürer's journal has a journey plan, its costings, whom he met, where he stayed and a list of the gifts he gave.

'On Thursday after St Kilian's Day, I Albrecht Dürer, at my own charges, and costs, took myself and my wife from Nuremberg away to the Netherlands, and the same day, after we had passed through Erlangen, we put up for the night at Baiersdorf, and spent there 3 crowns, less 6 pfennigs… the next day, Friday, we came to Forchheim, and

AACHEN–COLOGNE

In 1515, an annual pension, paid to Dürer out of taxes due to Maximilian I from Nuremberg Council, was agreed by the emperor. It stopped in January 1519 when Maximilian I died. Dürer wanted it reinstated by Charles V, who was to be crowned in Aachen on 23 October 1520. Dürer stayed in Aachen from 6–24 October, attended the coronation, then followed the royal party to Cologne, where he was successful in getting Charles V's agreement on 12 November. He had to work hard to get it, meeting senior courtiers and socialising with them in the all-male baths. Finally, it was agreed 'after great labours and exertions.'

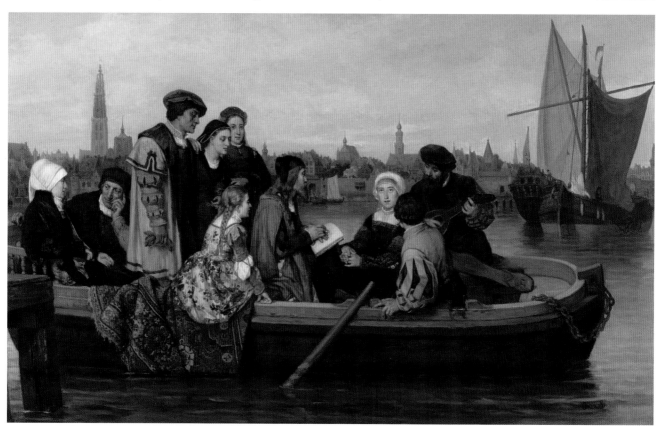

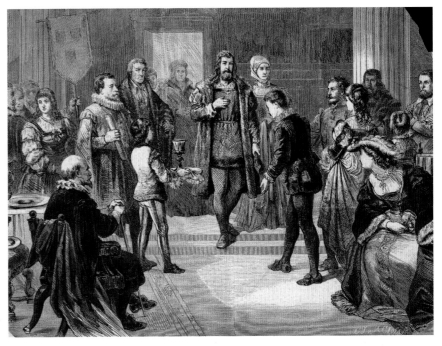

Above: Portrait of Margaret of Austria, *about 1518, by Bernaert van Orley (c.1488–1541). Dürer was given an audience with Margaret of Austria, Duchess of Savoy (1480–1530), during his stay in the Netherlands.*

there paid for the conveying thence on the journey to Bamberg 22 pf., and presented to the Bishop a painted Virgin and a 'Life of the Virgin', and an 'Apocalypse', and a florin's worth of engravings. He invited me to be his guest, gave me a toll pass and three letters of introduction, and settled my

Below: From Dürer's sketchbook, A Young Woman from Bergen-op-Zoom and a Young Woman from Goes, *1520, silverpoint, 13 x 19cm (5.12 x 7.5in), Musée Conde, Chantilly, France.*

bill at the inn, where I had spent about a florin…'

ANTWERP

On 2 August 1520, after 22 days travelling via Frankfurt, Mainz and Cologne, Dürer, his wife Agnes and maid Susanna, arrived in Antwerp, a prosperous city. It was an international hub for merchants, and the residence of over 200 Master painters. On 5 August he records dining at the Antwerp Painter's Guild, receiving a warm reception. Dürer based himself in Antwerp, then travelled to other towns and cities. He carried a vast amount of prints to sell, and to give as gifts. He travelled to Mechelen (Malines) and Brussels, and met Margaret of Austria, who agreed to speak to the new emperor Charles V regarding Dürer's

Above: Dürer in Antwerp, *a woodcut after a painting by Louis Katzenstein (1822–1907), a 19th-century interpretation of Dürer being warmly received in Antwerp.*

annuity. Everywhere he travelled he made sketches of local people, such as young women from Bergen-op-Zoom and Goes (see below left), and *Marx Ulstat* and *The Beautiful Young Woman of Antwerp* (see overleaf), architecture such as *The Town Hall of Aachen* and *The Cathedral at Aachen* (see page 232), and locations of interest such as as the port (see below right).

Below: The Port of Antwerp near the Scheldepoort, *1520, pen and black ink, 21.5 x 15.8cm (8.5 x 6.2in), Dürer's study of the waterfront in perspective.*

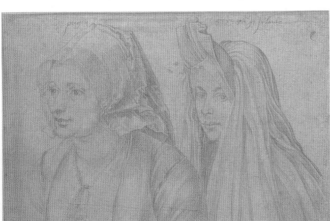

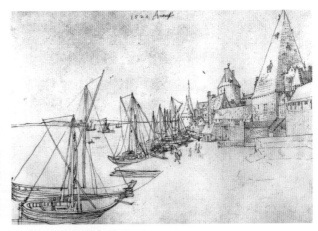

MORE TRAVELS

An excursion to Zeeland in December 1520 to see a beached whale resulted in a perilous journey and near-shipwreck, without seeing the creature. Stemming from this journey Dürer was laid low with a serious infection – possibly malaria – but he continued his travels including visits to Antwerp, Bruges and Ghent.

From December 3–14, 1520, Dürer travelled through Zeeland. He recorded it as 'beautiful and wonderful to see on account of the water, for it stands higher than the land.' The whale he had come to see had been carried off by the tide. He records the portraits he created of his hosts. Dürer returned to Antwerp late December 1520, and stayed until April 1521. His journal mentions gifts of shells, fish scales and white coral, velvet and Turkish cloth, his purchase of a monkey, and money lost at gambling.

SAINT JEROME

On 16 March 1521 Durer noted in his journal that he had '…painted a Jerome in oils, taking care over it, and gave it as a gift to Roderigo the Portuguese', his friend Roderigo Fernandez d'Almada, of the Portuguese trade delegation in Antwerp. *St Jerome*, 1521 (see page 235) is one of Durer's greatest paintings. He records that the model for

Above: Albrecht Dürer visiting Antwerp in 1520, *by Hendrik Leys (1815–69). Painted after Dürer's diary description, also depicted are Desiderius Erasmus and Quinten Massys, who were not present but Dürer did meet them during his stay.*

Below: Marx Ulstat; and The Beautiful Young Woman of Antwerp, *1520–21. Two sketches were made on the same page; Dürer drew Ulstat during a four-day sea voyage, returning to Bergen in December 1520.*

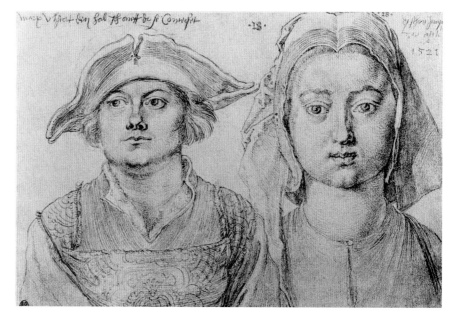

St Jerome was a man of 93 years. The preparatory drawings rival the painting (see page 236).

BRUGES AND GHENT

Accompanied by the painter Jan Prevost (1462/65–1529) Dürer set off for an excursion to Bruges and Ghent. He reports visiting the Church of our Lady in Bruges, to see the marble sculpture *Madonna and Child*, 1504, by Michelangelo Buonarotti (1475–1564), and afterwards visiting churches to see fine paintings. He records that in the evening a banquet, attended by 60 people, was given in his honour with many gifts given to him. The next day Dürer made a silverpoint portrait of Jan Provost, and then set off for Ghent. Here he was received honourably by members of the Painters' Guild, and given a tour of the town. A highlight was to see the *Ghent Altarpiece*, 1432 (see page 21). He remarked 'I saw the Jan [van Eyck] picture, which is a very splendid, deeply studied painting, and especially the "Eve", the "Mary", and "God the Father" were extremely good'. On 10 April he visited a zoo, and was astonished to see lions. He visited other zoos and made sketches in silverpoint (see page 237).

ILLNESS RECORDED

In Antwerp from 11 April until 17 May 1521, Dürer made portraits of local people and servants, including a depiction in silverpoint of 20-year-old Katharina, servant of João Brandão (see page 238). His journal refers to

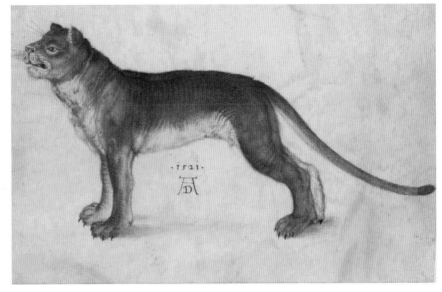

Above: Standing Lioness, *1521, pen, brown ink, gouache and watercolour on vellum, 16 x 25.6cm (6.2 x 10.2in), Musée du Louvre, Paris, France. Painted in 1521 during his stay in Antwerp. In his travel diary Dürer states that he visited the zoological park and studied the lions.*

feeling ill again, 'a great weakness, nausea and headache.' He states that the first occurrence was in Zeeland, 'a strange illness came over.' Amongst records of portraits created, buying cloth for his mother-in-law and his wife, buying a cloak for himself, and fur skins, he mentions repeatedly his illness and fees paid to a doctor. Payments recur many times for medical visits and medication. He records the items he is packing to send home to Nuremberg in preparation for departure, the courier's costs, and more fees paid to the doctor

and apothecary. His diary continues with visits to plays, important people he has met, and 'splendid dinners'.

ROYAL PATRONAGE

In early June, a second visit to Mechelen with Agnes to meet Margaret of Austria included her rejection of a gift of Dürer's portrait of her father Maximilian I. She gave a tour of her art collection, which included Jan van Eyck's *Arnolfini Portrait*, 1434. On 2 July, Christian II, king of Denmark, who as visiting Antwerp, commissioned a portrait from Dürer.

Below: The Entrance of Emperor Charles V into Antwerp in 1520, *1878, by Hans Makart (1840–84). A 19th-century vision of Dürer standing at the left under the rostrum. Dürer did witness the entry of Charles V into the city.*

LAMENT ON LUTHER

Dürer owned many texts by Martin Luther, and made a list of sixteen of them. He had plans to make an engraved portrait of the theologian. While in Antwerp, he received false news that that Luther was arrested and held in captivity. He was overcome with anguish and in an outburst, dated 17 May 1521, wrote in his journal a 'Lament on Luther', known as his *Lutherklage*. (Its authenticity is debated.)

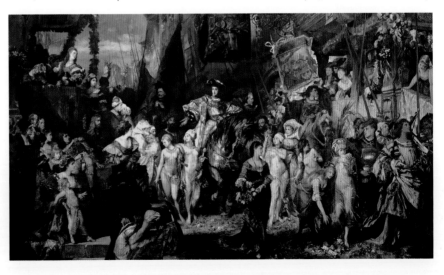

BACK TO NUREMBERG

Between 12–15 July 1521, Dürer, his wife and maid left Brussels and journeyed to Nuremberg via Aachen and Cologne, arriving home at the end of July. A prestigious commission from the town council for designs to refurbish the Town Hall saw work begin in August.

One gift Dürer brought back was an 'exceedingly large horn' for his friend and, importantly since 1515 his preferred woodblock cutter, Hieronymus Andreae. But, after notable commissions, including a royal portrait, Dürer's Netherland's journal ended on a low note. He had been honoured and met notable people, including painters such as Lucas van Leyden, whose portrait he created (see page

Below: Drafts for the The Chariot of the Emperor Maximilian I *and* Slander *(also titled* Calumny*) of Apelles (see also page 244). These were Dürer's preparatory works for the vast chariot scene for the Nuremberg Town Hall.*

239) in Antwerp. However, adding up his expenditure and the works he had given away, Dürer felt he had made a monetary loss on his travels.

NUREMBERG TOWN HALL

In July 2016, Dürer had worked on designs for Town Hall refurbishments, possibly the Minstrels' Gallery on the north wall. In 1521, the Great Council, of which Dürer was a member and arts advisor, wanted to redecorate. The imminent presence of the new emperor, Charles V, visiting Nuremberg for the first Imperial Diet of his reign, hastened the council's wish to upgrade the interior with murals in the Great Hall. Dürer was to receive 100 gulden,

THE GREAT CHAMBER MURALS

In the 17th century the Nuremberg Town Hall's Great Chamber murals, designed by Albrecht Dürer, had to be repainted due to deterioration. The originals had been painted *al secco*, that is, on to dry plaster by Dürer's skilled assistants. Over time, the surface paint had flaked. The murals were repaired several times. Unfortunately, a bombing raid on Nuremberg in 1945 demolished the Town Hall. (A surviving detail of the original design is on page 240.)

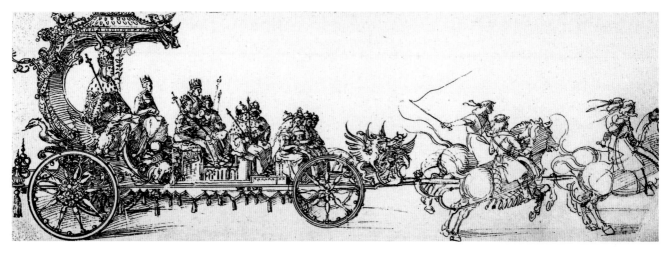

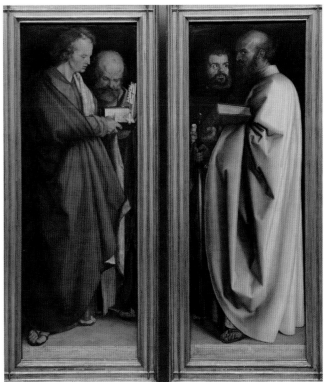

Above: The Four Holy Men, *also known as* Four Apostles *and* Four Saints. *Durer's last religious oil paintings, a legacy to his city of Nuremberg (see also page 250).*

Above: Coat of Arms of the German Empire and City of Nuremberg, *1521, Albrecht Dürer, woodcut, 24.8 x 17.1cm (9.76 x 6.73in). This was used as the front illustration for a revised edition of* Reformation of Statutes and Laws Undertaken by the Honourable Council of the City of Nuremberg in the Service of the Common Need and Cause.

a vast sum, 'for all his trouble in making a design for the town hall'. For this, Dürer integrated part of the *Triumphal Procession* he had created for the now-deceased Maximilian I in 1515–18 (see pages 226–27). The new works included *The Chariot of the Emperor Maximilian I* and *The Slander of Apelles* (see opposite). Haste was lessened when the Diet transferred to Worms. Additionally, for the Council he designed an intricate coat of arms for the City of Nuremberg and Empire of Germany (see above) that was used as the front illustration for a revised edition of *Reformation of Statutes and Laws*, published in 1521. (Dürer created his

own family Coat of Arms in 1525; see page 89.) In 1521, Anna Frey, Agnes's mother, died, followed two years on by the death of her father.

LATER WORKS

The undiagnosed illness contracted in Zeeland had left Dürer debilitated. The years from 1521 saw him focus on portraits of friends, remarkable works of realism in different media. The outstanding woodcut portrayal of Dürer's friend *Ulrich Varnbüler*, 1522 (see page 241) was copied many times. Engravings included *Duke Frederick III*, 1524, and *Willibald Pirckheimer*, 1524 (see page 242); and stunning painted portraits of *Jakob Muffel*, 1526 (see page 247), *Hieronymus Holzschuher* (see page 248) and his last portrait in oils, *Johannes Kleberger*, 1526 (see page 251). *Virgin and Child* (see page 249) was also painted that year. Like many other artists, the content of any religious work had to be carefully considered, due to Reformation disquiet, iconoclast riots, and the differing religious views

of patrons. After a public debate, Nuremberg adopted the Lutheran Reformation in 1525. Dürer devoted more time to writing his theoretical works on human proportion, fortifications, and poetry.

A NUREMBERG PATRON

On 6 October 1526, Albrecht Dürer offered two over-lifesize companion paintings *The Four Holy Men* to the city council. The attached letter read: 'I have been intending for a long time past, to show my respect for your excellencies by the presentation of some humble gift of mine as a remembrance; but I have been prevented by the imperfection and insignificance of my works…'

He continued that he had spent more time and effort on these paintings than any others and felt them worthy to be offered as his legacy. The council willingly accepted the works and hung them in the upper chamber of the town hall. In addition, they awarded Dürer an honorarium of 100 florins, his wife 12 florins and their servant 2 florins.

A FAMILY CHRONICLE

It was a tradition in German families to record births in the family bible, or in a family chronicle. Albrecht Dürer the Elder kept family records, and in 1524 Dürer the Younger put together these papers in a chronological order, adding records of events that he had made too.

DÜRER'S AUTOBIOGRAPHY

Dürer the Younger includes an autobiography of his life, growing up in his parents' house. He records his father living 'a life of great toil, of hard and taxing work' to support the family. Then, he recalls his own apprenticeships and journeyman years, and marriage to

Below: Portrait of Albrecht Dürer the Elder, *c.1484–86, attributed to him as a self-portrait, in silverpoint on paper, depicting the goldsmith holding a figurine.*

Agnes Frey. He writes of the sad deaths of his father and mother, and deaths of his parents-in-law.

'Nuremberg, after Christmas in the year 1524'

I, Albrecht Dürer the Younger, have put together from my father's writings this account of where he came from, how he settled and remained here until he died in the Lord. God have mercy upon him and on us. Amen'. [Extract from 'After 1467/1524', Ashcroft, J. Vol. I, pp.31-40]

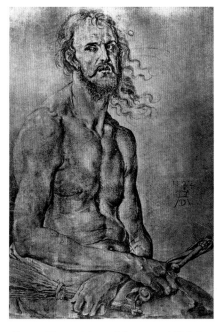

Above: Christ, Man of Sorrow, *1522, by Albrecht Dürer, lead pen on paper, 40.8 x 29cm (16 x 11.4in). From Isaiah 53:3, Christ, with a ravaged body, holds the tools of torture used during his persecution. This work, lost during World War II, is possibly a self-portrait of Dürer as Christ.*

So begins the opening entry written by Dürer the Younger relating to the family chronicle kept by Albrecht Dürer the Elder, which recorded the eighteen children born to him and his wife Barbara. The dates and times of birth, the children's names and the godparents names were all included. The first child, a daughter named Barbara, was born in 1468; the last child, a son named Karl, was born 22 years later in 1492 when Dürer the Younger was already travelling as a journeyman.

DEATH OF ALBRECHT DÜRER THE ELDER

The poignant death of Dürer's father, on the Eve of St Matthew (September) 1502, was recalled and recorded by Dürer the Younger in 1524:

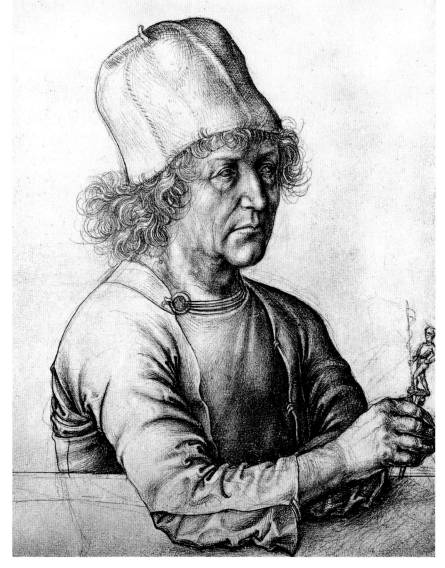

'…It then so happened that my father fell sick with dysentery, so bad that no one could staunch it. And seeing death before his eyes he submitted to it most meekly, giving my mother into my care… He received the holy sacrament and… passed away like a Christian after midnight in the early hours of the Eve of St Matthew, 1502…'.
[Extract from 'After 1467/1524', Ashcroft, J. Vol. I, pp.35-36]

Dürer recalls the events leading up to his father's death, when his father had got up, in distress, soaking with sweat. After a small sip of a Rheinish wine, he lay down, and entered his death throes, bringing release from pain soon after. Dürer was deeply unhappy that although he was in the house, he had been sleeping. A maid woke him to say that the end was imminent, but he missed the moment of his father's passing. It affected him greatly and he was determined to be with his mother when the end of her life came (see pages 68–69).

DÜRER'S COAT OF ARMS

Dürer created his new coat of arms by linking aspects of his mother and father's family emblems with traditional

Right: Coat of Arms of the Dürer Family, *Albrecht Dürer, 1523, woodcut, 35.5 x 16.6cm (13.9 x 6.5in).*

NUREMBERG RECORDS

Information about citizens of Nuremberg, including Dürer and his family, were kept by the city council, and remain in the Nuremberg Archives; some documents were kept in the collections by families. It is known that Endres Dürer, as an example, surrendered his rights to shared ownership of his parents' house, bequeathed to him by his deceased mother and father. He transferred his share to his brother Albrecht, on 24 November 1518, in exchange for a cash sum. The non-official transaction was witnessed by Willibald Pirckheimer with copies possibly kept by him and Albrecht Dürer.

Right: Fragment from the Gedenkbuch *('A Memory Book') ,1502–14, pen, burin and paintbrush in brown and grey, 31.1 x 21.5cm (12.2 x 8.4in), kept by the Dürer family with records of births and deaths including reports on the deaths of Dürer's parents, and family matters.*

symbols. The imagery of a black person or Moor in profile at centre has been traced back to 13th-century Bavaria, lower Saxony and the upper Rhineland. The magnificently splayed eagle's wings were customary in the heraldry of southern Germany. They were on the coat of arms of Dürer's maternal grandparents, the Holper family, and can be seen in the conjoined coat of arms of the Dürer-Holper family (see page 15), thus bringing together generations of Albrecht Dürer's family heritage. The open door depicted in the foreground of the coat of arms is a word derivation for the Hungarian translation for door, and a reference to Dürer the Elder's surname. The helmet appears in many coats of arms, and is a symbol of honour and loyalty.

ON HUMAN PROPORTION

Following in the footsteps of theoretic writers, artists and architects, including Pliny the Elder, Vitruvius, Leon Battista Alberti and Marsilio Ficino, and possibly even Leonardo da Vinci, Albrecht Dürer turned his attention to publishing his theories on measurements, fortification, and human proportion. (See also pages 66–67.)

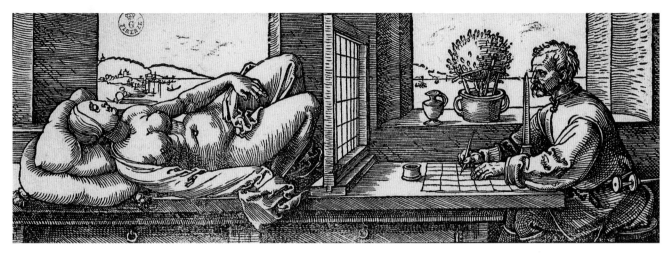

Dürer's interest in theories of mechanisation, fortifications and human proportion stemmed from various sources. Ancient and contemporary writers, his intellectual friends in Nuremberg, his visits to Venice, and his appreciation of artists practising geometric perspective in relation to the landscape, architecture and the human figure. His aim was to write a treatise on human proportion for artists.

VITRUVIUS, DA VINCI, ALBERTI

De Architectura ('On Architecture'), a work of ten volumes by Roman civil and military engineer and architect Vitruvius (70–15BC), included theories on the architecture of a building being proportionate to the human body,

to achieve strength, utility and beauty (*firmitas*, *utilitas* and *venustas*). It was a manual to preserve the classical tradition in the building design of Hellenistic Greece and Ancient Rome. As the only treatise of its kind to survive from antiquity, it was hugely influential in Europe, especially Italian cities with Roman heritage. In the 15th century, a rebirth of interest in Italy's heritage included study of Vitruvian theories, as visualised by one of the great Renaissance masters Leonardo da Vinci in illustrations such as *The proportions of a standing, kneeling, and sitting man* (see below) and *The Proportions of the Human Figure (after Vitruvius)*, c.1490 (see page 67). In 1435, Leon Battista Alberti (1404–72),

Above: Man Drawing a Female Nude, *1525–1528, Albrecht Dürer, woodcut, 22.43 x 8.48cm (8.83 x 3.34in). An* Illustration from Dürer's Four Books on Proportion, *published in 1528.*

the noted Italian polymath, wrote *De Pictura* ('On Painting'), his theories on perspective and optics. It was published near 100 years later in 1540 but copies of the manuscript were circulated in Dürer's lifetime and known to him.

THE PUBLICATIONS

Early drawings used by Dürer to illustrate the proportions of the figure were in process from 1500, and published near 30 years later in 1528, in German. It was a lengthy, drawn-out creation with six versions drafted between 1523 and publication. In a book postscript Willibald Pirckheimer explained that Dürer had only time to proofread and edit the first volume before his death. The other three were published in the proof form submitted to the printer. 'Aesthetic Discourse' is the most known of the texts.

The texts were formulated and published as: *Treatise on Measurement* (1525), *Instructions on Measurement* (1525) and a *Treatise on Fortification* (1527), followed by a separate

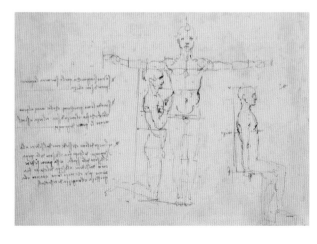

Left: The proportions of a standing, kneeling, and sitting man, c.1490, Leonardo da Vinci (1452–1519), pen and ink on paper, 16.1 x 21.8cm (6.3 x 8.5in). From Theories on proportion *by Da Vinci.*

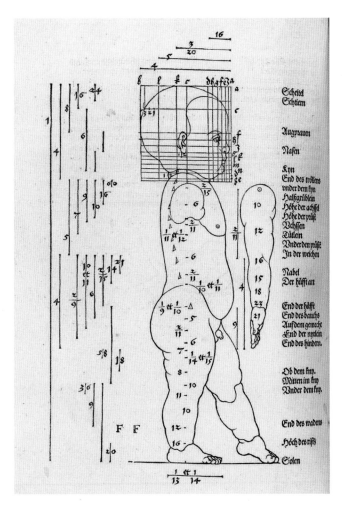

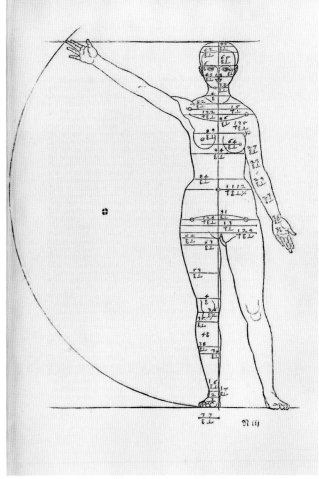

Above: Anatomical illustration from Four Books on Human Proportion *by Albrecht Dürer, published 1528, 25.04 x 43.18cm (9.86 x 1in), showing the proportions of the baby's head in relation to his body.*

Above: Female anatomical drawing from Four Books on Human Proportion, *published 1528, Albrecht Dürer.*

book *Instruction on Fortification* the same year, a book dedicated to King Ferdinand of Hungary and Bohemia. Dürer wanted the content of his text to contribute to a defence initiative against the Turks. The final works were published posthumously as *Four Books on Human Proportion* ('Vier Bücher von menschlicher Proportion'), in autumn 1528, with the aid of Pirckheimer and Agnes Dürer: 'Printed in Nuremberg by Hieronymus Formschneyder/At the expense of Albrecht Dürer's widow in the year/of Christ's birth 1528 on the last day of October'. On the title page Dürer wrote: '1523/At Nuremberg/This is Albrecht Dürer's/First book that he wrote himself. This book I have improved and in the year 1528/prepared for printing'.

Left: Title page for Four Books on Measurements *or* Instructions for Measuring with Compass and Ruler, *1538, third edition, published by Hieronymus Andreae, Nuremberg, Germany.*

PUBLISHING AND PLAGIARISM

Agnes Dürer oversaw publication of *Four Books on Human Proportion* a few months after Dürer's death. In Nuremberg she brought a court case against the painter Hans Sebald Beham and Hieronymus Andreae, a block cutter, who tried to publish a book *The Proportion of Horses*, informed by, perhaps stolen from, Dürer's notes, before his work was published in October 1528. She had the book banned, and the Council briefly to exile Beham. A version of Dürer's Triumphal Chariot woodcuts, by publisher Hans Guldenmund (c.1490–1560), was banned in 1532 after Agnes Dürer's intervention. She protected her husband's name and copyright.

DEATH AND BURIAL

On 6 April 1528, at home in Nuremberg, Albrecht Dürer died. He was buried in St John's Church, Nuremberg, in the Frey family grave (in what is now the Johannis Friedhoff cemetery). A day or so after, his body was exhumed by his artist friends in order to cast a death mask, before being re-interned.

Albrecht Dürer died in 1528, at the age of 56. His burial took place outside the city walls, in the family plot of his parents-in-law, due to an outbreak of a plague in Nuremberg. Agnes Dürer was buried alongside her husband Albrecht nearly a decade later. Her mother Anna Frey had been buried here in 1521, and her father Hans Frey in 1523.

Nuremberg patrician Christoph Scheurl (1481–1541) – Dürer was godfather to Scheurl's son Albrecht – recorded the body being exhumed and a death-mask (now lost) cast on the day after the funeral. A lock of Dürer's hair had been cut and was in the possession of painter Hans Baldung Grien, a lifelong friend. It passed, like a relic, through several ownerships, and eventually to the Academy of Arts, Vienna.

EULOGIES

The death and burial led to a flood of obituaries from Dürer's friends, patrons and admirers. Willibald Pirckheimer wrote an elegy for Dürer, an outpouring of grief and remembrance. He wrote

Below: Durer's old friend Mathes Gebbel, a goldsmith and medallist, struck a medal of Dürer in 1527.

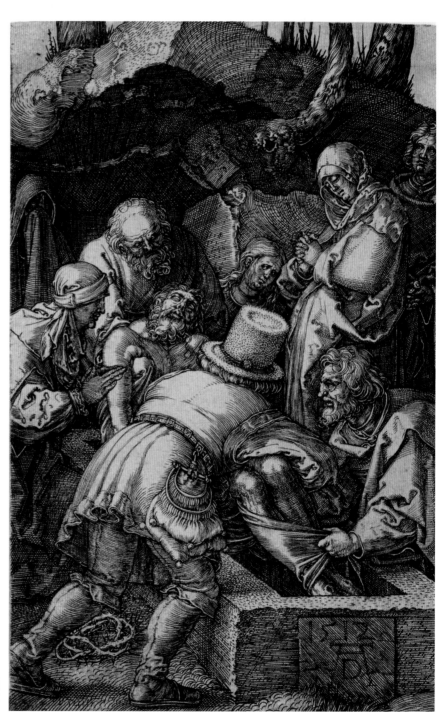

Above: The Entombment, 1512, by Albrecht Dürer, engraving, 11.6 x 7.5cm (4.5 x 3in). Part of the Engraved Passion sequence created some years before, this is an expressive depiction by Dürer of the

dead Christ being laid in his tomb. Some of the characters are in contemporary dress. The melancholy felt by Dürer's friends can be mirrored in his magnificent engraving of Christ's family in grief.

to a mutual friend Ulrich Varnbüler on Dürer's 'sudden departure' that 'A man of such greatness is snatched from us, whilst many useless men of little worth continue…' The humanists, Nuremberg-born Hieronymus Paumgartner (1498–1565) and Thomas Venatorius (1488–1551), and Helius Eobanus Hessus (1488–1540) of Hesse-Kassel, all friends and patrons of Dürer, worked on funeral laments in poetry and prose. Lutheran reformer Philipp Melanchthon (1497–1560) wrote from Wittenberg on 12 May 1528 to German scholar Joachim Camerarius (1500–74), mutual friends of Dürer, '…I grieve that Germany has been deprived both of such a man and such an artist'. Erhard Schön, a resident in Dürer's house for several years, may have created the last portrait of the artist (see below right).

ERASMUS ON DÜRER

In 1528, Erasmus paid a compliment to Dürer, calling him the 'Apelles of black lines', a reference to the artist's skills in engraving and woodcut. On the sudden death of Dürer, Erasmus defined the humanist vision, paying this tribute to Dürer in his publication *Dialogue on Latin Pronunciation*:

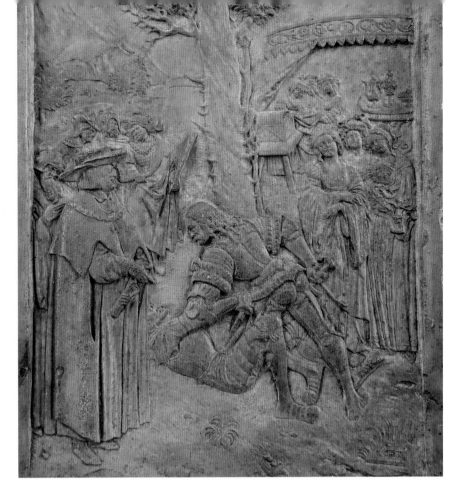

'…the feelings, all the emotions — in brief, a man's whole mind shining through the body's outward features, and almost the very voice… He can paint anything… even things he cannot paint – fire, sun rays, thunder, electric storms, lightning, and banks of fog…'

Above: Allegorical duel between Albrecht Dürer and Apelles, *1522, by Hans Daucher (1486–1538), a bas-relief in Solnhofen limestone. Apelles of Kos was arguably the greatest painter in Ancient Greece, and Dürer arguably the greatest artist in Germany.*

Below: The Tomb of Albrecht Dürer of Nuremberg, *19th century, French School; an illustration for 'Le Magasin Pittoresque' (published in 1871). The church of St John rises behind the tomb.*

Below: Portrait of Albrecht Dürer in Old Age, *1527, attributed to Erhard Schön (c.1491–1542). A late portrait of the artist; his hair is now short and neat but the distinctive facial features remain.*

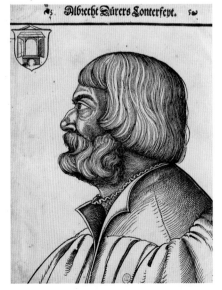

DÜRER'S INHERITANCE

Albrecht Dürer died without making a Will, so his brothers as well as his wife inherited. On Agnes' death in late 1539, her last Will and Testament bequeathed the remainder of Dürer's material wealth to his brother Endres, his cousin Nikolaus Dürer, her sister Katharina and mutual relatives by marriage.

As Dürer did not write a Will to acknowledge his wife as successor to all his material possessions, in German intestate law this meant that Agnes Dürer legally inherited as wife, as there were no children, but was obligated to give one quarter of Dürer's wealth to his brothers, Hans and Endres.

HANS AND ENDRES LEGACY

A document dated 9 June 1530 stated that Albrecht Dürer, married but 'without lawful issue' and dying intestate, by law, left one quarter of all the married couple's goods and chattels as the legitimate property of his brothers Hans and Endres Dürer. The inventory of Dürer's material wealth totalled 6,848 gulden, 7 pounds and 24 pence. The brothers were to receive one quarter, 1,712 gulden, one pound and 28 pence, and one heller. Agnes Dürer handed over 553 gulden,

Below: St Anne, 1519, by Albrecht Dürer, posed by Agnes Dürer for a study of the saint with her head covered by a veil. At top right in the corner is a note with the monogram and the year 1519 (see also page 229).

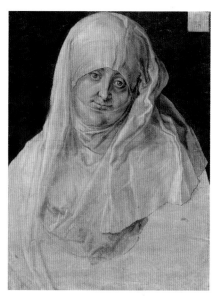

3 pounds and 11 pence to each of her brothers-in-law, agreeing that each would be paid the remainder of 302 gulden, 5 pounds and 18 pence on her death. Her freehold house on the corner of Zisselgasse was pledged as surety. [Nuremberg City Archive, 39, folio 163b] The delayed inheritance payment came too late for Hans. He had spent the first half of money left to him and, although working for the King of Poland in Cracow in 1531, was plunged into hardship. Endres rescued him from destitution, but Hans died in poverty in c.1538 before receiving the second payment of his inheritance. Agnes died in 1539.

AGNES DÜRER: BUSINESSWOMAN

In histories of Albrecht Dürer's life, Agnes Frey-Dürer is glimpsed fragmentally, visually in drawings and paintings, and occasionally referenced in letters. From the fragments it is hard to create a fully-rounded perception of who she was, and her views on marriage to the most celebrated artist in Europe. From the moment Dürer was summoned by his father in 1498 to meet and marry Agnes Frey, an arrangement agreed between the fathers, little is known of her life, except for her support in selling Dürer's work, and overseeing the workshop in his absence. It was Willibald Pirckheimer who spoke badly of Agnes Frey in the first part of a lengthy letter to Johann Tscherte (1480–c.1552), an Austrian military architect and engineer who had met Pirckheimer and Dürer in Nuremberg in 1522. The letter was written between October and December 1530, two years after Dürer's death: '…Truly in Albrecht I have lost one of the best friends on Earth, and nothing grieves me more than that he died a harrowing death, which – except for God's inscrutable

purpose – I can ascribe to no one but his wife, whose nagging so tormented his heart that he took leave from this life the sooner, for he was withered like a bundle of straw… that was how this evil woman cared for him… she was at him day and night, cruelly driving him to work, for no reason than that he might make more money and leave it to her when he died…'. [Letter excerpt from Ashcroft, J. Albrecht Dürer: Documentary Biography II, pp.930-935]

Pirckheimer's words are damning. He blamed her, 'the sum of it is, she alone is one main cause of his death…' He states that she was jealous of Dürer having many friends. He acknowledges that Agnes and her sister (Katharina Frey 1478/9–1547) were 'righteous god-fearing women', not 'evildoers' but also 'nagging, scolding, suspicious and sanctimonious'. Pirckheimer's letter has influenced historians since, as there are few sources to balance his opinion.

In his letters to Pirckheimer, from Venice in 1506, Dürer mentions that neither his wife nor mother needed any loans, as Agnes was at the Frankfurt trade fair selling prints, and his mother was selling prints on their stall in Nuremberg market. [Letter: Venice, 6 January, 1506.] Agnes would oversee the daily maintenance of the workshop. She was an influence in his print business. Perhaps Pirckheimer was right to say that money was her main aim, for Dürer had borrowed money to finance the trip to Venice and was known to undercharge for his work.

AGNES' DEATH AND WILL

Agnes Dürer may have been aware that her death was nearing. In March 1539 she sold her heritable rights to a garden and house she owned, situated outside the Menagerie Gate in Nuremberg. If Agnes Dürer was receiving Dürer's Imperial liferent of 100 gulden, it

would cease on her death. It was not mentioned in the Will. The Nuremberg Council annuity of 40 gulden, given to Dürer, and inherited by Agnes, was requested to be given to her sister Katharina, wife of Hans Zinner. On her sister's death, Agnes wanted the 40-gulden annuity to pay for a five-year bursary in theology, to be given to a craftsman's son who had studied the 'liberal arts' for four years.

Hans Dürer had died in 1538. Agnes bequeathed to the remaining brother Endres, 'all printed artwork in the form of copperplate engravings and woodcuts, and books with all the formes' [typesetting] which go together with them, a drinking vessel which was his masterpiece [possibly an apprenticeship work], an aquilegia' [perhaps a favourite Dürer watercolour].

In addition, a deed of 15 November 1538 showed that on the death of his brother, Endres had inherited his share of their parents' house in Unter der Vesten, as he described it in 1518, 'below the Castle, situated on the corner next to the house of the late Ortolf Stromer'. (Stromer was a papermaker). Endres had sold his own share to Albrecht in 1518 for a cash

Below: Andreas Dürer (Endres), 1514, by Albrecht Dürer the Younger, pen and brown ink, 28 x 21.8cm (11 x 8.5in). Dürer's younger brother Endres was a Nuremberg goldsmith. The initials on the work were not by Dürer.

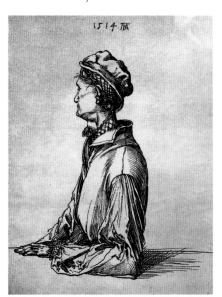

Right: Albrecht Dürer's House, Nuremberg, Germany, *a late 19th-century illustration from* Pictures from The German Fatherland *published c.1880, showing the notable house purchased by Dürer in 1509, inherited by his wife in 1528 and then on her death by her sister.*

sum, possibly needing the money to set up his goldsmith workshop. It is thought that Endres had continued to live there however.

THE HOUSE IN ZISSELGASSE

The large house in Zisselgasse was purchased by Albrecht Dürer in 1509, solely in his name. On his death it was inherited by his wife, who rented it out. Her Will bequeathed the house to her sister, Katharina. A few years later, in 1541–42, her sister sold the house to a blacksmith, Claus Freyenhammer, who installed a forge on the ground floor. The house was inherited by his son, also a blacksmith, in 1549.

COLLECTION DISPERSED

By 1570 Dürer's collection was widely dispersed, his close relatives dead. His copper engraving plates and woodblocks, passed on to family members, were sold on to collectors. Willibald Pirckheimer had Dürer's letters, some artworks, prints and books, and the copper engraving plate for Dürer's portrait of him; Pirckheimer

had purchased the plate at the same time as the engraving print.

Dürer's brother Endres, the heir to his print plates and blocks, is known to have made sales of Dürer drawings in Nuremberg after his brother's death. After Endres' own death in 1555, his wife, Ursula Dürer, sold the whole workshop collection in 1557 to Willibald Imhoff (1519–80), an avid art collector and a wealthy Nuremberg merchant. His grandfather was Willibald Pirckheimer, Albrecht Dürer's closest friend. Imhoff had already inherited Pirckheimer's substantial library in 1568, which included a vast collection of Dürer's work and his letters and texts. Many items were dispersed in 1568 on Imhoff's death, sold by Karl Imhoff, Pirckheimer's great-grandson. Around 1580, Regina Alnpeck, Ursula Dürer's niece, sold items to Bartholomeus Spranger, a court artist. The remainder of the collection was purchased by Rudolf II of Prague in 1588. Gradually, privately-owned works by Dürer were acquired over the succeeding years by museums and galleries.

DÜRER'S LEGACY

Dürer was acclaimed in the circle of his humanist friends as 'Apelles Albertus Durrer'. He was 'the Apelles of black lines' as Erasmus called him, and a true 'Renaissance Man' who embraced humanism, formulated treatises based on ancient texts, and created a wealth of unique works in print and paint.

It is estimated that during his working life Albrecht Dürer created over 100 paintings, 300 prints, and 1,000 drawings. He was a prolific writer, of letters, poetry – not always appreciated by other poets – and many theoretical works. Dürer, together with Martin Schongauer and Hans Holbein the Younger, was crucial to the strong establishment of a northern Renaissance in Germany. From the moment his prints were circulated in Venice, Dürer's innovative printmaking techniques were praised and copied.

DÜRER MANIA

Dürer's legacy was to elevate the humble woodblock print to a higher art form, from a workshop reference for craftsmen and painters, to prized collector prints, resulting in an obsession for prints as works of art. Dürer promoted his work as a

Below: Homage to Dürer, c.1628, by Lucas Kilian (1579–1637), a double portrait of Dürer based on his self-portraits in the Heller and Landauer Altarpieces (see pages 191 and 202).

Above: The Albrecht Dürer monument, Nuremberg, Germany, photograph c.1900–14. The monument was based on a design by Christian Daniel Rauch and cast in ore by Johann Daniel Burgschmiet. On the 300th year of Albrecht Dürer's death in 1828, the foundation stone of the monument was laid. The monument was unveiled in 1840.

commodity, a commercial operation, using agents and print fairs to market his work. The distinctive AD monogram (see page 55) introduced to prints and paintings around 1495–96, after Dürer returned from Venice, accelerated recognition of his work. Such was the continued interest in Albrecht Dürer after his death, that from 1570–1630 a mania ensued, resulting in many copies and pastiches of his works being created, and many forgeries passed off as originals.

DÜRER AS INSPIRATION

At the time of his death Albrecht Dürer was acclaimed as one of the greatest artists in Europe. His creative work in many mediums, and consummate

marketing skills, promoted his art and himself. After his death, original print copies from engravings and woodcuts became collectors' prizes, adding to the collections of European monarchs, heads of state, and coveted by many artists. Over 100 years after Dürer's death, Rembrandt van Rijn (1606–69) collected the artist's prints. He learnt from them and borrowed aspects of compositions to create his own versions. 200 years on, the English artist, designer, printer and author William Morris (1834–96) treasured his collection of Dürer works, displaying them in his house. In the 21st century, graphic artists and painters continue to be inspired by Durer's skill in woodcut and engraving, as much as his painting.

A RARE FIND

In 2017 an extremely rare find of an unknown Albrecht Dürer drawing, bought for $30 in a house-clearance sale in the USA, was then valued at around $10 million. The discovery added to Dürer's celebrity, as a 16th-century superstar in the 21st century. The drawing *The Virgin and Child with a Flower on a Grassy Bank*, c.1503 (see page 168) is thought to be a highly-finished study for Dürer's later watercolour *Virgin and Child with a Multitude of Animals and Plants*, c.1503 (see page 165). It was confirmed as a Dürer drawing in 2019 by international expert Dr Christof Metzger, chief curator at the Albertina museum in Vienna, Austria.

Opposite: Nemesis (*or* The Great Fortune), *c.1501. A highly decorative 'nemesis' with fabulous wings; Albrecht Dürer's famous engraving depicts the goddess of Fate directing mortal life (see also page 159).*

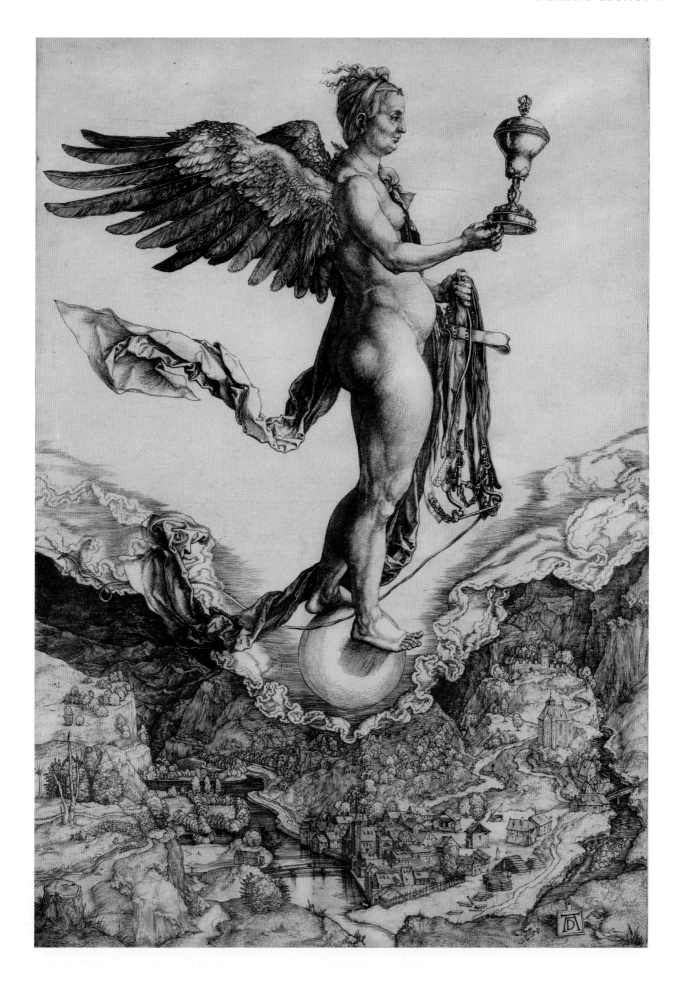

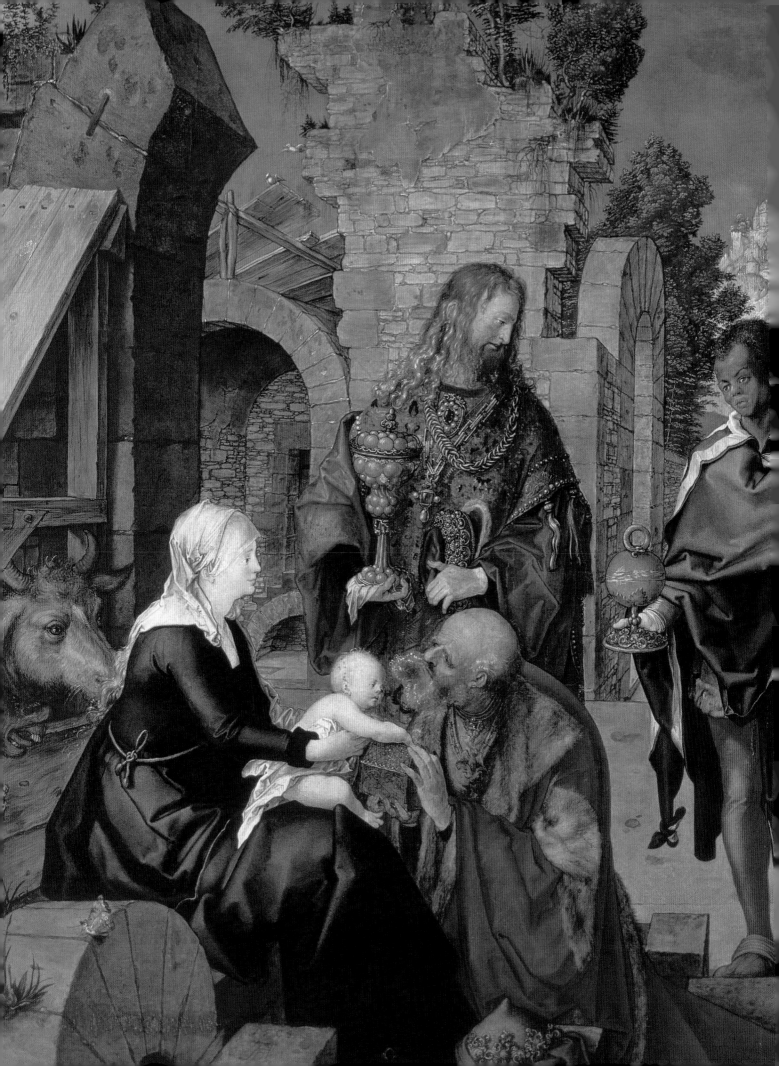

THE GALLERY

Albrecht Dürer was a prolific artist. From his 40-year career there are over 1,000 drawings, 100 paintings, and 300 prints extant today. His good fortune to be trained both as a goldsmith — key to Dürer's remarkable engravings, woodcuts and etchings — and as a painter in watercolour and oils, explains his unique versatility, making his catalogue of work truly sensational. The Gallery has been divided into three periods, opening with Dürer's apprentice-work *Self-portrait at the age of thirteen* in 1484 up to 1498 when the woodcut series *Apocalypse* brought the artist outstanding fame across Europe. The second section sees his achievements multiply, beginning with the outstanding *Self-portrait at age 28*, 1500, which reveals the maturity of his work. This chapter includes his success in Venice with a major painting *Madonna of the Rose Garlands*, 1506, and his three greatest engravings. In the third period from 1515, an unfinished project for Emperor Maximilian I was followed by a year-long trip to the Netherlands. Returning to Nuremberg, Dürer concentrated on prestigious works for the City council, and a series of remarkable portraits, with continued research and writings on Human Proportion before his untimely death at the age of 56, in 1528.

Left: Adoration of the Magi, *1504. Dürer captures a tender moment between earthly and spiritual or holy kingdoms, as the three kings attend the nativity of the infant Christ. A stone tablet at the feet of the Virgin has Dürer's AD monogram. (See also pages 170–71.)*

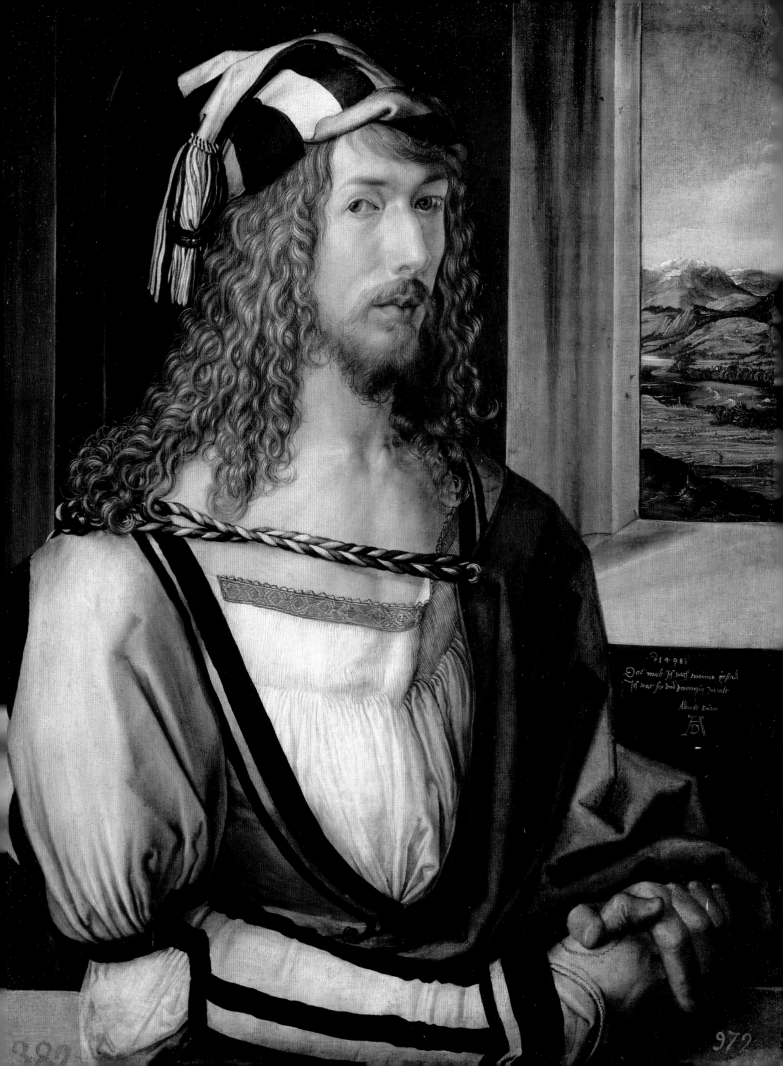

DÜRER
1484 TO 1499

The years 1484–99 highlight the diversity of Albrecht Dürer's skills, in woodcut, engraving, etching and painting. In 1486 Dürer had changed his career-path from goldsmith apprenticeship in his father's workshop to an art apprenticeship under the respected painter Michael Wolgemut. On completion of his training Dürer left Nuremberg to travel as a journeyman, to gain experience in the workshops of respected artists in other cities, before returning in 1494 to take part in an arranged marriage with Agnes Frey. He was travelling again for work later the same year, heading to Italy. The *Apocalypse* series of fifteen woodcuts made him famous. He employed agents to sell his prints at print fairs and in markets across Europe, promoting, publicising and heightening awareness of his work. The popularity of copying Dürer's prints led him to adopt a trademark AD monogram in 1497, to prove the authenticity of original works.

Above: The Beast with the Seven Heads and the Beast with Lamb's Horns *from* The Apocalypse *woodcut series (see also pages 40–41 and 130–33). The seven-headed beast with crowns is introduced in Revelation 13 and represents different governments, stated to rule over every tribe and people. It is considered to be a veiled, negative reference to the rulers of the Roman Empire.*

Left: Self-portrait at age 26, 1498 *(see also page 140).*

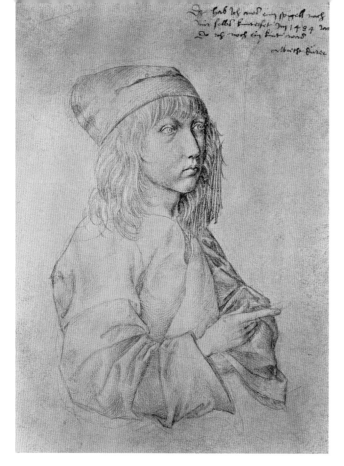

Self-portrait at the age of thirteen, 1484, silverpoint on paper, 27.3 x 19.5cm (10.7 x 7.6in), The Albertina Museum, Vienna, Austria

The first known self-portrait by Albrecht Dürer, aged thirteen, at the time assigned as an apprentice in his father's goldsmith workshop in Nuremberg. The medium of silverpoint is exacting; no mistakes can be erased, which reveals how skilled the artist was at an early age.

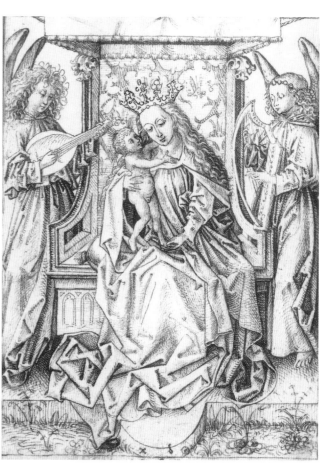

Madonna and Child enthroned with two angels making music, 1485, pen and ink, flesh tones with reddish watercolour, 21 x 14.7cm (8.2 5.7in), Staatliche Museen zu Berlin, Germany

Life-size angels accompany the Virgin Mary and lively infant Christ, who stands on her lap with his arms around her neck. She is seated on a throne under a baldachino, as the angels play music for them.

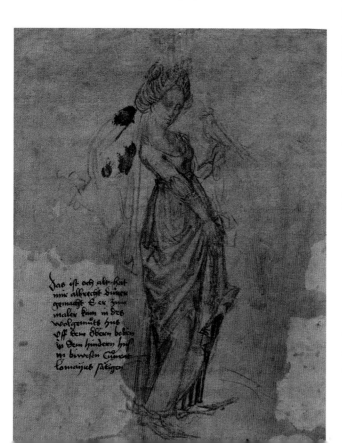

A *Lady holding a Hawk*, c.1484–86, charcoal on a paper prepared with a red ground, 27.3 x 18.4cm (10.7 x 7.2in), British Museum, London, England, UK

Possibly a preparatory study for a larger work, or a practice work. Dürer has concentrated on the proportions and stance of the woman's figure, and details of the drapery of her dress. There is a text written on the work, not by Dürer: '…Albrecht Dürer did it for me, before he entered Wolgemut's house to become a painter, up in the top attic of the back quarters of the house, in the presence of the late Konrad Lomayer.' [quote from Ashcroft, Book I, p.51] Dürer began his painter's apprenticeship on 1 December 1486. Lomayer, a goldsmith, possibly worked for Albrecht Dürer the Elder.

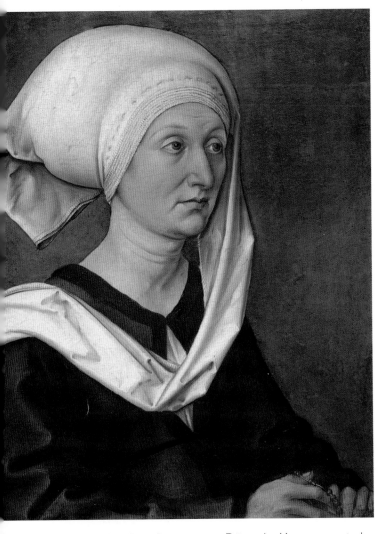

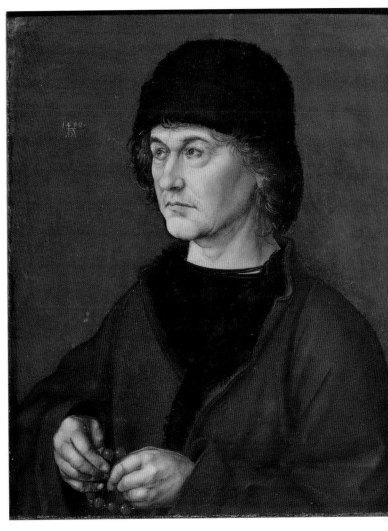

Portrait of Barbara Dürer, 1490, oil on wood 55.3 x 44.1cm (21.7 x 17.3in), Germanisches Nationalmuseum, Nuremberg, Germany

Barbara Dürer, née Holper (1452–1514) was the daughter of goldsmith Hieronymus Holper. Her husband-to-be Albrecht Dürer the Elder, a goldsmith, worked for her father in his Nuremberg workshop. She married Dürer in 1467.

Dürer the Younger created a closely-cropped, half-length portrait, in three-quarter profile of his mother, aged around 38 years, painted on a neutral background. It focused attention on her face, her Nuremberg headscarf, and the rich red dress she wore. She holds a rosary in her hands. Her eyes look toward her left, which links to the companion portrait of her husband, who also holds a rosary.

Portrait of Albrecht Dürer the Elder, 1490, oil on wood, 47 x 39cm (18.5 x 15.35in), Musée du Louvre, Paris, France

The father of Albrecht Dürer, born probably in Gyula, Hungary, c.1427, depicted here at the age of around 63. Dürer the Elder, in three-quarter profile, looks toward his right, which would be toward the companion portrait of his wife, Barbara Holper-

Dürer. He holds a rosary between his fingers, linking the composition to that of his wife. The deep green, plain background and sober-coloured clothing serve to highlight Dürer's facial features and his hands with careful precision. This work is thought to be an end-of-apprenticeship work, to denote Dürer's graduation from the studio of Michael Wolgemut. It is the oldest surviving painting attributed to Dürer.

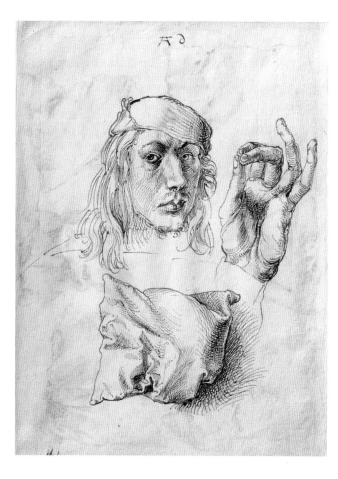

Left: *Self-portrait, Study of a Hand, and a Pillow* (recto), 1490–94, pen and ink, 26.7 x 20.2cm (10.5 x 7.9in), Lubomirski Museum, Wroclaw, Poland

Studies created during Dürer's years of apprenticeship. These drawings depict a close-cropped head portrait, a hand, and a pillow. On the reverse (shown below left) are six pillows.

Above: *Self-portrait with a Bandage*, 1491–92, ink and pencil, 29.3 x 20cm (11.5 x 7.8in), The Graphic Collection of the University of Erlangen-Nuremberg, Germany

Left: *Six Studies of Pillows* (verso), 1490–94, pen and ink, 26.7 x 20.2cm (10.5 x 7.9in), Lubomirski Museum, Wroclaw, Poland

On the reverse side of the self-portrait (above left) is an exercise in drawing six pillows. It may seem an unusual subject but the drawings depict light and shadow falling onto a soft inanimate object. It was possibly for a later work, or a practice task.

Created at the time of his apprenticeship, the young Dürer depicts a self-portrait close-up of his head, looking out to the observer. The face and hand are drawn in detail. The hair and clothing are in pencil outline. The hand-on-head pose is used for the head of Joseph in *The Holy Family, c.*1493 (see opposite), and for the pose of the hand resting on the face in *Melencolia I*, 1514 (see page 209).

Head of an Old Man, 1491, pen and dark brown ink, 18.7 x 13cm (7.3 x 5.1in), Musée National du Chateau de Malmaison, Paris, France

This is a remarkable work of realism, giving a sense of direct contact with the sitter, as if in his presence. Each hair of his head is defined, including the difference in texture and curl between side whiskers and bearded chin. The rims of his eyes sag with age but the eyes are sharp and clear and look away from the viewer, toward his left.

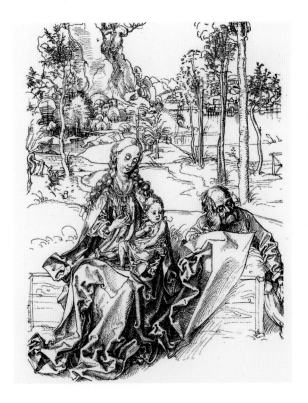

The Holy Family, c.1493, pen and ink drawing, 29 x 21.4cm (11.4 x 8.4 in), Staatliche Museen zu Berlin, Germany

The influence of artist Martin Schongauer is evident in Dürer's early work, particularly here. The seated, sleeping Joseph, with his head resting on his hand, was informed by Schongauer's *Agony in the Garden*, c.1480 (Ashmolean Museum, University of Oxford), and in the depth of perspective in the background landscape of trees.

THE COMEDIES OF TERENCE, 1492–93

The Comedies of Terence were written by Publius Terentius Afer (*c*.193/183–159BC), a Roman playwright. His biography was written by the Roman writer Suetonius (born 70AD) who commented that Terence was a Roman slave, born in Carthage in Africa. Terence wrote six plays: *Andria* (the girl from Andros), *Heauton Timouroumenos* (the self-tormentor), *Eunuchus* (the eunuch), *Phormio* (the screaming parasite), *Hecyra* (the mother-in-law), and *Adelphoe* (the brothers). Initially 150 woodblocks are said to have been commissioned

from Dürer by printer Johann Amerbach (1444–1514) of Basel, for publication. When Amerbach discovered that another print/publisher Johann Treschel of Lyon was completing a first edition (published in 1493), he dropped his plans, and Dürer's illustrations were not published. The woodcut series is generally assumed to be by Dürer, created during a stay in Basel, although there is no firm evidence to place him in the city. One clue might be that the main character Phaedria looks like Dürer, in hairstyle and dress, as depicted in a later work *Piper and Drummer* (see page 161).

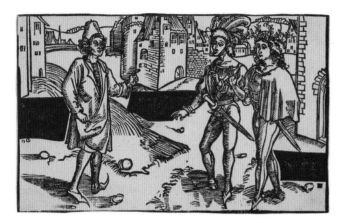

Andria, c.1492–93, woodcut, 8.9 x 14.3cm (3.6 x 5.6in), The Metropolitan Museum of Art, New York, USA

Andria (a girl of Andros) is the main character in Terence's comedy play of the same name, the first

of six comedies, dating to 166BC. Adapted by Niccoló Machiavelli (1469–1527) it was the first of the comedies to be performed in Florence in 1476. Dürer sets the scene, moving the action from Athens to a street in a medieval town.

Heauton Timouroumenos, 1492–93, woodcut, 8.9 x 14.3cm (3.5 x 5.6in), The Metropolitan Museum of Art, New York, USA

The Greek title of this Roman comedy means 'self-tormentor'. An Athenian,

Menedemus, torments himself for the punitive life he has given his son, Clinia, who was driven away by his harshness. Dürer creates a hilly outdoor setting for the characters.

Clinia and Syrus (Heauton Timouroumenos), c.1492–93, woodcut, 8.9 x 14.3cm (3.5 x 5.6in), The Metropolitan Museum of Art, New York, USA

Here, Clinia, son of Menedemus, meets a slave,

Syrus. Terence adds a romantic storyline as Clinia falls in love with the daughter of a poor woman, who becomes marriageable at the end of the story. Terence focused on two characters, to give diverse reactions to a situation.

Phaedria (Eunuchus IV 2), 1492–93, woodcut, 8.9 x 14.3cm (3.5 x 5.6in), The Metropolitan Museum of Art, New York, USA

Dürer depicts Phaedria, a young Athenian in love with Thais, a courtesan

from Rhodes. Phaedria was the son of a nobleman, Laches. The complex farce includes Phaedria purchasing a eunuch Dorus, as a love-present for Thais. As with all farces, many complications and misunderstandings drive the plot.

Laches and Parmeno (Eunuchus V 6), *c.*1492–93, woodcut, 8.9 x 14.3cm (3.5 x 5.6in), The Metropolitan Museum of Art, New York, USA

Eunuchus was a very successful play for Terence. It was performed at the Megalisian Games in Rome in 161AD. Here we see Laches, an Athenian nobleman, with Parmeno, the servant of Laches' son Phaedria. Terence used comedy to comment on social etiquette. It was often the servants who would save an awkward situation with diplomacy.

*Hecyra, c.*1492–93, woodcut, 8.9 x 14.3cm (3.6 x 5.6in), The Metropolitan Museum of Art, New York, USA

The storyline of Hecyra was to show how women are often mistreated and maligned by men. It was a comedy that played with human emotions. The play was, however, Terence's one failure. He rewrote the text and it then gained a better reception on two further showings, restoring his reputation.

The Martyrdom of the Ten Thousand, 1491–1501, woodcut, 39.2 x 28.5cm (15.4 x 11.2in), The Art Institute of Chicago, Illinois, USA

Dürer created a woodcut of this atrocity, his illustration based on a written account of the medieval legend. The Persian king, shown at left, is watching St Acacius, who converted 10,000 Romans to Christianity, lying on the ground in the right foreground. Around him the Roman Christian converts are martyred, on the instructions of a Roman emperor – the name is unknown, possibly Hadrian, Antonius Pius or Diocletian, angered at Romans acting against his will. The Persian king, an ally of Rome, acts as overseer. St Acacius's eye is being gouged out with a hand wrench. Had Dürer seen this equipment used, or conjured it from his imagination? The woodcut relates to his later painting dated 1508 (see page 196), which accentuates the atrocities in detail. The scene is depicted from a raised position that lets the viewer feel as if they are present, watching the spectacle from a close distance.

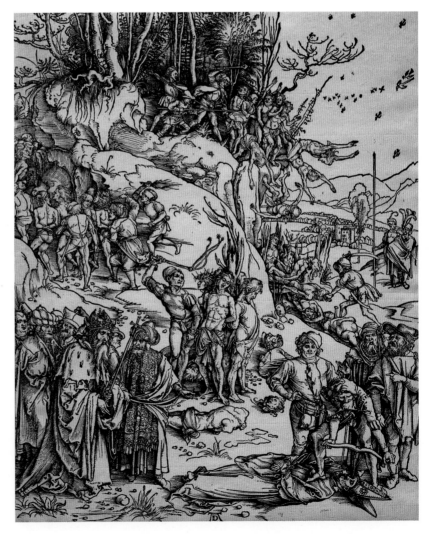

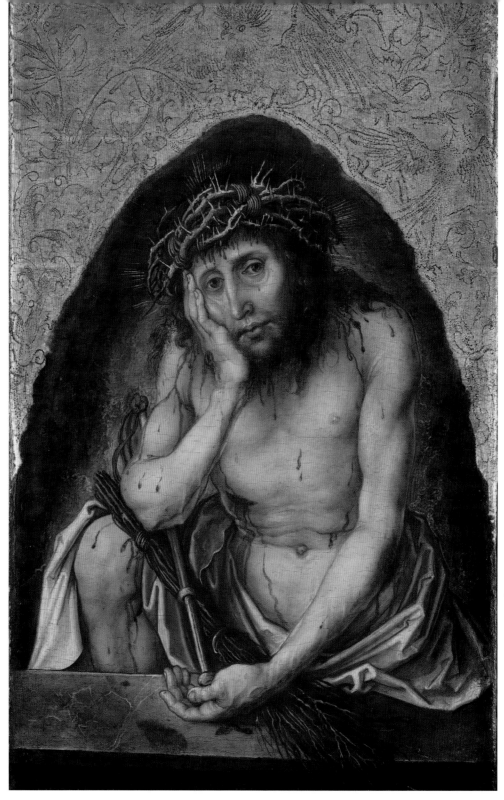

Christ as the Man of Sorrows,
1493–94, mixed media on
fir wood, 30.1 x 18.8cm
(11.8 x 7.4in), Staatliche
Kunsthalle, Karlsruhe,
Germany

At centre, Christ is in front
of a cave, connoting the
placement of his tomb. His
left hand rests forward,

on a low ledge, bringing
him closer to the observer.
Christ's body is near-naked
and spattered with his blood.
He has suffered torture and
crucifixion at the hands of
his oppressors. He wears a
crown of thorns, and holds
instruments used to flail his
flesh, a bundle of birch twigs,
and a three-knotted whip.

Blood leaks from the wound
near his heart, created
by the lunge of a soldier's
spear during the crucifixion,
to test if Christ was dead.
Christ's right elbow leans
on his raised knee. His
forlorn, melancholic face is
supported by his right hand.
The Messiah's tired eyes
look directly at the observer,

in a resigned manner. The
gold backdrop is decorated.
This work was probably
created during Dürer's
stay in Strasbourg, toward
the end of his journeyman
travels. 'Christ as the Man
of Sorrows' was depicted by
Dürer in different media.

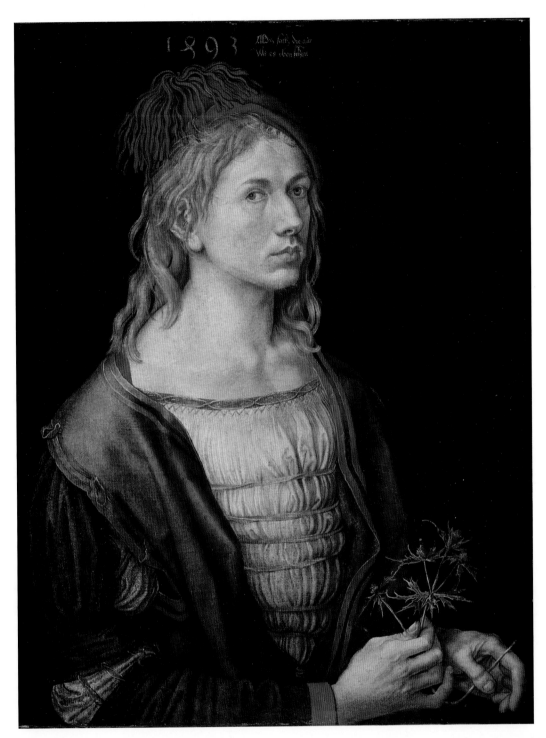

**Self-portrait with a Thistle,
1493**, oil on parchment on
canvas, 56.5 x 44.5cm (22.2
x 17.5in), Musée du Louvre,
Paris, France

In his hand the young
Albrecht Dürer, aged 22
years, holds an eryngium – a
thistle – interpreted by some
historians as a symbolic
courting gift for his fiancée
Agnes Frey. A light source
from the left highlights his
head and his hands, both
being tools – intelligence and
manual dexterity – of his
profession.

The inscription reads:
'My sach die gat als oben
schtat' ('My affairs must go
as ordained on high'), which
adds mystery to its meaning.
At the time of painting this
work, Dürer was living in
Strasbourg, at the end of
his journeyman three-year
sojourn, and preparing to
return to Nuremberg after
his father commanded him to
come home, in order to get
married. The thistle has the
attribute of 'man's loyalty'.

Dürer captures his youthful,
gamine looks, slightly tangled
hair, with discerning eyes
fixed on the viewer. He
is dressed in fashionably
elegant clothes. The painting
was created on parchment,
possibly to be portable, for
sending by courier.

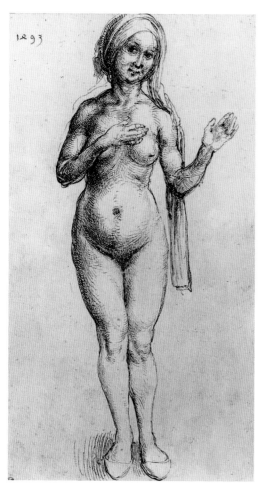

Bathing girl, 1493, pen and ink, 27.2 x 14.7cm (10.7 x 5.7in)), Musée Bonnat, Bayonne, France

Also titled *Femme aux babouches* ('Woman with slippers'), the work depicts a woman, near-naked except for a headdress and slippers, possibly a life drawing or preliminary drawing for a later work, such as *The Women's Bath*, 1496 or *Four Nude Women*, 1497 (see page 129 for both). Around 1493, Dürer created another semi-nude work, in pen and ink, *Youth kneeling before an executioner* (British Museum, London).

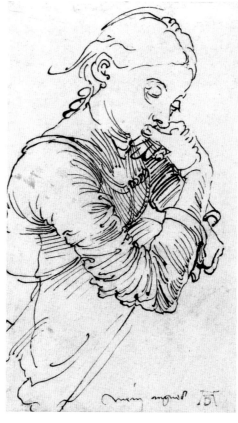

Agnes Dürer, née Frey, 1494, pen and black ink, 15.6 x 9.8cm (6.1 x 3.8in), The Albertina Museum, Vienna, Austria

Possibly Dürer's first portrait of his fiancée Agnes. The pen and ink drawing captures a gentle character as she sits with her elbows resting on a table. The thumb and fingers she holds close to her mouth suggest a thoughtful person. The depiction, and Dürer's inscription 'Mein Agnes' ('My Agnes'), outwardly conveys a tenderness between them.

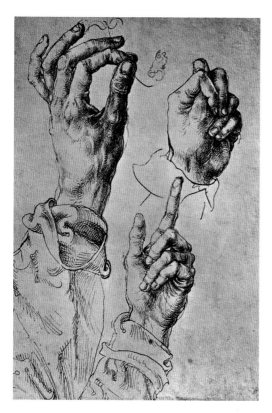

Study of Three Hands, c.1493–94, pen and ink, 27 x 18cm (10.6 x 7in), The Albertina Museum, Vienna, Austria

A study in hand movements created during Dürer's years of apprenticeship. They are portraits of his left hand, making a range of different gestures. At top left, a hand pinches the thumb and forefinger together; the second hand makes an obscene gesture known as the sign of the fig; the third hand points upward with the forefinger.

A Wise Virgin (recto), 1493, pen and brown ink on laid paper, 29.1 x 20.2cm (11.45 x 7.7in), The Courtauld Institute, London, England, UK

An early drawing, an exercise in figure study. The woman is moving, looking down, with her right hand raised in a gesture of greeting. In her left hand she holds a burning oil lamp, which identifies her as one of the five Wise Virgins in the bible narrative: Matthew 25: 1–13. Dürer pays attention to the delicate hand movement, the long tresses of hair that cascade down her back, and the folds of her dress.

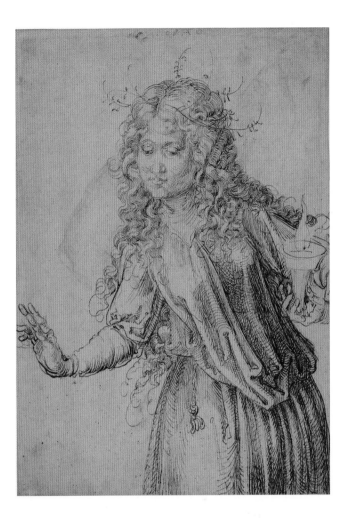

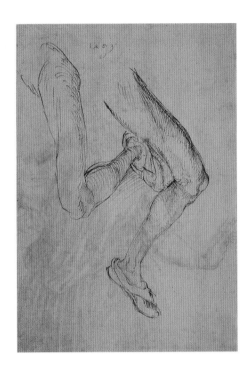

Above: *Study of a left leg from two viewpoints* (verso), 1493, pen and brown ink on laid paper, 29.1 x 20.2cm (11.45 x 7.7in), The Courtauld Institute, London, England, UK

An unusual drawing of Dürer's left leg, as seen from above in two studies. An exercise in leg, knee and muscle movement, it is to be found on the reverse of *A Wise Virgin*, 1493 (above).

The Christ Child as Saviour, 1493, opaque colours on parchment, nimbus grey, and orb in gold, 11.8 x 9.3cm (4.6 x 3.6in), The Albertina Museum, Vienna, Austria

This work was painted on parchment and created during Albrecht Dürer's journeyman years. It depicts Christ as a young boy. He holds a toy ball, a symbol of the orb of the world carried by the adult Christ. In the Upper Rhenish region where Dürer was working, this type of image was traditional, often used as a printed greeting for friends and family. Dürer kept the work in his collection.

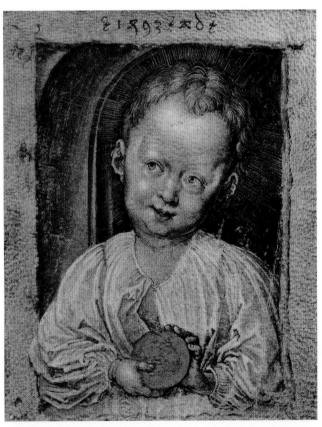

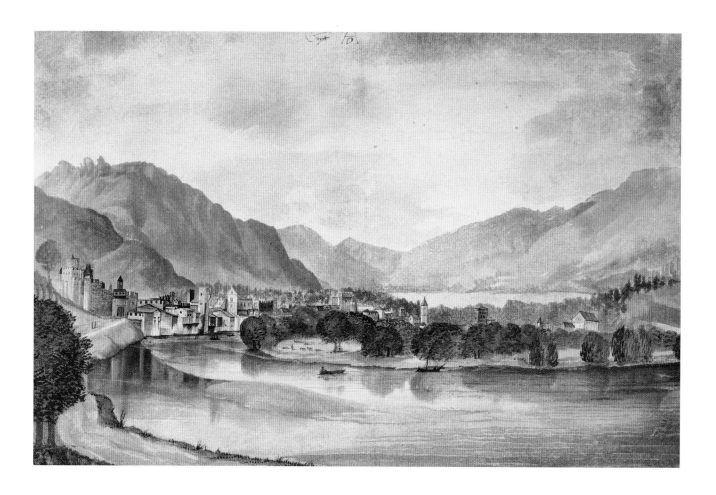

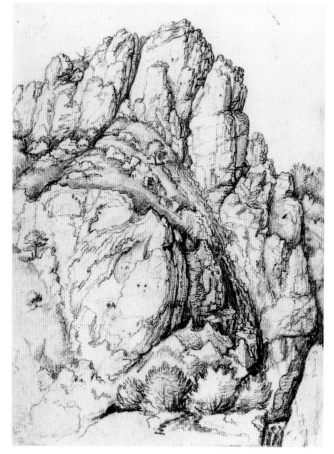

View of Trente, 1494,
watercolour and gouache
on paper, 23.8 x 35.6cm
(9.3 x 14in), Kunsthalle,
Bremen, Germany

A stunning view of the city
of Trente, on the Adige river,
in northern Italy.

Gorge in the mountains,
*c.*1494–95, chalk on paper
38.1 x 26.7cm (15 x 10.5in),
Goethe-Nationalmuseum,
Weimar, Germany

Albrecht Dürer's first
landscape drawing features a
rocky gorge. Early paintings,
drawings and woodcuts of
St Jerome have a similar rock
face. Inscribed in one corner
by Dürer is: 'Kalkrewt'. The
work was lost in the Bremen
evacuation during World
War Two.

Trintperg (Dosso di Trento, near Trento), 1494–95, watercolour with opaque white, 17 x 21.2cm (6.6 x 8.3in), Kunsthalle, Bremen, Germany

Dürer crossed the Alps to travel via Innsbruck and Trent. A watercolour of Trintperg, near Trent, as seen from the water, looks toward the walls of the church, and beyond to its houses, nestled at the base of the single mountain and its bare rock formation.

View of a castle overlooking a river, 1494–96, watercolour, 15.3 x 24.9cm (6 x 9.8in), Kunsthalle, Bremen, Germany

Dürer's view of Segonzano castle, Segonzano, in the Cembra Valley, Trentino, Italy.

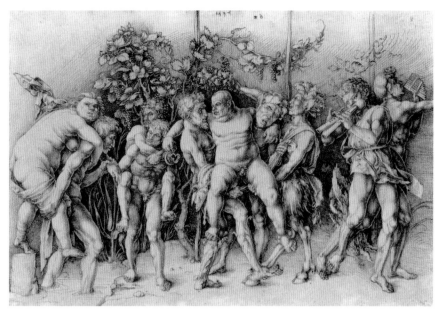

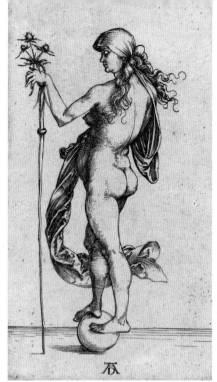

Bacchanal with Silenus, 1494, after Andrea Mantegna, pen and ink drawing, 29.8 x 43.3cm (11.7 x 17in), The Albertina Museum, Vienna, Austria

Informed by Andrea Mantegna's engraving *Bacchanal with Silenus*, c.1475–80 (Kunsthalle, Hamburg, Germany), Dürer closely copied Mantegna's composition for his near-identical pen and ink rendering. He may have found print copies of this engraving in Nuremberg, The detail of the human bodies and freedom of movement show an awareness of the Italian Renaissance, and of the interest in classical antiquity present in Mantegna's work. In the midst of Bacchanalian revels, the obese Silenus, companion to the wine god Dionysus, is carried by two supporters, alongside other revellers, through a vineyard. A musician, playing pan pipes, leads them on.

Little Fortuna, 1495–96, engraving, 12 x 6.7cm (2.6in), Private Collection

The near-naked 'Nemesis' or 'The Little Fortuna' is balanced on a globe. She holds a long stick to steady herself. The pinnacle of it is decorated with the starwort herb. It contrasts with the 'Great Fortune', which is highly decorated (see pages 97 and 159).

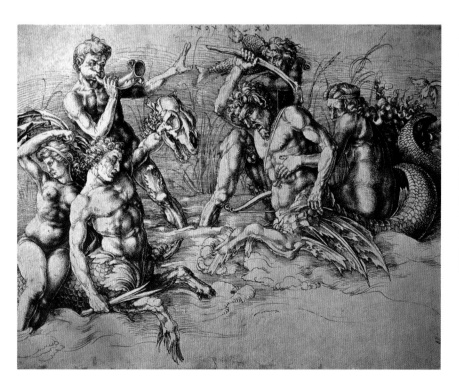

Battle of the Sea Gods, 1494, after Andrea Mantegna, pen and ink drawing, 29.2 x 38.2cm (11.49 x 15in), The Albertina Museum, Vienna, Austria

Dürer had seen Mantegna's magnificent *Battle of the Sea Gods*, c.1485–88 (see page 51) and may have owned a print from the engraving. Here, he copies the right-hand part of the work with the Sea Gods exhaustively fighting in ferocious combat, with the remarkable gradations of light and shade that Mantegna achieved in the engraving.

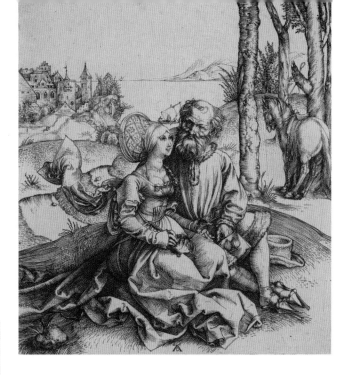

The Ill-Assorted Couple,
*c.*1495, engraving, 15.1 x
13.9cm (5.9 x 5.4in), British
Museum, London, England,
UK

One of Dürer's earliest
engravings. Seated on a hill,
with a distant landscape of
a town beyond, a couple
have tied their horse to a
tree, while they sit. The man,
much older than the young
woman, turns to look at
her. She stares ahead. The
significance may be of 'love'
bought for money. Both are
holding their money purses.

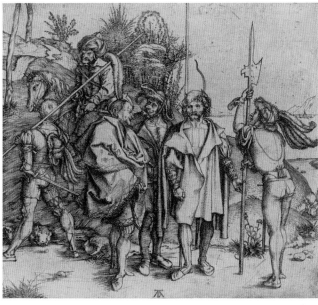

Five Soldiers and a Turk
on Horseback, 1495–96,
engraving, 13.3 x 14.6cm
(5.2 x 5.7in), Dallas
Museum of Art, Texas, USA

Dürer possibly encountered
soldiers and a Turkish man
on horseback on his journeys
travelling to, or from, Italy,
*c.*1495.

The Great Courier, 1495, engraving, 29.6 x
26.7cm (11.7 x 10.5in), Private Collection

Dürer captures the courier's horse at a gallop
in the countryside, en route to deliver letters,
messages and small packages. The courier would
have changed horse several times on long journeys.
The 'great courier' refers to the large size of the
engraving.

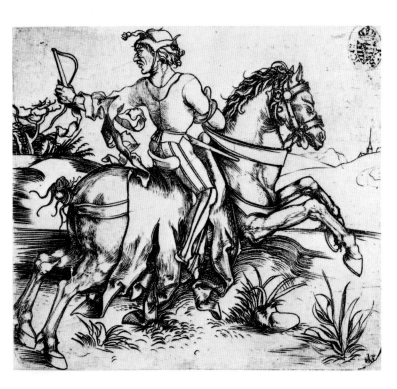

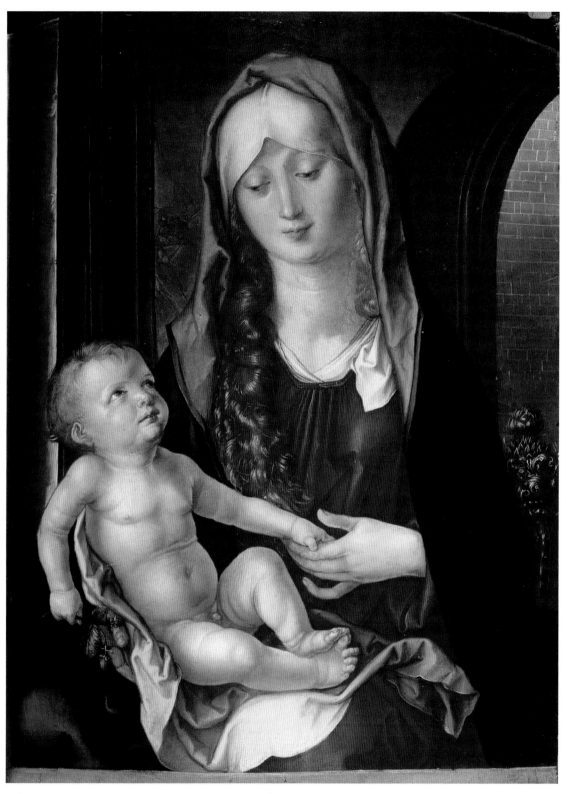

Virgin and Child (Madonna del Patrocinio), c.1495, oil on panel, 48 x 36cm (18.8 x 14.1in), Fondazione Magnani-Rocca, Parma, Italy

The date of this painting, attributed to Albrecht Dürer after some academic debate, is placed after his first visit to Italy, c.1495, or possibly to c.1507, after his second visit to Italy. What is evident is the influence of Italian painting in the work. The three-quarter length composition of the seated Madonna uses a pyramidal, triangular shape, to outline the figures of the Virgin Mary holding the infant Christ on her lap. Mother and son hold hands. The young child holds a strawberry stem in his right hand. The strawberry can be read as a symbol of the blessing of Christ. In the background there is an archway. It is also known as the *Bagnacavallo Madonna*, named after the monastary it was later located in.

The Virgin with a Butterfly, c.1495, engraving, 21.59 x 17.46cm (8.5 x 6.8in), San Diego Museum of Art, San Diego, USA

Also known as *The Holy Family with a Dragonfly* (or *Mayfly*, or *Locust*). Dürer created many engravings of the Madonna and Child, a traditional and highly popular subject for prints. While mother and infant remain central, Dürer created a world surrounding them. In this depiction, the Holy Family rest on their journey after the birth of Christ. God the Father looks down from above. Joseph, at left, is on the ground asleep, his arm resting on a bank of grasses. Behind him are buildings in a rural landscape. Beyond is a familiar Dürer setting of sea and ships, a castle, and a bridge. The Madonna, seated on a wooden bench, looks affectionately at her baby, and he at her. A butterfly (or dragonfly, mayfly, locust) is in the front right corner. This is the first engraving to which Dürer added his AD monogram, in its earliest version.

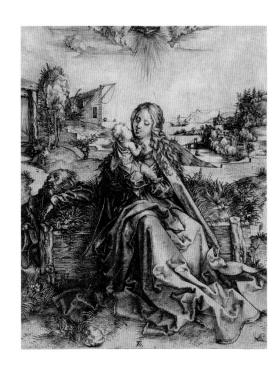

Study of a Female Nude with a Staff, from the Back, 1495, pen and black-brown ink, brush, and grey wash, 31.9 x 21.3cm (12.5 x 8.3in), Musée du Louvre, Paris, France

Similar to the body of Nemesis or 'Little Fortuna' (see page 114), the naked figure with back to the viewer rests her right hand on the top of a staff. The tip of a long piece of soft material is held in her right hand and swathed across her body and draped over her left shoulder. Her body is in the contrapposto position. Her weight rests on right leg with left foot stepping forward, which swivels the body, creating realistic movement. The contrapposto pose was favoured by Italian artists, and Dürer may have copied this position from artists or antique sculpture.

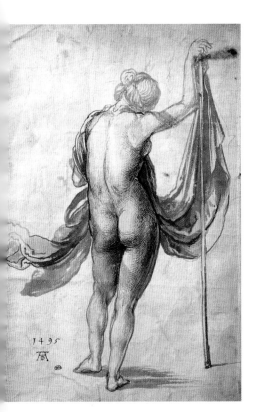

St Jerome in Penitence in the Wilderness, 1496–97, engraving, 31.7 x 22.3cm (12.5 x 8.75in), Cooper Hewitt Museum, Washington DC, USA

An engraving close in date and content to the small oil painting *St Jerome in the Wilderness*, c.1496 (see page 127). Here, in the midst of a rocky landscape with a church in the far distance, reached by a rock-strewn path that runs between the cliffs, the penitent Jerome kneels in front of a crucifix that is fixed to an old tree stump. He is in the action of beating his chest with a rock, to replicate the suffering of Christ's Passion. At his feet his companion, a protective lion whom he helped by removing a thorn from his paw, keeps a watchful eye. St Jerome has a muscular body, possibly to denote the manual labour of living a solitary life. At right a river can be seen, meandering toward a town in the far distance.

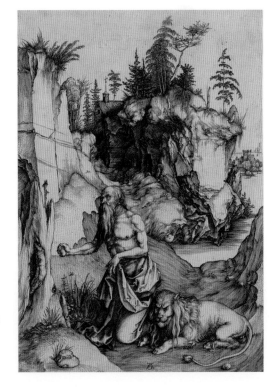

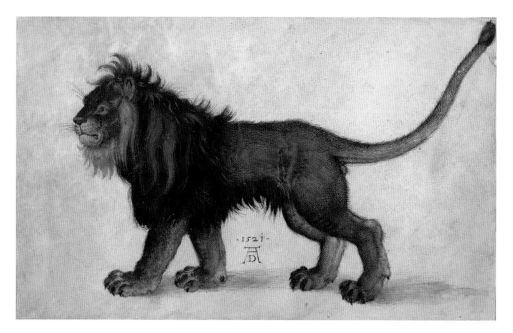

Left: *Lion*, c.1495–1500, watercolour and body colour on parchment, 17.7 x 28.8cm (6.9 x 11.3in), The Albertina Museum, Vienna, Austria

The lion watercolour was created between 1495 and 1500, before Dürer had seen a lion. His depiction is remarkable. It captures the leonine shaggy, thick mane, the stance, bravura and majestic aura of a male lion.

Below: *Lion*, c.1495–1500, watercolour and body colour on parchment, 12.6 x 17.2cm (4.9 x 6.7in), Kunsthalle, Hamburg, Germany

Dürer had not seen a lion when this painting was created but he must have seen many depictions of the animal to illustrate it. The legs are more like a dog than a lion but the aura and on-guard temperament are captured. The face seems to have human qualities. Tiny feather-like sprinkles of gold paint add to the charm and reflects the decoration of medieval manuscripts. This depiction is connected to the lion in *St Jerome in the Wilderness* (see page 117).

Right: *Türkenbund* – or *Turk's cap lily* – *lilium martagon*, 1495, watercolour and opaque paint, 54.6 x 18.1cm (21.5 x 11in), Kunsthalle, Bremen, Germany

A lily studied and painted for later use in other works.

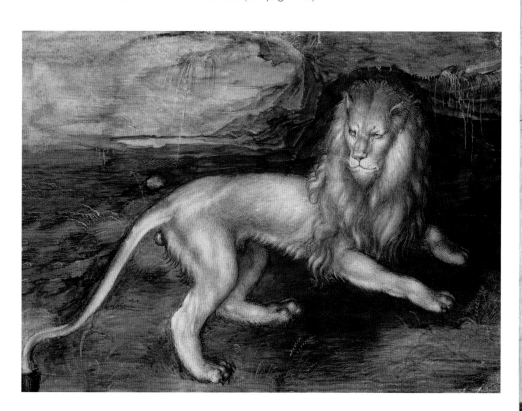

The Small Piece of Turf, c.1495–1500, opaque colours on very fine and polished parchment raised with opaque white, 11.7 x 14.7cm (4.6 x 5.7in), The

Albertina Museum, Vienna, Austria

This is a close observation of small wild plants and grasses, a watercolour study to utilise later in other artworks. Dürer captures the delicacy and individuality of each plant leaf, stalk and flower. One method was to dig up a chunk of grass or wild flowers and set it up in the studio to draw and paint from a close-view vantage point.

Lobster, 1495, pen and brown ink, brown and black watercolour on paper, 24.6 x 42.8cm (9.6 x 16.8in), SMB, Berlin, Germany

A close-cropped study of a lobster, its antennae, eye, large claw, spiny, armour-like shell body, tail fin, and walking legs all meticulously observed and copied.

View of Innsbruck from the North, c.1495, watercolour, body colour heightened with opaque white, 33.5 x 26.2cm (13.1 x 10.3in), The Albertina Museum, Vienna, Austria

In 1495 Albrecht Dürer recorded the layout and housing of the courtyard of the east wing of Innsbruck castle, from two different viewpoints, in two watercolours. The emptiness of the street creates an unnatural view of the city but highlights the diversity of its architecture.

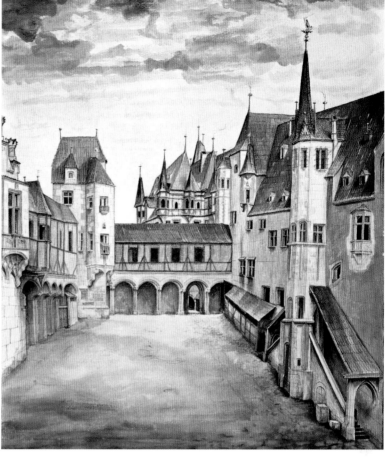

Courtyard of Innsbruck Castle (Without Clouds), c.1495, watercolour and opaque paints, 36.8 x 26.9cm (14.4 x 1.5in), The Albertina Museum, Vienna, Austria

A view of the courtyard of the east wing of Innsbruck Castle, from a slightly elevated viewpoint. This is a companion work to the view from the opposite end of the courtyard (see above). The architecture has been meticulously studied to produce a visual reproduction of the east wing layout with glimpses through entrances to other parts of the castle.

Innsbruck from the North, c.1495, watercolour, traces of opaque colours, with opaque white, 12.7 x 18.7cm (5 x 7.3in), The Albertina Museum, Vienna, Austria

The sight of Innsbruck from the water was possibly viewed on Dürer's journey home from his first visit to Venice, and drawn or sketched on site but painted in the studio. The armorial tower is covered in scaffolding, after the original burnt down in 1494. From the left is the Hofburg palace, going right toward the Inn bridge. In the far distance are Glunzeger and Patscherkoff, snow-tipped mountains. In the forefront, the light reflects shallower waters, with a boat and people on shore.

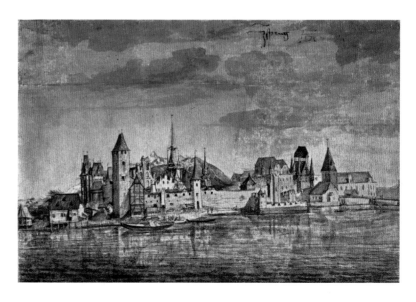

Road in the Alps, 1495, gouache and watercolour on paper, 20.5 x 29.5cm (8 x 11.6in), Monasterio del Escorial, Madrid, Spain

One of many watercolour drawings of locations viewed by Albrecht Dürer, this one dates from his journey across the Alps, soon after his marriage in 1494. This is the Brenner road in the Eisack Valley. The topographical view directs the observer to the road at right, which winds through rock formations. In the near distance a forest of rich green trees takes the viewer through the valley into the distant hills. It is understood that Dürer made sketches, which would inform his watercolours at a later time.

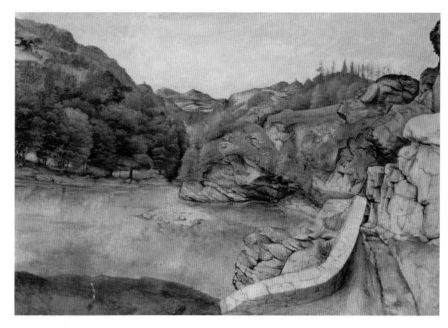

View of the Arco Valley in the Tyrol Meridional, 1495, pen and ink and watercolour on paper, 22.3 x 22.3cm (8.7 x 8.7in), Musée du Louvre, Paris, France

This is probably a combination of views of a citadel north of Lake Garda, in the Val d'Arco in the South Tyrol, that Dürer studied and recorded on his travels when returning to Nuremberg via Trento and Innsbruck. It is one of 30 landscape watercolours he painted during his first visit to Italy. The lower walled city, and the tree-lined road leading to the upper castle, brings together the citadel location and rockface landscape, drawn from different viewpoints into one depiction. Many of Dürer's landscape watercolours were created for workshop stock images, to be used as scenic backdrops in religious and secular paintings, woodcuts and portraits. This work is remarkable for its attention to detail.

Steinbruch (stone quarry), *c.*1495–97, watercolour and gouache, 22.5 x 28.7cm (8.8 x 11.2in), British Museum, London, England, UK (signature and date not by the artist)

A richly colourful view of the stone quarry at Steinbruch, probably drawn and later painted as part of Dürer's stock of images for landscapes. An inscription says '1506' with the AD monograph; its position on the rock face and not in the blank space beneath the drawing suggests it was added at a later stage, and not by Dürer.

Three Orientals, c.1496–97, pen and black and brown ink, with watercolour, 30.6 x 19.7cm (12 x 7.7in), British Museum, London, England, UK

Dürer would have seen men dressed in Turkish costume in Venice, a city that was a hub for trade with the East. They wear traditional Turkish long coats, collarless shirts, and turbans. He may have copied the three men not from life but from three men visible in the background of a painting by Giovanni Bellini, *Corpus Christi Procession in Piazza San Marco*, 1496, seen in process before the painting was finished, during Dürer's stay in the city, c.1494–95, or from Bellini's drawings. Dürer and Bellini had met in Venice.

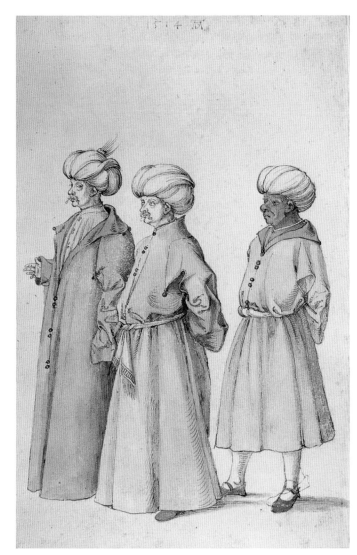

An Oriental Ruler Seated on his Throne, c.1495, pen and black ink on laid paper, 30.6 x 19.7cm (12 x 7.7in), National Gallery of Art, Washington DC, USA

Dürer captures a sombre ruler, his serious expression almost overshadowing the breathtaking array of jewellery that he wears, from the ornate crown and heavy neck chain to jewel-encrusted slippers. The artist would have seen many Turkish and Middle Eastern styles of dress in Venice.

Above: *Hercules Conquering Cacus*, c.1496, woodcut, 39.1 x 28.4cm (15.3 x 11.1in), Dallas Museum of Art, Texas, USA

In this woodcut Dürer visualises the moment when Hercules has slain the warrior Cacus, who had stolen his cattle. Cacus's sister holds up her arms in shock. She had betrayed her brother to Hercules. Behind her a fury seeks revenge and aims to strike her.

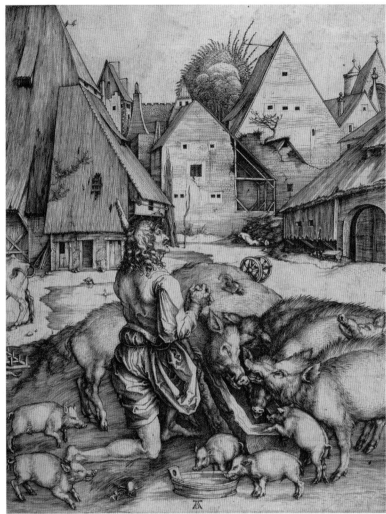

Above: *The Prodigal Son*, 1496, engraving, 24.9 x 19.3cm (9.8 x 7.5in), The Metropolitan Museum of Art, New York, USA

This remarkable engraving relates to the bible narrative of the Prodigal Son (Luke 15: 11–32). Created around 1496, it is an indicator of Dürer's potential in this skilled medium. The preparatory drawing (see below) shows his work in process. He created individual sketches for animals, and a compositional layout for the total work. Set in a German village, the Prodigal, having spent the fortune his father gave him, kneels to face the distant church, symbol of God's presence. He is surrounded by his hungry farm animals. The roofs, walls and thatches of his property are in a serious state of neglect. He kneels, to pray to God to help him.

Left: *The Prodigal Son*, c.1496, pen and black ink drawing, 21.7 x 21.9cm (8.5 x 8.6in), British Museum, London, England, UK

A preparatory drawing for *The Prodigal Son* engraving (above). The figure of the Prodigal, and some of his hogs, are well-defined, including the bristly quivers of hair on the hogs' backs and faces. They feed avariciously while he looks heavenward, toward the church in the distance, and to God, for forgiveness and help. In 1604 biographer Karel van Mander wrote that Dürer's own physiognomy is clearly defined in the Prodigal Son's face and figure.

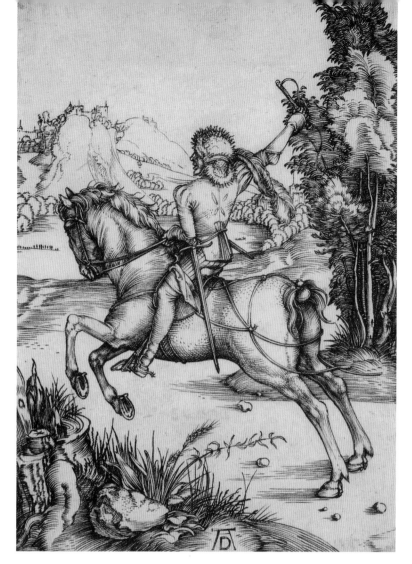

The Small Courier, c.1496, engraving, 10.8 x 7.7cm (4.2 x 3in), Saint Louis Art Museum, Missouri, USA

Dürer captures the adventuring attitude of the courier – 'small' refers to the size of this work – travelling to towns, or crossing through countries, to deliver small packages and letters. Dürer would have seen many couriers travelling across country, during his journeyman years and en route to Italy. His letters to Willibald Pirckheimer, from Venice in 1506, mentions sending precious stones via courier to Nuremberg.

The Monstrous Pig of Landseer, 1496, engraving, 12.1 x 12.7cm (4.7 x 5in), The Whitworth, University of Manchester, Manchester, England, UK

Dürer creates a backdrop of the city of Landseer, with its recognisable gate, to place the unfortunate multi-legged animal in the location where it was born on 1 March 1496. The piglet only lived for hours but Dürer depicts it as an adult animal, standing on six of its eight legs. 'Monstrous' births with deformities were seen as portents of a calamity. Dürer made a drawing of conjoined twins too, *The Siamese Twins of Ertingen*, 1512 (Ashmolean Museum, Oxford, England).

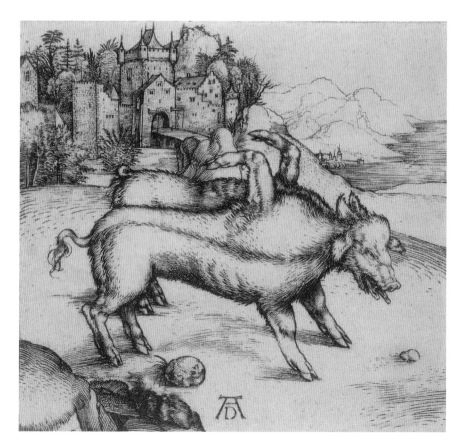

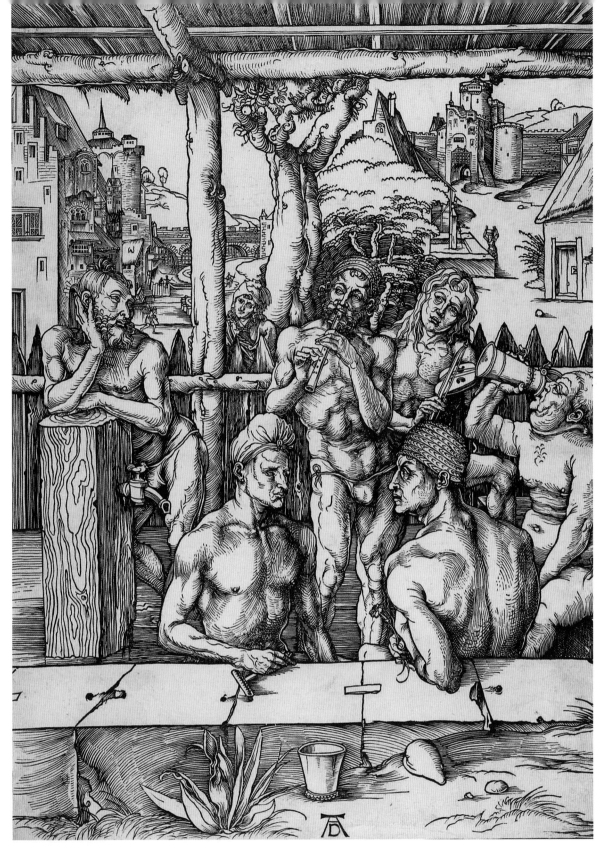

*The Men's Bath, c.1496–97,
woodcut, 38.89 x 28.1cm
(15.3 x 11in), Minneapolis
Institute of Arts,
Minneapolis, USA*

The woodcut illustrates
six men relaxing in a male
communal bath, set in an
outdoor location, possibly on
the outskirts of a town. They
are observed by an onlooker
in the background. The
woodcut highlights Dürer's
skill in portraying the human
body. Varying opinions
suggest who the men might
represent. The men leaning
on the parapet are thought
to be the Paumgartner
brothers. Willibald
Pirckheimer, Dürer's friend,
might be the man seated at
right. Two or three of them
could be Dürer self-portraits.
Historians speculate that he
is the bearded man standing
at left by the water pump but
Dürer was 25 when the work
was created. Perhaps he is the
young, long-haired musician,
next to the flute player? The
intricacy of the woodcut,
and the subject, made it
saleable as a solo print.

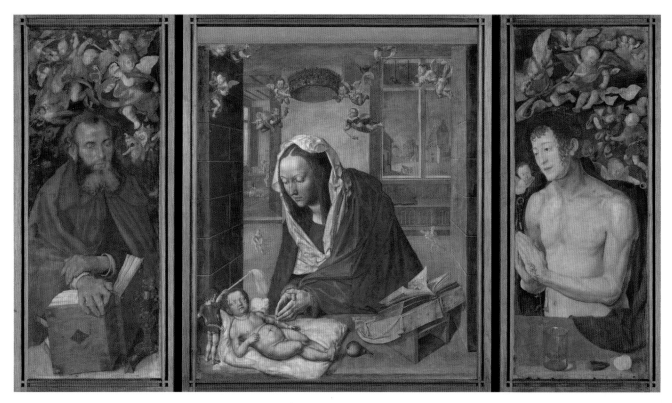

The Dresden Altarpiece,
1496, central panel not
attributed to Albrecht
Dürer, tempera on canvas,
117 x 186.5cm (46 x
73.4in) (main panel 117 x
96.5cm and wings 114 x

45cm), Gemäldegalerie Alte
Meister, Dresden, Germany

The Dresden altarpiece was
commissioned by Frederick
the Wise (1463–1525),
Elector of Saxony, for the

church of Wittenberg Castle.
It has been debated that
the central panel, depicting
the Madonna adoring the
Christ Child, is not the
work of Dürer but a Dutch
painter. The left wing of

the altarpiece depicts the
hermit St Anthony; the
right wing portrays the
martyr St Sebastian, both
dated to around 1500 and
possibly painted by Dürer's
workshop.

St Jerome in the Wilderness,
c.1496, oil on pearwood,
23.1 x 17.4cm (9 x 6.85in),
The National Gallery,
London, England, UK

The size of this small,
exquisite double-sided
painting in oils suggests
that it was created for
private devotion. In the
composition, the hermit St
Jerome (c.347AD, Stridon,
Dalmatia – c.420AD,
Bethlehem, Palestine), in a
rugged wilderness, holds

an open book, and kneels
before a crucifix that is
attached to a tree stump
(connoting the 'tree of life').
The book is the bible, which
St Jerome translated from
Greek into Latin, known as
the Vulgate. The penitent
beats his chest with a
rock, a symbol of Christ's
Passion. Before him on the
ground are his cardinal's
robe and hat (although
there were no cardinals
in the time of St Jerome).
Alert, and lying behind

him, is his trustworthy lion,
who protects the saint.
In the distance to the left
is a church with a Gothic
spire. The dark skies have
broken above the saint and
a glorious sunlight is seen
on the horizon. Not to be
missed are two tiny birds –
a bullfinch and a goldfinch
– in the forefront at right,
drinking from a small stream.
The goldfinch is a symbol
of Christ's suffering. Dürer
places the saint in a northern
European landscape, with

craggy cliffs and deciduous
trees, unlike the bible
narrative of a desert near
Bethlehem. Dürer created
more works of St Jerome,
in oils, woodcuts, and
engravings, than any other
saint in his body of work.

On the reverse side
is another painting, near-
abstract in content, which
features a spectacular
explosion of colour, with
planets and a comet in the
night sky (also possibly a bolt
of lightning).

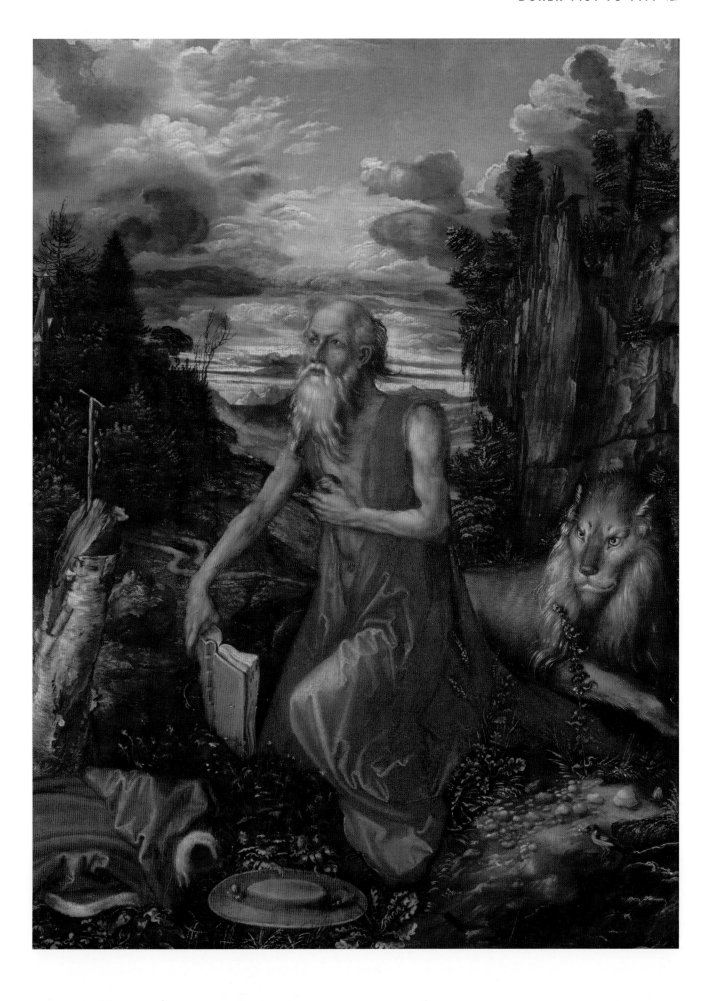

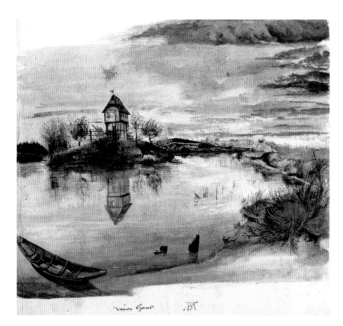

A 'weierhaus' (fisherman's house) *on a lake,* c.1496, watercolour and bodycolour on paper, 21.3 x 22.5cm (8.3 x 8.8in), British Museum, London, England, UK

A fisherman's house on a lake, near Nuremberg, was painted circa 1496. The small building is identified from an atlas published by Paul Pfinzinger about 1595 [State Archive Nuremberg] as the Weyerhaüsslein ('small pond house') at St Johannis. Dürer used this fisherman's house as a backdrop to *Madonna with the Monkey,* c.1498 (see page 141).

A Pastoral Landscape with Shepherds Playing a Viola and Panpipes, 1496–97, watercolour and gouache heightened with pen and ink and gold, 30 x 21cm (11.8 x 8.2in), National Gallery of Art, Washington DC, USA

Aldus Manutius published Theocritus *Idylls* in Venice in 1496–97. Dürer's illustration was pasted on to page one. (The page shown here is from a later c.1504 edition of *Idylls.*) Theocritus (c.305–255BC) was a Greek poet.

View of the Castle at Trent, 1496–97, pen and black ink, with watercolour, touched with white, 19.6 x 25cm (7.7 x 9.8in), British Museum, London, England, UK

Dürer took advantage of his journeys to Italy and to the Netherlands to draw and paint the locations he visited, often for use in later works. The circular towers and walls with crenelations are viewed from slightly below the mound. The work is inscribed by the artist in black ink along the upper edge, 'trint'.

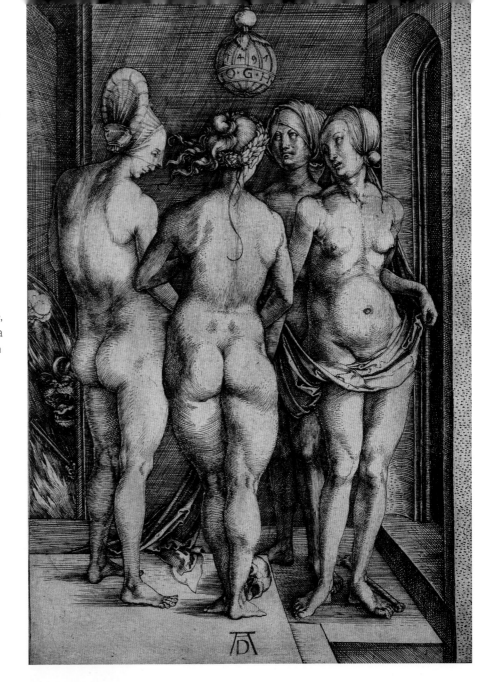

Four Nude Women, 1497,
engraving, 19 x 12.8cm
(7.4 x 5in), Cleveland Museum of
Art, Cleveland, Ohio, USA

Also known as *The Four Witches*,
four women, one possibly a
female servant in the background,
stand in a circle, close together,
in the interior of a house. Three
have headwear, the fourth, with
back to the viewer, wears a floral
garland. The woman at right has a
malformed left foot. Above their
heads a circular ball states the date,
1497. At their feet lies a skull and a
large bone, perhaps symbols for an
initiation rite. To the left, a strange
creature watches the proceedings.
The initials OGH on the ball have
not been identified. .

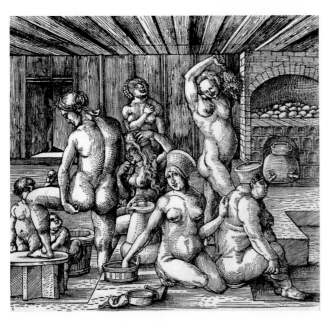

The Women's Bath, 1496,
pen and ink on paper,
23.2 x 22.9cm (9.1 x 9in),
Private Collection

In a similar scene to the
woodcut *The Men's Bath*,
c.1496–97 (see page 125)
and the engraving *Four Nude
Women*, 1497 (see above),
Dürer portrays a female
bathing room. In a low-
ceilinged room, constructed
of wood, several naked
women of different ages
are washing themselves. A
woman, kneeling at centre –
looking directly at the viewer
– washes the back of an
older woman, seen in profile,
seated on the step of the
bath. At left, young children
play. In the background a
voyeur peers into the room.

THE APOCALYPSE, 1497–98

Albrecht Dürer created a series of fifteen woodcuts depicting scenes from the Revelation of St John, the *Apocalypse* series, shown here on pages 130–33, and on pages 36, 40–41 and 101. In 1498 the series was published, at first in German; in 1511 it was published with a Latin text. The prints were hugely successful and sold both singly and as a complete series throughout Europe. Engravings were made too.

Left: *The Apocalypse, John before the Mother of God*, title page, 1511, woodcut, 38.2 x 26.4cm (15 x 10.3in), Fitzwilliam Museum, University of Cambridge, England, UK

The Revelation of St John (The Apocalypse), the last book of the New Testament, reveals events that precurse the end of the world. The title page of Dürer's woodblock series features St John, the Virgin Mary and the Christ Child. The first and only German edition was published in 1498. The title was *Die Heimlich offenbarung ionnis* (The Revelation of John). Here, *Apocalipsis cum figuris* ('Apocalypse with Pictures') is the title page of the later 1511 Latin edition.

Right: *The Apocalypse, St John's Vision of Seven Candlesticks*, 1497–98, woodcut, 39 x 28.5cm (15.3 x 11.2in), Private Collection

Having heard the voice of God, the first vision of John of Patmos (Revelation 1: 12–20) was of seven golden lampstands (or candlesticks), and in their midst, a vision of the Son of Man, hair as 'white as snow', in a long robe with a girdle. In his right hand he held seven stars, and from his mouth issued a two-edged sword. Dürer closely follows the text, visualising John kneeling at the feet of Christ.

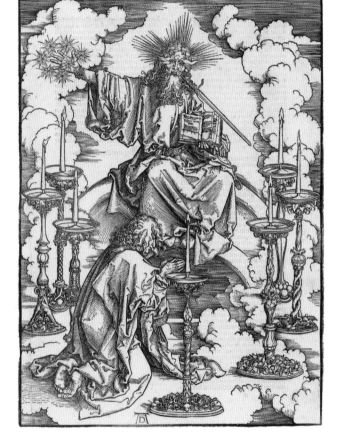

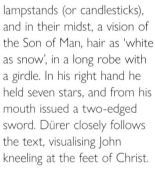

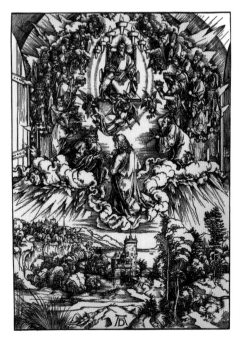

Left: *The Apocalypse, St John Kneeling Before Christ and 24 Elders*, 1497–98, woodcut, 39.5 x 28.5cm (15.5 x 11.2in), Private Collection

This complex, vividly full narrative (Revelation 4: 7–9) is visualised by Dürer: '…And round the throne [of Christ] was a rainbow that looked like an emerald… and twenty-four thrones and seated on the thrones were twenty-four elders clad in white garments, with golden crowns on their heads… and from the throne, flashes of lightning… And before the throne, burn seven torches of fire… and four living creatures, a lion, ox, the face of a man, and an eagle, each with six wings.' Dürer sets the celestial scene above an earthly, undulating landscape with a hilltop village, and imposing castle set amongst woods.

Right: *The Apocalypse, The Opening of the Fifth and Sixth Seal*, 1497–98, woodcut, 40 x 29cm (15.7 x 11.4in), The Clark Institute, Williamstown, Massachusetts, USA

Dürer combines the opening of the fifth and sixth seals (Revelation 6: 9–12) in one composition. On the upper level the fifth seal saves the souls of those who have been killed, dressed in white beneath the throne of God. Below, in the lower register the sixth seal opens to great earthquake, '…and the sun became black as sackcloth, the full moon became like blood and the stars of the sky fell to earth…. And men, women and children, the rich and poor, hid from the sight.' Dürer replaces colour with texture and movement to construct the description of the scripture.

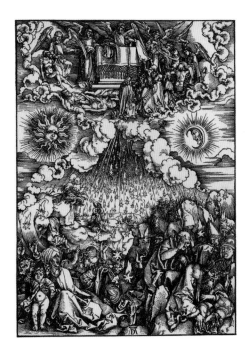

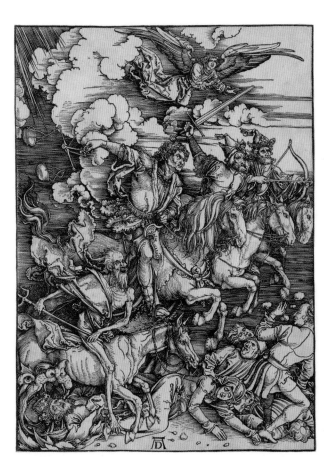

Left: *The Apocalypse, The Four Horsemen*, 1497–98, woodcut, 39 x 28cm (15.3 x 11in), The Clark Institute, Williamstown, Massachusetts, USA

This is the most celebrated woodcut of *The Apocalypse* series (also shown large on page 2). Dürer visualises the opening of four of the seven seals by the Lamb (Christ) in Revelation 6: 1–8. As the first seal opens a rider on a white horse appears, carrying a bow, to conquer. He is given a crown. With the second seal a red horse with rider appears; he is given a great sword, to take Peace from Earth. The third seal brings a rider on a black horse with a balance in his hand, weighing earthly goods. The fourth seal is Death on a pale horse, allowed power over one quarter of Earth, and to kill with sword, pestilence, famine and wild beasts.

Right: *The Apocalypse, Four Angels Holding Back the Winds*, 1497–98, woodcut, 39 x 27.5cm (15.3 x 10.8in), Private Collection

Revelation 7 reveals four angels standing at the four corners of the Earth, holding back the four winds of the earth, that no wind might blow. Another angel directs them not to harm Earth until 144,000 people from every tribe of Israel – visualised en masse below the angels – were 'sealed upon their foreheads'.

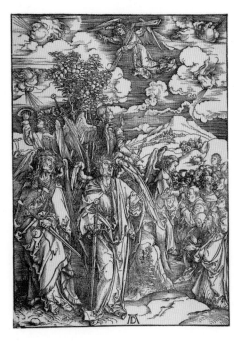

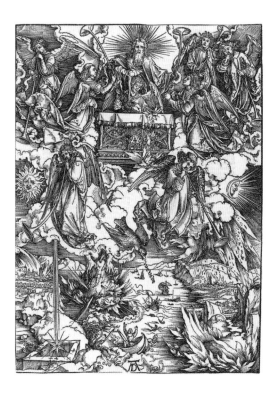

Left: *The Apocalypse, Opening of the Seventh Seal*, 1497–98, woodcut, 39.5 x 28.5cm (15.5 x 11.2in), Private Collection

When the seventh and last seal was opened, the bible (Revelation 8–9) records that there was a silence, then seven angels with seven trumpets appeared. All stood before a golden altar, to honour the vision of the Lamb of God (a symbol of Christ), a difficult apparition to portray in black and white. The four living creatures reappear. Dürer uses light and shade, and different thicknesses of line, to produce movement.

Right: *The Apocalypse, Four Angels of Death*, 1497–98, woodcut, 39.5 x 28.5cm (15.5 x 11.2in), Private Collection

This is Dürer's visual interpretation of the four angels of death seeking vengeance, as described in Revelation 9: 13–19. Their mission was to kill one third of men. The bible text reveals this to be 200,000,000.

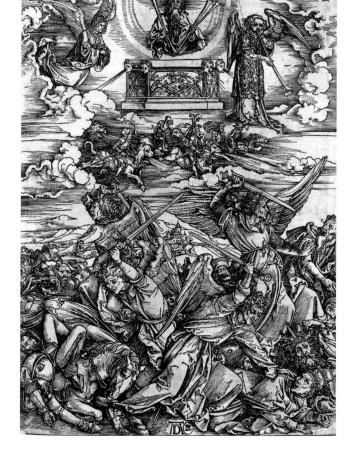

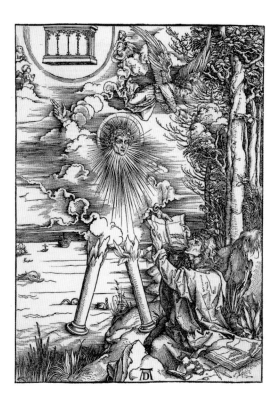

Left: *The Apocalypse, St John Devouring the Book*, 1497–98, woodcut, 39 x 27.5cm (15.3 x 10.8in), Fitzwilliam Museum, University of Cambridge, UK

Dürer literally illustrates two texts from the bible narrative Revelation 10: 1–5 and 8–10.

An angel appears from heaven, clothed in a cloud, with a rainbow on his head and his face as the sun. His right foot is on the sea and left foot on Earth. He carries a little book of prophesies, which is given to St John the Evangelist who 'devours' the contents.

Right: *The Apocalypse, St Michael Fighting the Dragon*, 1498, woodcut, 39.2 x 28.2cm (15.4 x 11in), Germanisches Nationalmuseum, Nuremberg, Germany

A remarkable woodcut, reminiscent of Martin Schongauer's work (see page 26), visualises St Michael and his angels fighting the dragon (Revelation 12: 7–9). The dragon, who is both the Devil and Satan, is defeated and thrown down to Earth. Dürer captures the struggle between good and evil. In the previous woodcut in the series, *The Apocalyptic Woman* (see page 41) the dragon – Satan – plans to eat the pregnant woman's child when it is born, but St Michael overpowers him. (Revelation 12: 1–6).

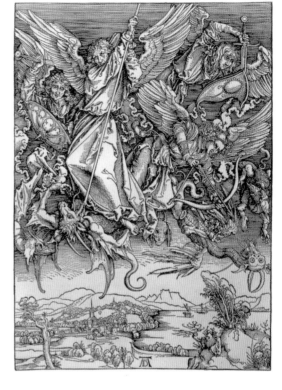

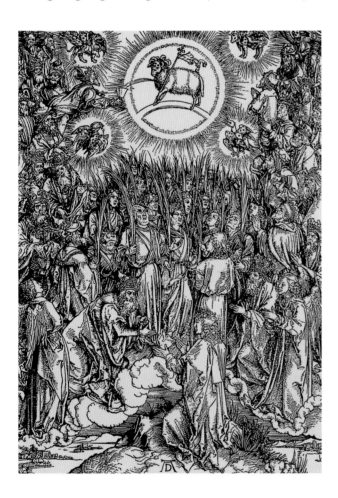

Left: *The Apocalypse, Adoration of the Lamb*, 1497–98, woodcut, 39.5 x 28.5cm (15.5 x 11.2in), Private Collection

The full title is the *Adoration of the Lamb and Hymn of the Chosen* (Revelation 14: 1–13; 14–17). The Lamb of God is standing on Mount Zion, Jerusalem. The lamb is a representation of 144,000 people who carried the name of God on their foreheads.

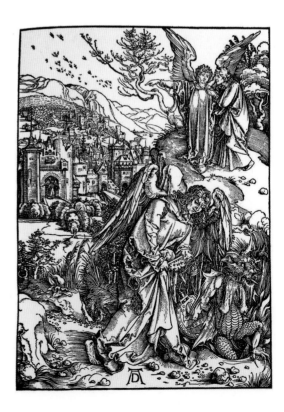

Right: *The Apocalypse, The Angel with the Key to the Bottomless Pit*, 1497–98, woodcut, 40 x 29cm (15.7 x 11.4in), Baltimore Museum of Art, Baltimore, USA

The angel with the key to the bottomless pit – or the abyss – appears in Revelation 20: 1–2, 'I saw an angel come down from heaven, having the key to the bottomless pit and a great chain in his hand'. Set against an earthly backdrop of a landscape with castle, the angel lays hold of the dragon at bottom right, who is the Devil or Satan, using a seal to lock him in the pit for a thousand years.

THE LARGE PASSION, 1497–1510

The Large, or Great Passion, is so-called due to the large size of the woodcuts, each 39 × 28cm (15.3 × 11in). The series was made over different years, to sell as individual prints, eventually creating twelve woodcuts. The complete set was published in 1511. Title wordings can vary but the woodcuts comprise the frontispiece, *The Last Supper, Christ on the Mount of Olives, Christ Arrested, Flagellation of Christ, Ecco Homo, Christ Carries his Cross, Crucifixion, Lamentation, Burial of Christ, Christ Descends into Limbo,* and *The Resurrection* (see page 59).

Left: *The Large Passion (Frontispiece), Man of Sorrows Mocked by a Soldier,* **1510, The Art Institute of Chicago, Illinois, USA**

The frontispiece depicts Christ as the 'Man of Sorrows' (Isaiah 53: 3) for the trial he endured during his arrest, torture and crucifixion. Here Christ is depicted after crucifixion, denoted by the marks of nail holes on his feet and hands, still wearing the 'crown of thorns'. At his feet a soldier mocks him. A Passion series can begin with Adam and Eve, moving forward to the Annunciation, the Nativity, the Crucifixion, and Resurrection. In this series it begins with *The Last Supper.*

Below: *The Large Passion, The Last Supper,* **1510**

Christ's Last Supper was a popular subject for prints. Dürer shows Christ at the centre of the table with his close followers. Judas is recognisable from the money pouch carrying 30 pieces of silver. Christ told his disciples that one of them will betray him. The expressions of the disciples show disbelief.

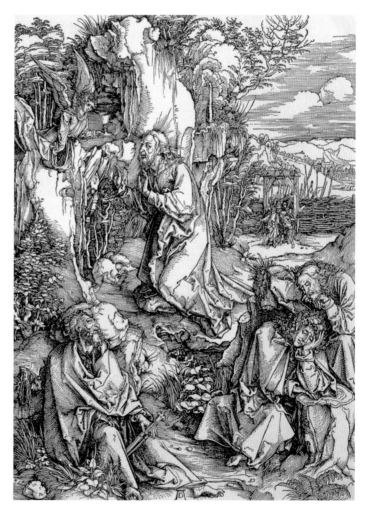

Above: *The Large Passion, Christ on the Mount of Olives,* **c.1497**

In this work Christ prays all night to God (Matthew 26; Mark 14). An angel, a messenger of God, visits him. At his feet are his loyal disciples, Peter, James and John, who have accompanied him but have fallen asleep. The Mount of Olives was part of a mountain ridge on the eastern side of the old city of Jerusalem, shown in the distant landscape. At the foot of the Mount was the garden of Gethsemane where Christ was arrested.

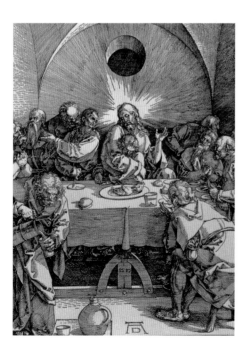

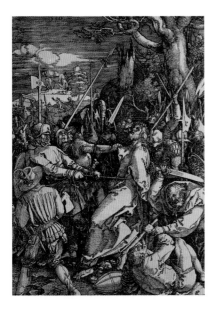

Above: *The Large Passion, Christ Arrested, 1510*

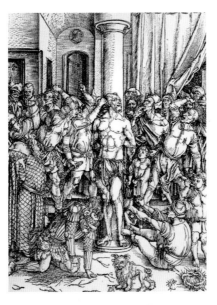

Above: *The Large Passion, Flagellation of Christ, c.1497*

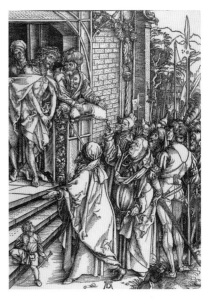

Above: *The Large Passion, Ecce Homo, c.1499*

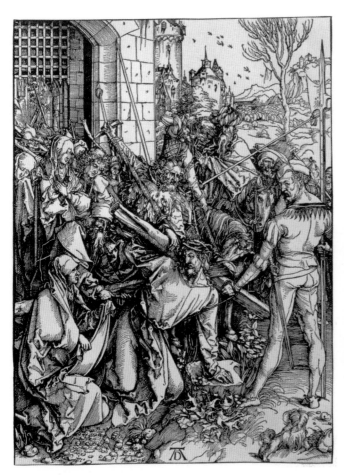

Above: *The Large Passion: Christ Carries His Cross, c.1498*

Dürer creates a vision of chaos with figures surrounding Christ as he steadies himself to carry the burden of the cross. A man holds and tightens the rope around Christ's waist. The unfinished wood of the cross is unusual.

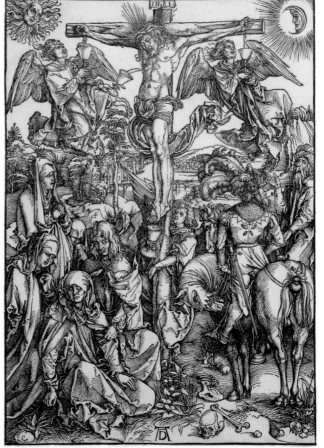

Above: *The Large Passion: Crucifixion, c.1498*

The crucifixion on the hill of Calvary (Golgotha), outside the city of Jerusalem (Luke 23: 33). The Holy Family are present, their faces melancholic.

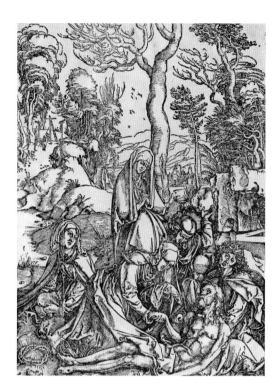

Left: *The Large Passion, Lamentation, c.1497*

Dürer depicts the moment that Christ's dead body, removed from the cross, is laid out on a sheet. The Holy Family grieves for their loss. The composition is filled with the events of the narrative. The city of Jerusalem can be seen in the distance. At left, the steep hill leading to Calvary (Golgotha) on the outskirts of the city shows the crucifixion crosses of Christ and the two thieves, who are still tied. At right is the open tomb, ready to receive Christ's body. Above, high winds move branches of the trees, a symbol of the temporality of life.

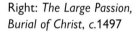

Right: *The Large Passion, Burial of Christ, c.1497*

Dürer depicts the moment that a throng of people gather round, as the stiffened body of the dead Christ is prepared to be laid to rest in a tomb. The hill of Calvary (Golgotha) can be seen in the distance at left, with the crucifixion cross visible on the steep hill.

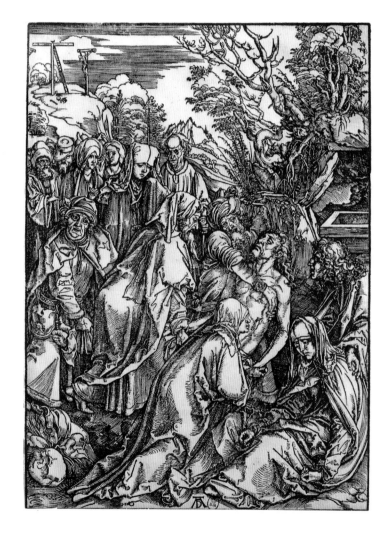

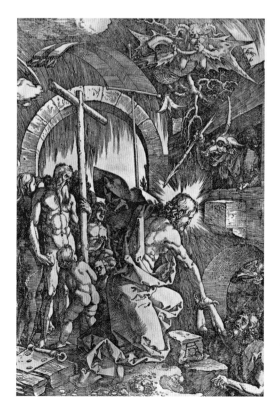

Left: *The Large Passion, Christ Descends into Limbo, 1510*

A poignant scene as Christ kneels to reach down to the hands of those in limbo – the edge of Hell where the deceased await judgement, designated to be assigned to Hell or to attain Heaven. Christ is taunted by unearthly devil-creatures who mock him. The final woodcut in the Large Passion series is *The Resurrection*, 1510, shown on page 59.

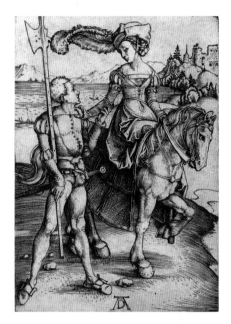

A Lady on Horseback and a Lansquenet, c.1497, engraving, 10.8 x 7.7cm (4.2 x 3in), Private Collection

A German foot soldier (lansquenet), holding his halberd pike, says farewell to his lady before he leaves. He holds her arm, and she puts her hand on his shoulder, as she prepares to depart. Her horse paws the ground impatiently. An unequal love match was a popular subject for prints. Dürer pays meticulous attention to the woman, riding side-saddle, wearing fine clothing and a plumed hat.

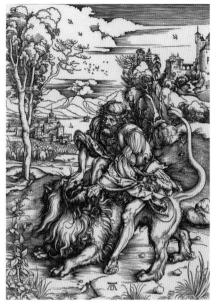

Samson Rending the Lion, c.1497–98, woodcut, 39.1 x 27.9cm (15.4 x 11in), The Metropolitan Museum of Art, New York, USA

Dürer captures the moment Samson sits astride a wild lion, and grabs its mouth with both hands, to rend it apart. The depiction of the lion is realistic with a long mane of fur, a large body and tail held up, although in 1497–98, Dürer had not seen a lion except in illustrations. The powerful, muscular left leg of the lion mirrors the muscular leg of Samson. Dürer visualises a life-struggle between man and beast. The bible narrative, Judges 13: 5-6, states that Samson tore the lion to pieces as if it were the small body of a young goat. Dürer covers the foreground with wild plants and grasses.

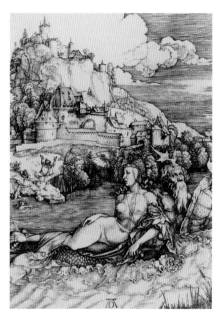

The Sea Monster, The Abduction of Amymone, 1498, engraving, 25.2 x 18.8cm (9.9 x 7.4in), The Metropolitan Museum of Art, New York, USA

This work has been given many titles, but Dürer referred to it as a 'Sea Monster' in his Netherlands' diary, dated 24 November 1520, when he sold a print copy of it. The visual reference may be to an Italian legend of a sea monster, but the focus is on a naked woman, lying on the fish-scale tail of a half-man half-sea-creature. On the far bank, below an imposing castle, a man with hands raised in alarm runs toward the river, as others bathe.

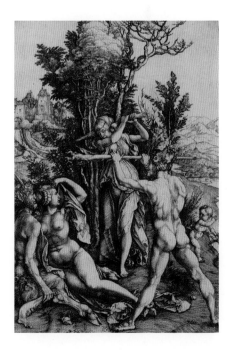

Hercules at the Crossroads (also known as 'Jealousy' or 'The Large Satyr'), 1498, engraving, 31.8 x 22cm (12.5 x 8.8in), Ashmolean Museum, Oxford, England, UK

The Florentine painter and art historian Giorgio Vasari referred to this work as 'engraved with the greatest mastery'. The subject is thought to represent the Greek myth of Hercules (Latin version of the Greek name of Heracles), where the hero is reaching a crossroads and

making a choice between the path of virtue and the path of pleasure, good and evil, both personified as women. Pleasure (Voluptas) is sensually seated next to a satyr. Virtue (Virtus) takes aim to strike. The infant Pan behind her watches. Hercules stands with legs apart, holding his club between the satyr and seated woman. A print of this engraving was given as a gift by Dürer in the Netherlands, in November 1520, over 20 years after its creation.

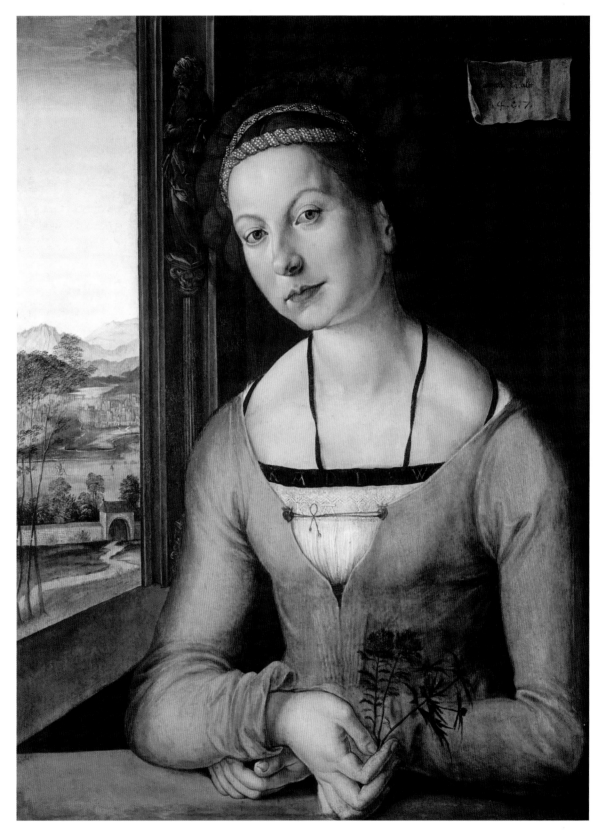

Portrait of Katharina Frey, 1497, oil on linden wood, 58.5 x 42.5cm (23 x 16.7in), Museum of Fine Arts, Leipzig, Germany

Katharina Frey was sister-in-law to Dürer, and married to Hans Zinner. The work was previously interpreted as a portrait of Katharina Fürleger, now believed to be a fictitious person. This work was originally one half of a diptych, with *Portrait of a Young Woman* (see opposite), although the works are quite different in composition. This young woman has her hair up, the other woman has her hair long and loose.

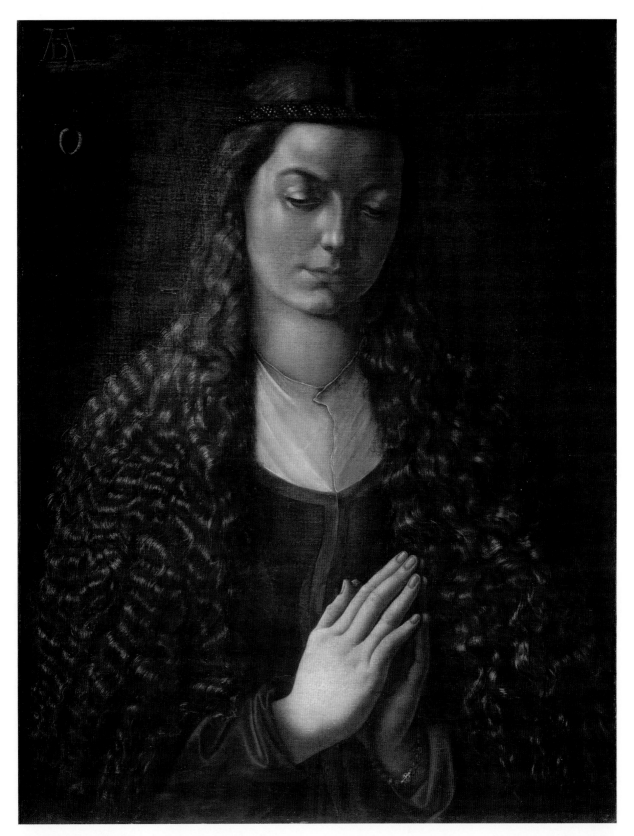

Portrait of a Young Woman, 1497, oil on canvas, 56.3 x 43.2cm (22.1 x 17in), Staedel Museum, Frankfurt am Main, Germany

The identities of the woman in this portrait, and its diptych companion (*Portrait of Katharina Frey,* opposite) – now separated and in different museums – has attracted intense scrutiny from Dürer historians over many years. Could the sitters be sisters or sisters-in-law, or cousins? Or members of Dürer's extended family through his marriage? This woman is depicted looking down, with hands possibly clasped in prayer.

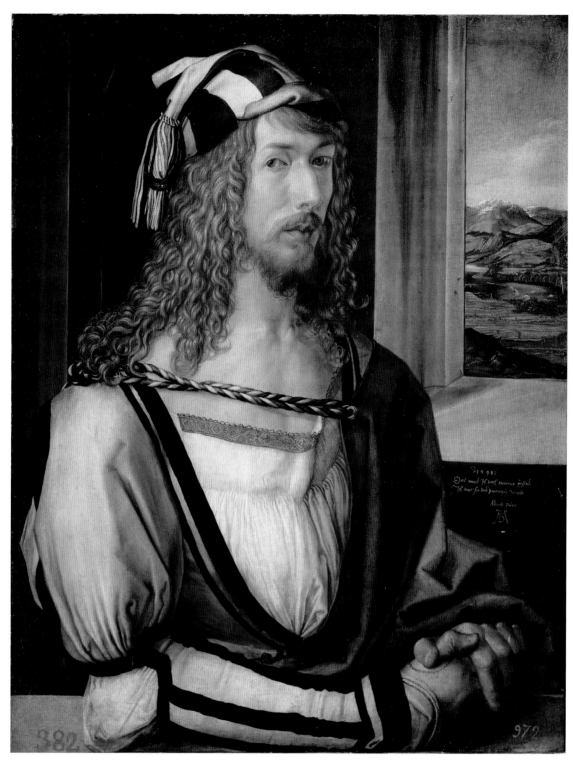

Self-portrait at age of 26, 1498, oil on wood panel, 52 x 41cm (20.4 x 16.1in), Museo del Prado, Madrid, Spain

The inscription on this painting, above Albrecht Dürer's signature, states 'I painted this according to my image when I was twenty-six years old.' Dürer portrays himself as a prosperous young man. It is denoted in the fashionable, expensive clothing he wears, and the spacious room with a beautiful landscape visible through the window behind him. He rests his right arm and fine leather-gloved hands on a ledge, creating a realistic space. His eyes rest on the observer. In 1498 Dürer became a celebrity though his *Apocalypse* woodcut series of prints. The self-portrait reflects his new status, an admired painter throughout Europe. Whilst the fashion for men was shorter hair and no beard, Dürer created his own style of long hair, and goatee beard with moustache.

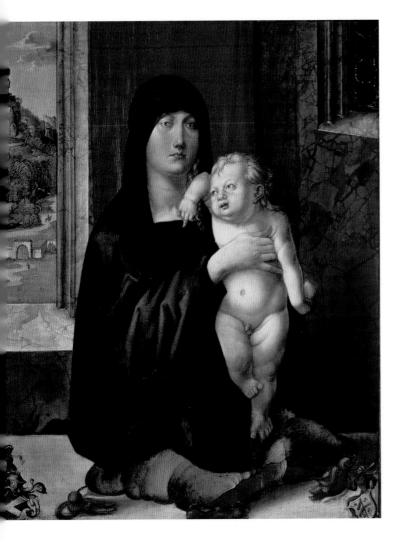

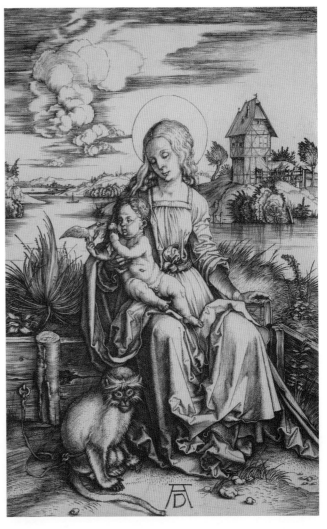

Madonna and Child (or Haller Madonna), c.1496–99, oil on wood panel, 52.4 x 42.2cm (20.6 x 16.6in), National Gallery of Art, Washington DC, USA

Albrecht Dürer pays homage to Venetian artist Giovanni Bellini and his style of portraiture (see page 34) in this stunning portrayal of the Madonna holding the infant Christ. This is evident in the pyramidal composition of the figures, the partly drawn, bright red curtain as a backdrop for the Madonna, the view through a window to an earthly landscape beyond, and realism in the humanity of the Christ child and his mother. Dürer uses complementary red and green to give the figures a strong presence, with the Madonna contrasted in deep blue, a traditional colour for the robes of the Virgin. Warm light from an unseen source streams on to their figures The standing infant, supported by his mother, holds an apple in his left hand. The painting is also known as the 'Haller Madonna', after its patron. The family's coats of arms are painted in the foreground. Another painting is on the reverse, see overleaf.

Madonna with the Monkey, c.1498, engraving on off-white laid paper, 19 x 12.2cm (7.4 x 4.8in), Saint Louis Art Museum, Missouri, USA

Dürer was fond of animals and possessed many, including a monkey, a parrot and dogs. In this portrayal of the Madonna and Child, set in a river landscape, the naked infant is seated on his mother's lap. Below him a vervet monkey is chained to the low wooden fence on which the Madonna sits. He looks out, observing the viewer. The infant feeds a bird that has perched on his hand. The building in the background is identified as a fisherman's house, depicted in the earlier watercolour *Fisherman's house on a lake* c.1496 (see page 128). The location was near Nuremberg, later identified as a 'small pond house' in a 1595 atlas published by Paul Pfinzinger.

Lot and his daughters,
*c.*1496–99, oil on wood
panel, 52.4 x 42.2cm (20.6
x 16.6in), National Gallery
of Art, Washington DC,
USA

On the reverse side of the
Madonna and Child (see
page 141), Dürer painted a
religious narrative portraying
the Old Testament Book
of Genesis 19. Lot and his
daughters flee the cities of
Sodom and Gomorrah. In
the far distance, on a path
they have just travelled, Lot's
wife can be seen, standing
like a sculpted statue, turned
into a pillar of salt, as she
turned to look back at
the burning cities. Dürer
used primary colours with
complementary red and
green dominant. The coat of
Lot flaps, possibly to signify
their speed of travel. The
landscape is similar to that
seen through the 'window'
of the obverse painting.

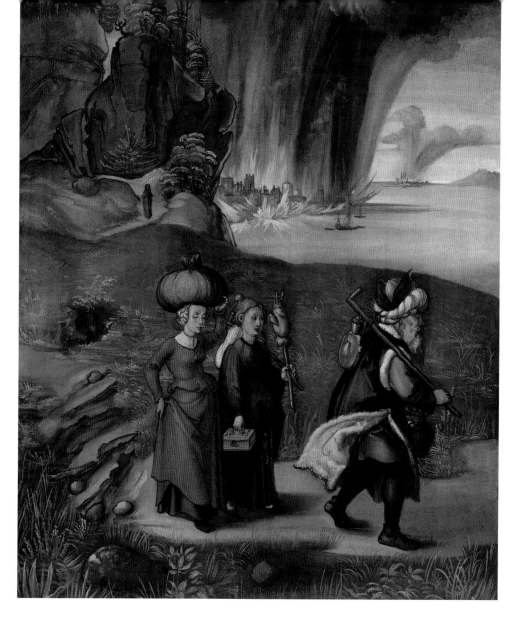

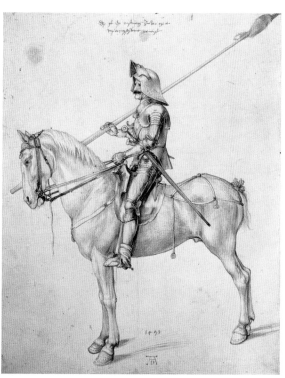

*A Maximilian Knight on
Horseback,* 1498, pen and
watercolour, 41 x 32.4cm
(16.1 x 12.7in), The Albertina
Museum, Vienna, Austria

The handwritten comment on
the watercolour states: 'Dz
ist dy rustung Zw der zeit im
tewtschlant gewest' ('Armour
worn in Germany today'). This
large pen and watercolour
depiction of a knight in the
service of Maximilian I shows
Dürer's skill to create the
illusion of shining metal for
the breastplate and back plate
armour, the fluted armour
pieces, and the German
sallet (combat helmet) with
its extended half-visor worn
up off the face. The warrior
wears a leather gugel, hood-
type clothing, with a chin
protector that also protected
the throat. The jacket is yellow,
which denotes which troop
the warrior belonged to,
from four colour groups. The
armoured rider contrasts with
the unarmoured horse, its soft
skin gleaming. The legs of the
horse appear to be anatomically
short in length but attention is
paid to the small details of the
horse's hooves and tail, and the
vast sword at the rider's side.
The lance he carries has a fox
tail attached to its tip, on the
instructions of Maximilian I.
The fox tail acted as a military
standard for 100 armoured
horsemen.

Tournament helmet in three views, c.1498–1500, pen and brown ink, opaques and watercolour, 42 x 26.5cm (16.5 x 10.4in), Musée du Louvre, Paris, France

A jousting helmet is shown from three viewpoints: in profile, in three-quarter frontal view, and from the rear. Dürer paints the gleaming, polished metal with remarkable realism, created with a combination of opaque watercolour paints. This would probably be a practice sheet for inclusion of a helmet in other works. The added date of 1514 is apocryphal. The watercolour links to *A Maximilian Knight on Horseback*, 1498 (see opposite below).

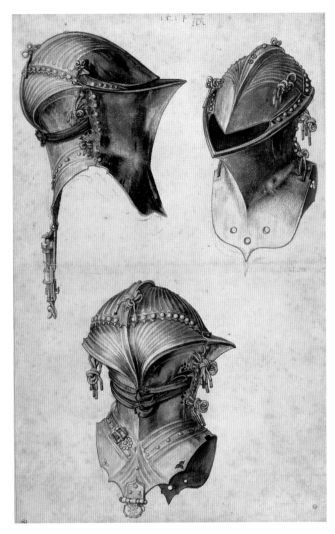

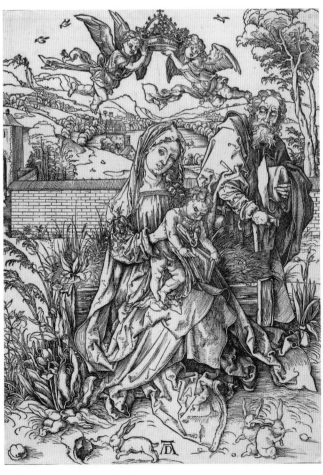

The Holy Family with Three Hares, c.1497–98, woodcut, 38.4 x 27.9cm (15.1 x 10.9in), National Gallery of Art, Washington DC, USA

This work is so-named for the depictions of three small hares at the feet of the Virgin Mary. Above, angels hold her crown. She is seated on a bench with Joseph standing behind looking toward her. The infant Christ is standing, supported by her, on her lap. He is looking at her book with its pages open. Within this work are many examples of Dürer's studies of animals, drapery, wildflowers and landscapes. Informal depictions of the Madonna and child seated in a natural landscape were popular from the 15th century.

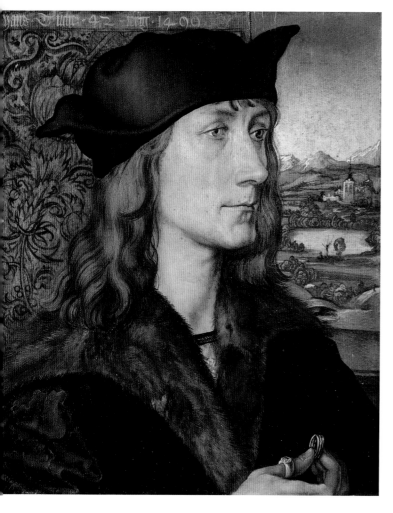

Left: *Portrait of Hans Tucher*, 1499, oil on panel, 28 x 24cm (11 x 9.4in), Schlossmuseum, Weimar, Germany

Below: *Portrait of Felicitas Tucher (née Rieter)*, 1499, oil on panel, 28 x 24cm (11 x 9.4in), Schlossmuseum, Weimar, Germany

In 1499 two brothers, Hans and Nicolas Tucher, of Nuremberg, commissioned four portraits from Albrecht Dürer, to be displayed in the form of two hinged diptychs: one of husband and wife Hans and Felicitas Tucher, and one of husband and wife Nicolas and Elsbeth Tucher. In Hans Tucher's portrait he holds a ring. Felicitas Tucher, looking out to the observer, holds a flower. The bejewelled clasp of her dress has her husband's initials HT.

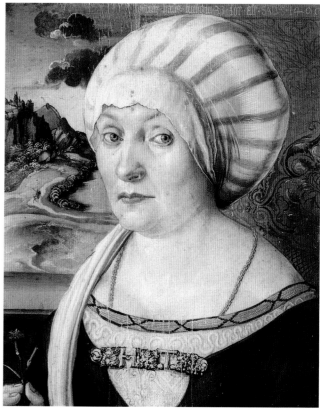

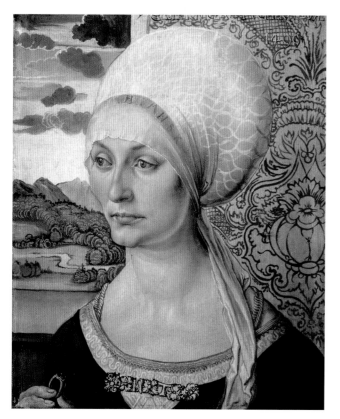

Left: *Portrait of Elsbeth Tucher (née Pusch)*, 1499, oil on panel, 29.1 x 23.3cm (11.45 x 9.1in), Gemäldegalerie Alte Meister, Kassel, Germany

This portrait is of Elsbeth Tucher, the sister-in-law of Hans Tucher, and wife of Nicolas Tucher, whose portrait is now lost. It was created by Dürer to be displayed as a diptych, in the same style and composition as the double portrait of Hans and Felicitas Tucher above. The backdrop landscape would have continued across the missing work. Elsbeth wears a similar dress to Felicitas, with a jewelled clasp on her dress, baring the initials of her husband NT. She holds a ring in her right hand. It is possible that Nicolas Tucher would have looked out to the viewer, as Felicitas does, for visual symmetry.

Coat of Arms of the Tucher-Rieter Families, c.1499, oil on panel, 28 x 24cm (11 x 9.4in), Schlossmuseum, Weimar, Germany

This combined Coat of Arms of the Tucher and Rieter families was painted on the reverse of the portrait of Hans Tucher, 1499 (see opposite above). It was the first of Dürer's many Coats of Arms, created in woodcut, or painted. At left, the Tucher Coat of Arms has a cameo bust of a Moor, traditionally thought to be St Maurice, born in North Africa. At right is the Coat of Arms of the wealthy merchant Rieter family of Nuremberg. The crowned mermaid with two fishtails, a Rieter emblem dating back centuries, possibly symbolised the seafaring trading of the Rieter family. A later memorial painting for Dr Lorenz Tucher, in St Sebald church, Nuremberg, painted by Dürer's former student Hans von Kulmbach in 1513, features a large illustration of the Tucher Coat of Arms.

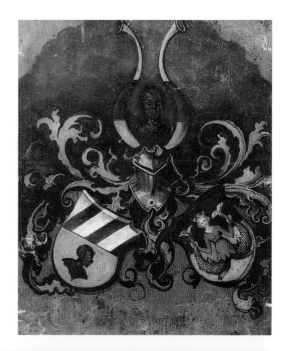

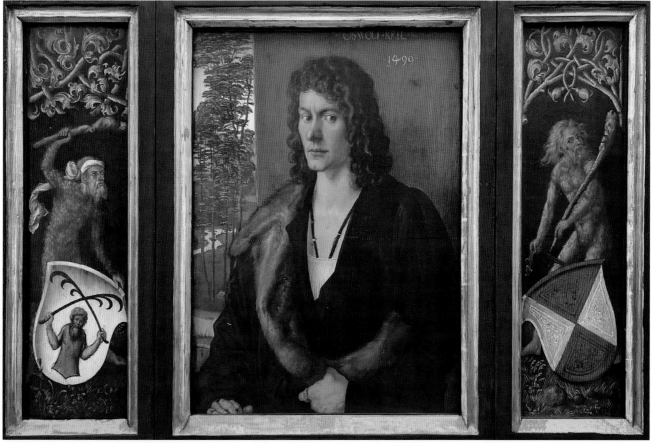

Portrait of Oswolt (Oswald) Krel (Krell), triptych, 1499–1500, oil on wood, 49.7 x 38.9cm (19.5 x 15.3in), Alte Pinakothek, Munich, Germany

Dürer uses a composition technique learned from Bellini for the central portrait, which has a curtain of bright colour drawn two-thirds across the background, giving a plain background to push focus on to the depiction of the sitter. The remaining third shows an open landscape beyond the picture frame, placing the sitter in an actual location, to add realism. Either side of the portrait are the coats of arms of Krel (Krell), and his wife Agathe von Esendorf, held by a popular symbol in German heraldry, a 'wild man'. The central panel could be enclosed by the sides. Oswolt Krel, a merchant from Landau, was the managing director of the Nuremberg company Grosse Ravensburger Handelsgesellschaft. The superb detail of Krel's distinctive features and expression, and the luxurious textures of fur and clothing, makes this one of Dürer's most outstanding works.

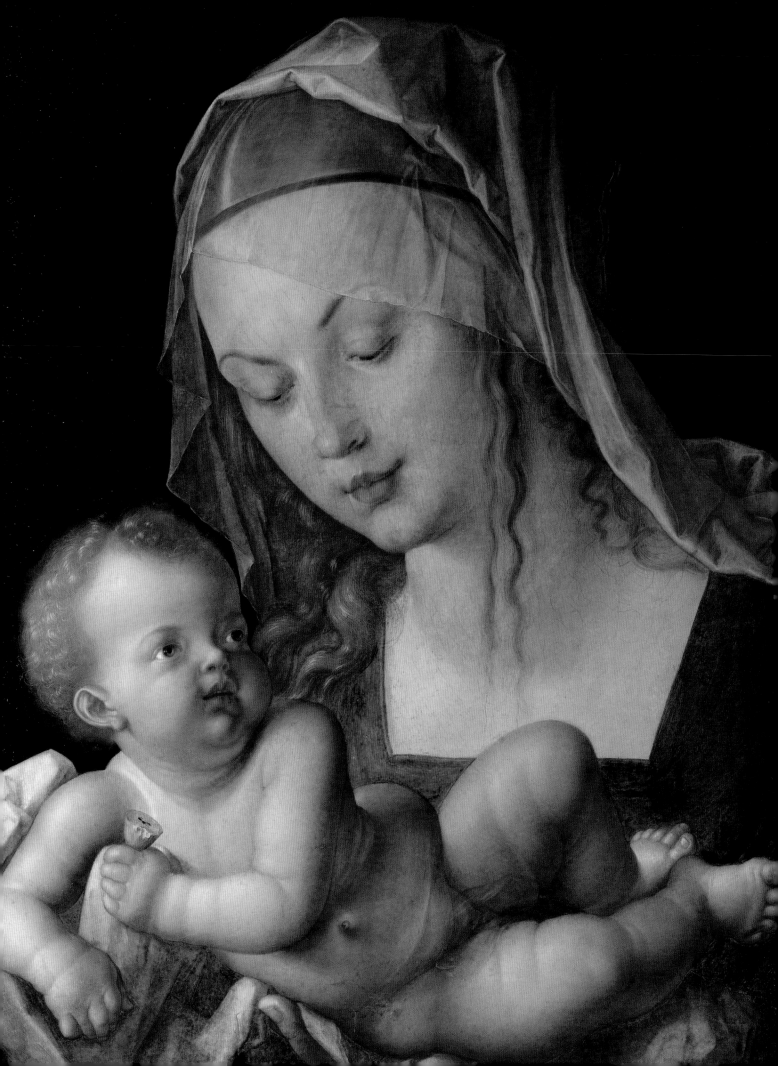

DÜRER
1500 TO 1514

The most beautiful drawings and watercolours created by Albrecht Dürer from 1500–1514 give insight to his ingenuity, noticeable in the many preparatory studies for paintings. Many were created as stock images, background material for later paintings, such as *The Great Piece of Turf* and the *Stag beetle*. Dürer's talent for self-portraiture created remarkable artworks: he appears in many paintings, playing different parts, or pointing to himself as the artist, and in drawings too; a glimpse into his private life lies in a note to his physician, that accompanied a drawing of himself. Dürer's first apprenticeship as a goldsmith, in the workshop of his father, provided skills in engraving beyond other painters' abilities. The incised, complex lines of his compositions flowed across the metal sheets, transforming lines to compelling narratives, as in the three wondrous masterpieces created in this period: *Knight, Death and Devil; Melencolia I* and *St Jerome in his Study;* and the joyous observation of *Peasant Couple Dancing*, produced the same year. This chapter brings together artworks that reveal his extraordinary talent.

Above: Head of the Lute-Playing Angel, *1506, a preparatory drawing for the musician-angel in Dürer's* Madonna of the Rose Garlands *(see also page 184).*

Left: Virgin and Child, *1512. Little is known about this work, also called* Madonna and Child with a Pear, *due to the partially-eaten fruit held by the infant Christ. It was created for an unknown patron. (See also page 205.)*

Left: *Portrait of a young man*, 1500, oil on linden wood, 29.1 x 25.4 cm (11.4 x 11.4 in), Alte Pinakothek, Munich, Germany

Art historians consider that this may be a portrait of Albrecht Dürer's younger brother Hans Dürer but there is no confirmed proof. The sitter has a determined expression. The sense of realism in the portrayal, denoted by the rough appearance of skin texture, facial hair, and the plain clothing, would suggest not a patron of Dürer but possibly a friend or relation.

Below: *The Dream of the Doctor* (or, *The Temptation of the Idler*), c.1498, engraving, 18.8 x 11.9cm (7.4 x 4.6in), Minneapolis Institute of Arts, Minneapolis, USA

The Doctor, or Idler, is sitting up asleep, his head resting on a pillow, a depiction that symbolised a lazy sluggard, or a sinner. He sits by a German ceramic brick stove. Behind him a devil blows air from bellows into his ear. A near-naked female tries to engage with him, perhaps to wake him, or is she in his dream? A winged putto plays with a pair of stilts at her feet. Is it Cupid with Venus? Art historian Irwin Panofsky considered that the devil had conjured up a vision of *Venus carnalis*, a goddess of lust, in the idler's dreams.

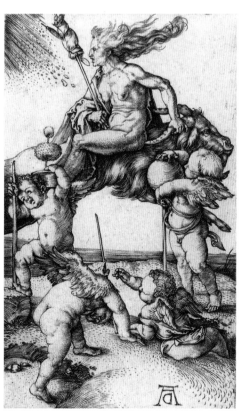

Left: *Witch riding backwards on a Goat*, c.1500, engraving, 11.4 x 7cm (4.5 x 2.7in), National Gallery of Art, Washington DC, USA

A naked, muscular, haggard woman, her hair flowing opposite to the direction she travels, rides backwards on a vast he-goat, possibly symbolising vulgarity and carnal instinct. She is accompanied by four winged amoretti (cupids). To add to the otherworldliness, the Albrecht Dürer copyright AD initials are illustrated backwards.

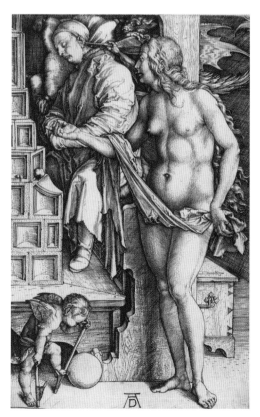

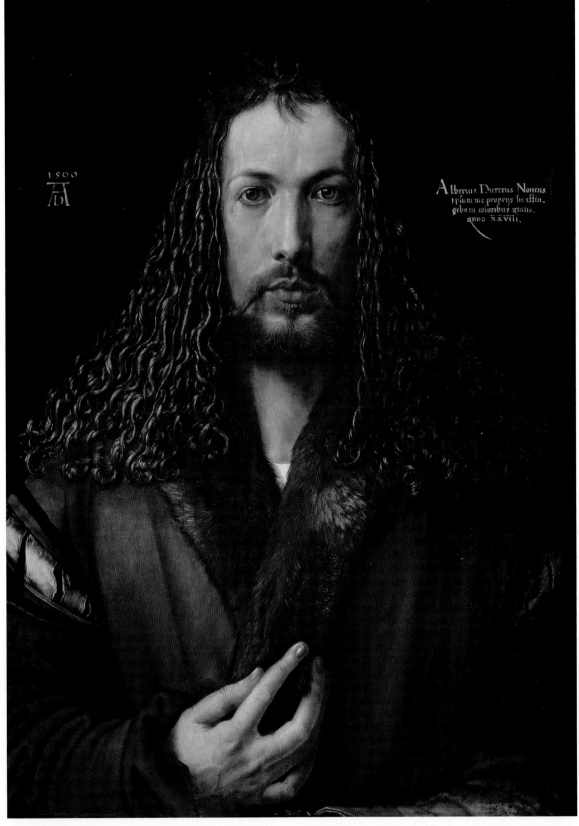

Self-portrait at age 28,
1500, oil on linden wood,
67 x 49cm (26.3 x 19.2in),
Alte Pinakothek, Munich,
Germany

What makes this painting
so remarkable is the realism
it portrays. Dürer's eyes
focus directly on the viewer.

His solemn expression and
refined facial features attract
attention. He is present,
face-to-face, a charismatic
man, looking at you. One
notices the fine hairs of his
moustache and bearded
chin, and the luscious, shining
ringlet hair; a stunning visual
effect. It contrasts with the

thick fur collar of his clothing,
and the fashion of it,
particularly the sleeves. The
dark background accentuates
light streaming from the left
side, to highlight features.
Dürer concludes the self-
appraisal with attention
drawn to the elegant hand
of a successful, celebrated

artist. The text at left
gives the date and the AD
monogram. At right it states:
'Thus I, Albrecht Dürer
from Nuremberg, portrayed
myself with characteristic
colours in my 28th year.'

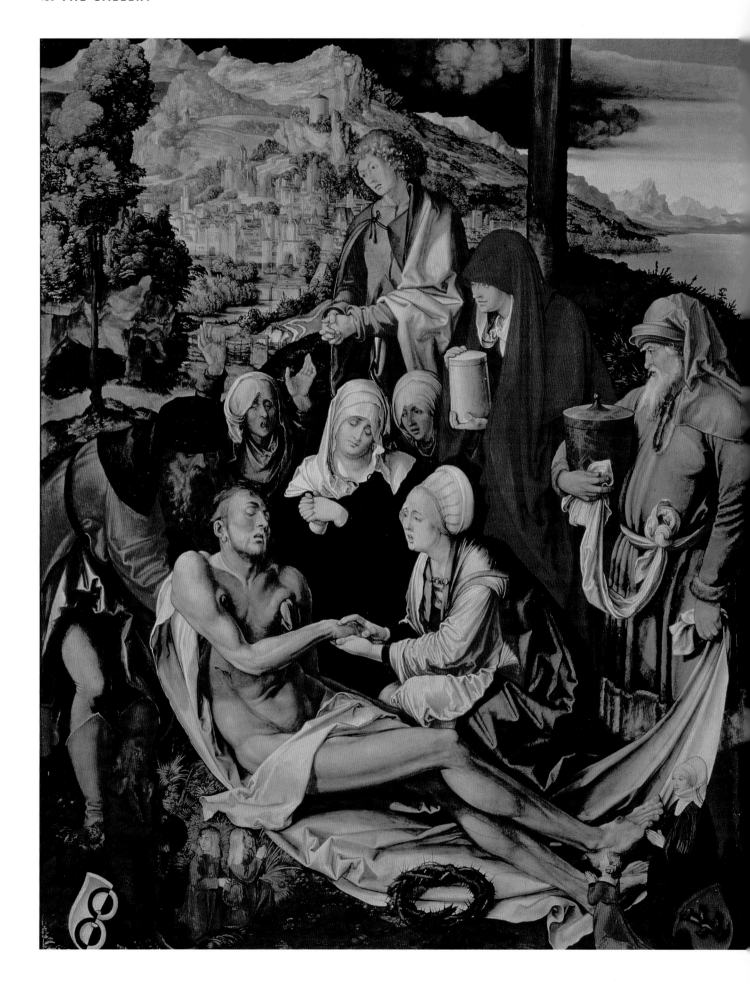

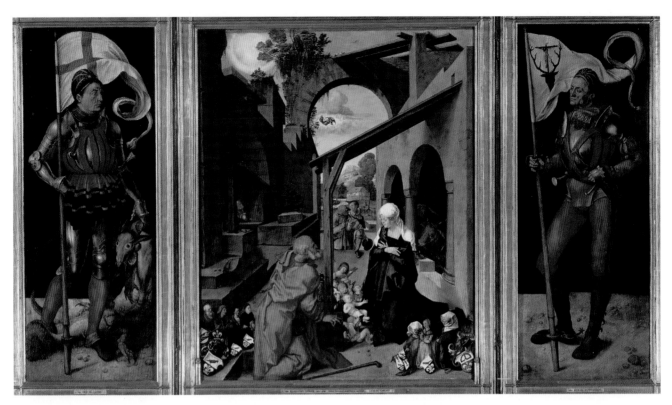

Left: *Lamentation of Christ* (Glimm Lamentation), 1500, oil on canvas, 151.9 x 121.6 cm (59.8 x 47.8in), Alte Pinakothek, Munich, Germany

This work was dedicated by the Nuremberg goldsmith, Albrecht Glimm, in memory of his wife, Margareth, *née* Holzhausen. The dark clouds that hover over the scene of Christ's death by crucifixion are related to the bible narrative Luke 23: 45. In a stunning landscape backdrop, Dürer paints the darkness clearing, possibly meant as a symbol of Christ's coming resurrection, as written in the apocryphal text of St Peter. Symbols of Christ's crucifixion are present in the crown of thorns in the foreground and the base of the Cross under which saints, family and friends of Christ congregate to mourn. The composition of the figures is pyramidal. In the top line stands Nicodemus, Mary Magdalene holding a pot of oil to anoint Christ's body, and St John the Evangelist holding a heavy pot of myrrh to embalm the body. In the lower line Joseph of Arimathea, Christ's earthly father, gently supports the body of Christ. Mary, a cousin of Mary Magdalene, stands to the left of the Virgin, her hands thrown up in grief.

Above: *Paumgartner Altarpiece*, *c.*1500, tempera on panel, 155 x 250cm (61.8 x 98.4in), Alte Pinakothek, Munich, Germany

The central panel of the Paumgartner altarpiece depicts The Adoration of the Christ Child with Mary and Joseph surrounded by angels, as protectors. Shepherds and farm animals watch close by. Joseph, a prominent figure, kneels facing the Virgin mother, and leads the eye from left toward the central scene, which takes place in a corridor between two buildings. Dürer uses perspective to lead the eye from the Holy Family to the distant landscape beyond the shepherds. The composition of the work follows the *Golden Legend* ('Legenda aurea', or 'Legenda sanctorium') by Jacobus de Voragine (*c.*1228–98) where the scene took place between two buildings. Members of the patron Paumgartner family congregate in the foreground of the painting, with Barbara Paumgartner and her second husband Hans Schönbach kneeling. The wings of the triptych (painted earlier) depict magnificent portrayals of the Paumgartner brothers Stephen and Lukas, portrayed as St George – with dead dragon – and St Eustace (see also page 45).

Left: *Paumgartner Altarpiece* (detail), *c.*1500

Depicted in miniature, the Paumgartner family congregate on either side of the Holy Family.

Hercules and the Stymphalian Birds, 1500, tempera on unprimed canvas, 84.5 x 107.5cm (37.2 x 42.3in), Germanisches Nationalmuseum, Nuremberg, Germany

In this rich artwork Dürer takes the viewer directly into a mythological conflict, in a close-up of the muscular body of Hercules battling against the Stymphalian birds, one of the twelve labours set for him by King Eurystheus, of Greek legend. Set against a mythical, serene landscape, the near-naked Hercules – recognisable from his club on the ground, and the Nemean lion skin tied at his waist – runs forward, hair flowing, with a quiver full of arrows slung over his shoulder. The large rattle at his waist has been shaken to wake the birds from their swampy resting place. He takes aim with his bow, to shoot at the metal-feathered man-eating birds, who are a composite bird, fish, animal and human. Those at left, reel back and raise their clawed paws in horror, whilst another bird flies above him, trying to land on his head. The claws are just visible. The images of the mythical creatures are based on those seen by Dürer on Roman reliefs. The physiognomy of Hercules bears similarity to Albrecht Dürer, his facial features, beard and long, red hair, which suggest it to be a self-portrait. The client for this work was Duke Frederick 'the Wise', for whom Dürer created many works, such as *Martyrdom of the Ten Thousand*, 1508 (see page 196). This work was commissioned for the duke's collection in Wittenberg Castle. It is the only extant mythological painting by Dürer.

Below: *Hercules and the Stymphalian Birds*, 1600, artist unknown, after Albrecht Dürer, oil on panel, 90 x 113cm (35.4 x 44.4in), Kunsthistoriches Museum, Vienna, Austria

This 1600 copy after Dürer's original work of 1500 is exact in detail, including Dürer's AD monogram and the date. The copy has been included here because it shows us in clearer detail the composition of the original work, from the magnificent figure of Hercules to the beautiful landscape, castles and buildings. We can see Dürer's favourite key inclusions, such as the natural grasses and the small rabbit in the right foreground.

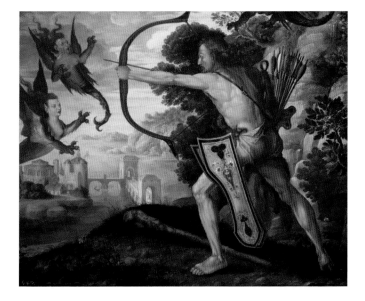

St Eustace, 1501, engraving, 35.5 x 26cm
(13.9 x 10.2in), The Metropolitan Museum of
Art, New York, USA

Dürer visualises the story of the Roman general,
Placidus (Placidas) active under Emperor Trajan
(reigned AD98–117), who was hunting near
Tivoli, Rome, when he encountered a vision of a
stag with a crucifix between its antlers. He heard
a voice prophesying that he would suffer for
Christ. He converted to Christianity immediately
and was baptised as Eustace (Eustachius). He
became the patron saint of hunters. In Dürer's
magnificent engraving, Eustace, in hunting
clothes, has dismounted to kneel in front of the
crucifix. Around him his hunting dogs wait. The
depictions of dogs are based on Dürer's own
animals. The event takes place in a wooded
landscape with a castle on a hill, viewed in the
far distance.

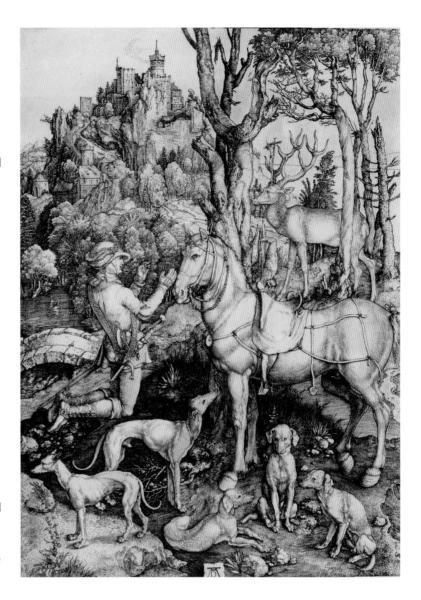

*The covered bridge and dock on Hallertor,
Nuremberg c.*1500, pen, black ink and
watercolour, 16 x 23.2cm (6.2 x 9.1in), The
Albertina Museum, Vienna, Austria

A watercolour drawing with precise architectural
detailing of the covered footbridge, erected in
1441, at the Haller Gate in Nuremberg. Dürer
includes many details of the houses and hospices
close by and a chapel in the distance.

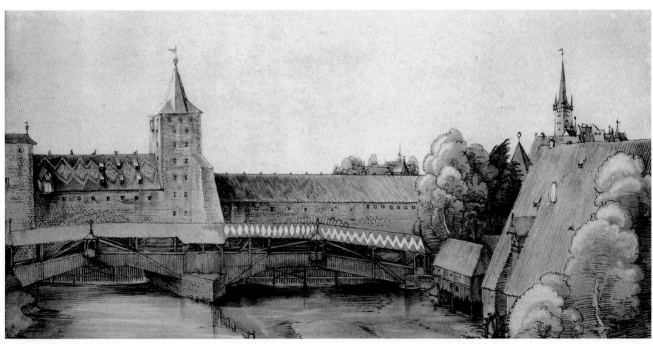

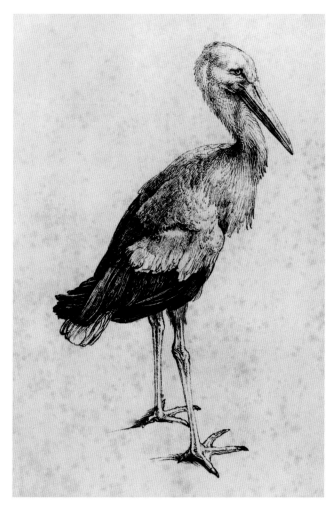

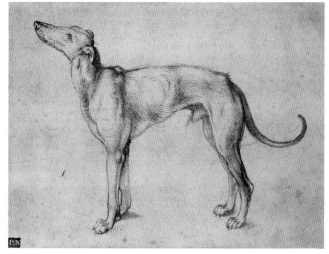

Above: *Greyhound, c.1500–01*, brush and ink, the outlines indented with a stylus, 14.8 x 19.8cm (5.8 x 7.7in), Royal Collection Trust, London, England, UK

Dürer studied and drew many portraits of his dogs, which feature in his works.

Here a small greyhound looks up. The composition matches the greyhound standing near a horse, in the large engraving *St Eustace*, 1501 (see page 153), which featured many hunting dogs, possibly one or two dog-models in different stances.

Above: *Stork, c.1500*, pen and ink drawing, 28 x 19cm (11 x 7.48in), Ixelles Museum, near Brussels, Belgium

A study of a stork, probably for Durer's collection of drawings and watercolours, for use in other artworks by him or his workshop assistants.

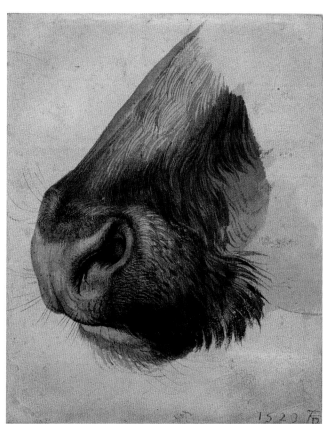

Right: *Mouth of an ox from the side, c.1500*, watercolour and opaque paints, 19.9 x 15.8cm (7.8 x 6.2in), British Museum, London, England, UK

One of several studies of cows and oxen. This superb study is of the nose and mouth of an ox. Dürer concentrates on every detail of the animal's head, including the smallest hairs around its nose and mouth.

Right: *Left Wing of a Blue Roller*, c.1500 [date 1512 added later], watercolour and opaque colours with gold raised with opaque white, on smoothed and polished parchment, 19.6 x 20cm (7.7 x 7.8in), The Albertina Museum, Vienna, Austria

A wing of the blue roller bird (*Coracias garrulus*) reveals the subtle gradations of colour, from royal blue to pale turquoise, across its stunningly beautiful plumage. Each feather is painstakingly recorded and painted. The wing has been torn from a dead bird. Dürer shows the dried blood wound. Initially a study of a bird wing would have been for scientific or naturalist research purposes. Here Dürer elevates the wing of a bird to high art. In the present day the bird is located more in southern Europe.

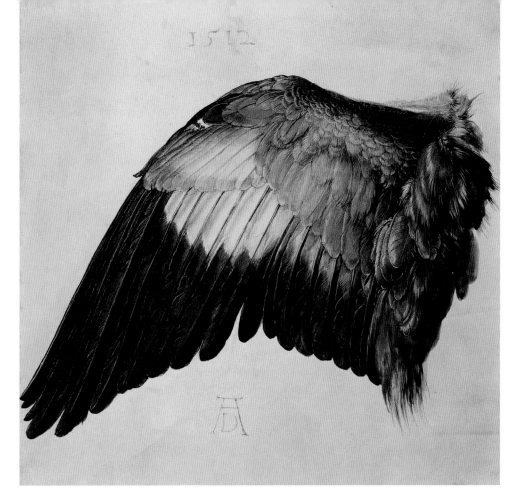

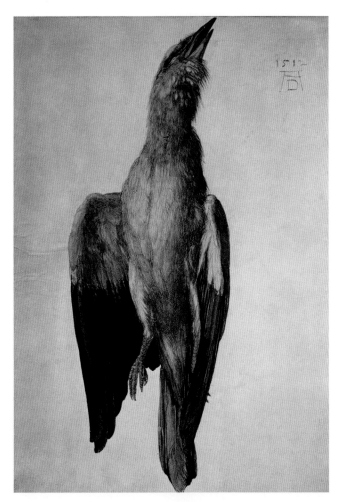

Left: *A Blue Roller*, c.1500 [or 1512], watercolour and gouache on vellum, heightened with white and gold, 28 x 20cm (11 x 7.8in), The Albertina Museum, Vienna, Austria

The blue roller (*Coracias garrulus*) is known in Germany as *blauracke* for the crowing 'caw caw' sound it makes and its stunningly beautiful blue wings. Dürer captures the subtlety of the bird's plumage, across a spectrum from pale turquoise to royal blue. Each feather is defined. The feathering around the beak is orange-red in tone, in line with the colouring of its feet. It is difficult to ascertain if Dürer hung the bird on the wall or laid it flat to paint it. European rollers are on average 29–32cm (11–13in) in length with a wingspan of 52–58cm (20–30in).

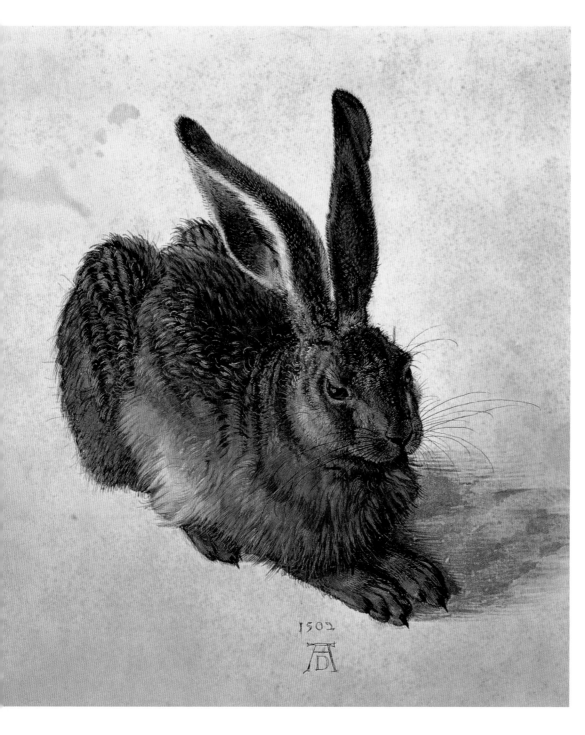

Young Hare, 1502, watercolour on paper, 25 x 22.5cm (9.8 x 8.8 in), The Albertina Museum, Vienna, Austria

Young Hare is recognised as one of Dürer's greatest works. The small hare sits in a crouched position, alert. Dürer captures the animal's body language and calm facial expression in meticulous detail. Each strand of its soft brown fur is visible, its ears upright, like antennae, each facial whisker clearly defined. Dürer used washes of brown, grey and black tones with a sharply pointed brush for the hare's coat, whiskers and claws. If one looks closely at the animal's eyes, a reflection of the window in Dürer's studio can be detected. Admiration for this work was widespread and copied many times by other artists and forged too with fake AD monogram. In 1585, Emperor Rudolf II commissioned a copy to be painted from the original owned by the Imhoff family.

Studies of Hares, 1501–04, pen and black ink, 12.6 x 22cm (4.9 x 8.6in), British Museum, London, England, UK

Hares and rabbits appear in many of Dürer's works, in outdoor settings, in woodcuts, drawings and oils. Here he studies a hare from its right side, from the rear, and a close-up of the head and ears of a hare, facing left. These may have been preliminary studies for his watercolour of a hare, *Young Hare* (see above), or the earlier woodcut *The Holy Family with Three Hares*, c.1497–98 (see page 143).

Right: *Peonies*, c.1500, watercolour and opaque colour, 37.6 x 30.8cm (14.8 x 12.1in), Kunsthalle, Bremen, Germany

A close study of peonies, often a flower included in outdoor depictions of the Madonna and Child. Dürer studies the leaf formation and the peony flower and bud, from different angles.

Above: *Little Owl*, c.1502– 08, watercolour on brownish paper, heightened with opaque white, brush and pen in brown and grey-black ink, 19.2 x 14cm (7.5 x 5.5in), The Albertina Museum, Vienna, Austria

The *Little Owl* is one of Dürer's studies from life, for later inclusion in other works. He has carefully replicated the feather colouring, and the sharp claws essential for picking up small rodents to eat. Two owls are visible close to the seated Virgin in the watercolour *Virgin and Child with a multitude of animals and plants*, c.1503 (see page 165).

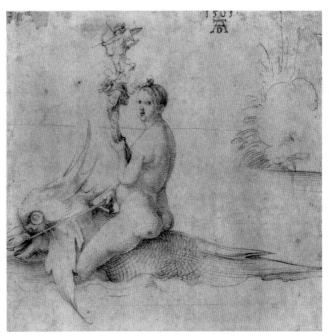

Venus on a Dolphin, 1503, feather in black and grey, 21.2 x 21.2cm (8.3 x 8.3in), The Albertina Museum, Vienna, Austria

A naked Venus, goddess of love, sits astride a mythical dolphin, her son Cupid poised with bow and arrow on top of a horn of plenty. The smiling dolphin glides across the waters. Dürer conjures a wondrous animal with many teeth, a winged head and scaly body. Venus turns her head, to observe the observer.

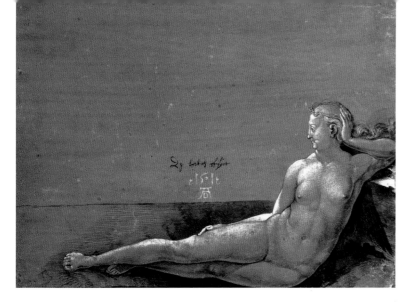

Reclining female nude, 1501, pen and pencil on coloured prepared paper, 17 x 22cm (6.6 x 8.6in), The Albertina Museum, Vienna, Austria

This is considered Dürer's earliest chiaroscuro drawing on coloured paper. The naked woman, half lying, half upright, reclines with her left arm resting on a block, hand supporting her head. She looks out across an empty landscape. Above a horizontal line are the words 'Dz hab ich gfisyrt' ('I constructed this'). The drawing may possibly be for Dürer's research on human proportion. The position is similar to the figure in the earlier *The Sea Monster* (see page 137).

Self-portrait – nude study, 1500–05, pen and brush on green-primed paper, 29.2 x 15.4cm (11.4 x 6in), Schlossmuseum, Weimar, Germany

An intense three-quarter length study by Dürer of his naked body in classical contrapposto with weight on his right leg, which swivels the body's hips. It is similar to the central figure playing a flute in *The Men's Bath*, c.1496–7 (see page 125). The unseen light source at right highlights the upper body, making the skin gleam. The artist wears his long hair off the face, tied in a hairnet. He views the observer (himself, looking in the mirror) with curiosity.

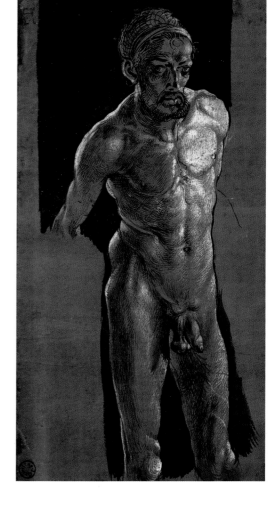

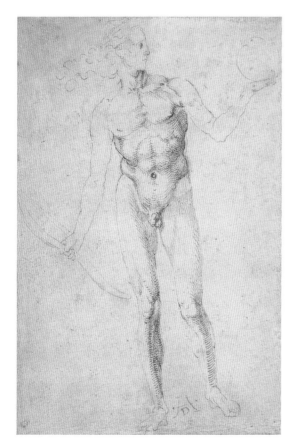

Standing Male Nude Holding a Bow (or *Poynter Apollo*), 1501–3, pen and brown and black ink, 21.9 x 14.5cm (8.6 x 5.7in), The Metropolitan Museum of Art, New York, USA

A similar drawing of a male nude, in the character of the sun-god Apollo. Here he holds a bow in his right hand. The work may have been a preparatory study for Dürer's treatise on human proportion.

Nemesis (or *The Great Fortune*) c.1501, engraving, 32 x 23cm (12.6 x 9in), National Gallery of Victoria, Melbourne, Australia

Dürer visualises Nemesis, the goddess of Fate, with magnificent wings standing naked on a ball in an ethereal sky, as if crossing the globe. She is high above a vast landscape featuring an Alpine town. The meticulous detail identifies the town as Klausen of the South Tyrol, in the Eisack Valley. In her left hand Fate holds reins – to tether the unrighteous. In her right hand she holds a magnificent goblet. (Also shown large on page 97.)

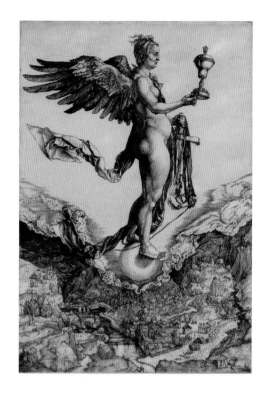

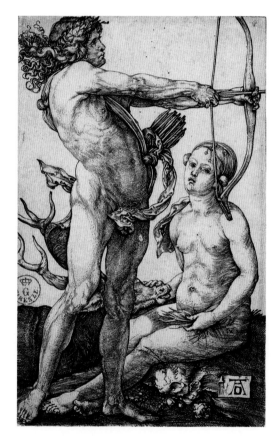

Apollo and Diana, 1503, engraving, 11.5 x 7cm (4.5 x 2.7in), Gallerie degli Uffizi, Florence, Italy

Dürer's depictions of naked figures from the early 1500s coincide with his interest in human proportion. In this engraving, recognised as one of his masterpieces, the muscularity of Apollo is well-defined. Diana has a youthful figure. Dürer's monogram is written on a scroll at bottom right. The head and figure of Diana also appears in *Venus on a Dolphin,* 1503 (see page 157).

Naked Man with Sun and Staff (or *Apollo*), c.1500, feather and brown and black ink, 28.5 x 20.2cm (11.2 x 7.9in), British Museum, London, England, UK

A sheet of studies depicting the sun-god Apollo, and the back of a seated figure. A sunburst of light from the god's outstretched left hand bears the name Apollo in reverse, as if engraved. A rod is held in his right hand. Above the horizon is a landscape of clouds and sky.

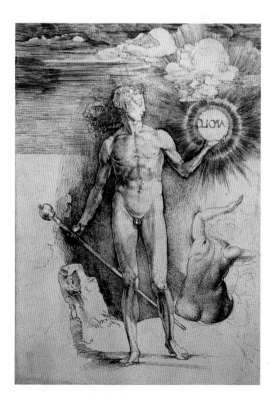

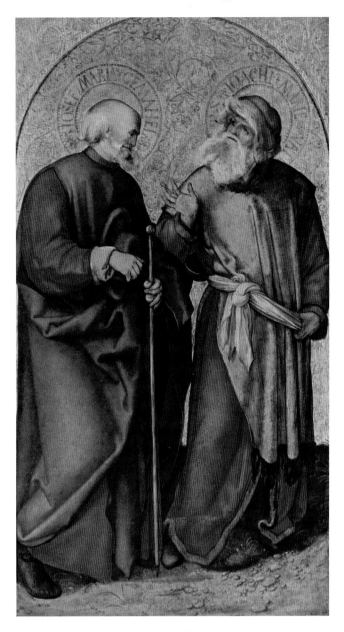

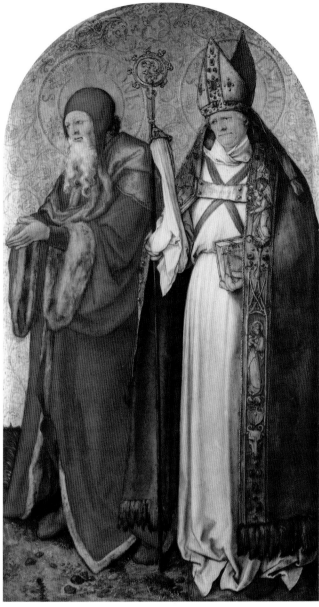

Left: *St Joseph and St Joachim* (Jabach Altarpiece), *c.*1503, oil on linden wood panel, 96 x 54cm (37.7 x 21.2in), Alte Pinkothek, Munich, Germany

Right: *St Simeon the Leper and St Lazarus* (Jabach Altarpiece), *c.*1503, oil on linden wood panel, 96 x 54cm (37.7 x 21.2in), Alte Pinkothek, Munich, Germany

The pair of side wing panels was part of a triptych, of which the central panel is now missing. The outer wings, now separated, are shown opposite. They are thought to have been created by Albrecht Dürer for the Epiphany altar in Wittenberg Castle Church, commissioned by Frederick III. It is now called the 'Jabach altarpiece' from the name of the collector, Everhard Jabach (1618–95) of Cologne, who purchased the retable in the late 17th century. Using a colour scheme of complementary red and green to create a rich composition, at left St Joseph and St Joachim walk together, deep in conversation. Joachim is the father of the Virgin Mary, and Joseph her husband. At right St Simeon (Simon) the Leper and St Lazarus, both receivers of Christ's healing, stand side by side, facing toward Joseph and Joachim in the left panel. St Simeon is mentioned in Matthew: 26: 6–13 and Mark: 14: 3–9; and St Lazarus in John 11: 1–44. All four saints stand on the same ground with identical backdrops behind.

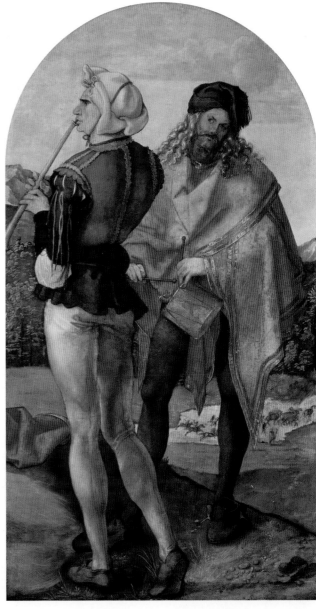

Left: *Job on the dung heap* (Jabach Altarpiece), *c.*1503–05, oil on linden wood panel, 93 x 51cm (36.6 x 20.1in), Staedel Museum, Frankfurt am Main, Germany

Right: *Piper and Drummer* (Jabach Altarpiece), 1504, oil on linden wood panel, 93 x 51cm (36.6 x 20.1in), Wallraf-Richartz-Museum, Cologne, Germany

This pair of paintings show two of four panels created for the retable (altarpiece) for Wittenberg Castle Church. The wing panels were later sawn apart, to create four paintings – two interior panels with portraits of saints (see opposite) and two exterior panels telling the story of Job (shown above). Job is an individual of the Old Testament whom Satan chose to abuse, covering his body in boils and sores: Job 2:

7–13. In despair Job sits on a dung heap; his wife pours water over him, a possible reference to water used to cleanse the skin of lepers, and other skin diseases. The hem of Job's wife's pinkish-red dress is visible in the separate panel with the piper and drummer. The colour also links to the mantle worn by the drummer. Dürer uses complementary colours of red and green to create a lively contrast to the depiction of the

forlorn figure of Job, his hand holding his face, recognised as a melancholic pose. The naked body of Job pairs with the figure of the piper, who wears near-nude tights. The foreground and landscape in both panels are connected. At left, Job's farm is being consumed by fire. In the right panel thieves steal his cattle. In *Piper and Drummer* there is a self-portrait of Albrecht Dürer posing as the drummer. He looks out at the observer.

LIFE OF THE VIRGIN SERIES, 1503–11

A series of nineteen woodcuts on the Life of the Virgin was created over an eight-year period;. seventeen were produced between 1503 and 1505 before Dürer set off for Venice, Italy, and two further woodcuts were created in 1510. The series focused on major events in the Virgin's life, from her conception and birth to her death and ascension to Heaven. Six are shown here (the seventh woodcut, *Annunciation*, is shown on page 58). In 1511 Dürer created an additional frontispiece bookplate, and the series was published in book form with a Latin text.

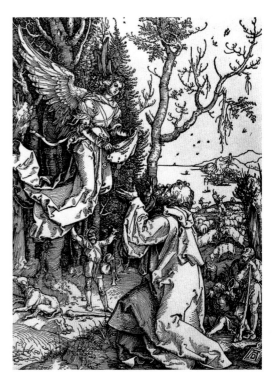

Right: *Life of the Virgin, The Angel Appears to Joachim*, 1505, woodcut, 30.2 x 21.6cm (11.8 x 8.5in), Private Collection

The second in the series. There is an account of Mary's beginnings in a 2nd-century apocryphal text, the Protoevangelium of James 5: 2. Joachim does 40 days' fasting penance in the desert for his childlessness and is visited by an angel before being blessed, with his wife Anne, with a daughter.

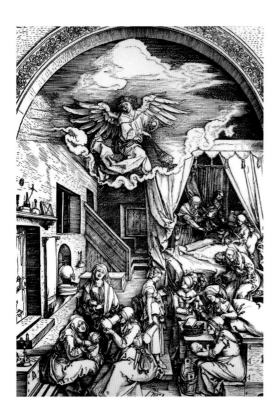

Left: *Life of the Virgin, The Birth of the Virgin*, *c.*1503–04, woodcut, 30.2 x 21.6cm (11.8 x 8.5in), Davis Museum and Cultural Centre, Wellesley, Massachusetts, USA

The fourth in the series. The birth of the Virgin Mary is not recorded in the bible but it is in the acpocryphal text of James. In comparison to Dürer's later engraving in the series, *The Death of the Virgin*, 1510 (see opposite, below), where she is surrounded by men, here the new mother Anne and her infant daughter Mary are surrounded by females.

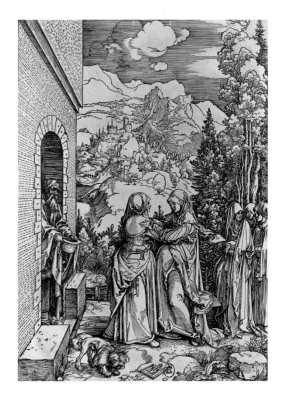

Right: *Life of the Virgin, The Visitation*, *c.*1505, woodcut, 30.2 x 21.6cm (11.8 x 8.5in), Smithsonian Design Museum, Cooper Hewitt, Washington DC, USA

The eighth in the series. The Virgin Mary visits her cousin Elizabeth to tell of the impending birth of Jesus Christ; Luke I: 39–56 and Isaiah 12: 2–3. Elizabeth was six months pregnant with her son, John the Baptist. The visitation is celebrated on 31 May each year.

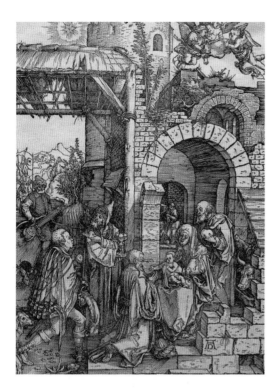

Left: *Life of the Virgin, Adoration of the Magi*, 1504, woodcut, 30.2 x 21.6cm (11.8 x 8.5in), Cleveland Museum of Art, Cleveland, Ohio, USA

In the tenth of the series, the three kings are visiting the Holy Family, bringing gifts to the infant Christ, who lies in a crib amongst ruins of buildings. Shepherds watch in the background. One of the royal entourage sits on his horse with a musical instrument.

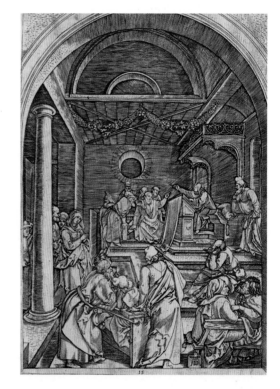

Right: *Life of the Virgin, Christ Among the Doctors*, 1504–05, woodcut, 30 x 21cm (11.8 x 8.2in), Cleveland Museum of Art, Cleveland, Ohio, USA

The Virgin and Joseph stand at far left to see their son, seated at a high lectern, discussing theology with the Elders of the church, who are scattered around him. He was twelve years old. Luke 2: 41–52 sets the scene that Dürer has visualised in the fifteenth plate. In Jerusalem, his parent search for three days to find Christ in the temple debating with theologians. He remonstrates: '…How is it that you sought me? Did you not know I must be in my Father's house?'

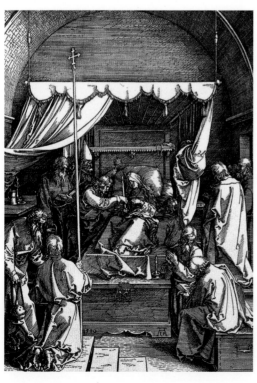

Left: *Life of the Virgin, The Death of the Virgin*, 1510, woodcut, 30 x 21cm (11.8 x 8.2in), Cleveland Museum of Art, Cleveland, Ohio, USA

The death of the Virgin Mary, Christ's mother, is not mentioned in the bible. Without a text to visualise, artists created their own vision of the deathbed scene. In this woodcut, the seventeenth in the series, Dürer surrounds her canopied bed with many priests. She is half-sitting, half lying in bed, her head and shoulders propped on a deep pillow. Her head is drooping to one side as her eyes close. The candle she holds in her right hand is being removed. The Virgin Mother looks fragile, her face slowly draining of life. The final two scenes, created in 1510, show the *Coronation of the Virgin*, and the *Virgin Adored by Angels and Saints*.

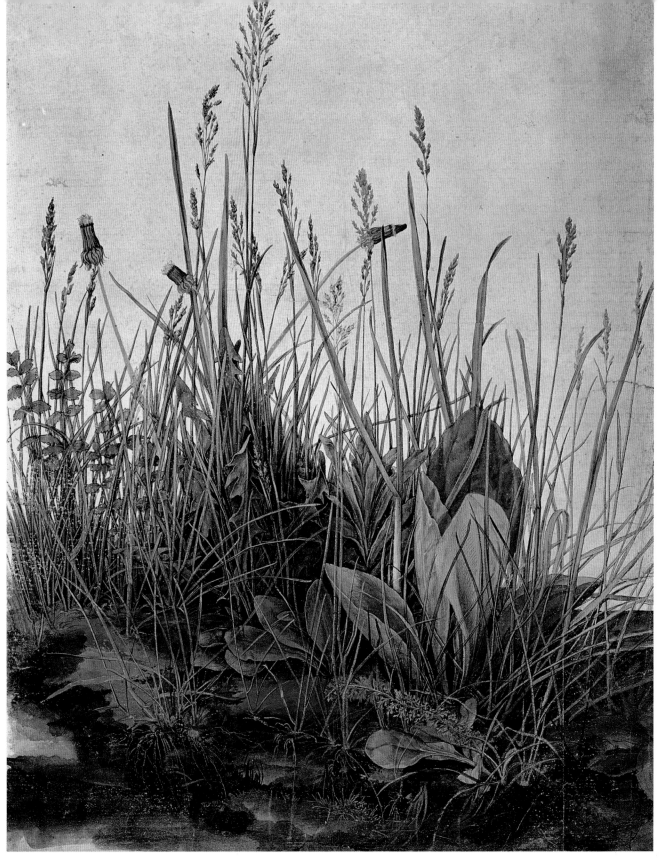

The Great Piece of Turf, 1503, watercolour, bodycolour heightened with opaque white on vellum, 40.8 x 31.5cm (16 x 12.4in), The Albertina Museum, Vienna, Austria

The Great Piece of Turf is arguably one of the most famous pieces of grass in art, and one of Dürer's most masterful pieces of draughtsmanship. It is thought that Dürer dug up a piece of turf from a hedgerow, placed it at eye-level in his studio, and painted what he saw. He may have painted different plants separately. He used a fine brush to create the wispy pinnacles of grasses, arrayed in a wide spectrum of tonal greens. It was created for use as a stock image of grasses, and elements of this work appear in different artworks.

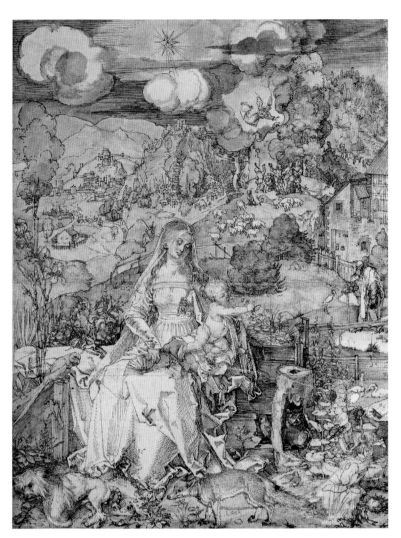

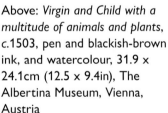

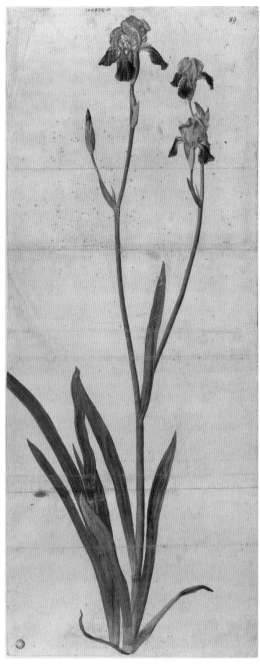

Above: *Virgin and Child with a multitude of animals and plants*, c.1503, pen and blackish-brown ink, and watercolour, 31.9 x 24.1cm (12.5 x 9.4in), The Albertina Museum, Vienna, Austria

In a character-filled depiction, the Virgin, holding the infant Christ in her left arm, is seated on a bench with an open book on her lap. They are surrounded by animals, birds and wildflowers. A fox, dog, owls and a parrot are close by, with a stork and swans nearby. The child leans out to pick a flower. In the near distance is Joseph, at right. Scenes from the bible are taking place in the background. Enacted on the hills are scenes of the angels proclaiming the birth of Christ to shepherds, and the entourage of the three kings arriving at his birthplace. The composition is based on a late medieval depiction *Hortus conclusus* ('enclosed garden') stemming from passages in Song of Solomon in the Old Testament, 'Song of Songs'.

Above: *Iris (Iris germanica)*, 1503, watercolour, gouache and pen and ink on two sheets glued together, 77.5 x 31.3cm (30.5 x 12.3in), Kunsthalle, Bremen, Germany

An iris, closely studied and painted, one of Dürer's collection of stock images for other artworks, to be copied by himself and his workshop assistants. It can be seen in *The Virgin and Child (The Madonna with the Iris)* shown on page 52.

Right: *Coat of Arms with Lion and a Cockerel, c.*1502, engraving, 18.3 x 11.8cm (7.2 x 4.6in), Private Collection

Commissioning a coat of arms was a popular tradition in Germany. Often painted on wood, it would be placed above the door of the owner's property, or above the door of a hostel or inn when travelling. The visual aspects could be a play-on-words, or symbols of a person's name or occupation, or family heritage, or character. Artists created fanciful coats of arms to attract buyers. The lion and cockerel were popular symbols, the cockerel being the only creature to frighten a lion.

Left: *Coat of Arms with a Skull, c.*1503, engraving, 22.3 x 15.8cm (8.75 x 6.3in), Minneapolis Institute of Arts, Minneapolis, USA

The helmet in this coat of arms is the one depicted in the watercolour on page 143. It is also used in the *Coat of Arms with a Lion and a Cockerel* (see above) and other works. Here, the Coat of Arms is viewed in profile, with a skull, a symbol of human mortality, prominent in the forefront. Differing opinions are held by art historians on the meaning behind the work, some views suggesting it is an allegory of love and death.

Right: *Portrait of an unknown man,* 1503, black chalk on paper, 29.6 x 21.3cm (11.6 x 8.3in), The Albertina Museum, Vienna, Austria

The handwritten text on the anonymous portrait reads: 'So pin Ich gschtalt in achtzehn Jor alt' ('So I am looking when eighteen years old'). Nothing else is known about the identity of the sitter.

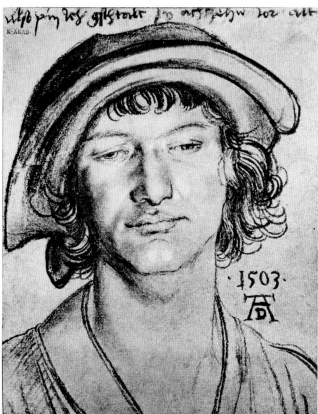

Left: *The Bookplate of Willibald Pirckheimer, c.1503,* woodcut, 14.9 x 11.9cm (5.8 x 4.6in), The Metropolitan Museum of Art, New York, USA

A helmet, two Coats of Arms, swags, angels, twisted columns and fighting putti are tightly packed into this bookplate of Willibald Pirckheimer. The elaborate design was supervised by him. The Coats of Arms are of the Pirckheimer family and of Crescentia Rieter (died 1504), his wife's family. There is a Latin inscription on the bookplate SIBI ET AMICUS P[ositus] ('Dedicated to himself and his friends').

Right: *Death of Crescentia Pirckheimer,* in 1504; a 1624 copy after Albrecht Dürer by Georg Gärtner the Younger (c.1577–1654), oil on oakwood, 90 x 60cm (35 x 23.6in), Imhoff Family Trust, Nuremberg, Germany

In 1504 Dürer created a watercolour on parchment, now lost, known as *Death of Crescentia Pirckheimer.* The composition showed Crescentia, née Rieter, the wife of Dürer's close friend Willibald Pirckheimer, on her deathbed with her husband by her side, two priests, a midwife – she died in childbirth – and five female attendants. This copy after the original was painted by Gärtner the Younger, in Nuremberg. He was hailed by his contemporaries as 'felicissimus Düreri imitator'.

Left: *Portrait of Willibald Pirckheimer,* 1503, charcoal heightened with white below the eyes and on the forehead, 28.1 x 20.8cm (11 x 8.1in), Staatliche Museen zu Berlin, Germany

A portrait of Albrecht Dürer's close friend, the wealthy Nuremberg patrician, Willibald Pirckheimer. He is portrayed in profile, head and shoulders. Dürer includes Pirckheimer's misshapen nose, and beginnings of a double chin. His eyes are sharp. An engraving was created in 1524 (see page 242).

Right: *The Virgin and Child with a Flower on a Grassy Bank*, c.1503, drawing, 16.2 x 16.4cm (6.38 x 6.45in), Private Collection

One of several Virgin and Child drawings created by Dürer. The Virgin Mary is seated on a grassy bank. Wooden planks create a rustic bench. The naked infant

Christ is held protectively within her arms. He stands on her lap looking outward. He holds a wild flower with long stalk in his hand, possibly picked from the grassy bank. The angle of the Virgin's head is replicated in *Mary with the Child at her breast*, 1503 (see below).

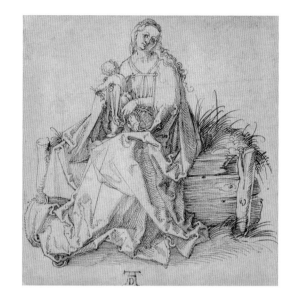

Left: *Mary with the Child at her breast*, 1503, oil on linden wood, 24 x 18cm (9.4 x 7in), Kunsthistorisches Museum, Vienna, Austria

This small painting, a tender portrayal of mother and child, is one of Dürer's several portrait depictions of the Virgin Mary with the infant

Christ. The motif of the *Madonna lactans* focuses on Christ's humanity, and the mother and child bond. In this work, the baby is suckling at her breast. The dark background and light source at left accentuate the soft, pastel colours of the Virgin's clothing and the pale blond curls of the baby's head.

Right: *Virgin with Child on a Grassy Bank*, 1503, engraving, 26.7cm x 40.9cm (10.5 x 16.1in), Cleveland Museum of Art, Cleveland, Ohio, USA

The Virgin enfolds the infant Christ in her arms, looking at him with deep devotion. She has stopped on her journey, to sit on a grassy bank to feed her baby.

The infant's left hand holds onto his mother's wrist whilst she guides his mouth to suckle at her breast. Dürer captures a tender, private moment. The grassy knoll is bordered by a wooden fence on which a goldfinch sits. The dead tree outside the fence and the bird are symbols of Christ's Passion. The Virgin and Child was one of Dürer's favourite subjects.

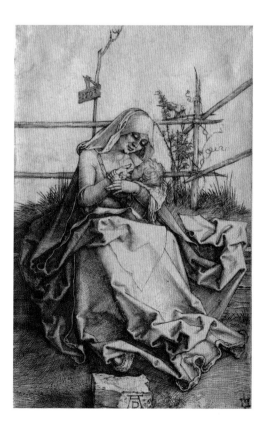

 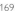

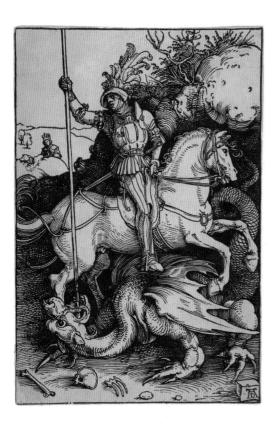

St George and the Dragon, 1504, woodcut, 21 x 14.1cm (8.2 x 5.5in), The Metropolitan Museum of Art, New York, USA

St George, astride his horse, is depicted in the action of killing a dragon, its head facing upward as St George skewers it to the ground with his lance. The legend tells of a dragon terrorising a village, demanding food. When the villagers' animals were all eaten, the dragon demanded human flesh.

St George has been sent to save a princess who had been chosen by lottery as the dragon's next victim. She can be seen hiding in the distance, while St George and the dragon fight. Dürer focuses on meticulous details, from the knight's plumed helmet to the magnificent dragon with its large-eyed face, spiky wings, clawed feet and an intensely cross-hatched coiled tail, so long in size that St George's horse has to jump over it.

The Birth of Christ, 1504, engraving, 19 x 12.5cm (7.4 x 4.9in), The Albertina Museum, Vienna, Austria

Dürer pays great attention to the architectural structure of the weathered wooden building that houses the Virgin and infant Christ. She kneels at his crib in adoration. Behind her, by the stable, a shepherd kneels in prayer. Nearby, Joseph, kneeling, fills a jug of water that he has drawn up from the well, a symbol of the sacrament of baptism. The engraving is a reworking of the Paumgartner altarpiece central panel (see page 151), with a few alterations to the placement of the Holy Family.

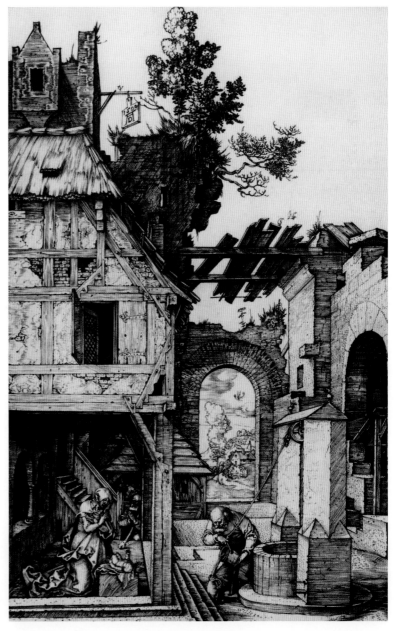

ADORATION OF THE MAGI, 1504
Oil on fir wood panel, 100 x 114cm (39.3 x 44.8in),
Gallerie degli Uffizi, Florence, Italy

(Shown small, right; see pages 98–99 for a larger
reproduction of the painting.) Another important commission
from Frederick III 'the Wise', Dürer places the biblical
narrative amongst ruined buildings, a possible reference to
the *Golden Legend* publication, also known as *Lives of the
Saints* written in the Middle Ages by Jacobus de Voragine
(*c.*1228–98), archbishop of Genoa. Dürer possibly had read
de Voragine's description of the location of the Adoration,
to symbolise the end of the paganism of antiquity that was
heralded by the birth of Christ and Christianity. The magi,
or kings, or wise men of the Orient – Caspar, Melchior and
Balthasar the Moor – bring gifts of gold, frankincense and
myrrh (Matthew 2: 1–12). The gifts are symbolised as gold
for a king, frankincense for God, and myrrh used to anoint
the dead. At left, from a stable, a cow watches and a donkey
brays, adding realism to the scene.

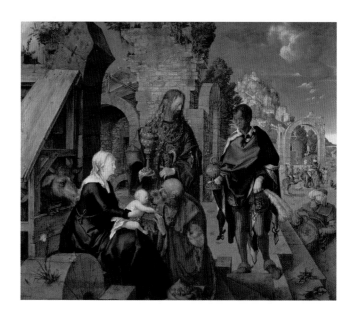

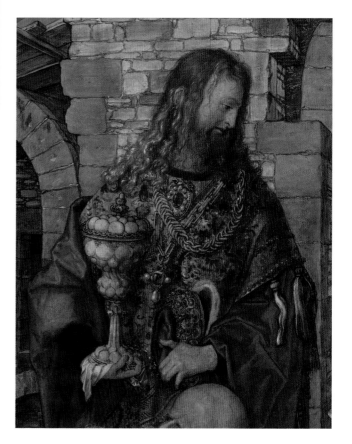

Left: *Adoration of the Magi*
(detail), 1504

Caspar, the older king, kneels,
studying the face of the
Messiah, while the baby takes
hold of the gold casket. Their
hands meet. Mary holds the
infant protectively on her lap.
There is a contrast between
the plainly dressed Madonna
in traditional blue robes, the
naked infant, and the wealthy
robes of the Magi.

Right: *Adoration of the Magi*
(detail), 1504

The magus Melchior holds a
magnificent lidded gold cup,
containing frankincense, in
his right hand, and clasps his
jewelled hat in the left hand.
The cup's design relates to
the decorative gold cups
made in Dürer's father's
goldsmith workshop. It is
generally accepted that this
is a self-portrait of Albrecht
Dürer.

Right: *Adoration of the Magi* (detail), 1504

The third magus, Balthasar the Moor, is depicted as a young man. He wears a royal blue and gold mantle. Behind him is a spectacular backdrop of a castellated hillside town. A road winds up toward it from the central scene below.

Left: *Adoration of the Magi* (detail), 1504

Behind Balthasar the Moor, one can see the entourage that accompanied the three Magi. In the architecture of ancient ruined buildings, they wait on horseback, or walk, or stand, watching the proceedings from a distance. Close to them local people walk their dogs. In the background the land stretches to the sea, connoting the long journey of the Magi to reach the infant Messiah.

Right: *Adoration of the Magi* (detail), 1504

Dürer is noted for meticulous attention to detail, including wild plants and insects. He often sketched them to keep a stock of illustrations to use in other works. At lower right in the picture plane, he places a stag beetle, near a wild plant – a weed – that is growing in a crack of the steps. He also depicts a crawling insect and butterflies (the butterfly is a symbol of the Resurrection), see page 53.

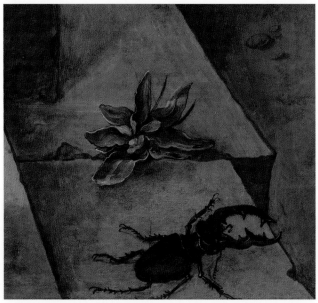

ADAM AND EVE, 1504

Dürer made several pen and ink drawings of Adam and Eve, together and as separate bodies, as preparatory works for the masterful engraving. The work reflects Dürer's interest and research on the proportions of the human body. In the use of test printings, as the engraving progressed, Dürer was able to monitor exactly what he needed to add or remove, and where to place flora and fauna.

Studies for the arm of Adam, 1504, pen and ink on paper, 21.6 x 27.5cm (8.5 x 10.8in), Private Collection

Dürer experimented with various positions for the arm of Adam in the *Adam and Eve* 1504 engraving (see opposite). Studies of rocks and bushes are on the sheet too.

Proportion studies of Adam and Eve, 1504–07, pen and brown ink with brown wash on paper, each drawing 26.2 x 16.6cm (10.3 x 6.5in), Private Collection

The nude bodies of a man and woman, 'Adam and Eve' are geometrically sectioned into leg, body and head. They show numbers to indicate the measurements. The compass circles indicate the proportions. Eve has her hand raised at the moment of picking fruit from the tree. Adam and Eve both stand in a contrapposto position.

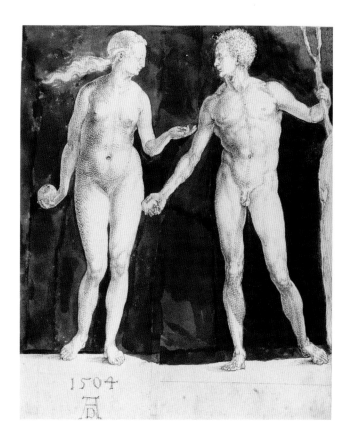

Left: *Adam and Eve,* 1504, pen and brown ink with brown wash, 24.2 x 20.1cm (9.5 x 7.9in), Pierpont Morgan Library, New York, USA

Above: *Studies of Adam and Eve,* 1504, pen and brown ink, background of the figure with brush in brown, each work 26.2 x 16.6cm (10.3 x 6.5in), The Albertina Museum, Vienna, Austria

Below: *Eve, c.*1504, pen and brown ink on paper, 22 x 12cm (8.6 x 4.7in), Ashmolean Museum, University of Oxford, England, UK

A study of the female human body, possibly for Dürer's proposed treatise on human proportion. At this date he was creating the engraving *Adam and Eve* and made many preparatory studies with which this could be associated.

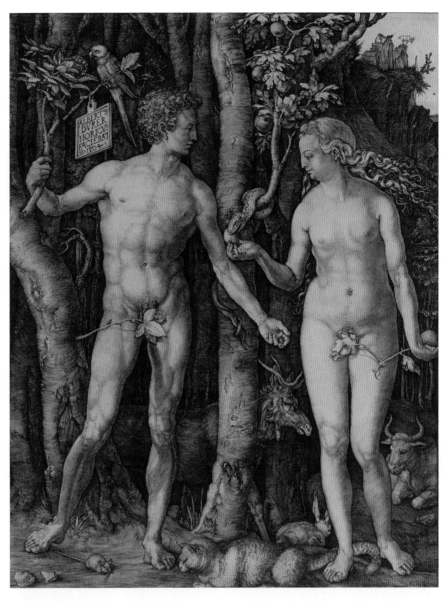

Above: *Adam and Eve,* 1504, engraving, 25.2 x 19.5cm (9.9 x 7.6in), The Clark Art Institute, Williamstown, Massachusetts, USA

Dürer made trial impressions of this engraving – two are extant – before its completion. Adam and Eve, the first man and woman on Earth, according to the bible narrative in Genesis 1, are depicted in a wooded setting – the 'Garden of Eden' – with a hilly landscape in the distance. In Adam, one can see the influence of the ancient statue of the Apollo Belvedere (AD120–140) rediscovered in Rome in the 1490s and much copied by engravers for prints, of which Dürer would have been aware. His creative process included close attention to flora and fauna: nature and animals, evident here in Eden's lush foliage and trees, and the goat, rabbit, cow, cat and mouse, slithering serpent – Satan tempting Eve – and the parrot. Each one is meticulously drawn in this masterpiece. In contrast to the paintings of 1507 (see page 190) this Adam has a highly muscular body, possibly created in line with Dürer's ongoing study of the human body and his theories on the rules of human proportion. (Detail shown large on page 8.)

THE GREEN PASSION, 1503–04

In 1503–04 Albrecht Dürer created a series of eleven scenes from the Passion of Christ (five are shown here). It begins with Christ's capture in the Garden of Gethsemane and ends with his burial outside Jerusalem, near the site of his crucifixion. The pen and brush drawings in ink and opaque white were created on a bluish-green primed paper, hence the name now given of the Green Passion. The monochromatic format of the Green Passion concentrates attention on the figures and their actions. Dürer fills each scene with figures in movement, either in anger, as at Christ's arrest, or with a stillness, in the weeping over his body. The six other scenes in the series (not illustrated here) are *Christ before Pilate, The Flagellation, The Crowning of Thorns, Christ is shown to the People; Christ carrying the Cross,* and *Christ on the Cross.*

The Green Passion, The Captivity (or Arrest) of Christ, 1503, pen and brush in ink and opaque white, 28.7 x 17.8cm (11.2 x 7in), The Albertina Museum, Vienna, Austria

In the first of the sequence Dürer depicts the capture of Christ, from the bible narrative Mark 14: 32–50. Christ is betrayed with a kiss – a sign of friendship – by Judas. In the garden of Gethsemane, the chief priest and Elders, with an armed mob, surround Christ. One of Christ's followers cuts off the ear of the chief priest's servant.

The Green Passion, Christ in front of Caiaphas, 1504, pen and brush in ink and opaque white, 28.7 x 18cm (11.2 x 7in), The Albertina Museum, Vienna, Austria

Matthew 26: 57–68 records that Christ was brought before Caiaphas, the Chief priest. In the second scene Dürer illustrates Christ dragged before Caiaphas and accused of blasphemy, as the mob surround him and try to tear at his clothes.

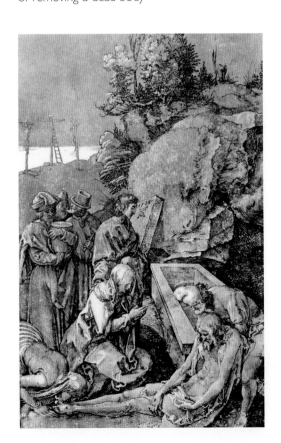

Left: *The Green Passion, Christ is Nailed to the Cross*, 1504, feather in black, brush in grey and white, 28.3 x 17.8cm (11.1 x 7in), The Albertina Museum, Vienna, Austria

The atrocity of nailing a human being to a piece of wood is shown in graphic detail in this work. Crucifixion was a form of punishment utilised by the Romans; its torturous process would have been known to the gathered crowd. In the eighth scene of the series Dürer focuses on Christ's suffering in contrast to the matter-of-fact actions of the men nailing him to a crucifix.

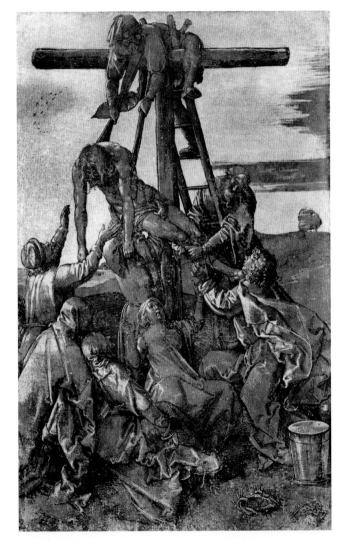

Right: *The Green Passion, Christ is taken down from the Cross*, 1504, pen and brush in black ink and opaque white, 29.8 x 18.9cm (11.6 x 11.3in), The Albertina Museum, Vienna, Austria

The difficult procedure of removing a dead body from a crucifix after death is graphically visualised in this work, the tenth in the series. The dead weight and limpness of the body compares to the struggles of the men to remove it from the cross and bring it to the ground.

Left: *The Green Passion, The Entombment of Christ*, 1504, pen and brush in black ink and opaque white, 29.6 x 18.3cm (11.6x 7.2in), The Albertina Museum, Vienna, Austria

The family of Christ are poignantly visualised in this work, the eleventh and final image of the series. Matthew 27: 59 relates that a rich man, Joseph of Arimathea, gave up his own newly cut tomb for Christ's burial, around which the mourning family are gathered.

Mouse c.1504–07, pen and ink on paper, 25.4 x 11.9cm (10 x 4.7in), Everett Collection, New York, USA

A realistic mouse drawn by Dürer as a stock image reference which would appear in other works. A mouse is included in the engraving *Adam and Eve*, 1504 (see page 173).

Stag beetle (Lucanus cervus), 1505, watercolour and gouache, 14.1 x 11.4cm (5.6 x 4.5in), J. Paul Getty Museum, Los Angeles, USA [Upper left corner of paper added, with tip of left antenna painted in by a later hand]

Dürer's drawings and watercolours give insight into his creative thinking, noticeable in the many preparatory studies for paintings.

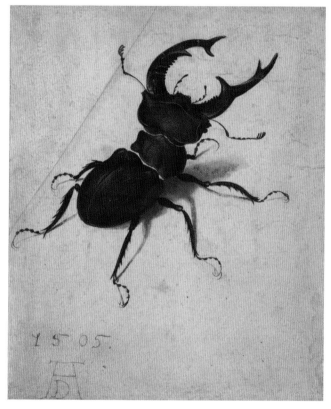

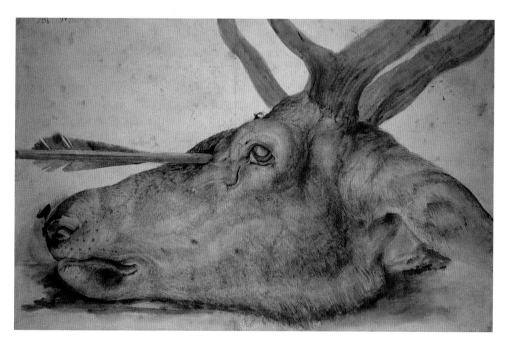

Head of a killed deer, c.1504, watercolour and opaque paints, with white, 25.2 x 39.1cm (9.9 x 15.3in), Bibliothèque Nationale, Paris, France

A structural study of a stag, shot through the head with an arrow. A stag appears in Dürer's engraving *St Eustace*, 1501 (see page 153). Dürer's domesticated, farm and wild animals were painted from life models, with the exception of a lion until he saw a real one in 1520–21.

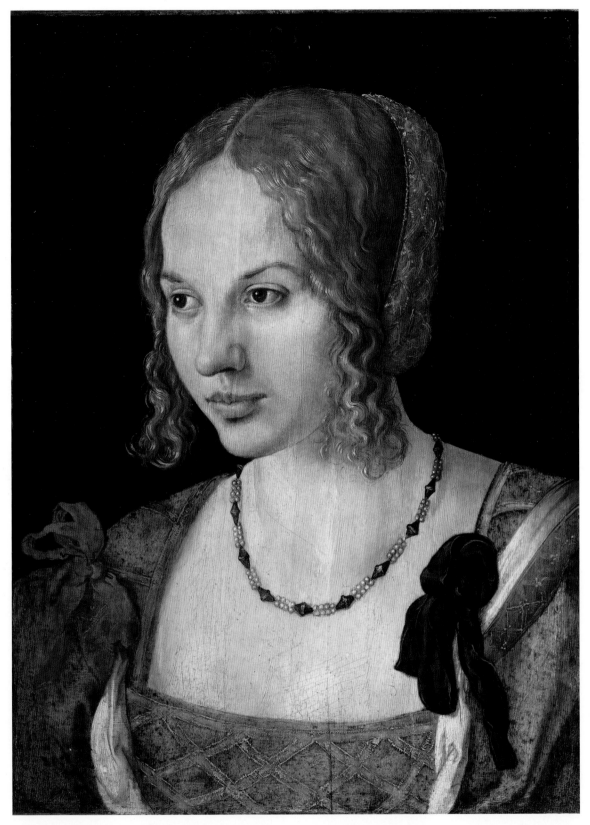

Portrait of a young Venetian woman, 1505, mixed media on spruce wood, 32.5 x 24.5cm (12.7 x 9.6in), Kunsthistoriches Museum, Vienna, Austria

This painting was created during Dürer's 1505–07 stay in Venice. Facial characteristics of the young woman, the nose and mouth, are comparable to those of Burkhard von Speyer who features in the *Madonna of the Rose Garlands*, 1506 (page 182), and in a personal portrait of him by Dürer (see page 180). However, the sitter remains anonymous with no record of her name in Dürer's accounts or if she is a relative of von Speyer.

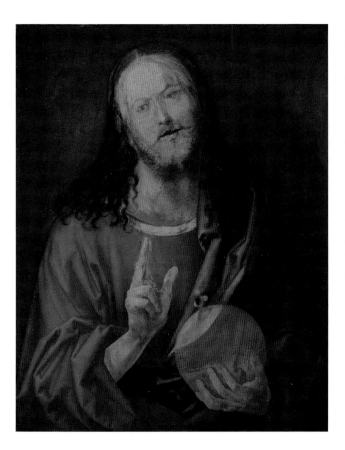

Salvator Mundi, c.1505, oil on linden wood, 58.1 x 47cm (22.8 x 18.5in), The Metropolitan Museum of Art, New York, USA

The unfinished painting of *Christ as the Salvator Mundi* (Saviour of the World) was created around 1505, and possibly started just before Dürer left Nuremberg for his 1505–07 visit to Venice or just after he arrived in the city. In composition and colouring it shows the influences of artworks by Italian painters, Andrea Mantegna and Jacopo de' Barbari, for example. Some historians suggest that this painting was the central panel of a triptych with side panels, one depicting St Onuphrius and the other St John the Baptist (both in the Kunsthalle, Bremen, Germany) but the theory remains unproven. Dürer may have used his own likeness to depict Christ.

Farmer's wife from Windisch, 1505, pen and brown ink with brown wash, 41.6 x 28.1cm (16.3 x 11in), British Museum, London, England, UK

Inscribed by Dürer: 'una vilana windisch'. This watercolour portrait in brown ink with a brown wash background is of a peasant woman, from Windisch, south Austria. Her clothing is barely defined except for the patterned scarf she has wrapped around her head. Dürer has caught the moment the woman laughs, its spontaneity and happiness revealed in the laughter lines of her mouth and her eyes. She is thought to be a farmer's wife from Windisch Mark, an area around Gurk, in Kärten, and possibly a person Dürer met on his journey to Italy, travelling through the country. There is another Dürer drawing of a Windisch woman, dated to 1505 (Museum Boymans-van Beuningen, Rotterdam, Netherlands).

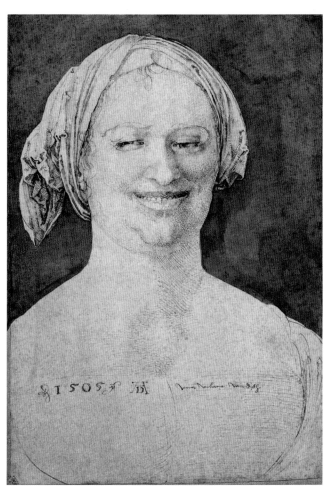

Above: *Death riding a horse*, 1505, charcoal on paper, 21.1 x 26.5cm (8.3 x 10.4in), British Museum, London, England, UK

A depiction of skeletal 'death', crowned and viewed in profile holding a sickle, astride a skeletal horse. The inscription reads 'MEMENTO MEI' ('Remember me'). The horse has a death knell bell around its neck – announcing death, or calling for dead to be brought forth, which may be linked to an outbreak of plague in Nuremberg in 1505. Are horse and rider en route to deliver death to an unsuspecting person? The drawing's subject follows Dürer's popular *Four Horsemen of the Apocalypse*, 1497–8, featuring Death on a pale horse (see page 131).

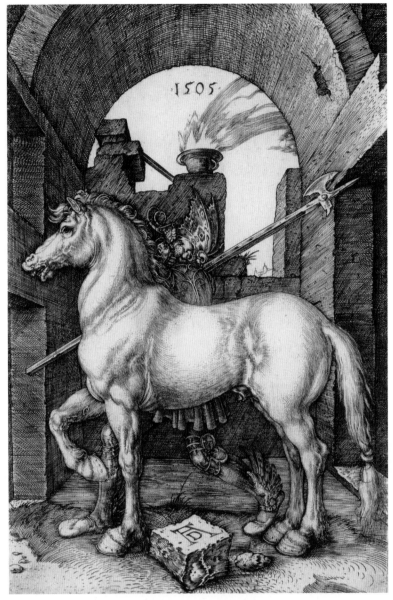

Above: *The Small Horse*, 1505, engraving, 16.4 x 10.8cm (6.4 x 4.2in), Museum of Fine Arts, Houston, Texas, USA

Art historians consider that *The Small Horse* engraving was an exercise in proportion. In an exquisite study of the dimensions, proportions and musculature of a horse's body, the beauty of the animal is highlighted. Set underneath a Roman arch with a cauldron of fire blazing on top of a wall, the animal and its near-hidden rider are within the walls of a partly ruined building. Horse studies by Leonardo da Vinci were known to Dürer, and this engraving may have been informed by Da Vinci.

Left: *Fifth of Six Knots*, 1506, woodcut, 26.9 x 20.8cm (10.5 x 8.1in), The Clark Art Institute, Williamstown, Massachusetts, USA

During his stay in Venice 1505–07, Dürer created a series of six knot woodcuts. This is the fifth Knot, a white shield with six points in the centre, designed for embroidery. Dürer was directly informed by Italian engravings.

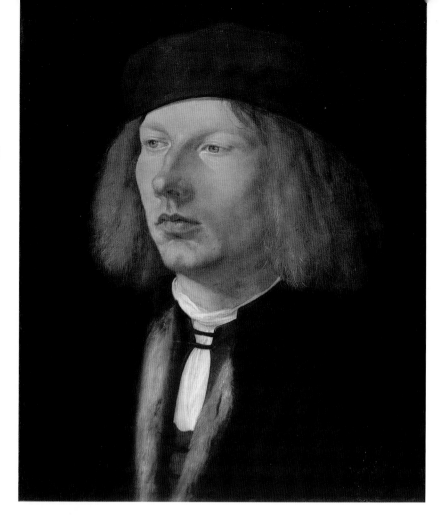

Portrait of Burkhard of Speyer, 1506, oil on panel, 31.7 x 26cm (12.48 x 10.2in), Royal Collection Trust, London, England, UK

Burkhard von Speyer, almoner of the Church of San Bartolomeo, appears in the *Madonna of the Rose Garlands*, 1506 painting, where von Speyer is the fourth figure from the left (see page 183). He wears identical clothing in this portrait, possibly created at the same time as the larger work. Von Speyer is recognised from another source, a miniature portrait of the same year, in the Schlossmuseum, Weimar with an inscription: 'Burcardus de Burcardis Spirensis 1506'.

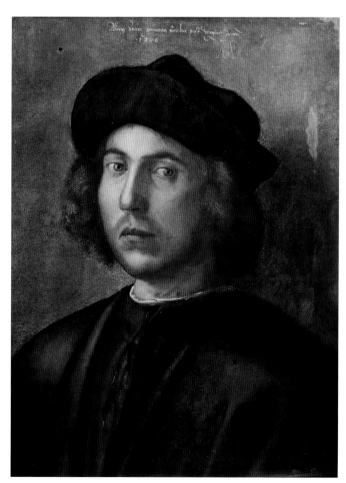

Portrait of a Young Man, 1506, oil on panel, 47 x 35cm (18.5 x 13.7in), Palazzo Rosso, Musei di Strada Nuova, Genoa, Italy

The identity of the young man is unknown. The portrait's creation is dated to Albrecht Dürer's 1505–07 stay in Venice. His letter to Willibald Pirckheimer dated 25 September 1506 mentions portraits he was painting: 'I have promised to do portraits of several people...', probably including this one. The text on the portrait states: 'Albrecht Dürer the German was painting this in the year since the Virgin gave birth 1506'. Dürer used a larger panel than other portraits. The backdrop is plain green, to focus attention on facial characteristics. The man's clothing is similar to a man standing at far left in *Madonna of the Rose Garlands*, 1506. That person was noted to be the Superior of the Church of San Bartolomeo. He has an older face, but possibly the men are linked in some way.

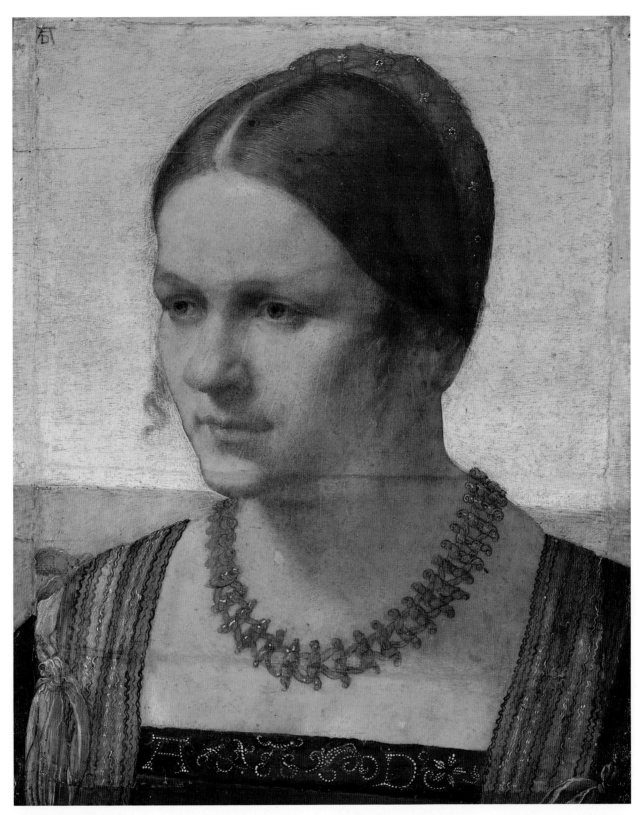

Young Venetian Woman, c.1506, oil on poplar wood, 28.5 x 21.5cm (11.2 x 8.46in), Staatliche Museen zu Berlin, Germany

A small portrait of a Venetian woman, dated to Dürer's 1505–07 stay in the city. He painted six portraits, three of men and three of women, during his stay, and portraits of persons unknown to historians today. This work is possibly the wife of a dignitary or a relation of one featured in the *Madonna of the Rose Garlands* painting. The woman wears an exquisite necklace of dancing figures. The restrained hairstyle denotes status, reflecting directives in Venice on the expectation of decorum in dress and hair for women. Dürer's initials are painted on the decolletage of the dress.

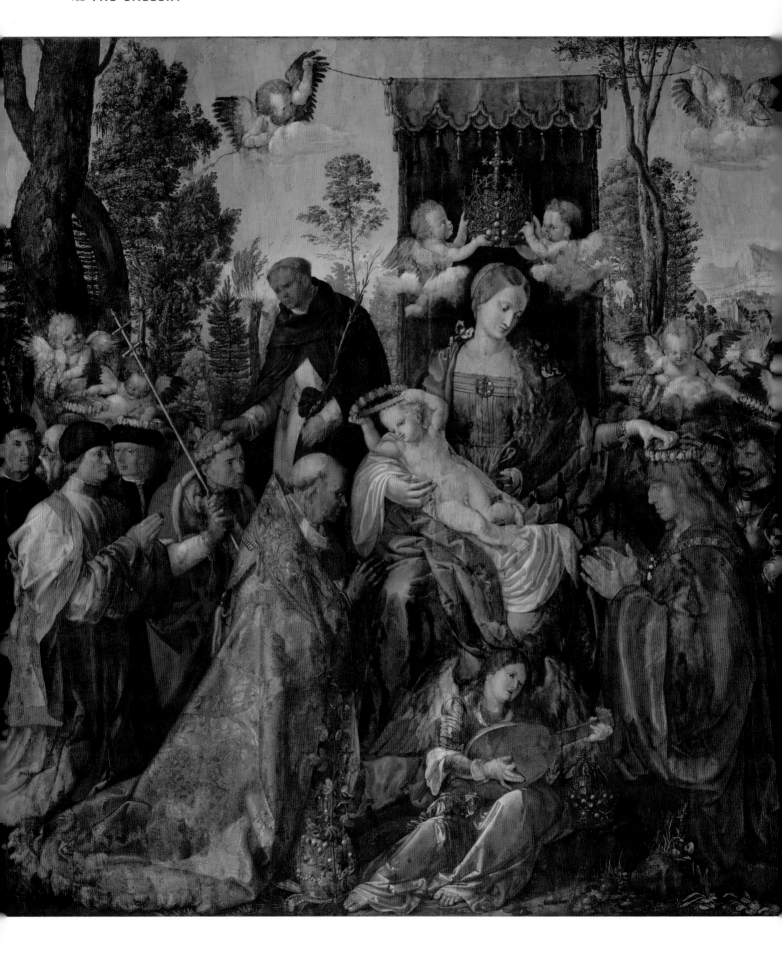

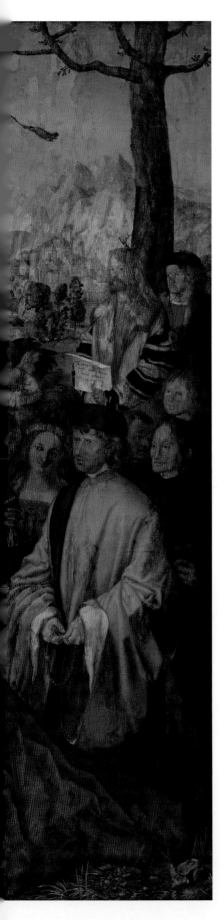

Madonna of the Rose Garlands, 1506, oil on wood, 162 x 192cm (63.7 x 75.6in), National Gallery, Prague, Czech Republic

One of Dürer's greatest religious altarpieces, created for the church of San Bartolomeo, this painting sealed Dürer's reputation in Italy. It was greatly admired by the Venetian arts community, by painter Giovanni Bellini, and the Doge of Venice, Loredan, who paid a special visit to see it and meet Dürer. It depicts a community of distinguished people in Venice, coming together to honour the Madonna, and receive her blessing, symbolised in the rose garland. The setting is amidst trees and greenery with view of a city and Alps beyond. The Madonna is

Madonna of the Rose Garlands (detail), 1506

Dürer placed himself in the work, top far right, depicted standing under a tree. Recognisable from his long, corkscrew ringlets of auburn hair, distinctive beard and flamboyant coat, which he treasured, he looks directly out at the viewer. He holds a painted piece of paper that identifies him as the creator of the painting, stating in Latin: 'Exegit quinque mestri spatio Albertus Dürer Germanus – MD – VI' ('Albrecht Dürer the German accomplished this in the space of five months in 1506'). The founder of the Brotherhood of the Rosary, Leonard Vilt, might be the man under the tree next to Albrecht Dürer.

placed under a baldachino. Representatives of the Church are on her right (the viewer's left), and representatives with secular powers on the other side. A crown is held above her head by two angels. The infant Christ, wriggling on her lap, copies her actions. A rose garland was a symbol of the rosary and the Venetian sect of the Brotherhood of the Rosary, who commissioned the painting. The original painting was severely damaged; what we see here is a restoration. (See also pages 48–49.)

The many details of this painting reveal a wide variety of facial expressions, and movement within the group is captured in turning heads and bodies. The Dominican humanist Johannes Cuno, standing on the Madonna's right, distributes garlands

to the gathering, while she places a rose garland on the head of the kneeling King Maximilian I, the Holy Roman Emperor after 1508. The infant Christ holds a garland above his head and directs it toward the head of the kneeling pope, Giuliano della Rovere (1443–1513) who became Pope Julius II (1503–13). A donor dressed in pale blue kneeling behind the emperor is possibly Georg Fugger, of the Augsburg dynasty. Burkhard von Speyer (also the subject of a portrait, see page 180), almoner of the Church of San Bartolomeo, is in the black cap on the Madonna's right, facing away. Hieronymus of Augsburg, architect, is shown far right, wearing black (see also page 185, for his portrait study). Dürer's innkeeper landlord Peter Pender is behind him.

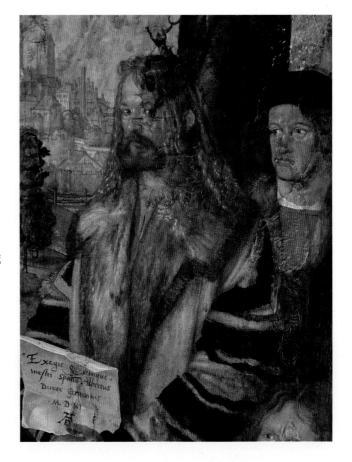

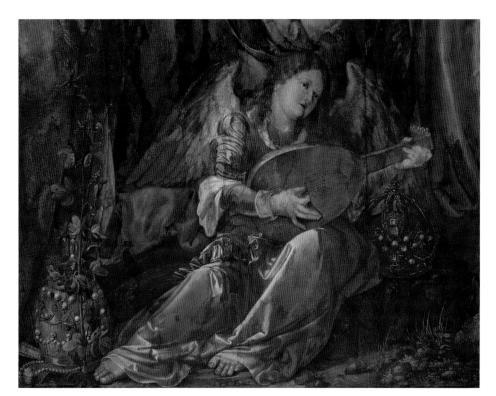

Madonna of the Rose Garlands
(detail), 1506

The lute-playing angel is seated
at the feet of the Madonna. At
either side of her are the papal
tiara of the Pope and Imperial
crown of the Emperor, symbols
of spiritual and temporal power,
removed to receive the rose
garlands from the Madonna. The
angel's carefully painted wings
reflect the intense jewel-bright
colours and feather orientation
of birds known to Dürer, such
as his study of the *Left Wing
of a Blue Roller, c.*1500 (see
page 155). Dürer's young angel
resembles the angel-musician in
Giovanni Bellini's San Zaccaria
altarpiece painting of 1505,
which Dürer admired (see
page 48).

Head of the Lute-Playing Angel, 1506, brush
and grey ink, grey wash heightened with
white, on blue Venetian paper, 27 x 20.8cm
(10.6 x 8.1in), The Albertina Museum,
Vienna, Austria

Dürer used blue paper, purchased in Venice
– 'carta azzura' – for preparatory drawings
of *Madonna of the Rose Garlands*, 1506 (see
page 182). This study, and the Head of Christ
for *Christ, Among the Doctors* (see page 187),
were originally on the same folio sheet, and
the models for both are thought to be the
same person.

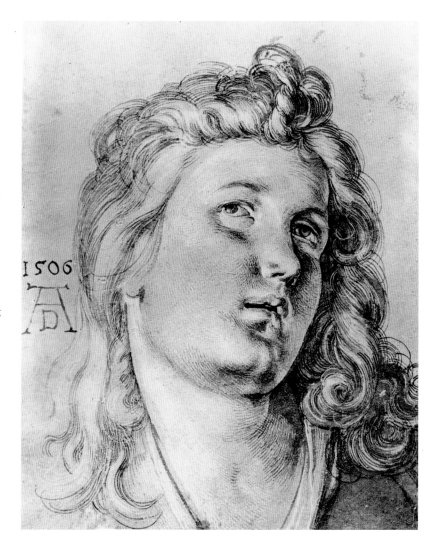

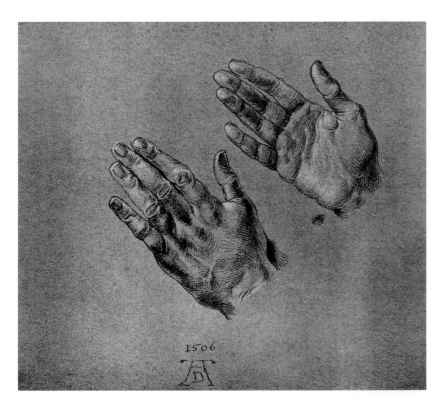

Study of Hands of the Emperor, 1506, brush drawing on blue Venetian paper heightened with white, 22.2 x 25.1cm (8.7 x 9.8in), The Albertina Museum, Vienna, Austria

The signature and date on this drawing were added later by another hand but the work is assigned as a Dürer original. The study relates to the hands of the kneeling emperor in *Madonna of the Rose Garlands*, 1506 (see page 182). Its realism equals the later *Praying Hands*, 1508 (see page 193), a preparatory study for the Heller altarpiece.

Study of an Architect (so-called Hieronymus of Augsburg in *Madonna of the Rose Garlands*), 1506, brush drawing on blue Venetian paper, 38.6 x 26.3cm (15.1 x 10.3in), Staatliche Museen zu Berlin, Germany

Delicate brushwork, cross-hatching and parallel hatching create a lifelike representation of the architect portrayed in *Madonna of the Rose Garlands* (see pages 182–83). An architect working in Venice, Hieronymus of Augsburg, is positioned at far right, toward the front, dressed in black. He is identified from one of 22 drawing studies, all drawn on Venetian blue paper, that Dürer created of various figures. Hieronymus was in Venice to rebuild the German trading house, Fondaco dei Tedeschi, burnt down in a fire in 1505.

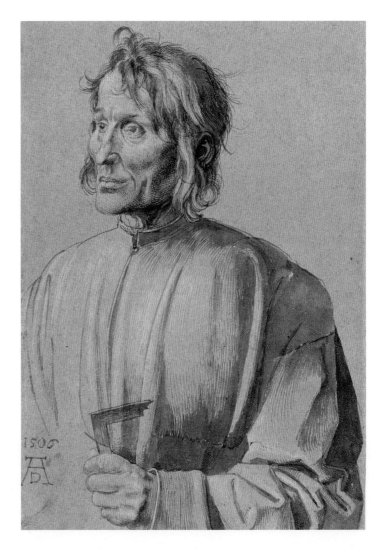

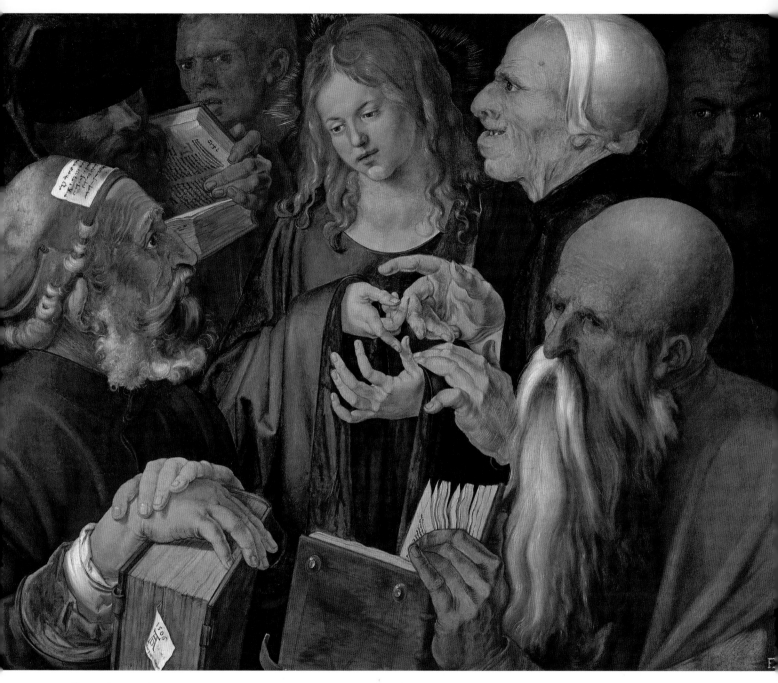

Christ, Among the Doctors, 1506, oil on poplar wood, 64.3 x 80.3cm (25.3 x 31.6in), Museo Thyssen-Bornemisza, Madrid, Spain

This painting was created in Venice, after Dürer had finished the *Madonna of the Rose Garlands,* 1506. He mentions it in a letter dated 23 September 1506, to Willibald Pirckheimer. The composition follows the bible narrative Luke 2: 46–52, which reveals Christ, aged twelve, in the temple debating religious doctrine with the church Elders. Preparatory drawings (opposite) concentrate on faces, books, and hand movements. The closely cropped finished painting focuses on hands and heads. An inscription on the work, in Latin, tells that it was completed in five days; swift work for a many-figured painting. The composition may have drawn influence from works by Andrea Mantegna and Giovanni Bellini. The grotesque faces are similar to depictions by Leonardo da Vinci, some of which were copied and distributed for sale through artist networks. For instance, the Flemish painter Quinten Massys (1465/6–1530) copied a Leonardo drawing of an ageing woman for his own painting, *An Old Woman,* 1513.

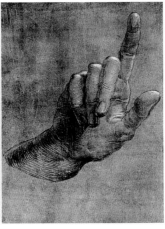

Hand studies for the painting *Christ, Among the Doctors*, 1506, Gallerie Barberini, Rome, Italy. Left: ink and brush drawing with white lights on blue paper; right: ink and brush drawing on green prepared parchment with white lights

The two studies concentrate on hand movements. One shows a left hand gripping a book with its pages open, as if referring to a particular narrative in the text. The other is a right hand with forefinger raised, a traditional visual for Christ's blessing, or for this composition, a relevant point in the discussion being raised. This is not however shown in the completed painting.

Head of Christ, 1506, brush and grey ink, grey wash, heightened with white, on blue Venetian paper, 27.5 x 21.1cm (10.8 x 8.3in), Gallerie Barberini, Rome, Italy

A beautiful study for the head and features of the young Christ, visualised at twelve years of age. The facial features are more defined than in the painting.

This study was created on one half of a double page with two drawings, the other being the *Head of a Lute-Playing Angel*, 1506 (see page 184). The similarity of facial characteristics suggests the same model for both characters. The double-page studies were linked, the shoulder of Christ overlapping the page with the study of the angel.

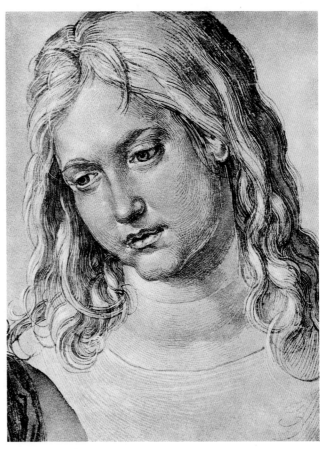

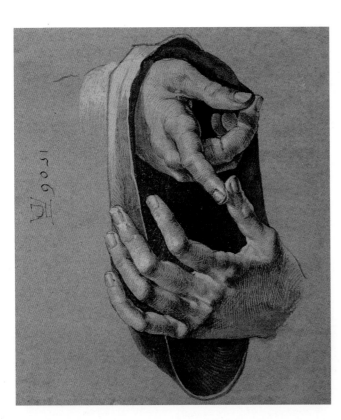

Hand study for the painting *Christ, Among the Doctors*, 1506, brush and black ink, heightened with white, on Venetian blue paper, 25 x 41.5cm (9.8 x 16.3in), Germanisches Nationalmuseum, Nuremberg, Germany

A superb preparatory drawing, created on Venetian blue paper. The meticulous crosshatching and use of white heightens attention on the young Messiah's expressive hands and fingers.

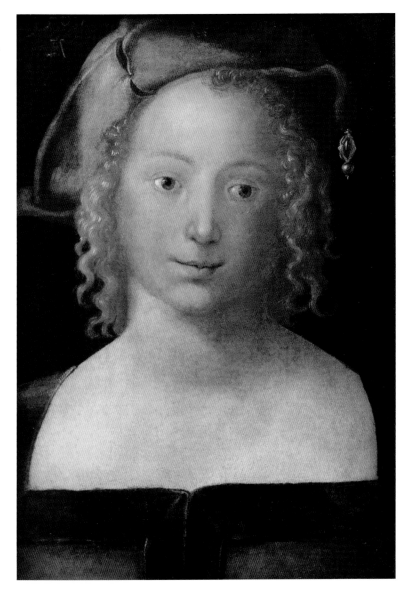

Portrait of a Girl with Red Cap, 1507, parchment on wood, 30.4 x 20cm (11.9 x 7.8in), SMB Gemäldegalerie, Berlin, Germany

The work, often debated as whether a portrait of a young girl or a boy, was possibly painted during Dürer's 1505–07 stay in Venice. He left for Nuremberg in the early Spring of 1507. The decolletage of the dress signifies a girl. Her pale skin is freckled; a realistic inclusion in the portrayal. Her golden hair is styled in meticulously painted soft, tiny ringlets. The red cap with dangling ornament is worn at the back of the head, and helps to frame her rose-cheeked face. Light shining from an unseen source colours the red hat to a shade of pink. The work was in the collection of the Nuremberg Imhoff family from 1573.

Madonna with the Siskin, 1506, oil on poplar wood, 93.5 x 78.9cm (36.6 x 31in), SMB Gemäldegalerie, Berlin, Germany

This work was painted during Albrecht Dürer's 1505–07 stay in Venice. The inscription on a cartellino lying on a table at near-front states 'Albertus Dürer germanus faciebat post virginis partum 1506' ('Albrecht Dürer the German was painting this in the year since the Virgin gave birth 1506'). Similar in style to the *Madonna of the Rose Garlands* (see page 182), possibly painted after its completion, the Madonna is seated under a baldachino, set in an outdoor landscape of many trees and distant buildings. Dürer surrounds her with cherubs, and includes a depiction of St John the Baptist, the young child at the feet of Christ, looking up at him. The Madonna holds his hand. The siskin refers to the small bird on the raised arm of the infant Christ. It is thought that Titian (1488–1576) saw this work before Dürer took it back to Nuremberg when he left Venice in 1507. It informed Titian's initial creation of *Madonna of the Cherries*, 1515 (Kunsthistorisches Museum, Vienna, Austria), later adding Saints Joseph and Zacharias.

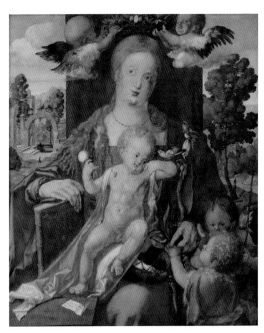

Portrait of a Young Man, 1507, oil on linden wood, 35 x 29cm (13.7 x 11.4in), Kunsthistoriches Museum, Vienna, Austria

A work from Dürer's 1505–07 stay in Venice; a head and shoulders portrayal, placing the sitter in three-quarter pose facing to his right. Dürer used a dark background with light source streaming from the left, which accentuates facial features, hair colour and the fine clothing of the sitter. It is thought that the sitter may have been a German merchant in Venice. On the reverse of the portrait, Dürer painted an elderly, semi-clothed, near-toothless woman, possibly an allegory of greed (see below).

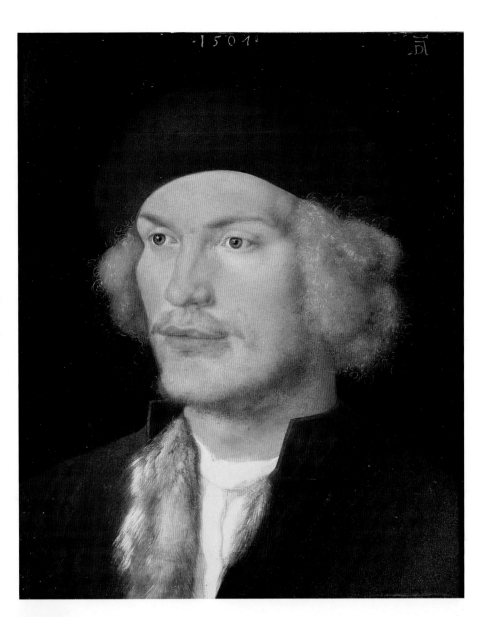

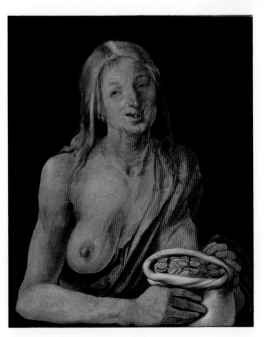

Allegory of Avarice, 1507, oil on linden wood, 35 x 29cm (13.7 x 11.4in), Kunsthistorisches Museum, Vienna, Austria

An unusual portrait, featuring a semi-naked, thin and elderly woman, who reveals a bare breast. She is depicted on the reverse of the painting, *Portrait of a Young Man*, 1507 (see above). It is thought to be an allegory of avarice or greed.

It has been suggested that the sitter did not pay the agreed fee, which led to a portrait of an allegory of avarice painted on the reverse. The real reason is not known. The woman holds a bag of coins in her hands. Dürer realistically paints the body of an ageing woman, her skin sagging, her eyes rimmed with red, and a faint smile on her lips that part to reveal a near-toothless mouth.

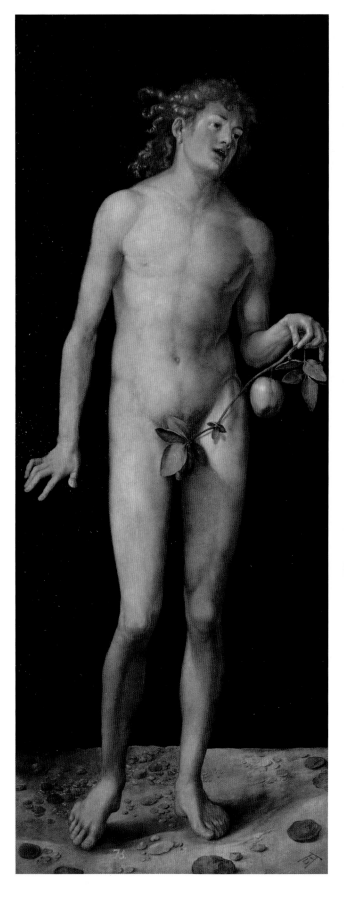

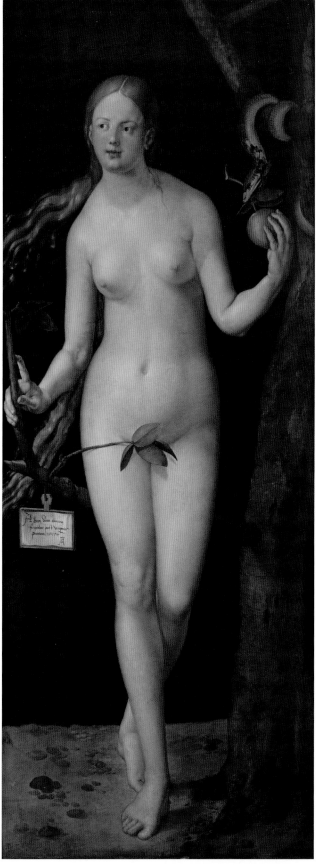

Left: *Adam* and *Eve*, 1507, oil on oak panel, both 209 x 81cm (82.2 x 31in), Museo del Prado, Madrid, Spain

Created as a pair of large-scale full-length paintings with the same foreground and background, the patron of the commission is not known. The paintings were in the possession of Nuremberg Town Hall in the late 16th century when they were presented to Rudolf II as a gift. They remained in his castle in Prague until the city was looted in 1648. The works depict idealised portrayals of Earth's first man and woman in the garden of Eden. On the left, Adam looks toward Eve. He holds a leafy branch of the tree of knowledge of good and evil, on which hangs a ripe fruit (Genesis 3). Eve holds part of the same branch in her right hand. To her left is the tree. At level with her head, Satan, disguised as a serpent, coils his body around a tree branch and proffers Eve a ripe fruit from the leafy branch held in his fangs. Dürer chose a plain dark background with a light source streaming from left, which concentrates attention on the frontal nudes. Movement is connoted by a wind from the right, or East, blowing the couple's hair, and from the movements of their feet.

Study of Arm of Eve, 1507, brush and grey and black wash, heightened with white gouache, on blue Venetian paper, 34.4 x 26.7cm (13.5 x 10.5in), Cleveland, Museum of Art, Cleveland, Ohio, USA

This exquisite drawing of the arm of Eve is the only extant preparatory study for the full-length paintings *Adam* and *Eve*, 1507 (see opposite).

Below: *Heller Altarpiece*, 1507–09, oil on panel, 190 x 260cm (74.8 x 102in), Historische Museum, Frankfurt am Main, Germany. Central panel is by Jobst Harrich (*c*.1579–1617) after Albrecht Dürer

Dürer's famous painting of the Assumption of Mary was destroyed by fire. His letters at the time indicate that Dürer considered this work to be one of his finest. He painted the central panel, and his workshop the side panels. Although we now know the work through the later copy, there are extant preparatory studies by Dürer, shown overleaf and on page 64. (See also pages 64–65.)

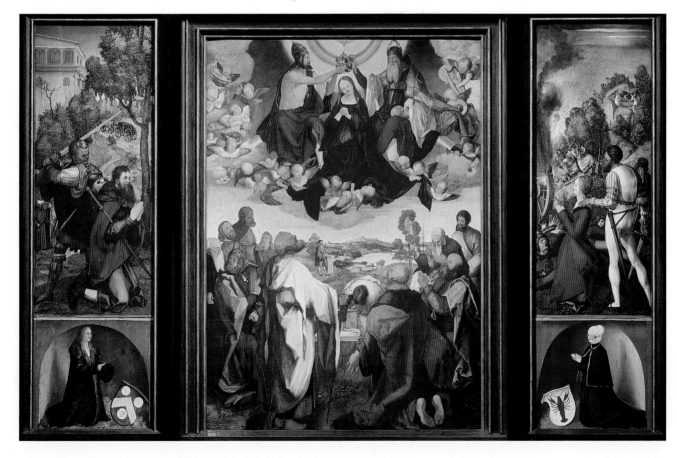

Head of an Apostle with a Cap, 1508, brush drawing on green primed paper, heightened with white, 31.7x 21.2cm (12.5 x 8.3in), The Albertina Museum, Vienna, Austria

In this study for the Heller Altarpiece (see pages 64–65 and 191), Dürer's shows his astounding ability to capture the nuances of a face. The thinning hair line, deep forehead lines, hollowing, sagging skin, sunken eye sockets and wispy, whitening beard connote ageing, yet depict a warm, kindly face, full of character. This apostle features on the lower register at upper right, his hand pointing to the scene above, where the Madonna appears to the throng of apostles on Earth.

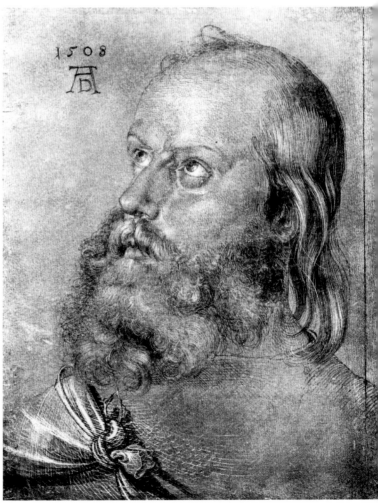

Head of an Apostle looking up, 1508, pencil drawing heightened with white, on blue paper, 29 x 23.6cm (11.4 x 9.2in), The Albertina Museum, Vienna, Austria

A preparatory study for the Heller Altarpiece, one half of a single folio sheet, depicting *Praying Hands* on the other half (see opposite above right). Here, the eyes of the apostle are fixed firmly on the figures above him, and on the ascension and coronation of the Virgin Mary in heaven. Another preparatory study for the Heller Altarpiece of an apostle's head looking upwards is shown on page 64.

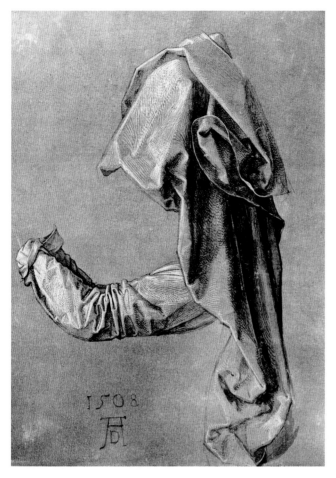

Above: *Drapery study for an Apostle*, 1508, ink and brush drawing on grey-green prepared paper, Private Collection

A preliminary study for the apostle's arm and drapery, in the central panel of the Altarpiece.

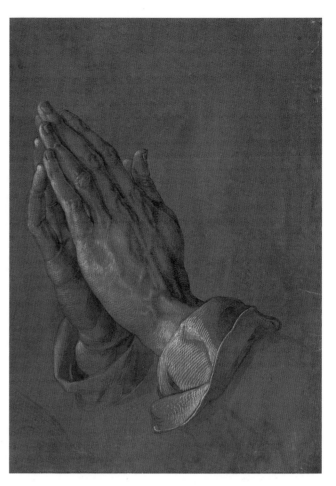

Above: *Praying Hands*, 1508, brush, grey and white ink, grey wash, on blue prepared paper, 29.1 x 19.7cm (11.4 x 7.75in), The Albertina Museum, Vienna, Austria

A remarkable study for the hands of the apostle (see opposite below). Using fine brushstrokes, Dürer pays close attention to the veins, the slim, bony fingers, and short nails of the elegant hands.

Above: *Feet of an Apostle*, 1508, brush in grey ink, grey wash, heightened with white, on green tinted paper, 17.6 x 21.6cm (6.9 x 8.5in), Museum Boijmons van Beuningen, Rotterdam, The Netherlands

An exquisite study for the bare feet of a kneeling apostle at centre of the Heller Altarpiece. Dürer creates a work of meticulous realism.

Right: *Study of the left hand of an Apostle*, c.1508, brush drawing, heightened with white, on green primed paper, 31.7 x 19.8cm (12.5 x 7.75in), The Albertina Museum, Vienna, Austria

The meticulous detail of this preparatory drawing pays attention to the positioning of the thin, long fingers and veins. Attention is also paid to the folds and creases in the apostle's sleeve.

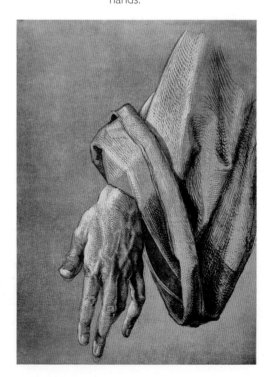

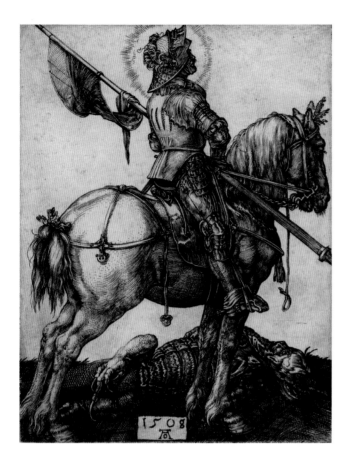

St George on Horseback,
1508, engraving, 10.9
x 8.5cm (4.3 x 3.3in),
Brown University Library,
Providence, Rhode Island,
USA

The legend of St George
slaying a dragon dates back
to Crusader knights' tales
of bravery in the Middle
Ages, although St George
(AD280–303) was a Roman
soldier, born in Cappadocia,
Turkey. Dürer created
this detailed engraving
depicting St George after
his combat with a dragon.
It lies vanquished, dead on
the ground. Dürer captures

a moment in time, after the
knight's conquest, and just
before he departs the scene.
The dragon's scaly body is
illustrated in detail. Dürer
began this engraving in 1505
but the date was changed
to 1508 on its completion.
The dating suggests that he
started the work before
his 1505–07 visit to Venice,
finishing it on return. The
composition and content of
this engraving was informed
by an earlier watercolour
A Maximilian Knight on
horseback, 1498 (see page
142) created ten years
earlier.

The Large Horse, 1509,
engraving, 16.7 x 11.9cm
(6.5 x 4.7in), Private
Collection

In the ruins of an ancient
building stands a horse and
a soldier, depicted in armour,
carrying a halberd pike. He
steps up to the ground

where the horse stands.
The animal is large and
muscular. It stands in three-
quarter profile, facing away
from the viewer. The horse
is groomed, its tail half-
plaited. Is this a depiction of
foreshortening of the body,
possibly to illustrate Dürer's
treatise on proportion?

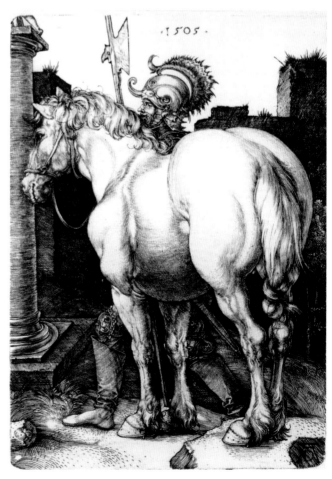

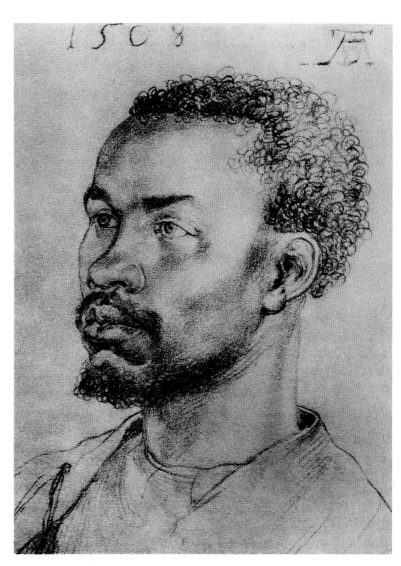

Portrait of a Young Man, 1508, black chalk, 31.8 x 21.7cm (12.6 x 8.6in), The Albertina Museum, Vienna, Austria

A superb study in a head and shoulders portrait of an African man, drawn from life, possibly in Nuremberg if the date of 1508 is correct; it was added to the drawing by another hand. Dürer portrayed Moors in depictions of the Adoration of the Magi, the three kings visiting the Holy Family. In 1505–07, Dürer in Venice would have met and mingled with many men from Africa and the Far East; the city was a central hub for trade and wealth. This study may have been created at the time. Dürer's mastery of the charcoal medium superbly renders the strong profile and the fine features, from the soft gleam of the man's fine skin to individual hairs on his head and chin beard.

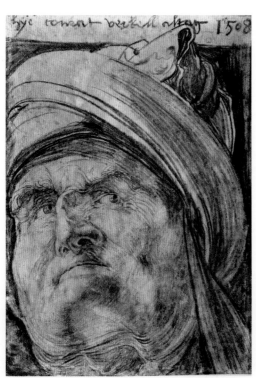

Conrad Verkell, 1508, black ink with brown wash and bodycolour, 29.5 x 21.6cm (11.6 x 8.5in), British Museum, London, England, UK

A head portrait of painter Conrad Verkell. Dürer has depicted him from below, his head turned almost to the front, with eyes looking up. He wears a turban-style headdress, a covering similar to that worn in Dürer's 1516 portrait of Michael Wolgemut (see page 218). Inscribed by the artist: 'hye Conrat Verkell altag' ('Here's Konrad Pig as ever was'). Only an enemy, or a great friend, could write such words, and Dürer was a very good friend of Conrad Verkell.

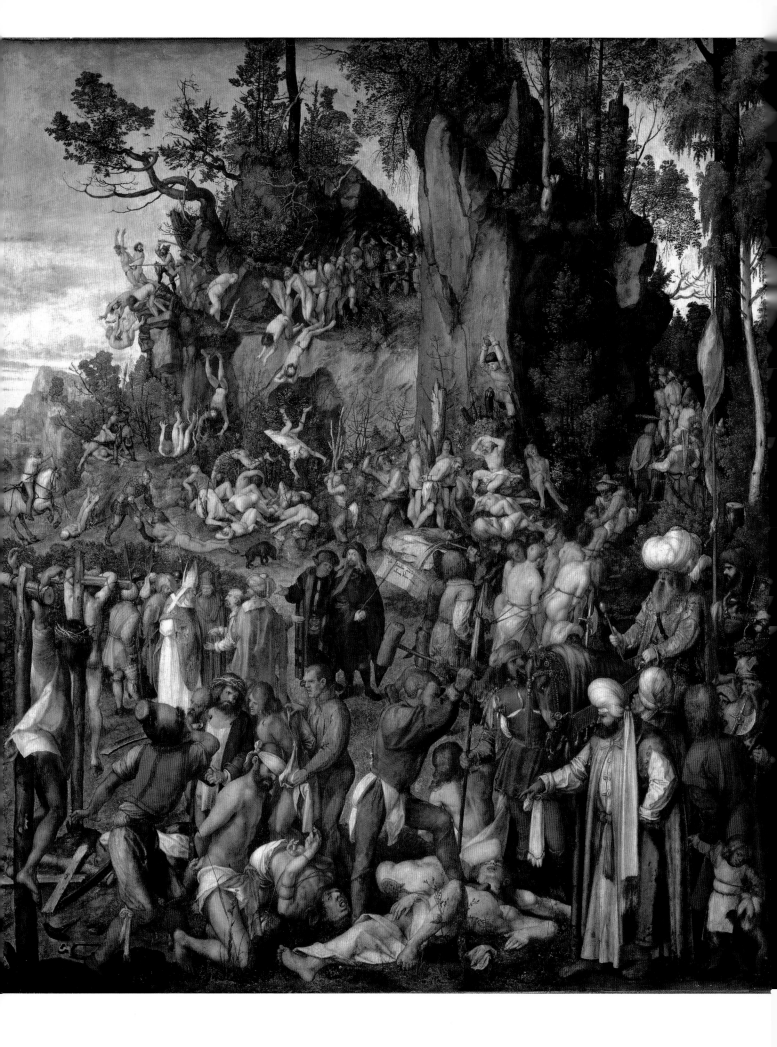

Left: *The Martyrdom of the Ten Thousand*, 1508, oil on wood, transferred on canvas, 99 x 87cm (38.9 x 34.2in), Kunsthistorisches Museum, Vienna, Austria

The scene depicted is a medieval legend, the martyrdom of 10,000 Roman soldiers who had converted to Christianity. Scenes of appalling cruelty are played out across Dürer's interpretation of the event. Men are crucified or forced to leap to their deaths from a cliff. Others are beheaded or stabbed. The mass conversion to Christianity was against the Roman rule that all citizens must sacrifice to Roman gods. Refusal meant death. The king of Persia, at the forefront right, on the orders of the Roman emperor, witnesses the horrific murders, and the execution of Saint Acacius, who had encouraged the soldiers to change their faith. The subject of the altarpiece

is a link to its patron Duke Frederick the Wise, Elector of Saxony, who owned many holy relics, including some of the bones of the 10,000 martyrs. They were kept in Castle Church, Wittenberg, where the duke planned this altarpiece to be placed. The altarpiece was commissioned by the duke on Dürer's return from Venice in 1507. After delays through Dürer's ill-health, it was completed by March 1508. Dürer's letter of 19 March 1508, to another patron, Jakob Heller, who was displeased with the delay of his own commission (the Heller Altarpiece), explains it is due to this other work. Dürer has placed himself in the centre, with Konrad Celtis, a friend and also a receiver of the Duke's patronage. Celtis died on 4 February 1508, around the time this painting was completed. It may explain why Dürer wears black mourning clothes.

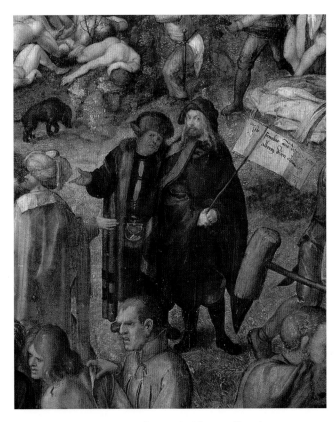

Above: *The Martyrdom of the Ten Thousand* (detail)

At the centre of the atrocities, Albrecht Dürer and Konrad Celtis stand and witness the brutality. Dürer holds a staff with a notice attached that reads 'Iste faciebat anno Domini 1508 albertus Dürer alemanus' ('This Albrecht Dürer the German was painting in the year of our Lord 1508').

Holy Family, 1509, oil on panel, 30.5 x 28.7cm (12 x 11.3in), Museum Boijmans Van Beuningen, Rotterdam, The Netherlands

Dated to 1509, the small size of this painting suggests it was created as a private devotional work. It is an intimate depiction of Mary, Joseph and the Christ child as a close family unit.

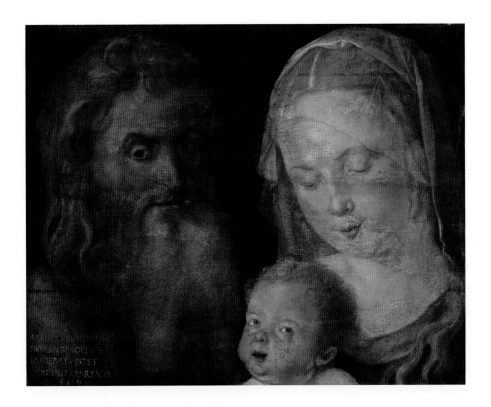

THE SMALL PASSION, 1509–11

There are four Passion series by Dürer, described by name for their size or colour, *Small Passion, Large Passion, Green Passion* and *Engraved Passion*, each created over a period of time and then published in book form (see also pages 58–59). *The Small Passion* is so-called because of its small page size; it was created 1509–10 and published in 1511. In this series of 36 works plus the frontispiece, Dürer begins with the creation of Adam and Eve and mortal life on Earth, and ends with The Last Judgement when mortals' souls are judged to reside in Heaven or Hell. Shown here are eight scenes and the frontispiece; *The Expulsion from Paradise* is also shown on page 29 and *The Resurrection* on page 59. Nearly all the original woodblocks for this series are now in the British Museum, London, England, UK.

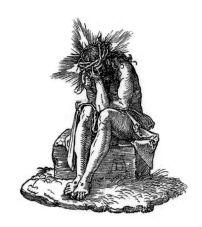

Left: *The Small Passion, Frontispiece,* 1511, woodcut, 12.8 x 9.8cm (5 x 3.8in), Private Collection

The title page of the published book, with Christ depicted as 'the Man of Sorrows'.

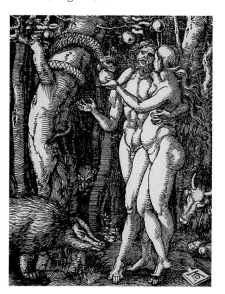

The Small Passion, Adam and Eve: The Fall of Man, 1510, woodcut, 12.8 x 9.8cm (5 x 3.8in), The Metropolitan Museum, New York, USA

In this first scene from the series, Dürer depicts Adam and Eve deep in conversation, their bodies in mirror image connoting empathy, love and affection. They stand by the tree of knowledge of good and evil, from which they must not eat the fruit. A serpent is coiled around the tree trunk and proffers a piece of fruit in its sharp jaws to Eve, who accepts it. Surrounding them are the animals of the Garden of Eden. Near every surface of the woodcut has been incised, adding depth to the background of trees in a deep wood, which focuses attention on the naked bodies of Adam and Eve.

The Small Passion, The Annunciation, c.1509–11, woodcut, 12.7 x 9.7cm (5 x 3.8in), Cleveland Museum of Art, Ohio, USA

An informal depiction of the Archangel Gabriel, accompanied by the Holy Ghost in the form of a dove, approaching the Virgin Mary in her bedchamber. The archangel gently moves aside a bed drape to address her. Kneeling in prayer, Mary turns to him, as he announces that she will conceive and give birth to Jesus, the Son of God (Luke 1: 26–38). Dürer includes a lily plant, a symbol of the Virgin's purity.

The Small Passion, The Nativity, c.1509–11, woodcut, 12.7 x 9.7cm (5 x 3.8in), Cleveland Museum of Art, Ohio, USA

In this depiction of the Nativity, the Virgin Mary is on her knees, worshipping the infant Messiah. More often she would be seated with the baby on her lap. The Holy Family, Joseph and Mary, with shepherds, are grouped around the newborn. An angel hovers above the infant. Dürer places the fourth scene in an old building without a roof, the vestiges of it hanging through the rafters. In the sky a bright star shines, guiding shepherds and kings to the birthplace of Bethlehem.

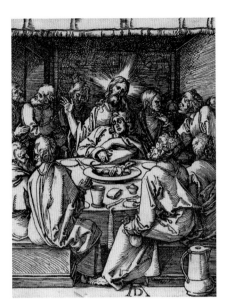

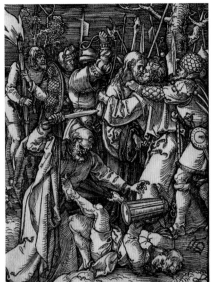

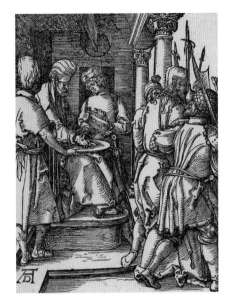

The Small Passion, Last Supper, 1509–11, woodcut, 12.7 x 9.7cm (5 x 3.8in), Cleveland Museum of Art, Ohio, USA

The Small Passion, The Betrayal of Christ, 1509–11, woodcut, 12.7 x 9.7cm (5 x 3.8in), Cleveland Museum of Art, Ohio, USA

The Small Passion, Pilate Washing his Hands, 1509–11, woodcut, 12.7 x 9.7cm (5 x 3.8in), The Metropolitan Museum of Art, New York, USA

The bible narrative of the Last Supper is found in Matthew 26: 17–30; Mark 14: 12–25; Luke 22: 7–20; and John 13: 1–30. In Dürer's visualisation, the eighth scene, four disciples are seated at a round table, facing Christ at centre, with their backs to the viewer. One is Judas who holds the bag of 30 pieces of silver, paid to him to betray Jesus. The supper is lively: the party animated, talking, listening, watching. John the Apostle has fallen asleep whilst Christ raises his right hand in benediction. The tightly cropped composition adds to the sense of close friendships.

A scene of violent action is visualised in the eleventh image, as Christ is taken prisoner by an angry mob. At centre Judas Iscariot kisses Christ on the cheek as if in friendship, but it is the signal to betray Christ, leading to Christ's arrest. At the left, disciple Peter raises a sword to smite Malchus, the servant of the High Priest, slicing off his ear (John 18: 10; Matthew 26: 27–53; Mark 14: 43–46). Dürer captures the mayhem of the scene and the movement of the bodies.

Pontius Pilate, the Roman governor of Judea (AD26/27–36/37) will not agree to commit Christ to death, and symbolically washes his hands of the decision, leaving it to the mob to decide. This is the twentieth scene.

Below left: *The Small Passion, The Crucifixion*, 1509–11, woodcut, 12.7 x 9.7cm (5 x 3.8in), National Gallery of Art, Washington DC, USA

Dürer follows the bible narrative of the crucifixion of Christ: Matthew 27: 32–66, capturing the intimacy and agony of the family in the 24th scene.

Left: *The Small Passion, Supper at Emmaus*, 1509–11, woodcut, 12.8 x 9.7cm (5 x 3.8in), The Metropolitan Museum of Art, New York, USA

Following Christ's crucifixion, burial and resurrection, he appears to travellers on the road to Emmaus (Luke 24: 13–35, and Mark 16: 12) in the 32nd scene. They stop for supper, and during their conversation, the men realise they are in the presence of the risen Christ.

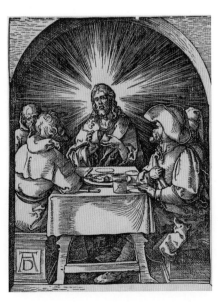

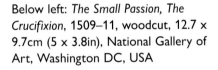

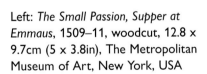

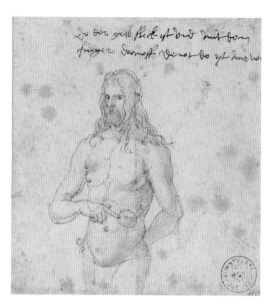

Self-portrait: The Sick Dürer, 1509–11, brown ink and watercolour, 11.8 x 12.8cm (4.6 x 5in), Kunsthalle, Bremen, Germany

Albrecht Dürer's gift for self-portraiture created remarkable paintings, and also drawings, and highlight his personal life. In this note to his physician, he graphically shows where he was suffering pain. The hand-written inscription on it states: 'Do der gelb fleck ist und mit dem finger drawff dewt do ist mir we' ('This is the yellow spot and when I press my finger on it, it hurts'). He was pointing to his spleen.

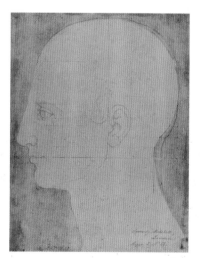

Design for a Table Fountain, 1509, pen and brown ink with green, pinkish-brown and brown wash and watercolour, 30.1 x 19.3cm (11.85 x 7.5in), Ashmolean Museum, University of Oxford, England, UK

An intricate, highly decorated goblet, designed by Dürer, shows detail that was typical of the pieces created in the workshop of Albrecht Dürer the Elder, where Dürer the Younger was first apprenticed.

Above: *Head of a man in profile*, c.1513–14, pen and ink and brush, 24.3 x 18.9cm (7.4 x 9.5in), Pierpont Morgan Library, New York, USA

A study of the sectional proportions of the human head.

St Christopher, 1511, woodcut, 21 x 21cm (8.2 x 8.2in), The Metropolitan Museum of Art, New York, USA

The legend of St Christopher, a tall, strong man, is that he devoted himself to carrying travellers, particularly the weak and in need, across a dangerous river. Unknowingly he carried the infant Christ across the water. The weight of the young child became heavier with each step and the infant revealed that Christopher was carrying the weight of the World on his shoulders. Dürer visualises St Christopher symbolically bearing the weight, carrying the infant across the river. The flowing robes connote the saint's movement.

Cain kills Abel, 1511, woodcut, 11.7 x 8.4cm (4.6 x 3.3in), Private Collection

A violent depiction of the bible narrative Genesis 4: 8–16, in which Cain murders his brother Abel. They are the children of Adam and Eve, Earth's first mortals. Dürer shows Cain wrestling his brother Abel to the ground. The brutal murder shocks – not only because they are brothers – but it breaks the sixth of the Ten Commandments from the Old Testament, 'Thou Shall Not Kill'.

The Holy Family with Two Music-Making Angels, 1511, woodcut, 21 x 21.1cm (8.2 x 8.3in), Cleveland Museum of Art, Ohio, USA

Set in a wooded, hilly landscape, the social interaction between the Holy Family and the surrounding group creates a realistic scene of a rest stop on the group's journey. At centre, the Virgin breastfeeds the infant Christ, while her mother, sitting next to her, reads. Her father Joachim and husband Joseph stand protectively near them. At left a man holding a water container converses with others, giving a sense of realism through their interactions. In the forefront, at the feet of the Virgin, are two small music-making angels, which elevate this natural scene to indicate that this is the Holy Family.

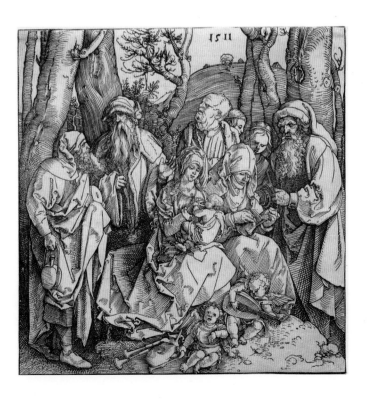

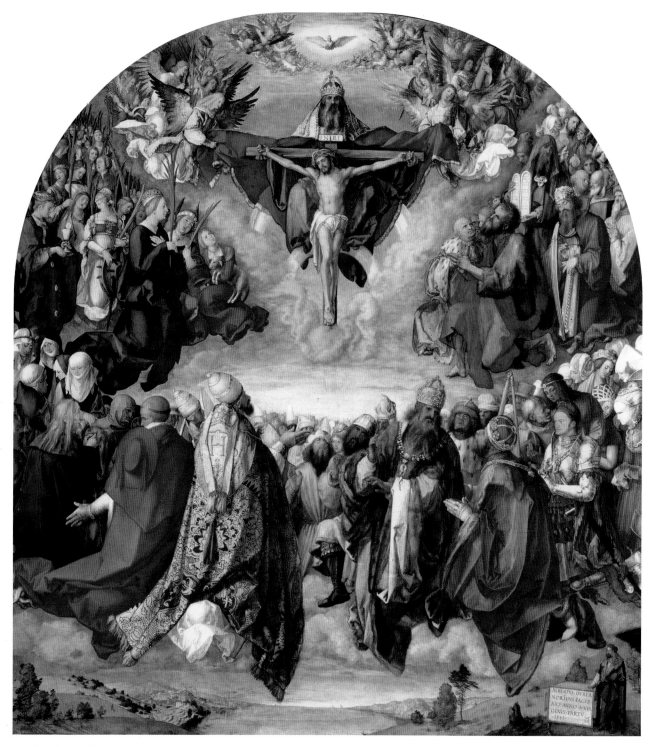

The Landauer Altarpiece, All Saints Day, 1511, oil on poplar wood panel, 135 x 123.4cm (53.1 x 48.5in), Kunsthistoriches Museum, Vienna, Austria

Also known as *The Adoration of the Holy Trinity*, this vision of a Civitas Dei (City of God) features images of the donors Matthäus Landauer and Wilhelm Haller. Landauer, a Nuremberg councillor, was

a wealthy metals trader, and foundry owner. His intention was to place the altarpiece in the All Saints Chapel of the House of the Twelve Brethren, an alms-house in Nuremberg (destroyed in WWII), which he founded. The patron wanted the painting to be as lavish as possible with much gold leaf. The frame was to be equally spectacular. The painting was commissioned in 1508 and completed in 1511, and remained in

the chapel until 1585. The single panel altarpiece depicts the Adoration of the Holy Trinity, depicted at centre at the highest level. In the next level are saints with the Virgin Mary at left with female saints; and John the Baptist at right with male saints. Below them on the lower level are the secular and celestial congregation with two popes present. There is a self-portrait of Dürer at the bottom right (see also page 32).

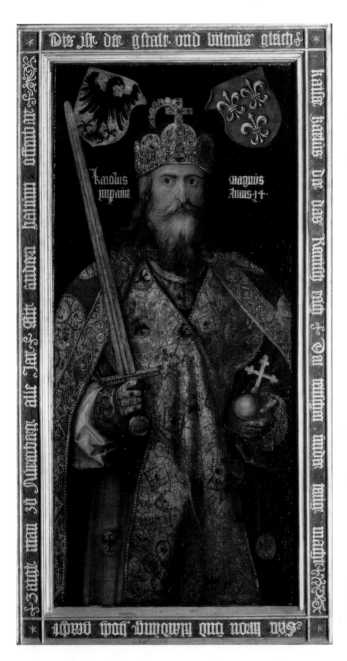

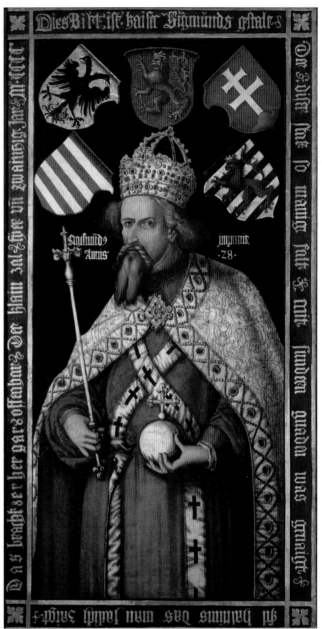

Emperor Charlemagne, 1511–13, oil on linden wood, 187 x 87.6cm (73.6 x 34.4in), Germanisches Nationalmuseum, Nuremberg, Germany

Emperor Sigismund, c.1600, after original by Albrecht Dürer, oil on canvas, 213 x 133cm (83.8 x 44.4in), Kunsthistoriches Museum, Vienna, Austria

Both paintings relate to the Holy Roman Emperor's official regalia kept in Nuremberg. Albrecht Dürer was commissioned to paint two portraits, one of each emperor, to hang in the Schopper Haus on Hauptmarkt. The emperor's regalia was displayed once a year to the public, in a ceremony called the Heiltunsweisung. Both emperors were dead, so Dürer, without depictions to refer to, idealised the portrait of Charlemagne, taking care to add regalia and emblems of the Imperial ruler. For the Sigismund portrait he researched and referred to earlier portraits of the emperor to replicate a likeness. Only the Charlemagne is the original Dürer; the Sigismund is a later copy (painted on canvas rather than wood). Above the head of Emperor Charlemagne (AD747–814), the 'Father of Europe', are two coats of arms: the German double-headed eagle of the Holy Roman Empire, and the French fleur-de-lis. He wears the heavily jewelled Imperial crown, with the sword of state in his right hand, and the orb in his left hand. Emperor Sigismund (AD1368–1437), Holy Roman Emperor, King of Hungary and Bohemia, is portrayed with five coats of arms: the German double-headed eagle of the Holy Roman Empire, of Bohemia, of Hungary (the new and old coats of arms) and of Luxembourg.

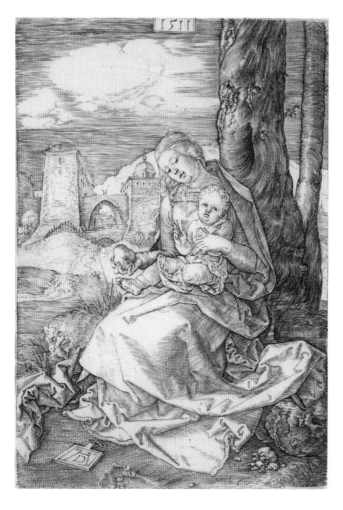

The Virgin and Child with the Pear, 1511, engraving, 15.9 x 11.1cm (6.2 x 4.3in), Dallas Museum of Art, Texas, USA

The Virgin, seated, resting against the trunk of a gnarled tree, holds her infant son on her lap. In her right hand she holds a pear, a symbol of the sweetness and affection between the Holy mother and child. The Christ child looks out toward the viewer. His right hand is raised, as if in the act of blessing the onlooker. In the distance at left is a watchtower and a bridge, possibly a setting observed by Dürer on his travels across countries.

The Holy Family with Joachim and St Anne, 1511, woodcut, 23.5 x 15.8cm (9.2 x 6.2in), Art Institute of Chicago, Illinois, USA

Under the shade of large trees with woods and a house in the distance, Dürer captures an intimate moment of interaction between the Virgin and her parents, St Joachim and St Anne, with St Joseph and the infant Christ. At left, Joachim stands, watching over his wife as she picks up the Christ child, her grandson, from the arms of the Virgin. The infant looks into his grandmother's face. Prints of Dürer's many depictions of the Holy Family, or the Virgin and Child, were immensely popular and sold well.

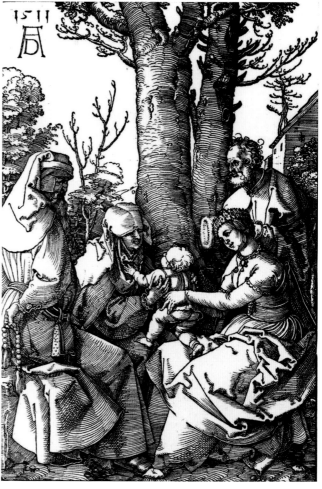

Virgin and Child (or Madonna and Child with a Pear), 1512, oil on linden wood, 49 x 37cm (19.3 x 14.5in), Kunsthistoriches Museum, Vienna, Austria

This work was probably a private devotional portrait, for an unknown patron. It is known also as *Madonna and Child with a Pear*, referring to the fruit held in the infant's left hand, a traditional symbol of Christ. A comparable depiction of the Madonna's head is found in Dürer's *Holy Family*, 1509 (see page 197). The composition, and depiction of the Madonna and infant, compares to Florentine art, in the work of Andrea del Verrocchio, Sandro Botticelli and Leonardo da Vinci. (Shown large on page 146.)

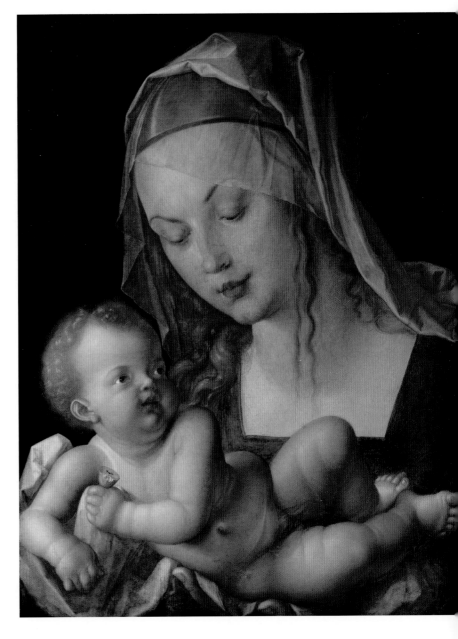

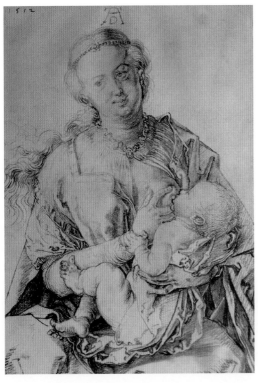

Virgin Mary suckling the Christ Child, 1512, charcoal drawing, 41.8 x 28.8cm (16.4 x 11.3in), The Albertina Museum, Vienna, Austria

A lifelike portrayal of a mother breastfeeding her infant child. The virgin Mary's eyes are turned to her right, as if in thought. The baby pushes his left foot into her arm, to balance his body, while lying in her arms. Dürer created many preparatory studies of drapery to add realism to clothing.

Above: *View of Kalchreuth, near Nuremberg*, 1511, watercolour on paper, 21.6 x 31.4cm (8.5 x 12.3in), Kunsthalle, Bremen, Germany

A view of the houses in the village of Kalchreuth, 15km (9.3 miles) north of Nuremberg, an easy distance to travel on horseback in a day. Dürer may have travelled to this location, to see family, friends or clients, or possibly to create images for his workshop. The watercolour depicts a group of houses nestling in the valley in a countryside landscape. The village was named after the Kalkreuth nobility, dating to the 13th century in this location.

Arion (or *Sea Monster*), 1514, watercolour on paper, 14.2 x 23.4cm (5.5 x 9.2in), The Albertina Museum, Vienna, Austria

Arion, a poet of ancient Greece, was held captive on a boat at sea. Before being thrown overboard he asked to play his lyre once more. The music was sweet and attracted dolphins who rescued him, and took him back to Lesbos, his island home. Dürer portrays the naked poet with lyre, hanging on to the back of a dolphin that resembles a friendly sea creature.

Above: *Squirrels*, 1512, tempera on parchment, Private Collection

A squirrel eating hazelnuts is observed from the front, in three-quarter stance and from the rear, with attention paid to the red squirrel's bushy tail and rich red tones of the fur. Dürer was masterful at capturing the characteristics of animals. He created many illustrations, including deer and owls, horses, squirrels, pigs and insects. They appear in major paintings.

Peasant Couple Dancing, 1514, engraving, 11.8 x 7.5cm (4.6 x 2.9in), The Art Institute of Chicago, Illinois, USA

Dürer created a series of portrayals of German people, including many of manual workers, living in rural areas and towns: peasants, farmers, a baker and more. These could be sold as solo prints or used as models for characters in other works. Here, the gaiety and movement of a peasant dance and its routine is captured. Dürer pays close attention to the clothing and footwear worn by the peasant couple.

Opposite: *Melencolia I*, 1514, engraving, 23.8 x 18.7cm (9.3 x 7.3in), The Clark Art Institute, Williamstown, Massachusetts, USA

Melencolia I – there is no further numbered work with this title – was created in 1514, one of three 'master engravings' with *Knight, Death and Devil* (see below) and *St Jerome in his Study* (see overleaf). (See also pages 70–71.) In an outdoor setting, a prominent winged figure, possibly female but not confirmed to be, with long hair crowned with a wreath of foliage, is seated amongst a plethora of intriguing objects. The figure's facial expression implies exhaustion or sadness. The sharp eyes connote concentration, or is it fatigue? Facing to the viewer's left, with left elbow resting on the knee, a fisted hand supports the cheek and head as if in deep thought (an established melancholic action). In the right hand the figure holds a woodworking compass, or dividers, on her lap. At her waist is tied a bunch of keys and a drawstring money-sack or purse. On her right a putto, writing on a slate, is seated on top of a partly covered millstone. Meanwhile, a sleeping dog is curled up at the winged figure's feet, oblivious to its surroundings. The sentient beings reveal nothing to the onlooker as to who they are or where they are, or what they are doing. Are they waiting for someone? It is a delicious conundrum, a masterpiece still today waiting to be revealed.

A plethora of objects fill the immediate space around the seated angel. A comet crosses the sky above calm waters with a glimpse of land in the distance. In the sky is written the title 'Melencolia I'. To the right, a building with large cornice has no entrance door. A ladder leaning against it may lead to an upper entrance in the building. Hanging from its walls is a pair of scales.

In *Libri de Vita Triplici* (*Three Books on Life*), 1480–89, by the Italian philosopher, humanist and Neo-Platonist Marsilio Ficino (1433–99), he referred to atra bilis 'black bile' (melaina) as one of the four fluids (humores) of the body – alongside blood (sanguis), yellow bile (chole) and phlegm (phlegma), with vapours that affected the mind's temperament. Thus, sanguis produces positivity; chole, a volatile character; phlegma induces lethargy; and melaina generates melancholy in an imaginative, artistic mind. These texts were available to Dürer through his friend Willibald Pirckheimer. In addition, German physician Heinrich Cornelius Agrippa von Nettesheim (1104/06–1535) in his first edition of *De Occulta* or *Occulta philosophia*, written in 1510, published 1530, referred to melancholia as a syndrome of artists, artisans, and architects. A friend of Dürer's, the classical scholar Joachim Camerarius, in *The Elements of Rhetoric,* (published 1541) described it with greater clarity as 'the emotions of a deep and thoughtful mind'. Associations with melancholy have also been suggested that stem from astrological theories. The 'children' of planet Saturn are prone to depression and melancholy when the planet is aligned with Jupiter, possibly the reasoning behind Dürer's inclusion of the magic square, a buffer against the destructive influence of Saturn. Across the centuries, authoritative theorists have varied opinions on Dürer's objective, including the German scholars Hartmut Böhme (born 1944), and Peter-Klaus Schuster (born 1943).

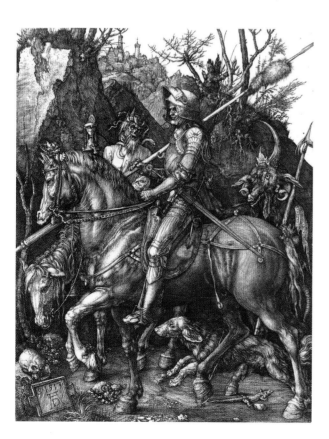

Knight, Death and Devil, 1513, engraving, 24.6 x 18.9cm (9.6 x 7.4in), Musée de la Ville de Paris, Musée du Petit-Palais, Paris, France

Dürer's *Knight, Death and Devil* (shown large on page 56) captures a tense journey through woods. The knight or pilgrim on horseback is riding at speed with his dog running alongside. They are watched by a tired devil on a near-dead horse, holding an hourglass, a symbol of the inevitability of death approaching. An unearthly creature in the background follows the knight's trail. Dürer's deliberate, tightly packed, engraved lines create a dark scene in a mystical forest. This is a period of heroic medieval knights with castles – viewed on the distant hill – as a protected space. The wooded, tangled forest symbolises wildness, the unknown path, and uncertainty of life. And there is more than one interpretation. The knight could be a sinner galloping through life, given a sudden warning by Death of his mortality.

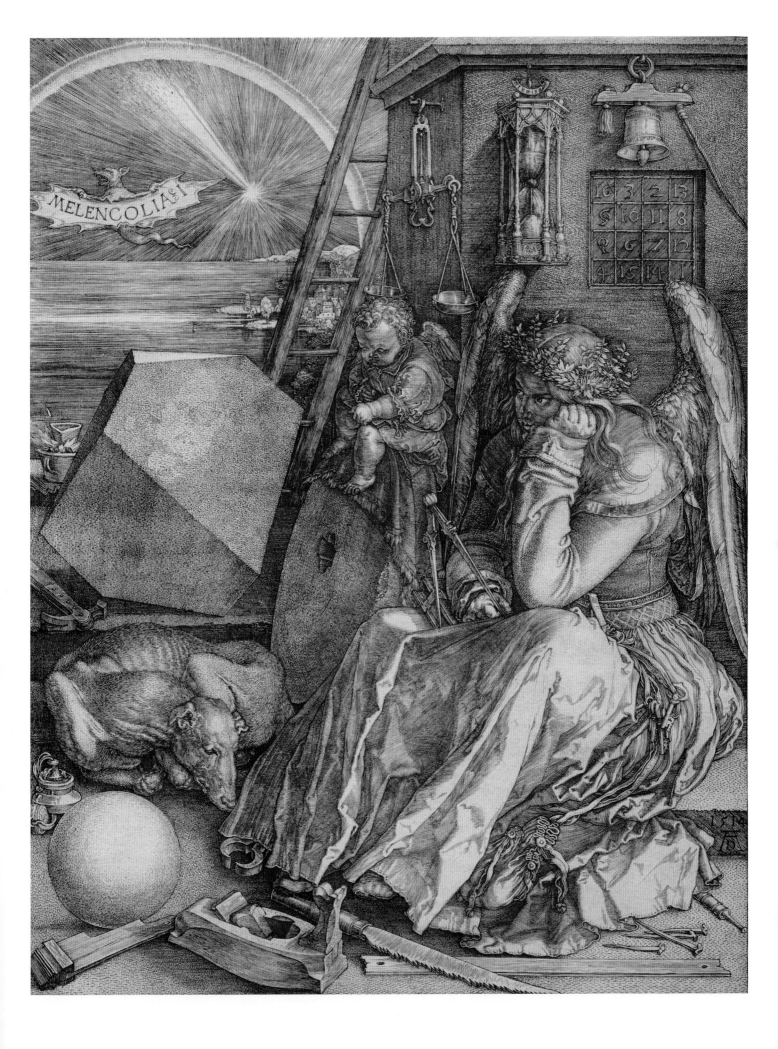

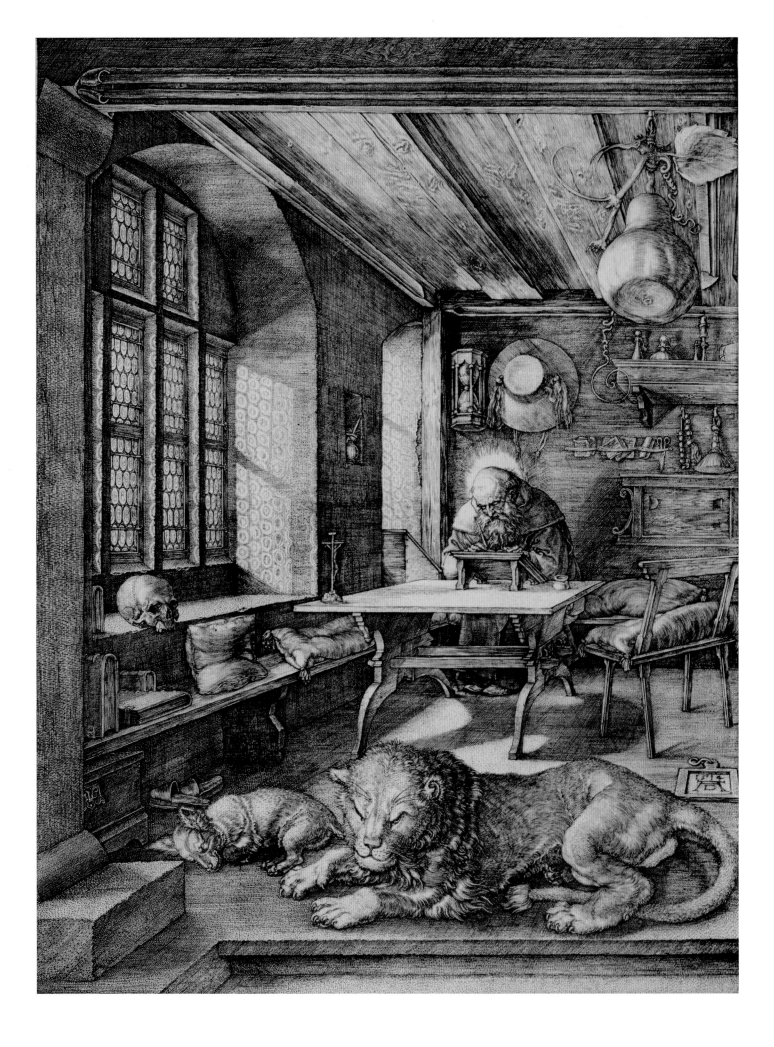

Left: *St Jerome in his Study*, 1514, engraving, 24.4 x 18.8cm (9.6 x 7.4in), Allen Art Museum, Oberlin, Ohio, USA

St Jerome was a favourite saint of Dürer, and he depicted the hermit many times, traditionally placing him in the wilderness, or in his study. Here, in this famous engraving, St Jerome sits in his study, at his table, with a small bookrest in front of him. A halo of light shines around his head, as he reads. In his room lies a lion, his protector companion, half-sleeping but alert, and close by, a small dog is curled up asleep. Rays of sun fall over their bodies, entering the room through bottle-glass windowpanes at left. The sunlight creates an ambience of warmth, cosiness, and calm. It is in stark contrast to the uneasiness and discord Dürer created in *Melencolia I* (see previous page). On the window ledge there is a skull, a symbol of man's mortality, along with the hourglass that hangs behind the seated saint next to his cardinal's hat. A chair is drawn up next to the table. Does it connote the presence of another person or a place set, ready to welcome in a visitor? Dürer's calling card lies on the floor. The close-cropping of the composition gives a sense that the spectator is in the room.

Above: *St Jerome*, 1511, oil on wood, 33.2 x 25.6cm (13 x 10in), Pinacoteca Nazionale, Siena, Italy

The rich red of a cardinal's robes contrast with the dark, plain background and the head of St Jerome. The head and shoulders, in a front-facing composition, concentrates on the saint's kindly face, with eyes lowered. His balding head catches the light from an unseen source at left, highlighting silvery white strands in his beard.

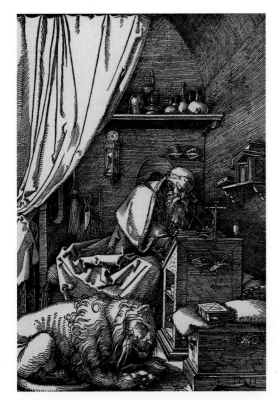

Left: *St Jerome in his Study*, 1514, woodcut, 22.9 x 16cm (9 x 6.2in), The Metropolitan Museum, New York, USA

Another depiction of the hermit St Jerome, in his cell with his companion lion. The tamed beast lies asleep at his feet. The long beard of the hermit compares to the magnificent mane of the lion. St Jerome is sitting on a cushioned bench, reading at a lectern. His hands rest on the book. On a shelf above, books and manuscripts are piled up. St Jerome wears his cardinal's hat, an attribute of the saint. A ceiling-to-floor curtain is pulled back and lifted up, possibly a curtain for his bed. Dürer creates a cell-like, cramped space, tightly cropping the body of the lion, and the low chest of drawers at forefront. Light floods into the room from an unseen source at left, connoting a window.

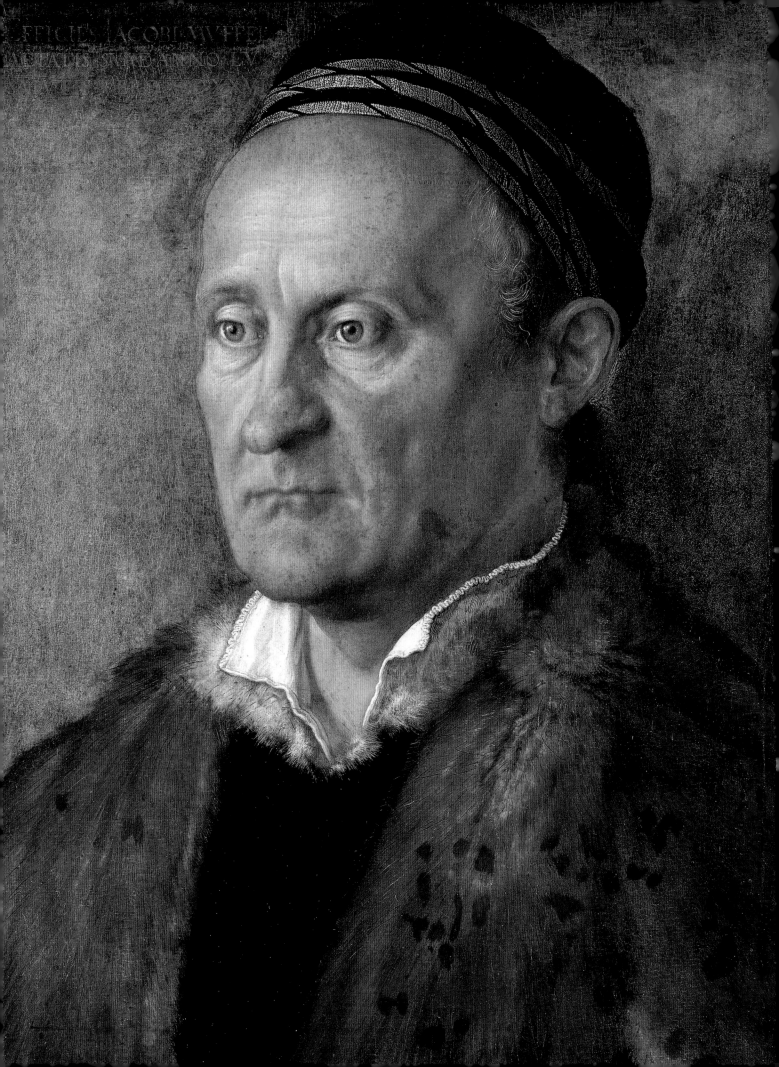

DÜRER
1515 TO 1528

In the third period of Dürer's life, a grand project for Maximilian I brought him together with other artists, only curtailed with the death of the emperor in 1518. It was possibly a plague in Nuremberg that made Dürer vacate the city in 1520 and travel again for work, this time to the Netherlands, with his wife and a servant. Wonderful silverpoint drawings record many of the ordinary people he met on his journey, and the sights he saw. In the Netherlands Dürer was feted as a celebrity, such was the respect artists and patrons had for him and his work. A short trip to Zeeland in December 1520 to see a beached whale may have been where Dürer caught a virus that made him sick. His health deteriorated, and his physical ability to paint larger works such as altarpieces diminished.

Instead, he concentrated on woodcuts and engravings, with a flourish of portraits in 1526. He had more time to continue research relating to his earlier treatises on painting, human proportion and fortifications, published posthumously. His death came suddenly.

Above: Abduction of Proserpine on a Unicorn, *1516, etching, 30.8 x 20.96cm (12.1 x 8.2in), Minneapolis Institute of Arts, USA. Proserpine, in Greek myth, was kidnapped by Hades, God of the Underworld. Dürer depicts Hades on a unicorn, capturing the violence of the assault.*

Left: Portrait of Jakob Muffel, Mayor of Nuremberg, *1526 (see also page 247).*

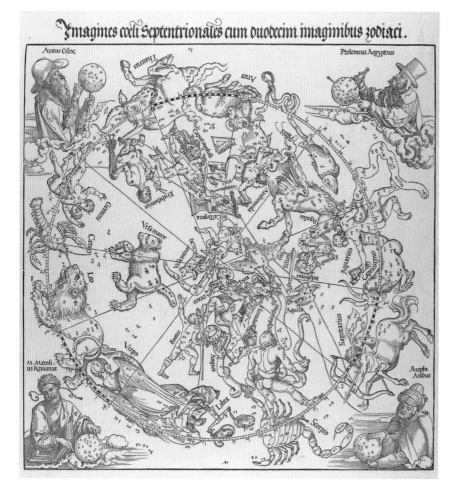

The Celestial Map – Northern Hemisphere, 1515, woodcut, 61.3 x 45.6cm (24.13 x 17.95in), The Metropolitan Museum of Art, New York, USA

The ancient tradition of making celestial maps can be traced back, by way of Arabic sources, to Classical ones. Dürer's two maps, of the Northern and Southern Hemispheres (left and below), derive from an Arabic type that depicted each hemisphere separately. Dürer's sources were two 1503 maps of the stars in Nuremberg. He made his different by adding the portraits of early astronomers with their names: Aratus Cilix, Ptolemeus Aegyptius (Ptolemy), M. Mamlius Romanus (Marcus Manilius), and Azophi Arabus (Al-Sufi), one to each corner.

The Celestial Map – Southern Hemisphere, 1515, woodcut, 42.5 x 43.2cm (16.7 x 17in), The Metropolitan Museum of Art, New York, USA

This woodcut of the southern sky is based on maps of the stars drawn by an anonymous artist living in Nuremberg in 1503. Recalculated to reflect the stellar positions of 1515, Dürer's celestial maps were the first ever published, and attest to the role that Nuremberg played as a centre for printing, as well as for the manufacture of scientific instruments.

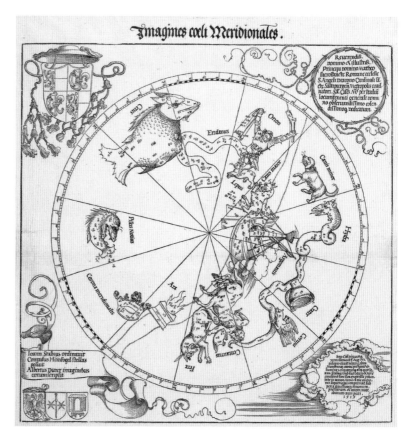

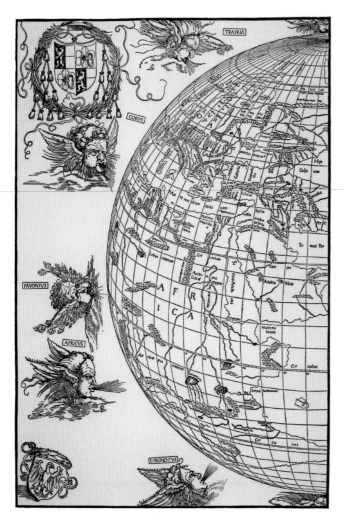

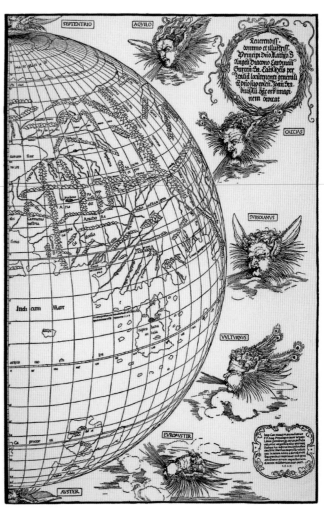

Stabius World Map – Western Half, 1515, woodcut, 22.1 x 16.2cm (8.7 x 6.4in), Private Collection

Stabius World Map – Eastern Half, 1515, woodcut, 22.1 x 16.2cm (8.7 x 6.4in), Private Collection

The humanist Johannes Stabius (1450–1522), astronomer to Maximilian I, co-ordinated with Albrecht Dürer on the creation of monumental prints, such as the *Triumphal Arch of Maximilian I* and *The Large Triumphal Procession of Maximilian I* (see pages 226–27). In addition, together they created four scientific images, including a visualisation of a world map, in woodcut, in two sections, as a sphere. It is surrounded by depictions of twelve wind-heads. In the four corners are the Arms of Cardinal Matthäus Lang, Archbishop of Salzburg, a dedication by Stabius to Archbishop Lang, a privilege granted to Stabius by Maximilian I, and the Arms of Stabius. In total four woodblocks were made to make the joined-up sphere. Stabius' designs were intended to be beautiful as well as practical; he and Dürer both agreed that art and science were compatible. The world map was a pendant to a pair of celestial chart maps (see opposite), designed as one.

Opposite: *Eight Studies of Wildflowers, c.*1515–20, watercolour on paper, 27.8 × 34.1cm (10.9 × 13.4in), Musée Bonnat, Bayonne, France

A collection of wildflower studies, for Dürer's collection of workshop stock, to reuse in paintings and portraits. There are eight different field flowers. Top left, *Galium aparine* (Cleavers or Stickyweed); lower left,

Lotus corniculatus (Birds' Foot Trefoil), followed by *Lamium orvala* (Archangel or Balm-leaved Red Deadnettle); in the middle, *Campanula trachelium* (Bellflower); in the middle at the top, *Carduus nutans* (Thistle); in the middle

at the bottom, *Cichorium intybus* (Chicory), followed on the right by *Silene latifolia* (White Campion) and on the far right, *Lythrum salicaria* (Purple Loosestrife).

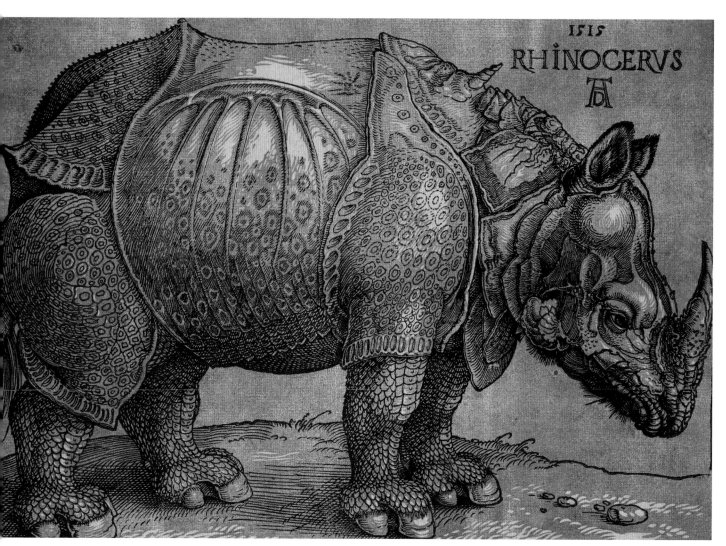

The Rhinoceros, 1515, **woodcut from two blocks, 23.5 × 30.1cm (9.2 × 11.8in), Private Collection**

In his famous (if inaccurate) woodcut, Dürer depicted the imposing presence of a majestic animal, with

its large proportions and distinct 'armour-plating' of heavy layers and folds of greyish-brown thick skin. He visualised its elongated head, trumpet-shape ears and singular large horn. The arrival in Portugal of a live rhinoceros in 1515 (see also

pages 72–73) caused great interest and excitement, and many artists depicted the new arrival in drawings and woodcuts. What Dürer added to *Rhinoceros,* and his other animal portrayals, was a sense of presence, the character and temperament

of a creature, even when working from a description alone. He had an empathy with animals which was represented in his art, beyond physical likeness and realism.

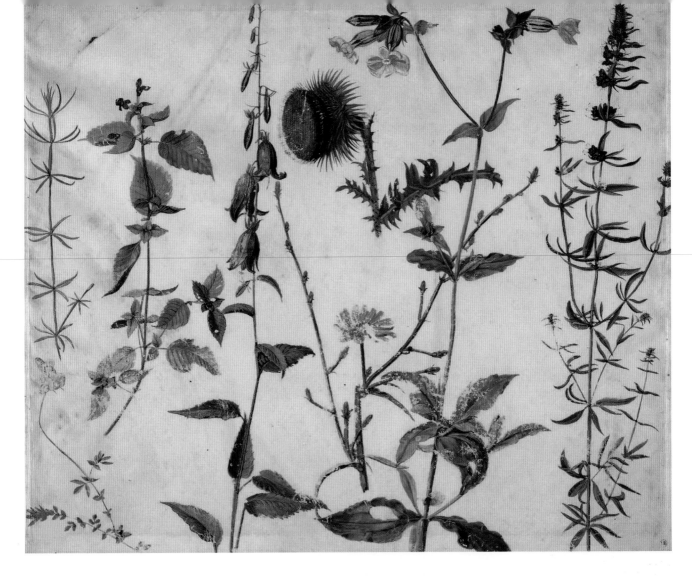

Portrait of a young girl, 1515, charcoal, 42 x 29cm (16.5 x 11.4in), Staatliche Museen zu Berlin, Germany

It is considered that the young girl might be a relative, possibly a Frey family member, a niece of Agnes. Dürer takes time to portray her face in detail, capturing her shy expression with eyes looking down. The drawing might be for his collection of workshop images.

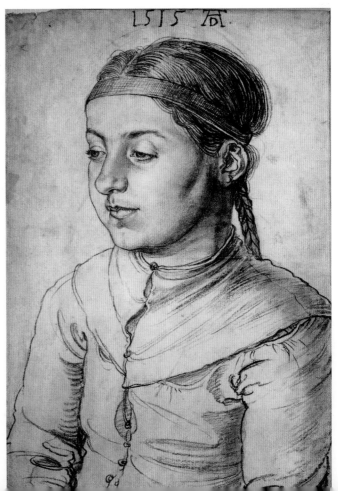

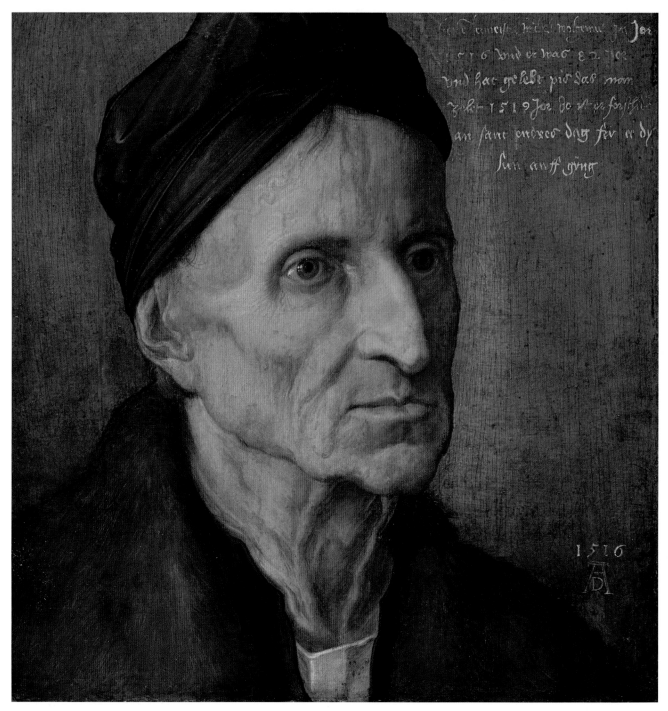

Portrait of Michael Wolgemut, c.1516, oil on linden wood, 29.8 x 28.1cm (11.7 x 11in), Germanisches Nationalmuseum, Nuremberg, Germany

Albrecht Dürer painted his former tutor, Nuremberg artist Michael Wolgemut, in 1516. The inscription on the portrait, written in Dürer's hand at top right states 'This was made by Albrecht Dürer of his teacher Michael Wolgemut in the year 1516'. After Wolgemut died in 1519, Dürer wrote the additional words 'And he was 82 years old and lived until 1519, it was then that he passed away on St Andrew's Day, in the morning, before the sun rose'. The realistic close-cropped, head and shoulders portrait, painted on a neutral green ground, concentrates attention on Wolgemut's elderly features. Dürer records Wolgemut's clear grey-green eyes with reddened rims, high cheekbones, the sagging skin of his neck; the black silk cap on his head, and the soft, rich texture of his fur collar, the individual hairs visible. But there is more, beyond the physical. Wolgemut, his face in a tranquil pose, looks out, beyond the picture plane, as if reminiscing on his full, artistically productive life, captured meticulously in oils by his most gifted pupil.

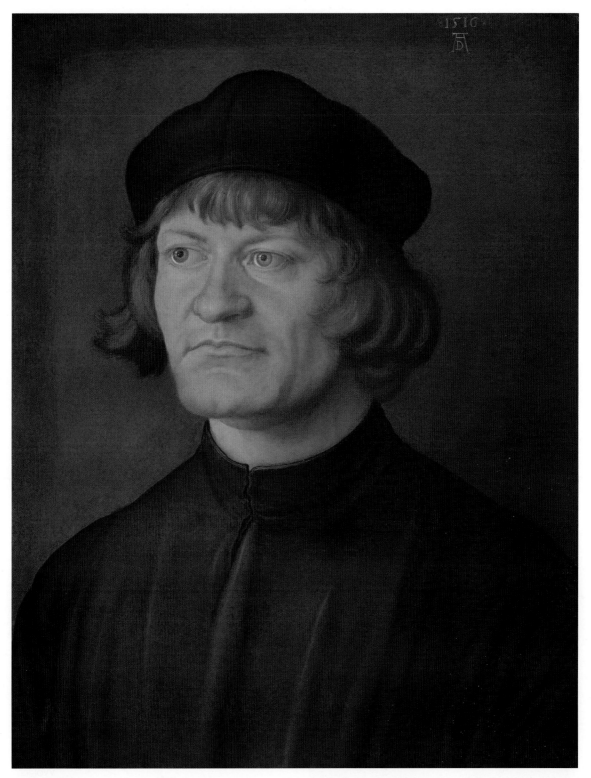

Portrait of a clergyman, 1516, oil on parchment on canvas, 41.7 x 32.7cm (16.4 x 12.8in), National Gallery of Art, Washington DC, USA

The clothing and hat of the person in this Dürer portrait, painted on parchment, suggest a church cleric. Seated facing toward his right, in three-quarter profile – Dürer's preferred composition for portraiture – the sitter is painted against a neutral backdrop, which draws attention to his facial features and bright hair of reddish-gold. Dürer captures the miniscule details, from the strands of his hair to his prominent jawline and facial wrinkles. His eyes are fixed on an unseen person or object, or in contemplation. The glass panes of a window in the room are reflected in the sitter's eyes, thus connoting the unseen room setting. It has been suggested that it is a portrait of cleric Johann Dorsch, of St John's church, Nuremberg but there is no positive confirmation.

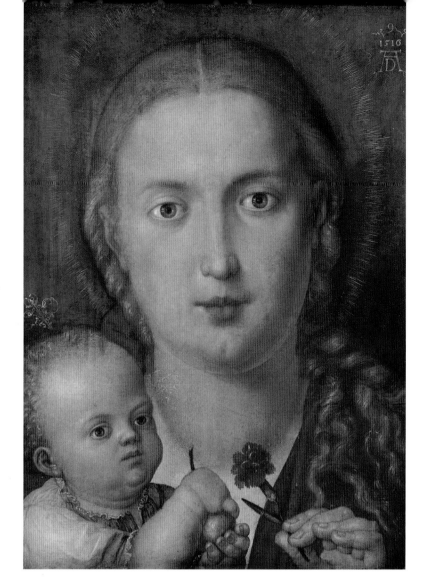

Madonna of the Carnation, 1516, parchment on linden wood, 39.7 x 29.3cm (15.6 x 11.5in), Alte Pinakothek, Munich, Germany

Attributed to Albrecht Dürer but possibly painted by his workshop from a study. The closely cropped portrait head of the Madonna with her infant is painted in a complementary green as backdrop, with the Virgin wearing red. The carnation she holds in her left hand also has a red flowerhead. Her eyes are fixated on the observer. The infant Christ looks out into the distance toward his left. He holds a pear firmly in his hands.

St Philip the Apostle, 1516, tempera on canvas, 46 x 38cm (18.1 x 14.9in), Gallerie degli Uffizi, Florence, Italy

A 'Tüchlein' – on cloth – painting, of the Apostle Philip, possibly intended as part of a series of heads of the apostles. There is another of Apostle Jacob. Dürer depicts the head of a saint against a dark background, which highlights the silvery strands of his hair, long highly curled moustache, and a beard in ringlets. The saint's eyes look down in contemplation.

Above: *Landscape with Cannon*, 1518, etching, 21.7 x 32.2cm (8.5 x 12.5in), Galleria degli Uffizi, Florence, Italy

This work is the largest of Albrecht Dürer's etchings. The landscape and village were sketched from the wealthy Nuremberg patrician Jakob Muffel's estate at Eschenau, situated 17.7 km (11 miles) from Nuremberg. The cannon is etched with a Coat of Arms of the city of Nuremberg, which provided support

Right: *Coat of Arms of Johann Tscherte*, c.1522, woodcut, 18.4 x 14.4cm (7.2 x 5.7in), The Metropolitan Museum of Art, New York, USA

and practical munitions to the emperor Maximilian I. Germany felt threatened by a Turkish invasion across European borders. For the cannon, Dürer used an older model; at the time of this work's creation much newer models were in use. The placement of the cannon in the foreground on a hill at left leads the eye across the lower plains to the dwellings in the middle distance, implying that the war machine was placed to protect the valley and its occupants.

Tscherte was an architect, engineer and mathematician specialising in military fortifications. He met Dürer in 1522 during the Imperial Diet in Nuremberg. The Coat of Arms was probably commissioned at that time.

Maximilian I, Emperor of Germany, 1518, charcoal, red chalk, heightened with white chalk, 38.1 x 31.9cm (15 x 12.5in), The Albertina Museum, Vienna, Austria

In 1518, during the meeting of the Imperial Diet of Augsburg, Albrecht Dürer, known to Emperor Maximilian I, was given access to draw a portrait in preparation for a painting. It took place on 28 June 1518. On the drawing he recorded what happened: 'This is Emperor Maximilian, whom I, Albrecht Dürer, portrayed up in his small chamber in the tower at Augsburg on the Monday after the feast day of John the Baptist in the year 1518.'

When Dürer sketched him, the emperor wore the regalia of his chain of chivalric order, on top of a brocaded mantle, his shirt, and his hat. In the study his three-quarter profile faces to his right. Dürer focused on the monarch's head, hair and facial features during the short time allotted to him for drawing. He made less-detailed sketches of clothing and regalia.

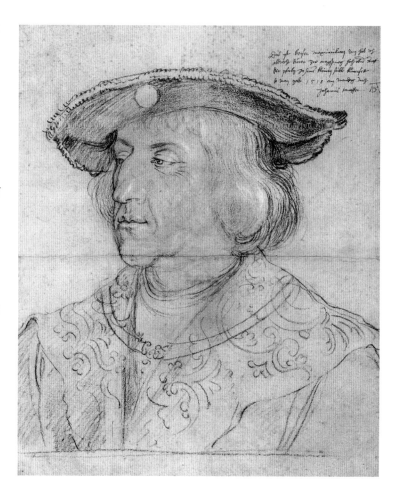

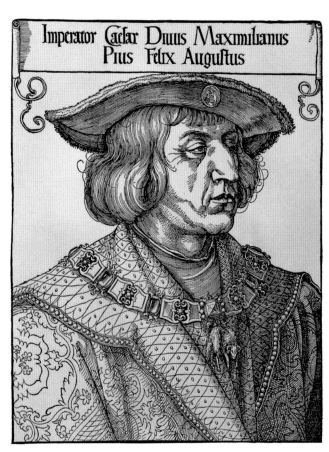

Emperor Maximilian I, c.1519, woodcut, 41 x 32cm (16.1 x 12.5in), Private Collection

This woodcut was created from the original drawing of Emperor Maximilian I, created by Dürer on 28 June 1518, during the Diet of Augsburg (see above). The emperor wears the chain of office of the Golden Fleece. The inscription above, on a scroll, reads: 'Emperor Cæsar Diuus Maximilianus / Pius Felix Augustus' ('Maximilian, the Divine, Commander and Emperor, the God-Fearing, the Successful and Sublime').

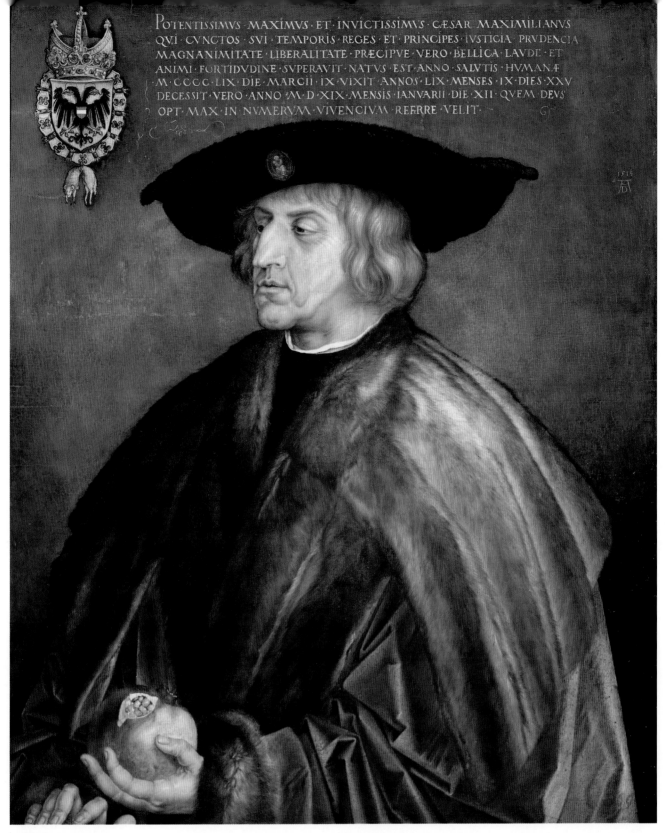

POTENTISSIMVS · MAXIMVS · ET · INVICTISSIMVS · CÆSAR · MAXIMILIANVS
QVI · CVNCTOS · SVI · TEMPORIS · REGES · ET · PRINCIPES · IVSTICIA · PRVDENCIA
MAGNANIMITATE · LIBERALITATE · PRÆCIPVE · VERO · BELLICA · LAVDE · ET
ANIMI · FORTIDVDINE · SVPERAVIT · NATVS · EST · ANNO · SALVTIS · HVMANÆ
M · CCCC · LIX · DIE · MARCII · IX · VIXIT · ANNOS · LIX · MENSES · IX · DIES · XXV
DECESSIT · VERO · ANNO · M · D · XIX · MENSIS · IANVARII · DIE · XII · QVEM · DEVS
OPT · MAX · IN · NVMERVM · VIVENCIVM · REFERRE · VELIT ·

Portrait of Emperor Maximilian I, c.1519, oil on linden wood, 86.2 x 67.2cm (33.9 x 26.4in), Kunsthistorisches Museum, Vienna, Austria

Painted on a green background, a colour Dürer favoured for neutral backdrops to focus attention on the sitter. The emperor wears a brilliant red silk ceremonial gown with a wide collar. His black hat is adorned with a medal decorated with a depiction of the Madonna and Child. In his hands he holds a pomegranate. At left, painted on the backdrop, is the Coat of Arms of the Habsburg family, surrounded by the Order of the Golden Fleece. Above is the Imperial crown.

The patron of this painting is thought to have been Jakob Fugger of Augsburg, commissioning it as an intended gift for Charles V, grandson of Maximilian I, and inheritor of the title Holy Roman Emperor.

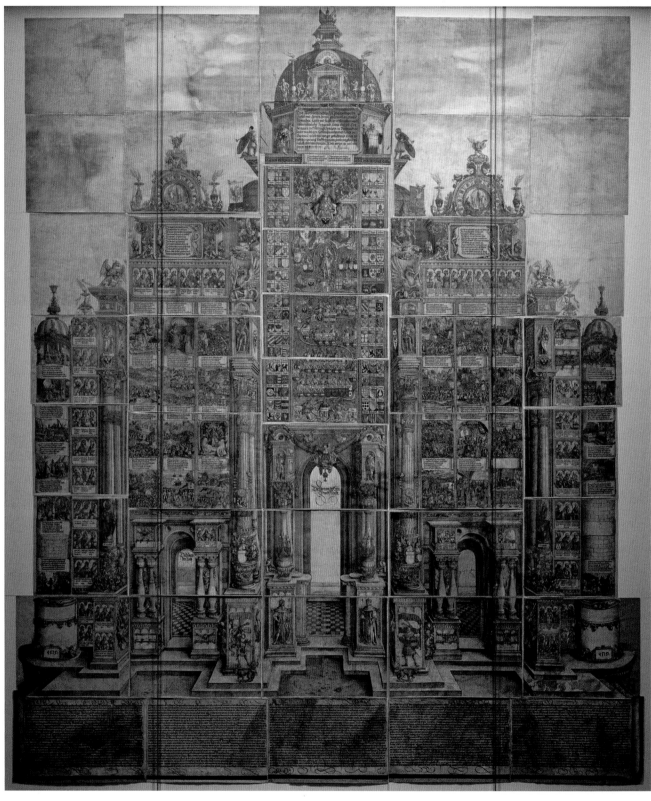

The Triumphal Arch of Emperor Maximilian I, printed 1517–18, Dürer and workshop, woodcut, partially gilded and original colouring, 3.54 x 3m (11.6 x 9.8ft), Herzog Anton Ulrich-Museum, Brunswick, Germany

The first edition of the monumental *The Triumphal Arch for Maximilian I* was created from 195 woodblocks on 36 large sheets of paper each measuring around 46 x 59cm (18 x 23in), making a picture over 3.5m (over 11ft) in height. It was produced as propaganda to promote Maximilian I, and 700 copies were made to be distributed. A few were coloured. The work took from 1512 to 1515, and was printed in 1517–18; there are different editions of the original. The black line version is shown on page 78, and in sample woodcuts opposite, revealing some of the incredible detail. Dürer was commissioned to create the overall design, working together with Albrecht Altdorfer, and assisted by woodcutter Hieronymus Andreae (see page 40), and artists Wolf Traut and Hans Springinklee.

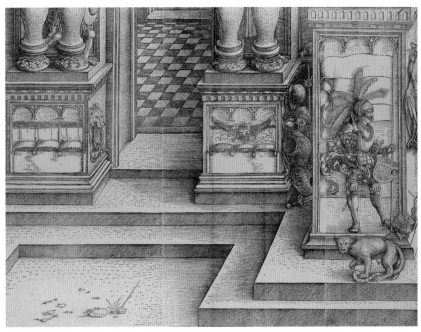

The Triumphal Arch (details), 1515, printed 1517–18, The Metropolitan Museum of Art, New York, USA

Close observation of *The Triumphal Arch* reveals wondrous details, depicting a wide range of themes relating to Maximilian I, such as his ancestry and, extended kinship, deeds, achievements and accomplishments, as well as personal interests. The images are both allegorical and specific. Top above shows a ram skin, the insignia of the Order of the Golden Fleece. Top right is the lower part of the entry to the front portal; there is a glimpse of a chequerboard floor, the *trompe l'oeil* illusion of steps to an interior space beyond. On the column base is a uniformed soldier, and below him, a monkey on a leash (and behind it, a huge snail crawling up the wall). Middle right, the Imperial crown tops the dome with a portrait of Maximilian on a lion. Lower right, two pillars flank the central portal of Honour (the gates of Praise and Nobility are on either side) with six hanged mermaids or sirens. Dürer is thought to have subcontracted the historical scenes and the family tree to his workshop and collaborators on the project.

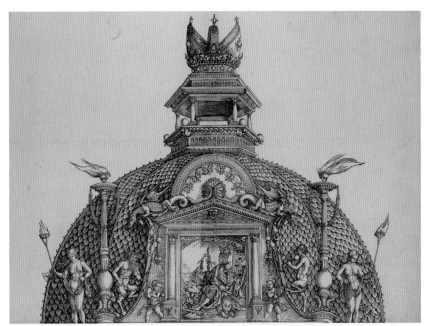

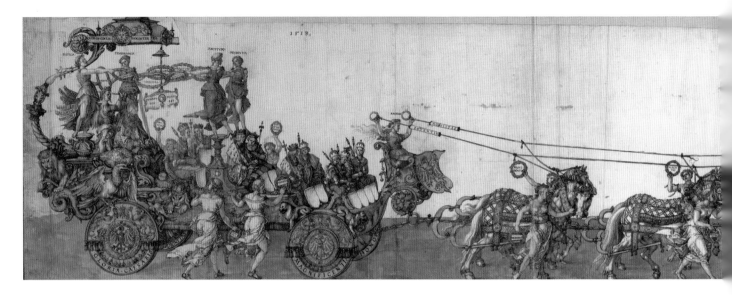

*The Large Triumphal Procession of Maximilian I (*also called *The Great Triumphal Procession),* **1518, feather in brown ink and watercolour, 46 x 253cm (18 x 99.6in), The Albertina Museum, Vienna, Austria**

Holy Roman Emperor Maximilian I commissioned a monumental frieze. Dürer created the initial design for the coloured presentation (see above). In overall charge of the project's execution were Johannes Stabius and Albrecht Altdorfer. It was to be 84m long (275ft), created from 210 woodcuts, although only 138 of the original number were cut, created by Albrecht Altdorfer, Burgkmair the Elder, Hans Schäufelein and other woodcutters. A later woodcut version, published 1522, annotated the participants (see detail on page 57). Dürer drew the emperor and his family seated in a wondrous state coach, led by six teams of horses. 'Virtues' would accompany them on their journey. The cardinal virtues were Justitia (Justice), Prudentia (wisdom), Temperantia (temperance) and Fortitudo (strength), standing on pillars next to the emperor. The chariot driver was Ratio (reason) . In attendance with the horses were Providentia, Moderatio, Alacritas, Opportunitas, Velocitas, Firmitudo, Viriliitsas, Acrimonia, Audacia, Experientia and Sollertia. The project was abandoned when the emperor died in 1519. The designs were however adapted for other works, including *The Burgundian Marriage* (see opposite).

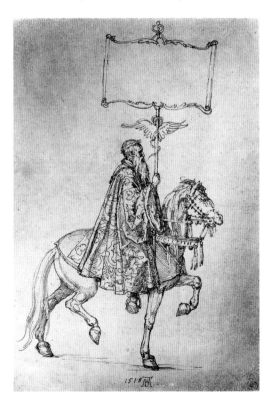

Left: *Old man riding in procession,* **1518, pen and black ink on white paper, 42.1 x 28.5cm (16.6 x 11.2in), The Albertina Museum, Vienna, Austria**

The long-bearded older man, wearing a laurel wreath, riding a horse for the triumphal procession of Maximilian I, is thought by some historians to be Johannes Stabius (1460–1522), a chief organiser of this project. The procession was a 'memory' trigger for events in the emperor's life, and to commemorate major achievements, such as the battles fought and won. It was an historic link to the Roman triumphal processions of antiquity, displaying the spoils of victory. Other drawings show a younger standard bearer, plus standard bearers with trophies from wars with France, Hungary, Bohemia and Italy. The death of the emperor curtailed the project.

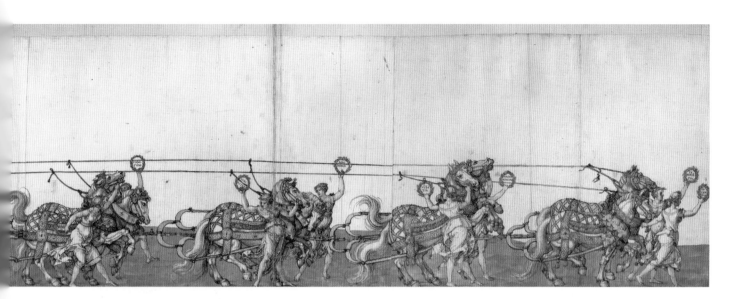

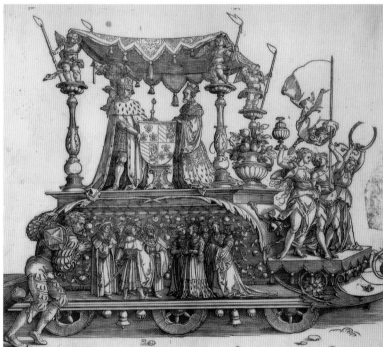

The Burgundian Marriage or *The Small Triumphal Carriage*, 1518, woodcut, 40.5 x 43.4cm (15.9 x 17in), Private Collection

The woodcut depicts the wedding chariot of Maximilian I (1459–1519), and Mary of Burgundy (1458–82). The couple stand together underneath a baldachino with the shield of Burgundy prominent. They were married in 1477, a union bringing the rich lands of Burgundy into the Hapsburg realm, uniting two powerful families. This is one half of two woodblocks (see below for the other half), created by Dürer in 1518 and published in 1522. It is a separate later work to *The Large Triumphal Procession of Maximilian I,* but related to it. Details on this work differ slightly from the other versions of the triumphal procession.

The Burgundian Marriage or *The Small Triumphal Carriage*, 1518, woodcut, 40.5 x 43.4cm (15.9 x 17in), Private Collection

This woodcut shows the triumphal chariot driven by the winged figure of Victory. Two pairs of horses with their heads up and tails flying denote the movement and speed of the carriage, as they pull the imperial chariot. This woodblock is the right-hand side of Dürer's *Burgundian Marriage* (see above) created in 1518 and published together as one print in 1522.

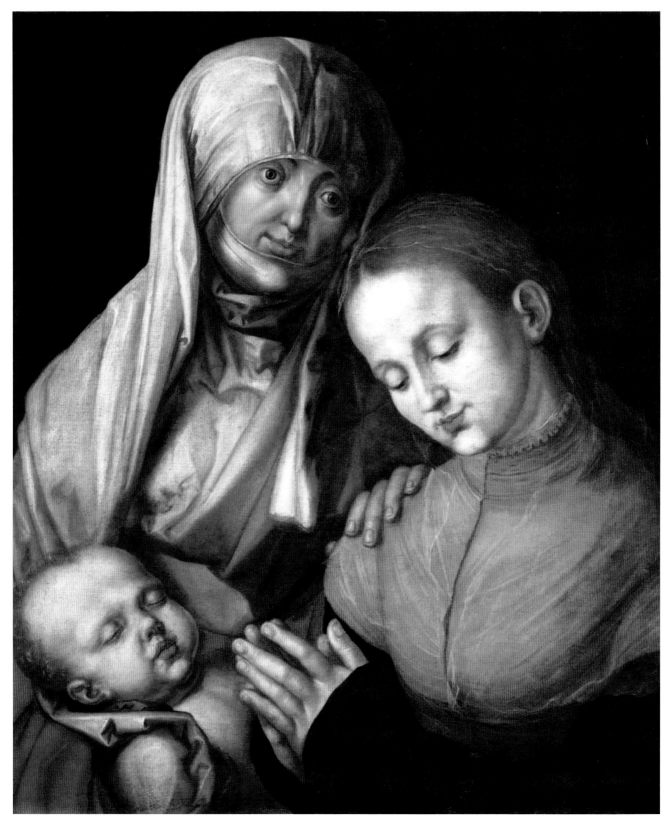

Virgin and Child with St Anne, 1519, oil on linden wood, 60 x 49.8cm (23.6 x 19.6in), The Metropolitan Museum of Art, New York, USA

Agnes Dürer modelled for St Anne, mother of the Virgin Mary. In this painting she has lost the matronly, tired features that are evident in the realism of the preparatory drawing (see opposite above). The models for the Virgin Mary and infant Christ were possibly relations of Agnes Dürer. St Anne, with head lowered, looks out beyond the viewer, in deep thought and contemplation. Her left hand rests on the shoulder of her daughter, who prays for her infant son.

St Anne, 1519, brush and grey, black and white ink on grey grounded paper (partly darkened by a later hand), 39.5 x 29.2cm (15.5 x 11.5in), The Albertina Museum, Vienna, Austria

Agnes Dürer modelled for the figure of St Anne in this preparatory study for the painting *Virgin and Child with St Anne*, 1519 (see opposite). The realism of the drawing reveals Agnes Dürer as a matronly person, reflected in her tired facial features. It is how Dürer portrayed his wife. St Anne also appears in a woodcut by Dürer, *The Holy Family with Joachim and St Anne*, 1511 (see page 204). Two later drawings by Dürer of St Anne dated 1522 are in the Museo Correr, Venice, Italy, and Kunsthalle, Bremen, Germany.

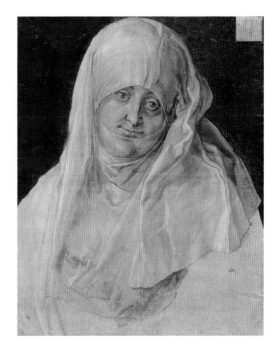

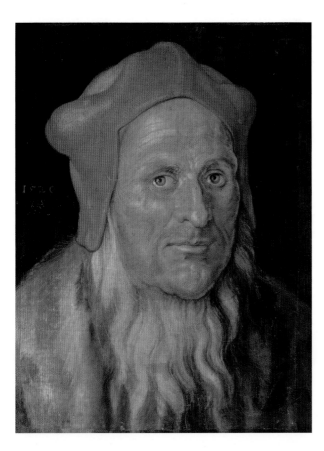

Bearded Man in a Red Cap, 1520, tempera on canvas glued on paper, 40 x 30.3cm (15.7 x 11.9in), Musée du Louvre, Paris, France

Monogrammed and dated 1520, the date indicates that the work was created in the Netherlands during Dürer's 1520–21 visit. It has been suggested that he may be a judge or a high-ranking official. It may be a person who aided Dürer during his stay. The dark backdrop allows the observer to focus on the bright red cap worn by the sitter. It frames his head, drawing attention to his clear green-grey eyes, pale eyebrows, gently-lined forehead, and faint stubble growth on his face. The preliminary drawing is visible in the lower part of the sitter's face.

The Virgin Mary in Prayer, 1518, oil on linden wood panel, 53 x 43cm (20.8 x 16.9in), SMB Gemäldegalerie, Berlin, Germany

The Virgin is pictured in near profile, turned to her right. She looks up, with her hands placed together in prayer. The painting is full of colour. A background of complementary red and green offsets the Virgin's clothing. She wears a blue cloak, a traditional colour of the Virgin; the hood is folded back on her head to reveal a flame-orange lining. Her body undergarment has pinkish-red sleeves. Her young face is shaped by the green head-shawl that covers her hair.

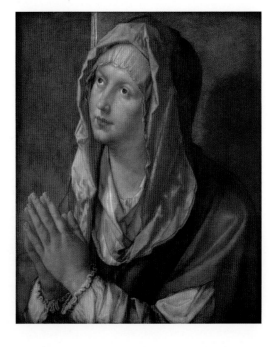

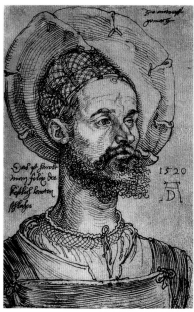 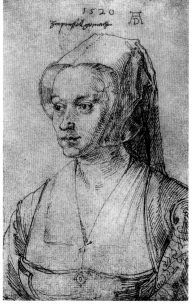

Felix Hungersperg, Captain and Lute Player, and *A Lady from Brussels*, 1520, pen drawings in brown ink, 16 x 10.5cm (6.2 x 4.1in) each portrait, The Albertina Museum, Vienna, Austria

Dürer drew the Imperial Captain twice. He did not hide the soldier's disfigurement in his left eye caused by an injury. On this work he wrote 'This is Captain Felix, the exquisite lutenist, done at Antwerp 1520'.

At right is a half-length portrait of a lady from Brussels. Dürer paid close attention to the fabric details of her headwear and dress. His travel journey through the Netherlands is filled with meetings, sales, materials bought, where he stayed, how much it cost, what he ate, who he met and the gifts he gave: 'I presented Lady Margaret a seated 'Jerome' engraved on copper'.

The Imperial Captain Felix Hungersperg in Full Figure, 1520, pen and ink drawing, 27.8 x 20.8cm (10.9 x 8.1in), The Albertina Museum, Vienna, Austria

Albrecht Dürer met Felix Hungersperg during his visit to the Netherlands. They became friends. In this sketch, the captain kneels with the Imperial Coat of Arms. On the inscription Dürer wrote of the Imperial Captain Felix Hungersperg, 'Felix Hungersperg, the exquisite and highly accurate lutenist'. Other notes state that Hungersperg and two other lute players were 'the best'. In his travel journal Dürer recorded 'I did a pen and ink drawing of Felix kneeling, in his notebook. He gave me a hundred oysters'.

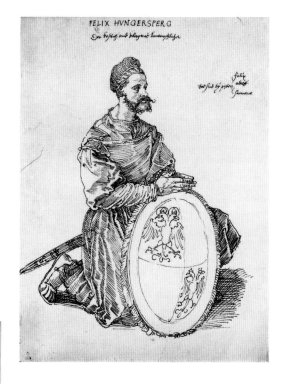

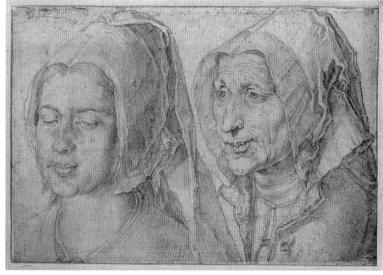

A Young and Old Woman from Bergen-op-Zoom, 1520, silverpoint on paper, 13 x 19cm (5.1 x 7.48in), Musée Conde, Chantilly, France

Wherever he travelled, and at home in Nuremberg, Dürer like to draw local people and clothing fashions. On this page Dürer contrasts a young woman and an older woman and their headwear. It was created in Bergen-op-Zoom, during his Netherlands journey, 1520–21.

Portrait of a 24-year-old man with a view of the St Michael's Abbey in Antwerp, 1520, silverpoint on ivory-coloured paper, 13 x 19cm (5.1 x7.4in), Musée Conde, Chantilly, France

In the forefront of this work, at left, Dürer drew in silverpoint a well-dressed young man (some query if it is a woman) in a close-cropped head and shoulders portrait composition. Behind him is a view of St Michael's Abbey, a significant building in Antwerp and one that Dürer greatly admired.

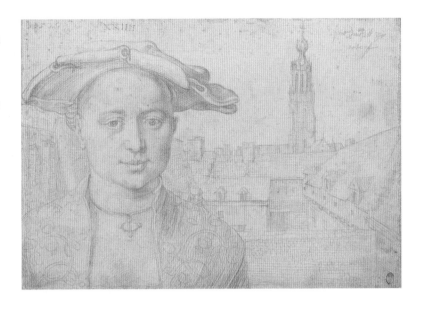

View of Bergen-op-Zoom, 1520, silverpoint on paper, 13 x 19cm (5.1 x7.4in), Musée Conde, Chantilly, France

From 3–7 December 1520 Dürer stayed in Bergen-op-Zoom in North Brabant, north of Antwerp, before he travelled by sea to Goes in Zeeland. In this topographical drawing, Dürer shows an outline landscape of the city's beautiful buildings..

Caspar Sturm with River Landscape, 1520–21, silverpoint on paper, 12.8 x 19cm (5 x 7.4in), Musée Conde, Chantilly, France

A page from Dürer's silverpoint sketchbook with a portrait of Casper Sturm (1475–1548) at left, and behind him a river landscape. The drawing has an inscription that states '1520 Casper Sturm 45 years old. Done at Aachen.' From October 1520 Sturm was an Imperial herald, who liaised with Nuremberg council. He is noted for escorting Martin Luther from Wittenberg to the Diet of Worms in 1521. The river landscape may have been added at a later date.

Left: *The Town Hall of Aachen*, 1520, silverpoint on paper, 12.8 x 19cm (5 x 7.4in), Musée Conde, Chantilly, France

An architectural drawing, noting the style of Aachen's major secular building with its decorative roof and castellations. It was built in the Gothic style during the first half of the 14th century. On completion it was proclaimed as one of the greatest and boldest achievements in secular architecture. Humanist Enea Silvio Piccolomini (1405–64) described it as the stateliest palace in all of Germany. In a small silverpoint drawing Dürer captured the vast dimensions of the town hall.

Below: *The Cathedral at Aachen*, 1520, silverpoint on paper, 12.6 x 17.4cm (4.9 x 6.8in), Private Collection

Dürer visited Aachen 4–26th October 1520. He noted the porphyry columns: 'At Aachen I saw the classically proportioned pillars with their fine capitals of green and red porphyry…' He noted that they had been sent to the city by Charlemagne from Rome. He commented on the proportions, created according to ancient writer Vitruvius's calculations. He notes the octagonal chapel of Charlemagne with its Gothic spire. The overview of the cathedral and buildings was possible as it was drawn from an upper window in the City Hall. Dürer was in Aachen at the time Charles V was crowned Holy Roman Emperor.

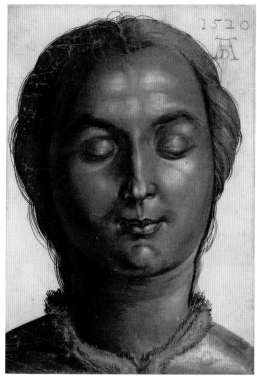

Above: *Head of a Woman*, 1520, brush drawing, in black and grey bodycolour, heightened with white, 32.4 x 22.8cm (12.7 x 8.9in), British Museum, London, England, UK

A close-cropped head of a young woman, with her hair tied back and her eyes closed. Dürer used a grey bodycolour copiously, to create the effect of a grisaille painting. He used the technique on several other head portraits. The sitter may be Zoetie, the daughter of a Genoese silk merchant, Tomasso Bombelli, whom Dürer met in Antwerp, but there is no confirmation. Dürer wrote of the Bombelli family in his journal.

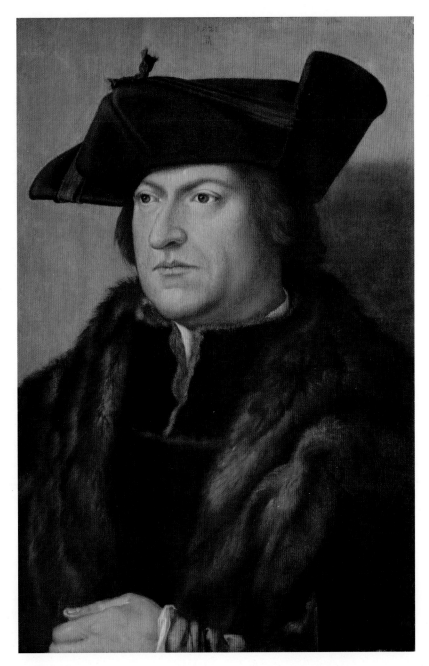

A Man in a Fur Coat, 1521, oil on oak panel, 50.6 x 32.9cm (19.9 x 12.9in), Isabella Stewart Gardner Museum, Boston, Massachusetts, USA

The identity of the sitter is unknown but the work dates to Albrecht Dürer's visit to the Netherlands, 1520–21. His travel journal refers to the painting of many portraits. German merchants of the Hanseatic League often commissioned portraits of themselves, to send home to their families in Germany. This is evident in Dürer portraits of merchants, and of Hans Holbein the Younger's many portraits of German merchants in London. The style of this work is close to Dutch portraiture by Quinten Massys (1465/6–1530), known to Dürer.

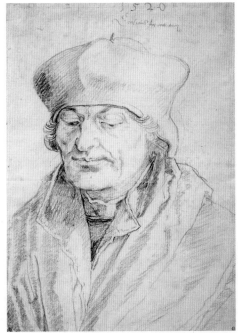

Desiderius Erasmus, 1520, drawing with black stone, 37 x 26cm (14.5 x 10.2in), Musée du Louvre, Paris, France

A drawing of Desiderius Erasmus of Rotterdam (c.1466–1536), created by Albrecht Dürer during his 1520–21 Netherlands' journey. He met the theologian in Brussels. After Dürer's death in 1528, Erasmus commented in his eulogy of the artist, 'He can paint anything…even things one cannot paint – fire, sun rays, thunder, electric storms, lightning and banks of fog… almost the human voice itself.' Here, Dürer 'draws' the wise nature of the theologian. (See also page 247.)

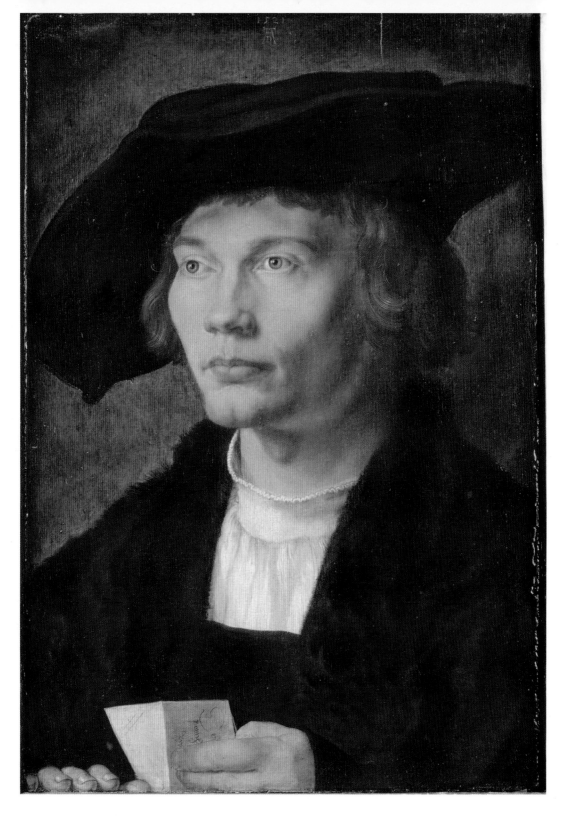

Portrait of Bernhard von Reesen, 1521, oil on oak wood, 45.5 x 31.5cm (17.9 x 12.4in), Staatliche Kunstsammlungen Dresden, Germany

A magnificent portrait of the wealthy Danzig-born merchant Bernhard von Reesen, living and working in the Netherlands, whom Dürer painted whilst there. It was possibly commissioned around December 1520 with initial drawings in charcoal. The oil painting was completed in March 1521. Dürer's travel journal mentions that von Reesen was a member of the German merchants in Antwerp. The merchant paid eight florins for the painting with additional gifts of money to Agnes Dürer and her maid. Von Reesen died of plague at the age of 30, in October 1521. Dürer gives the composition realism with the sitter's hands touching the lower edge of the painting. He holds a note in his left hand. An address, partially covered, is written on it: 'pernh… zw…', a visual denotation of the merchant's business dealings. The red backdrop throws interest on the sitter, who looks to his right. A strong unseen light from left highlights von Reesen's facial features. (See also page 239.)

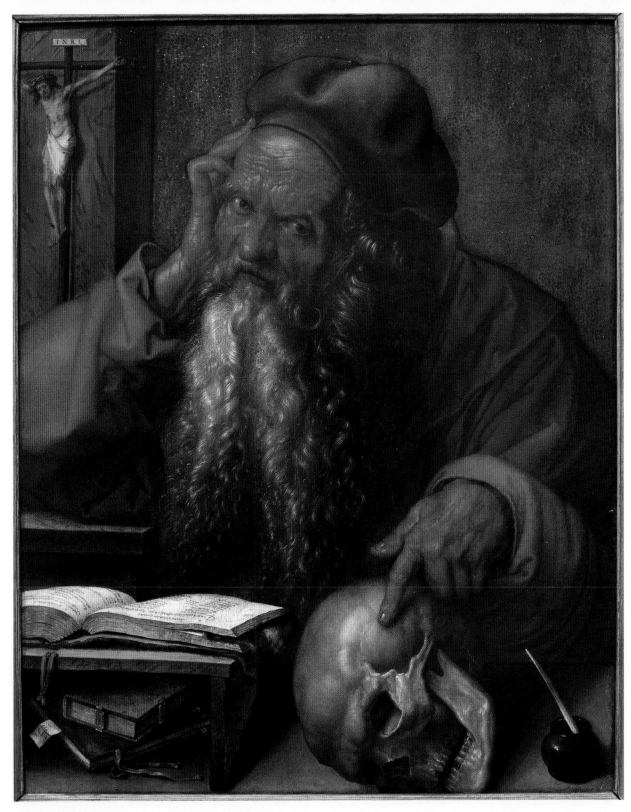

St Jerome, 1521, oil on
Baltic oak, 59.5 x 48cm
(23.4 x 19in), National
Museum of Antique Art,
Lisbon, Portugal

St Jerome was created
during Dürer's 1520–21
travels in the Netherlands.
Contemplating his mortal
life, St Jerome stares directly
out at the viewer. The close-
cropped half-length work
depicts the elderly saint
seated at his worktable, in
front of a bookrest with
books, and an opened
manuscript of Greek text
on the small lectern. Dürer
eliminates many of the
saint's attributes, including
his lion, as protector, an
hourglass, and the cardinal's
hat. Dürer condenses
them to a lifelike body on
the wall crucifix, a skull on
the table to which Jerome
points as a symbol of human
mortality, and books as
symbols of his intellectual life
as a theologian and role as
Church Father. The painting
was given to Dürer's close
friend Roderigo Fernandes
de Almada, an envoy of
the Portuguese trading
organisation in Antwerp. The
painting stayed in Antwerp
until 1548, allowing for
many copies to be made,
including by workshops of
Joos van Cleeve, Jan Sanders
van Hemessen, and Pieter
Coecke van Aalst.

Head of a 93-year-old Man, 1521, brush and black and grey ink, heightened with white, on grey-violet paper, 60 x 48cm (26.7 x 18.8in), The Albertina Museum, Vienna, Austria

This remarkable work is considered one of Dürer's most outstanding drawings, one of five extant created as preparation for the 1521 painting of St Jerome (see previous page). The male model for the large drawing was an elderly man that Dürer met during his working visit to the Netherlands. The sitting took place in Antwerp in January 1521. Dürer's travel journal records that he paid a 93-year-old man three stuivers to draw him, and it is thought it refers to this head and shoulders study. Dürer inscribed on the sheet 'ninety-three years old and still sane and healthy'. He made two studies of the man (the other is in the Staatliche Museen zu Berlin, Germany).

Arm and hand study, 1521, brush in black ink, heightened with white, on grey-violet paper, 39.3 x 28.3cm (15.4 x 11.1in), The Albertina Museum, Vienna, Austria

This work shows two other preparatory studies that Durer created for the painting in oils of St Jerome, 1521 (see previous page). At left, the drawing illustrates the upper left arm and the soft creases in the saint's clothing. At right, a larger drawing illustrates the lower left arm, and its hand with the index finger to be placed resting on the human skull. In this drawing, even more than in the painting, Durer highlights the prominent veins and worn-down fingernails of an old man. Pinholes around the work indicate a transfer to canvas.

Skull, 1521, brush in black ink, heightened with white, on grey-violet paper, 18 x 19.2cm (7 x 7.5in), The Albertina, Museum, Vienna, Austria

A preparatory study for the painting of St Jerome (see previous page). Dürer placed the skull on its right side with left side facing upward, giving it a lifelike appearance of sleeping with mouth agape. It is accurate in its anatomical realism. Dürer's travel journal records that he purchased a skull in the Netherlands. The skull is recognised as a symbolic memento-mori of human mortality.

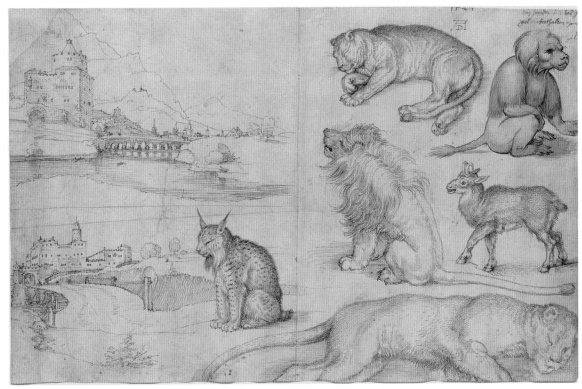

Sketches of Animals and Landscapes, 1521, pen and black ink with blue, grey and rose wash on paper, 26.5 x 39.7cm (10.4 x 15.6in), The Clark Art Institute, Williamstown, Massachusetts, USA

Six animals and two landscapes are drawn in silverpoint on this double page of Dürer's sketchbook, dated to 3–12 July 1521, when he visited the zoological gardens in Brussels. The inscription written at top left states: 'An extraordinary animal which I … Large, one-and-a-half hundredweight heavy…' He drew a lynx, sitting up, on the left-hand side, with two town landscapes. On the right-hand side are, from top, a lioness and a baboon. Beneath them are a lion sitting up, and a chamois – a species of goat-antelope – standing. At the bottom of the page, a large lion lies asleep. Its tail is extended to the left-hand page.

Two Studies of a Lion in Ghent Zoo, 1521, silverpoint on white prepared paper, 12.1 x 17.1cm (4.76 x 6.7in), Staatliche Museen zu Berlin, Germany

Two seated lions, drawn from life when Dürer travelled through the Netherlands in 1520–21 and visited a zoological park. From Dürer's album of sketches. Durer writes in his diary that he visited Bruges and Ghent April 6–11, 1521, and wrote 'saw the lions, and drew one of them in silverpoint.' He made four drawings of them.

Head of a walrus, 1521, pen and brown ink drawing, with watercolour, 20.9 x 30.9cm (8.2 x 12.1in), British Museum, London, England, UK

The inscription on this work states: 'The animal of those parts, whose head I have drawn here, was caught in the Netherlands sea and was twelve Brabant ells long with four feet.' That is a vast length, equating to over 8m (26ft). A walrus, full length, is 3.6m (11.8ft). It is considered that Dürer saw this walrus during his visit to Zeeland in December 1520.

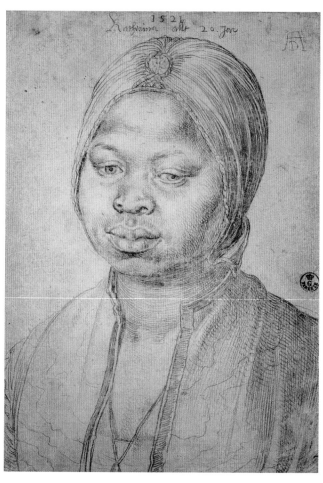

Agnes Dürer in Dutch costume, 1521, metalpoint on dark violet primed paper, 40.7 x 27.1cm (16 x 10.6in), Staatliche Museen zu Berlin, Germany

A bust portrait of Agnes Dürer, drawn during the couple's travels through the Netherlands. Under her headdress, her large eyes look to her right with a faraway expression. It is inscribed by the artist.

Portrait of Katharina, the 20-year-old servant of João Brandão, 1521, silverpoint, 20.1 x 14.1cm (7 x 5.5in), Gallerie Degli Uffizi, Florence, Italy

Katharina was a young servant of João Brandão,

that Dürer met during his Netherlands journey. He created a superb drawing of her head and shoulders in three-quarter profile, in silverpoint, in a closely-cropped drawing. Dürer kept the drawing.

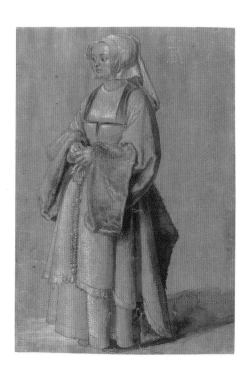

A Young Woman in Netherlandish Dress, 1521, brush and black and grey ink, heightened with white, on grey-violet prepared paper, 28.3 x 19.8cm (11.1 x 7.7in), National Gallery of Art, Washington DC, USA

Dürer's sketchbooks created during his year in The Netherlands include costumes and headdresses worn by local men and women and the people he met. In Dürer's travel

journal, he wrote at the end of the month of June 1521, 'I have also drawn two Netherlandish costumes with white and black on grey paper'. This work and another, of a Netherlandish woman seen from behind, showing the full length of her headdress and clothing, is probably the works to which he was referring. He took great care to include the texture of the fabrics and the pleating of the costume's drapery.

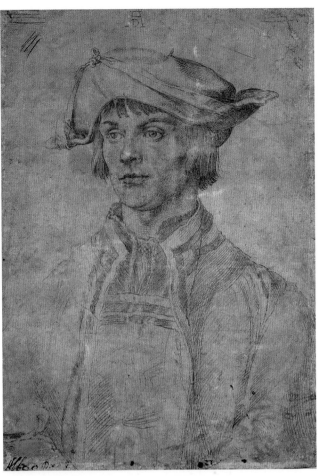

Portrait of a man, 1521, chalk on paper, 37.8 x 27.3cm (14.8 x 10.7in), British Museum, London, England, UK

This may be a portrait of the merchant Bernhard von Reesen, of Danzig, whom Dürer met in Antwerp, during his 1520–21 visit to the Netherlands. He made a portrait in oils of van Reesen in March 1521 (see page 234). The chalk drawing with van Reesen facing toward the light captures his strong facial features and curls of hair spilling out from under the large hat.

Lucas van Leyden, 1521, silverpoint on paper, 24.4 x 17.1cm (9.6 x 6.7in), Musée des Beaux-Arts, Lille, France

Dutch artist Lucas van Leyden (1494–1533) and Dürer became good friends during the latter's stay in the Netherlands. They created portraits of each other. Dürer made a half-length portrait of van Leyden on 22 June 1521, probably intended as a gift for the artist.

A Girl of Cologne and *Agnes Dürer in Boppard*, 1521, silverpoint on paper, 13.5 x 19.6cm (5.3 x 7.7in), The Albertina Museum, Vienna, Austria

In Dürer's silverpoint drawing book of his Netherlands' journey, he would draw first on the left side of the page. The right side may have been used at the same time, or at a later date. Here on the left, he made a portrait of a young girl wearing a festive headdress called *Stickelchen*, worn on special occasions. He makes a remark 'gepend' ('Gebande') in an inscription, a possible reference to the binding or braiding. Dürer had great interest in different fashions. At right, possibly at a later date, he made a half-length drawing of his wife Agnes, as they travelled near Boppard on their journey home. Dürer's inscription states: 'Cologne hair-banding/ On the Rhine, my wif/near Boppard'.

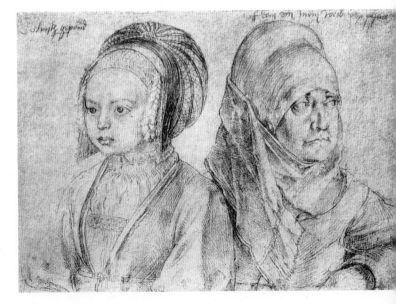

Design for the decoration of the Great Hall of Nuremberg Town Hall, 1521, feather in brown with watercolour, 25.6 x 35.1cm (10 x 13.8in), Pierpont Morgan Library, New York, USA

A section of Dürer's design for Nuremberg Town hall, instigated on his return from the Netherlands (see also pages 86–87).

Right: Coin made in 1521 depicting Charles V, King of Spain and Holy Roman Emperor, and on the reverse, the Imperial Double-Headed Eagle of the Holy Roman Empire, National Gallery of Art, Washington DC, USA

The use of coinage stamped with the head of a ruler dates back to ancient Greece and Rome. This coin, designed by Albrecht Dürer and cut by Nuremberg-born goldsmith Hans Krafft the Elder (1481–c.1542), is a dedication medal for the city of Nuremberg.

Right: *St Apollonia*, 1521, chalk on paper with a green ground, 41.4 x 28.8cm (16.2 x 11.3in), Staatliche Museen zu Berlin, Germany

Far right: *St Barbara*, 1521, chalk on paper with a green ground, 41.7 x 28.6cm (16.4 x 7.3in), Musée du Louvre, Paris, France

Detailed head and shoulders drawings of young women, for depictions of Saint Apollonia and Saint Barbara.

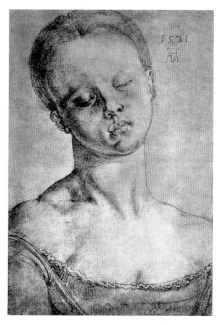

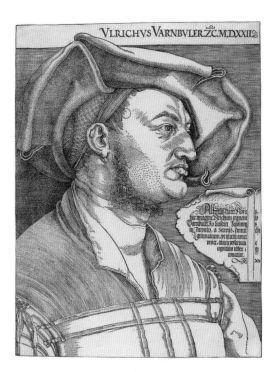

Portrait of Ulrich Varnbüler, 1522, woodcut, 43.4 x 32.4cm (17 x 12.7in), British Museum, London, England, UK

A bust-length portrait of Ulrich Varnbüler, facing three-quarters to the right, in near profile. Above his head is one line with his name, and the date in Roman numerals. Lower, on the right is a tablet with eight lines of Gothic inscription:

'Albrecht Dürer of Nuremberg wishes to make known to posterity and to preserve by this likeness his singular friend, Ulrich surnamed Varnbüler, Chancellor of the Supreme Court of the Roman Empire and at the same time privately a distinguished scholar of language.'

Ulrich Varnbüler, c.1522, charcoal drawing, 41.5 x 32cm (16.3 x 12.5in), The Albertina Museum, Vienna, Austria

Ulrich Varnbüler (1471– c.1544) was from 1507 chief clerk of the Imperial Chamber Court, becoming Chancellor in 1531. He was a friend of Albrecht

Dürer. The profile drawing captures the characteristics of the man, his face framed by a large hat worn at an angle. The dark background highlights Varnbüler's head. Dürer produced a woodcut of Varnbuler too, in the same year (see above), and this is probably a preliminary sketch, as the clothing, hat and composition are the same.

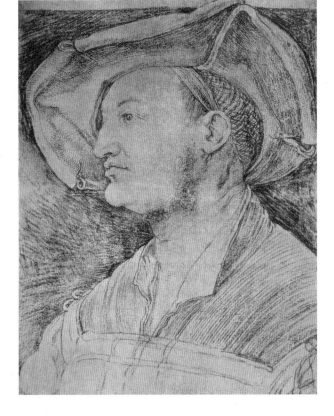

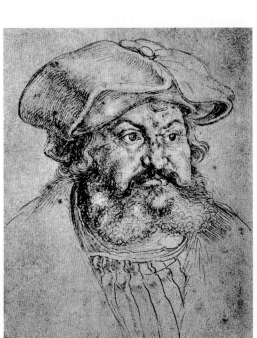

Frederick the Wise, 1522–23, drawing in silverpoint, Musée Bonnat, Bayonne, France

Duke Frederick III 'the Wise', Elector of Saxony, was one of Albrecht Dürer's earliest patrons, commissioning many religious

works and portraits. This intimate portrayal of the duke was probably made during a visit to Nuremberg from November 1522 to February 1523. Prints were created from the drawing. The work became a study for a portrait (see engraving overleaf).

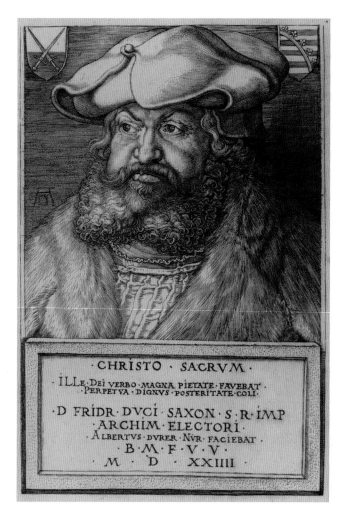

Duke Frederick III, Elector of Saxony, 1524, engraving, 18.8 x 12.2cm (7.4 x 4.8in), Private Collection

An engraving followed the 1522–23 drawing (see page 241) of Frederick the Wise, friend and patron of Dürer. In the upper corners are two Coat of Arms: Prince Elect of Saxony at left, and Dukedom of Saxony at right. There is much more detail given to the elector's facial features, particularly the eyes and beard, and the fur mantle he wears, than shown in the drawing. The 'D' of Dürer's AD monogram is reversed on this work.

The Latin inscription on a tablet beneath the portrait states: 'Sacred to Christ. He favoured the word of God with great piety, worthy to be revered by posterity forever. Albrecht Dürer made this for Duke Frederick of Saxony, Arch-Marshal, Elector of the Holy Roman Empire. B[ene] M[erenti] Fecit] V[ivus] V[ivo], MDXXIIII' ('Worthy of high praise even while still alive 1524').

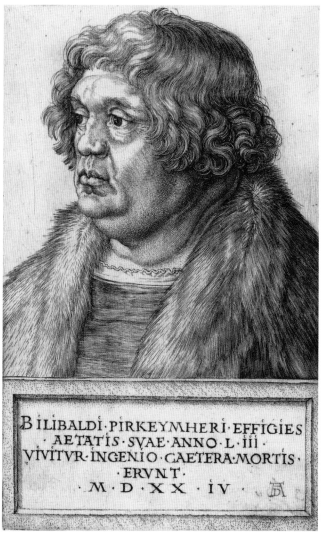

Willibald Pirckheimer, 1524, engraving, 17.8 x 11.2cm (7 x 4.4in), National Gallery of Art, Washington DC, USA

A print from an engraving of Willibald Pirckheimer of Nuremberg, a lawyer, humanist, scholar, military man, and mentor and friend of Albrecht Dürer. It can be compared to an earlier charcoal drawing of 1503 (see page 167). Dürer captures the nuances of Pirckheimer's thick-set head and shoulders, misshapen nose, heavy eyebags, double chin, the neatly-cut tousled hair, and the fur mantle he wears.

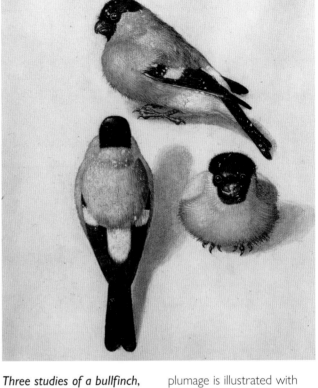

***Monkey*, watercolour and gouache on paper, Monasterio del Escorial, Madrid, Spain**

Albrecht Dürer owned pet monkeys amongst other animals. He captures their tentative characteristics, as in the engraving *Madonna with the Monkey*, c.1498 (see page 141). In another work, a curious monkey ambles across the steps of a column base of the *Triumphal Arch* (see page 225). Dürer's Netherlands' travel journal mentions purchasing a monkey during his year-long stay. He includes a baboon in his Brussels zoo sketches in July 1521 (see page 236).

***Three studies of a bullfinch*, watercolour and gouache on paper, Monasterio del Escorial, Madrid, Spain**

Dürer created three colour studies of an Eurasian Bullfinch *Pyrrhula pyrrhula*. Its favoured habitat is lowland woods and hedgerows. The male bird's distinctive plumage is illustrated with attention to detail, from above, side and front, highlighting the bird's rosy-red breast, black cap and thick bill. Dürer included a bullfinch drinking from a stream at the forefront of his small painting *St Jerome in the Wilderness*, c.1496 (see page 127).

***Bat*, 1522, watercolour on paper, 13.4 x 20.3cm (5.2 x 8in), Musée des Beaux-Arts et d'Archeologie, Besancon, France**

A spectacular watercolour study of a bat, its wings spread.

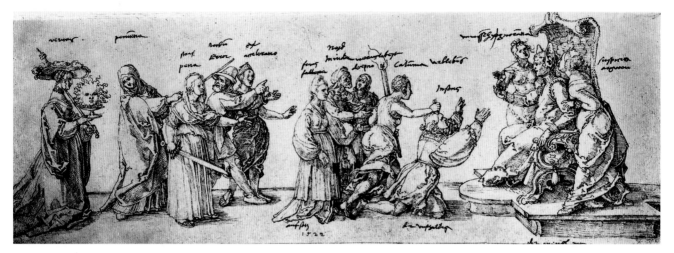

Slander (Calumny) of Apelles, 1522, feather in black, 15.1 x 44cm (5.9 x 17.3in), The Albertina Museum, Vienna, Austria

On his return from the Netherlands in 1521, Dürer received a commission from Nuremberg council to design a mural for the chamber of Nuremberg City Hall. It was to be an allegory of 'Slander', the defamation of Apelles, the revered painter of ancient Greece. The composition shows a seated judge and a procession of citizens with swords arguing against what they consider to be an unfair decision. Apelles had been falsely accused of plotting to overthrow the king. Apelles was nearly executed but the truth was revealed in time. (See also pages 86–87.)

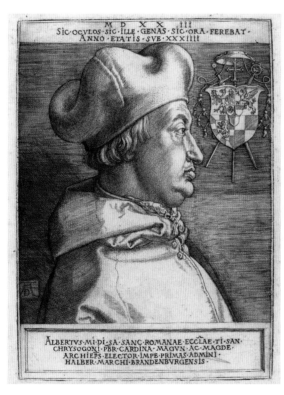

Cardinal Albert of Brandenburg, 1523, engraving, 17.5 x 12.9cm (6.8 x 5in), Private Collection

The German-born Cardinal Albert (aka Albrecht) of Brandenburg (1490–1545) is perhaps best known for the verbal attack on him by Martin Luther, for selling 'indulgences', a practice to raise money for the Catholic church. Luther condemned this practice in 95 theses, which may have been nailed to the door of the Castle Church, Wittenberg, on October 31, 1517. This is considered the beginnings of the Reformation.

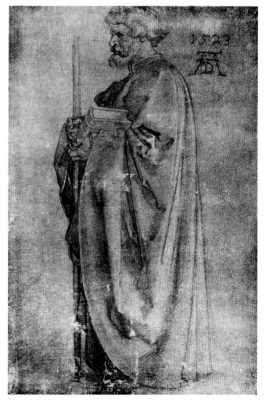

Standing Apostle dressed in a draped cloak, 1523, black chalk on green prepared paper slightly heightened in white chalk, 31.8 x 21.3cm (12.5 x 8.3in), The Albertina Museum, Vienna, Austria

The same study was used for the image of St Paul in the *Four Apostles* (see page 250).

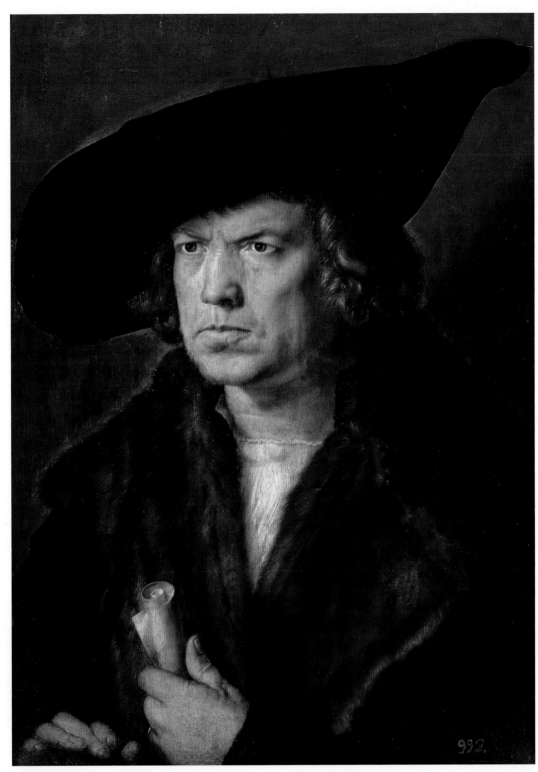

Portrait of an Unknown Man,
1524, oil on oak panel, 50
x 36cm (19.6 x 14.1in),
Museo del Prado, Madrid,
Spain

For such a magnificent
depiction it is perhaps
surprising that the name of
the sitter remains unknown.
The size of the hat infers
a big man with a strong

character. One suggestion
is of Lorenz Sterk, chief
tax collector in Antwerp,
for the Duchy of Brabant,
1514–25, whom Dürer
painted during his 1520–21
stay in the city. In Dürer's
travel journal, 'Antwerp
11 April–5 June 1521', he
mentions, 'I have taken
much trouble to paint a very
faithful oil-colour portrait of

Lorenz Sterk, the Treasurer.
I gave it to him as a gift,
and in response he gave
me 20 gulden, and Susanna
[Dürer's maid] a 1 gulden
gratuity.' Light streaming on
the sitter's features under a
vast hat reveals strong facial
features and determined
expression. The hooded eyes
are focused on an unseen
person or object. He frowns

in concentration with lips
pursed. In his left hand he
holds a rolled piece of paper.
Dürer paid painstaking
attention to every detail,
from the softness of the
vast hat brim to the delicate
stitching of the man's pleated
shirt, and the luxurious fur
collar of his black mantle.

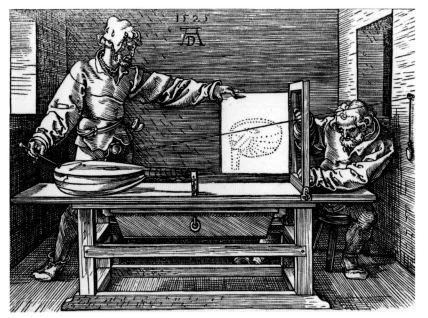

Left: Illustration from Dürer's *Treatise on Measurement*, published 1525, woodcut

This illustration depicts an artist drawing a lute with the aid of a perspective apparatus to measure distance. See also pages 66–67 and 90–91.

Below: Construction of Majuskel (upper case) letters from Dürer's serif typeface, 1525

In 1525 Dürer published *Treatise on Measurement* ('Underweysung der Messung mit dem Zirckel und Richtscheyt'). In it he created a font (known as the Dürer font), taken from lettering on Trajan's column, which could adapt its Roman numerals to Majuskel (upper-case) letters.

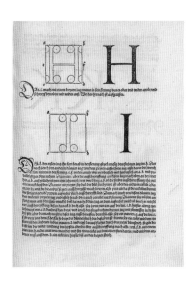

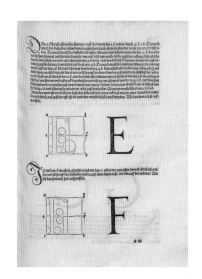

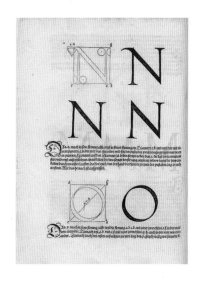

Illustration from Albrecht Dürer's *Four Books on Human Proportion* ('Vier Bucher von Menslicher Proportion'), drawing, 28.8 x 20.2cm (11.3 x 7.9in), The Metropolitan Museum of Art, New York, USA

Dürer was working on his theories of measurement from 1500 although they were not collated and published until 1525–28, the latter works posthumously. From the book published after Dürer's death in 1528 (see also pages 90–91), this illustration shows the body from front, back and side, and leaning in, divided into sections with measurements.

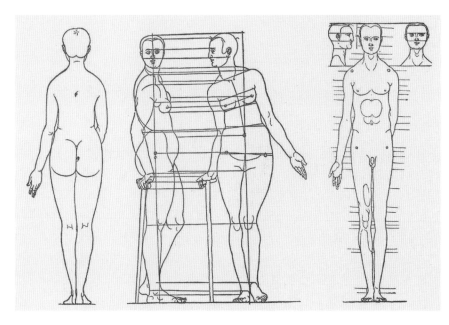

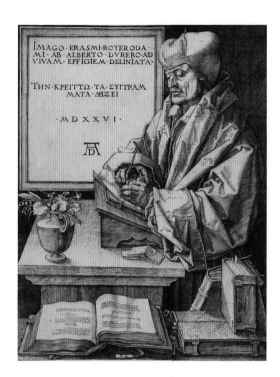

Erasmus of Rotterdam, 1526, engraving, 24.7 x 19.4cm (9.7 x 7.6in), Minneapolis Institute of Art, Minneapolis, USA

This is Dürer's last engraving. He had made a study of Desiderius Erasmus (1466–1536), the revered scholar, humanist and theologian, a few years previously when the two met in Brussels. The drawing (see page 233) was possibly intended for a painting of Erasmus, but no portrait was made. Erasmus, writing to Dürer's friend Willibald Pirckheimer in a letter dated 8 January 1525, asked to be portrayed by Dürer, reminding him that there was the earlier charcoal sketch, and Erasmus' likeness on a medal designed by Quentin Massys, that Dürer could copy. This engraving is perhaps a gift, as an apology to Erasmus, for not creating a portrait in oils. After receiving the engraving Erasmus wrote to Pirckheimer on 30 July 1526: 'I wonder how I can show Dürer my gratitude, which he deserves eternally. It is not surprising that this picture does not correspond exactly with my appearance. I no longer look as I did five years ago.' The inscription in Greek refers to Erasmus' writings. Dürer wrote in his diary, 'O Erasmus of Rotterdam, where will thou abide? O thou knight of Christ, seize the martyr's crown.' Erasmus replied, 'I am a heretic to both sides' (Roman Catholic and Protestant reformants).

Portrait of Jakob Muffel, Mayor of Nuremberg, 1526, oil on canvas, transferred to wood panel, 48 x 36cm (18.8 x 14.1in), SMB Gemäldegalerie, Berlin, Germany

From the slightly askew white shirt collar, creating a natural look, to the meticulous realisation of Jakob Muffel's fur coat and braided hat, this painting is considered one of Dürer's finest. Muffel was a rich patrician of Nuremberg. He died on 26 April 1526, and this portrait may have been painted in January 1526, shortly before his death. The neutral background places attention of Muffel's features, painted in three-quarter profile. The light source from left highlights the clear eyes, prominent nose, thin-lipped determined mouth, and the large vein throbbing on his forehead. Muffel served as mayor of Nuremberg many times and was one of Dürer's circle of close friends. (Shown large on page 212.)

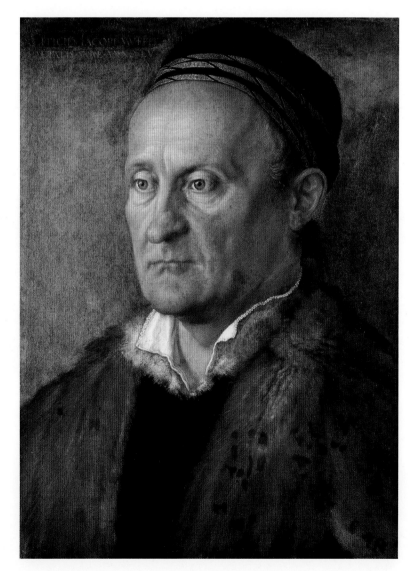

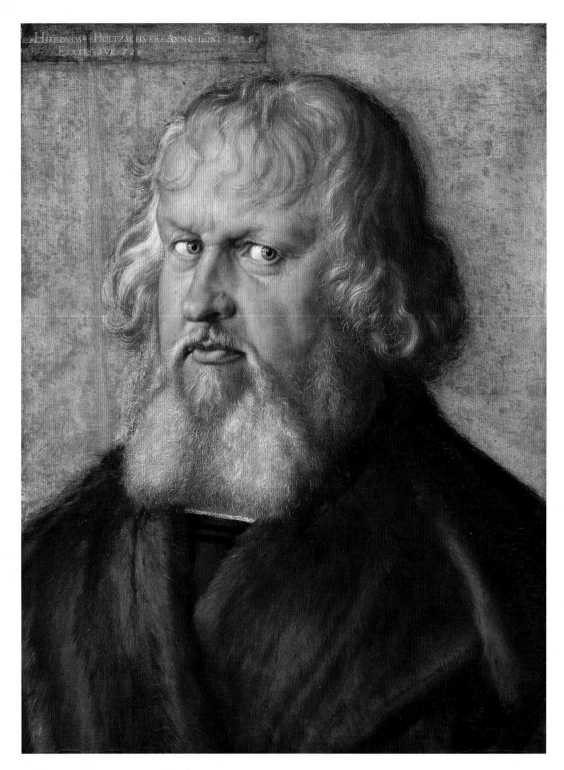

Hieronymus Holzschuher, 1526, oil on linden wood panel, 51 x 37cm (20 x 14.5in), Staatliche Museen zu Berlin, Germany

The Latin inscription, at top left on the painting, states: 'Hieronymus Holzschuher in the Year 1526 at the Age of 57'. The portrait bust depicts Holzschuher (1469–1529) – a wealthy Nuremberg patrician and city councillor since 1499 – positioned in three-quarter profile, his body facing toward his right with head turned to centre, to fix his eyes on the viewer with a frowning, inquisitive stare. His demeanour is solemn. Dürer meticulously paints the sitter's silvery-grey hair falling across his forehead and 'mutton chop' grey-white beard with sensational realism. Individual hairs of the wide, rich fur collar of his coat are visible. The painting, which remained in the Holzschuher family until 1884, had a sliding frame cover to protect the work. The Coats of Arms of Holzschuher, and the Müntzer family of his wife, were painted on it.

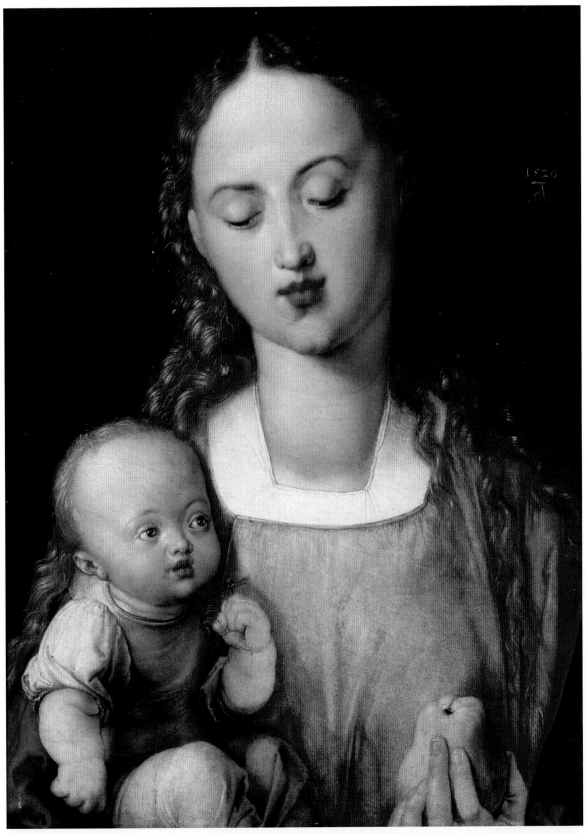

Virgin and Child, also known as *Virgin with the Pear*, 1526, oil on panel, 43 x 31cm (16.9 x 12.2in), Gallerie degli Uffizi, Florence, Italy

Also known as the *Madonna and Child*, or *Madonna with the Pear*, the Virgin holds a pear – a symbol of Christ – and looks down at her young son, the infant Christ depicted as a small child. The neck of the Virgin is elongated. The doll-like child is in the idealised Florentine manner of Andrea del Verrocchio and Sandro Botticelli. The Virgin is depicted as a young mother, without veil, crown or halo.

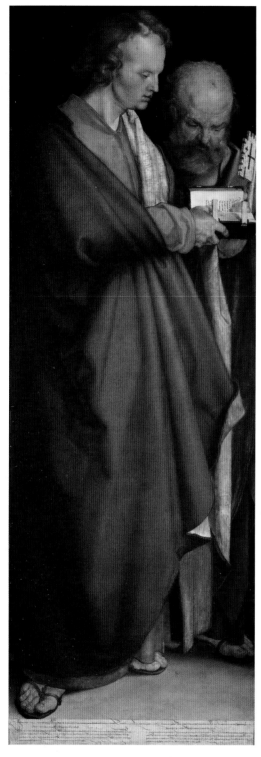
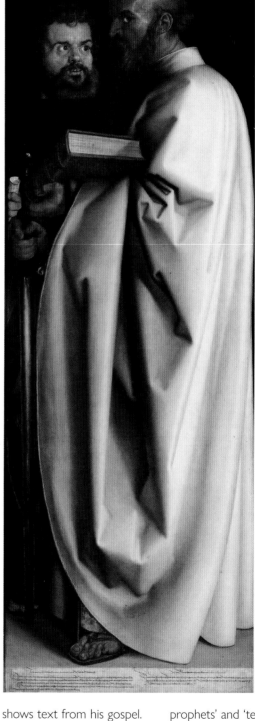

The Four Holy Men (or *Four Apostles,* or *Four Saints*), 1526, oil on linden wood – two panels, John the Evangelist and St Peter 212.8 x 76.2cm (83.7 x 30in); St Mark and St Paul 212.4 x 76.3cm (83.6 x 30in), Alte Pinakothek, Munich, Germany

This major religious large artwork by Albrecht Dürer was presented by him to Nuremberg council in 1526. There are four oversize depictions: John the Evangelist and St Peter in the left panel; St Mark and St Paul in the right panel. The open bible that St John holds

shows text from his gospel. St Peter leans in to read it. At the feet of the saints is a band of writing, with extracts from the biblical writings of the 'apostles', which may refer to the city of Nuremberg becoming Protestant in 1525. The extracts warn of 'false

prophets' and 'temporal agents' and to respect the words of the bible. (See also page 87.)

Portrait of Johannes Kleberger, 1526, oil on linden wood panel, 36.5 x 36.5cm (14.3 x 14.3in), Kunsthistoriches Museum, Vienna, Austria

This is the last portrait that Dürer created. The circular format was popular, reminiscent of ancient Roman medallion portraits, a *trompe l'oeil* painting representing a circle of green stone with portrait, inset into a square slab of marble. The portrait bust of businessman Johannes Kleberger (1486–1546) is painted in three-quarter profile, facing toward the sitter's right. A neutral background concentrates attention on the sculptural effect of the brightly lit, pale skin of Kleberger's face, - slim with high cheekbones and dark eyes – and his neck and shoulderbones. He wears his hair in the style of a Roman emperor, and long sideburns. The surrounding Latin inscription states: 'Portrait of Johann Kleberger of Nuremberg at Forty Years old'. Attributes of Kleberger's coat of arms are pictured in the lower corners.

Study of a lily, 1526, watercolour on paper, 9.7 x 11.8cm (3.8 x 4.6in), Musée Bonnat, Bayonne, France

A watercolour close-up of an open blue lily flower, the fleur-de-lis is composed of six blue-grey tepals. The flower was cut in the upper part of the stem with a leaf to the right of the flower. Created probably for Dürer's workshop collection.

Dream Vision, 1526, pen and ink with watercolour on paper, 30.5 x 32.5cm (12 x 12.7in), Kunsthistoriches Museum, Vienna, Austria

An apocalyptic dream that Dürer had in 1526 was copied down in ink and watercolour. He had dreamt of a dramatic flood caused by torrential, unremitting rain. It worried him but he allayed his fear by analysing what he had seen in his dream, relating it to cloud formation, and the distance between himself and the storm, writing his observations below the watercolour drawing.

BIBLIOGRAPHY

Ashcroft, Jeffrey. *Albrecht Dürer: Documentary Biography* (2 volumes), Yale University Press, New Haven and London, 2017

Ashcroft, Jeffrey. 'Black Arts: Renaissance and Printing Press in Nuremberg 1493–1528', Forum for Modern Language Studies Vol. 45 No. 1 doi:10.1093/fmls/cqn065, Oxford University Press for the Court of the University of St Andrews, 2008

Ashcroft, Jeffrey. 'Art in German: Artistic Statements by Albrecht Dürer', Oxford University Press for the Court of the University of St Andrews, 2012

Bailey, Martin. *Dürer*, Phaidon Press, London, 1995

Bartrum, Giulia. *Dürer and his Legacy: the Graphic work of a Renaissance artist*, exhibition catalogue, British Museum, London, 2002–03

Bartsch, Adam von. & Strauss, Walter L. *Sixteenth century German Artists: Albrecht Durer (The Illustrated Bartsch, 10 Commentary)*, Abaris Books, New York, 1981

Böhme, Hartmet. *Albrecht Dürer. Melancolia I*, Im Labyrinth der Deutung, Frankfurt-am-Main, 1989

Britton, Piers. ' "Mio malinchonico, o vero... mio pazzo": Michelangelo, Vasari, and the Problem of Artists' Melancholy in Sixteenth-Century Italy,' Sixteenth-Century Journal, XXXIV/3, pp.653–75 (oclc.org), 2003

Buck, Stephanie. & Porras, Stephanie. *The Younger Durer: Drawing the Figure*, exhibition catalogue, The Courtauld Gallery, Paul Holberton Publishing, London, 2013

Cochlaeus, Johannes. Luther's Lives, Google Books

Conway, William Martin, Sir. *Literary remains of Albrecht Dürer*, Cambridge University Press, 1889

Dackerman, Susan (ed.) *Prints and the Pursuit of Knowledge in Early Modern Europe*, Harvard Art Museums, Yale University Press, 2011

Dürer, Albrecht. *Albrecht Dürer: Diary of his Journey to the Netherlands 1520–1521*, Lund Humphries Publishers Ltd, 1971 (Diary reproduced from Sir William Conway (1856–1937), *Literary remains of Albrecht Dürer*, Cambridge University Press, 1889)

Doerner, Max. *The Materials of the Artist*, Rupert Hart-Davis Ltd, London, 1969

Foister, Susan. *Dürer and the Virgin in the Garden*, National Gallery Publications, Yale University Press, 2004

Fowler, Patrick W., and John, Peter E. 'Dürer polyhedra: the dark side of Melancholia,' in Discussiones mathematicae. Graph theory/Uniwersytet Zielonogórski, Wydział Matematyki, Informatyki i Ekonometrii. – Warsaw : De Gruyter Open. – 22 (2002), 1, p.101–09; Dürer polyhedra: the dark side of Melancholia – Digitale Bibliothek Thüringen (db-thueringen.de)

Jaeger, C. Stephen. Enchantment: *On Charisma and the Sublime in the Arts of the West*, University of Pennsylvania Press, Philadelphia, 2012

Jenkins, Catherine.., Orenstein, Nadine M., Spira, Freya. *The Renaissance of Etching*, Metropolitan Museum of Art, Yale University Press, 2019

Jones, Susan Frances. *Van Eyck to Gossaert: Towards a Northern Renaissance*, National Gallery Company, London and Yale University Press, 2011

Kharibian, Leah. *The Northern Renaissance: Dürer to Holbein*, Royal Collection Enterprises, London, 2011

Klibansky, Raymond., Panofsky, Erwin., and Saxl, Fritz. *Saturn and Melancholy: Studies in the History of Natural Philosophy, Religion, and Art*, Nelson, London, 1964

Koerner, Joseph Leo. *The Moment of Self-Portraiture in German Renaissance Art*, The University of Chicago Press, Chicago and London, 1993

Kotková, Olga (ed). *Albrecht Dürer: The Feast of the Rose Garlands 1506–1606*, exhibition catalogue, National Gallery of Prague, 2006

Landau, David. & Parshall, Peter. *The Renaissance Print: 1470–1550*, Yale University Press, New Haven and London, 1994

Laurie, A.P. *The Painter's Methods and Materials*, Dover Publications Inc., New York, 1967

Metzger, Christof. (ed) *Albrecht Dürer*, exhibition catalogue, Prestel Publishing, New York and London, 2019

Monson, Jim. 'The Source for the Rhinoceros' *Print Quarterly*, March 2004, Vol. 21, No. 1, pp. 50–53. Print Quarterly Publications, 2004 URL: https://www.jstor.org/stable/41826120

Nash, Susie. *Northern Renaissance Art*, Oxford University Press, 2008

Ottolino della Chiesa, Angela. *The Complete Paintings of Dürer*, Penguin Books, London, 1968

Panofsky, Erwin. *The Life and Art of Albrecht Durer* (4th Edition, revised), Princeton University Press, 1955

Panofsky, Erwin. *Studies in Iconology: Humanistic Themes in the Art of the Renaissance*, Oxford University Press, New York, 1939

Phillips, Margaret Mann. *Erasmus and the Northern Renaissance*, The Boydell Press, Rowman & Littlefield, 1981

Robison, Andrew, & Schröder, Klaus Albrecht. *Albrecht Dürer: Master Drawings, Watercolours, and Prints from the Albertina*, National Gallery of Art, Washington, Delmonico Books, Prestel Publishing, Munich, London and New York

Sander, Jochen. *Albrecht Dürer: His Art in Context*, exhibition catalogue, Prestel Publishing, Munich, London, andNew York, 2013

Silver, Larry & Wyckoff, Elizabeth (eds). *Grand scale: monumental prints in the age of Dürer and Titian*, Wellesley College, Massachusetts, in association with Yale University Press

Smith, Jeffrey Chipps. *The Northern Renaissance*, Phaidon Press, London and New York, 2004

Smith, Jeffrey Chipps. *Nuremburg: A Renaissance City 1500–1618*, University of Texas Press, Austin, 1983

Strauss, Walter L. (ed) *The Complete Engravings, Etchings & Drypoints of Albrecht Dürer*, Dover Publications, New York, 1973

Thausing, Moriz. *Albrecht Dürer, his life and works* (Translated from German original by Fred A. Eaton), John Murray, London, 1882

Van Mander, Karel. *Schilder-boeck* (1603–04)

Wagner, Bettina (ed). *Worlds of Learning: The Library and World Chronicle of the Nuremberg Physician Hartmann Schedel (1440–1514)*, Allitera Verlag, Munich, 2015

Wolf, Norbert. *Dürer*, Prestel Publishing, Munich, London and New York, 2011

Wolf, Norbert. *Albrecht Dürer: The Genius of the German Renaissance*, Taschen GmbH, 2016

Wölfflin, Heinrich. *Drawings of Albrecht Dürer*, Dover Publications Inc, New York, 1970

Zuffi, Stefano. *Dürer*, Prestel Publishing, 2012

REFERENCE

Records of Journeys to Venice and the Low Countries by Albrecht Dürer, Project Gutenberg eBook

'Of the Just Shaping of Letters,' extract from The Applied Geometry of Albrecht Durer, Project Gutenberg eBook

Nuremberg Chronicle, University of Cambridge, England (cam.ac.uk)

INDEX